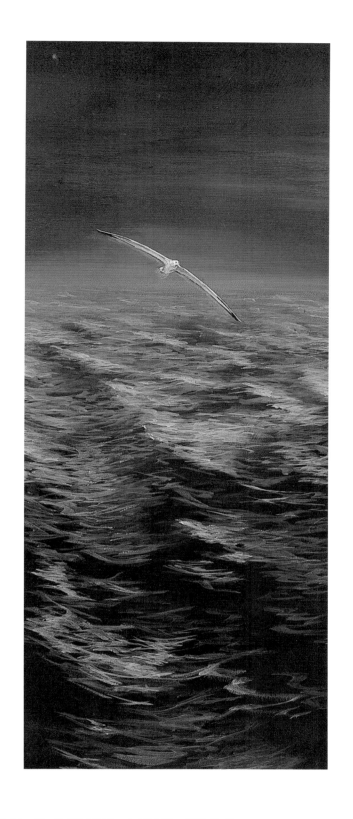

A VOYAGE ROUND THE WORLD IN PAINTINGS

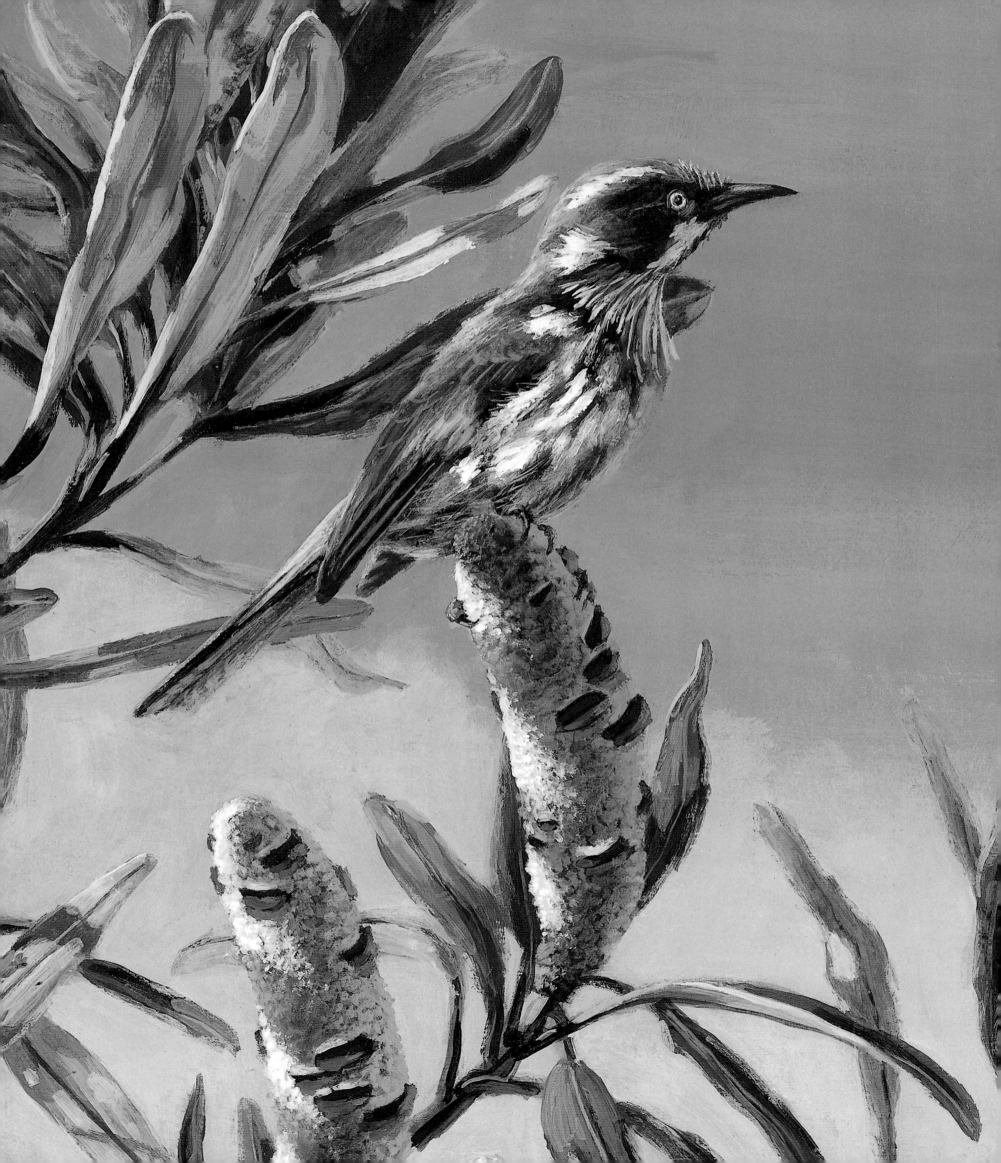

A Voyage Round *the* World *in* Paintings

THE ART OF JULIE ASKEW

NEW HOLLAND

Kindly sponsored by Joan F Rogers – Australia.

First published in 2008 by
New Holland Publishers (UK) Ltd
London • Cape Town • Sydney • Auckland

Garfield House
86–88 Edgware Road
London W2 2EA
www.newhollandpublishers.com

80 McKenzie Street
Cape Town 8001
South Africa

Unit 1,
66 Gibbes Street
Chatswood, NSW 2067
Australia

218 Lake Road
Northcote, Auckland
New Zealand

ISBN 978 1 84773 156 2

Assistant Editor: Amy Corbett
Design: www.bluegumdesigners.com
Production: Marion Storz
Editorial Direction: Rosemary Wilkinson

Reproduction by Modern Age Repro House Ltd, Hong Kong
Printed and bound by Tien Wah Press, Singapore

10 9 8 7 6 5 4 3 2 1

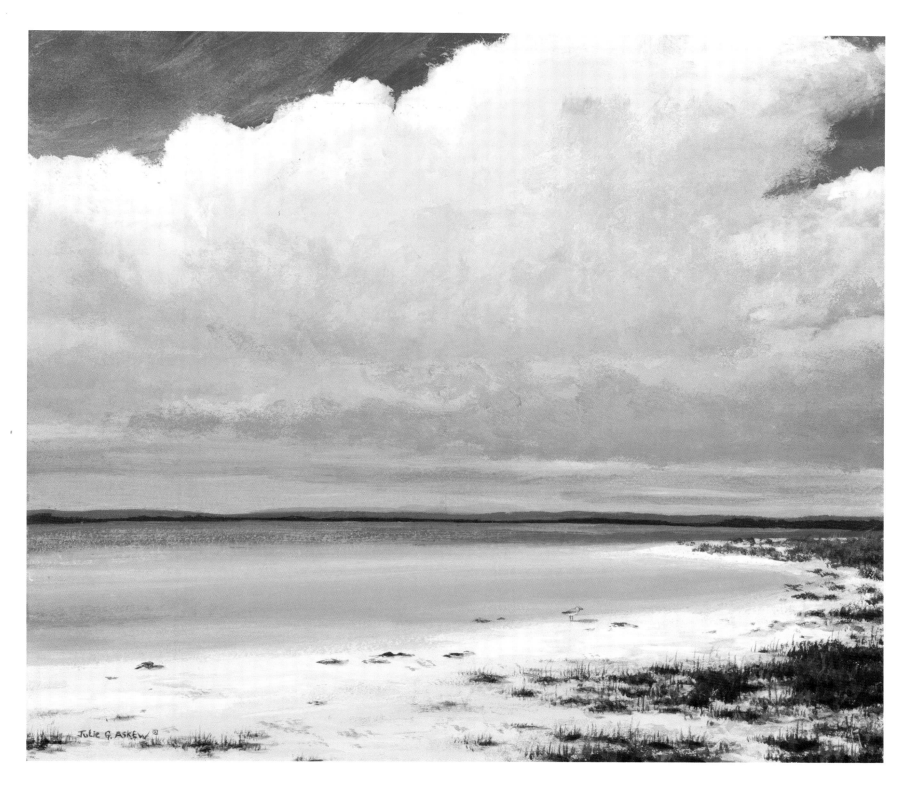

For Hans with my love

Acknowledgements

This book would not have been possible without the help and support of many people.

My thanks go to Jeffrey Whiting for writing a superb preface.
To Simon Trapnell for great encouragement and for writing such a wonderful foreword.
To Anne Vansvery for going above and beyond.
To Rosemary Wilkinson at New Holland Publishers for your imaginative insight and support.
Thank you to Liz Thorold and Oliver Swann at the Tryon Gallery for your unceasing support and encouragement over the years.
To Skip Tubbs of Frameworks Gallery in Montana, to all at the Nature in Art Museum and to Tony and Kaleidoscope, Birmingham.

Thank you to those collecting my work including Phyllis and Frank Graves OBE, Anne and Keith Sturdy, Pam Hart, The Daffin Family, Lorna and Max Bingemann, Joan Rogers and Jan McMaster Hon.Trust.CED., Jonathan Ratcliffe.

Thanks to my friends and fellow artists who have encouraged and inspired, including:
John Seerey-Lester, Robert Bateman, Dan Smith, John Banovich, Stig Weye, Su Lees, Toni and Graham Young, Jackie Garner, Lisa Clift, Janice Linden, Mark Slawson, Glenn Pagel, Dick Moulden, Pat Pauley, Roger Scott, Jeff Hoff, JR Monks (the Beartooth Gang) and Ann E. & Malcolm Kilminster, Jen and Tony Humphries, Lisa Farndon, Jenny Davies and Brian Salisbury.

A special thank you to my parents Margaret and Rodney and brother Philip – my appreciation is beyond words.

And finally to my friends and mentors Paco Young and Simon Combes for sharing your wisdom with your humble student. You are always with me.

Paco Young

Foreword

WHAT A PLEASURE it is to travel! The memories of new sights and cultures live with us for the rest of our lives and make us better people. For many of us those experiences are summed up in a collection of photographs or perhaps a written diary (which we rarely share with others!).

People like Julie are very fortunate people. She has found a real treasure – a vocation in life, seeing the world and recording her experiences through art, a skill that most of us envy. But, looking at the world through the eyes of an artist can take us on a thrilling journey, giving us new insights as well as stimulating our own memories of exploration.

Julie is a renowned wildlife artist. Yet there is a perception amongst some people that artists working from nature are almost exclusively about animal and bird portraiture or the depiction of the big cats of the African plains, for example. Julie's love of nature is evident in this book but she, like many artists, has the uncanny ability to see the world through fresh eyes. She is interested in everything. She is not looking at the world with blinkers on, but with an open view soaking up every nuance of the places she visits. By sketching and painting on the spot, she directs our gaze to both the minutest detail and the bigger picture. Artists see things that others fail to spot. They are constantly alert, drawing inspiration from every scene, familiar and unfamiliar. In fact, their way of seeing and of interpreting the world can help the rest of society get a hold on nature and conservation issues, to appreciate beauty and cultural differences and to celebrate diversity.

Art, like travel, can prick the conscience, sow the seed of awareness and nurture appreciation of our natural and cultural heritage. Put art and travel together and you have an intoxicating, challenging and inspiring mix.

That is partly what makes this book so irresistible. Rarely do you get the opportunity to experience a journey through the eyes of an artist, sharing their responses and reactions to what they see. But in this book we are given free access to a diary which, through images and words, wherever we are, can take us to a different place, teach us new things and remind us of our own treasured experiences. To have these memories punctuated by images of some of the finished paintings that have resulted from Julie's travels reminds us how her journeys are still inspiring her work.

So, whether you want to celebrate your own travel memories or invigorate plans for new trips, or simply to share someone else's journey, this book is sure to inspire.

Enjoy the adventure.

SIMON TRAPNELL, Director of the Nature in Art Museum. UK.

Preface

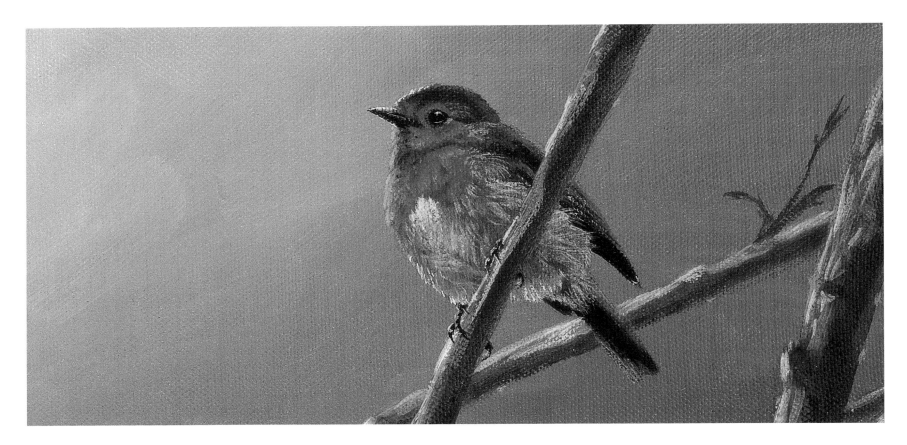

JULIE ASKEW IS a gifted artist and an explorer. Through her years traveling the globe with brush in hand, she has given us a unique window to the diversity that our world has to offer. Her work is as insightful as it is beautiful and represents homage to the extraordinary planet we call home. Julie is not only a communicator through her art, but she is also an educator through her lectures and workshops, and an active participant in helping to sustain the diversity of life in our world.

We share Julie's insight at a pivotal point in the natural history of our planet. If we were time-travellers, the year of this book's publishing would be a worthy stop. Civilization and culture in humanity, in many ways, has reached a peak. It is a time when regular citizens of many countries have the privilege and means to travel to four corners of the globe to witness this diversity first-hand and to marvel at it. Ironically, this privilege comes at a time when diversity as we know it is vanishing at an unprecedented rate. Cultural diversity is under increasing pressure by the sheer scale of modern communications. Popular culture is replacing local culture. This change is echoed in the planet's shrinking biodiversity in what the scientific community views as the sixth great extinction event in the three billion year history of life on Earth. This event also stands out from the other five in that it is being caused largely by the activities of a single species – humans. Most who read this book may well witness the permanent loss of one-third or more of the species on this planet, along with dozens of human cultural lines and languages.

Julie is an active participant in an important movement in the international nature art community, focusing the world's leading artistic talent toward the challenge of achieving a sustainable future. At the forefront of this movement is the Artists for Conservation Foundation (AFC) – an extraordinary group of gifted nature artists from around the world, dedicated to preserving biodiversity on our planet and to reaching out to the public by celebrating it in art. The AFC actively supports artistic field study around the world, with an emphasis on remote habitats and endangered species. Artists like Julie are sharing important stories, giving us a context and better understanding of the interconnectedness of our world, its beauty, its fragility and its vulnerability.

As a Signature Member of the AFC, and in many other ways, Julie is a model artist we hope will inspire others to follow. For all of us who just enjoy viewing her artwork, we are all fortunate that this compendium of Julie's talent has been created.

JEFFREY WHITING, BSc. SAA, AFC. Canada
President & Founding Artist
Artists for Conservation Foundation

Introduction

TRAVEL GIVES ME the basis for all my work. My destinations are reached by plane, ship, or a combination of the two. Our world has shrunk, and is continuing to do so, giving more of us the opportunity to experience the wonderful diversity of cultures, landscape and wildlife that makes our home planet what it is. There is so much beauty and good in the world. It is important that we all take a moment to stop and enjoy what we have around us.

Whilst I'm on the move, my pen is always busy. I sketch what I can see while I'm bumping along in a bus or a car, or as I am walking. Standing sketching at the railings of a ship as it goes through the Panama Canal, with butterflies circling my head, the sun beating down and the jungle melting into the brown and green waters, or as it approaches an island with a towering volcano reaching from a turquoise ocean into the clear blue morning sky, is an indescribable joy. I may be in a truck bouncing along, with cheetahs hunting nearby on the open plain, or crouching by autumn bushes as a huge bull elk proudly claims his females in front of me, or walking through a vibrant market with colours, smells, sights and the hustle and bustle – wherever I am, there are so many wonderful things to draw. I am anxious always to record as much of what I experience as possible. With field work by my side, studio paintings can then come to life.

In this book I have compiled destinations into a route, circumnavigating the globe. It is a compilation of eight years of my travels. I have been lucky to witness wonderful events and enjoy memorable experiences the world over. I happily continue to do so, sketchbook and paints in hand.

I hope you will enjoy the selection of work I have included as you travel through this book and will reach the end bitten by both the paint and travel bug!

A person who never travels believes his mother's cooking is the best in the world AFRICA

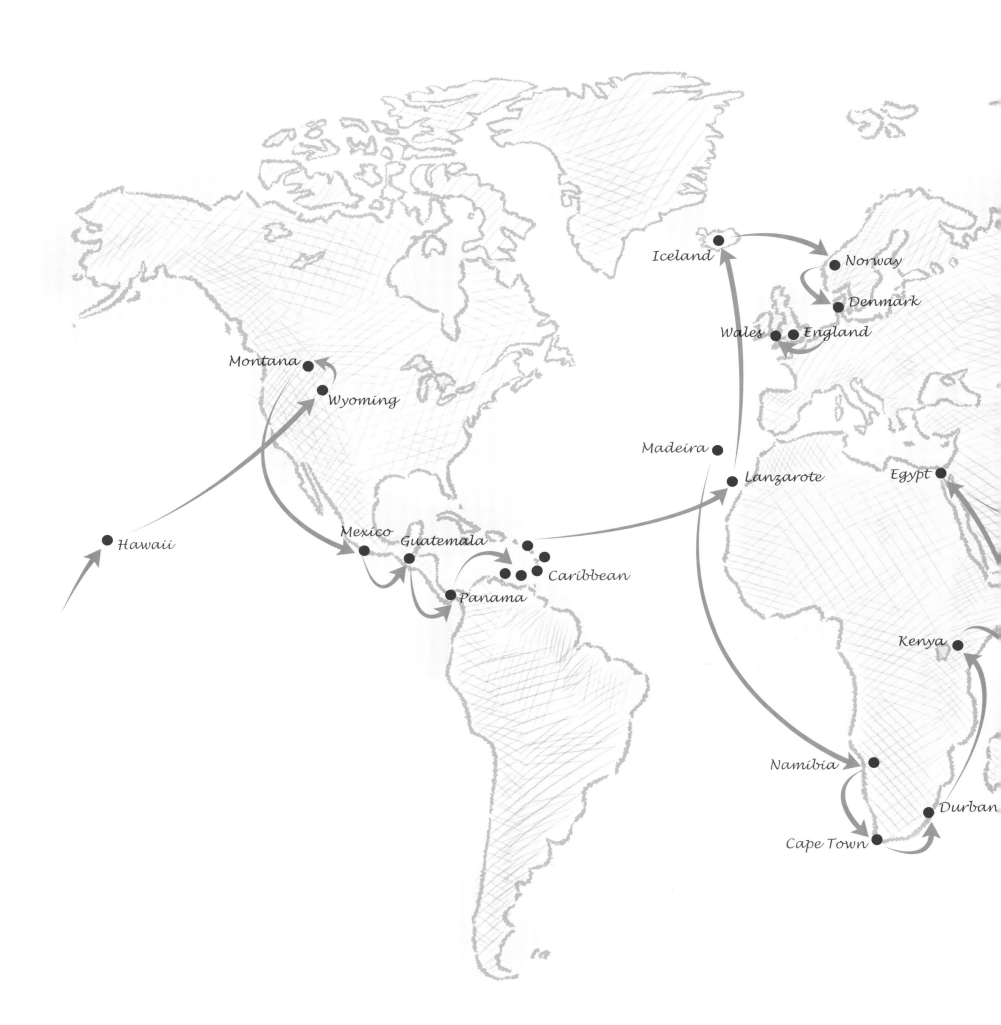

Iceland

Norway

Denmark

Wales England

Montana

Wyoming

Madeira

Lanzarote

Egypt

Hawaii

Mexico
Guatemala

Caribbean

Panama

Kenya

Namibia

Durban

Cape Town

Contents: The journey

India

Manila

Penang

Singapore

Borneo

eychelles

Bali

Queensland

South
Australia

South Pacific
Islands

Western Australia

New
South
Wales

New Zealand

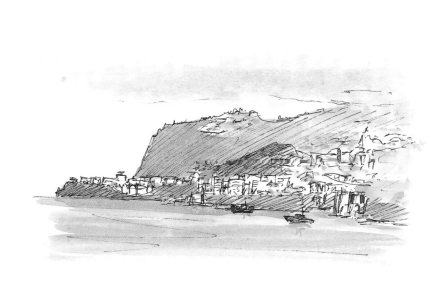

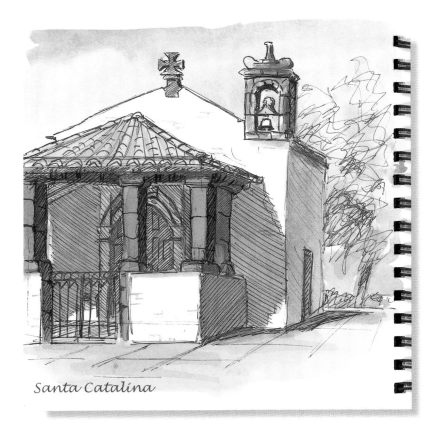

Santa Catalina

The flower market is a blaze of colour, particularly orchids and bird of paradise flowers. The scent is sweet and the colours startle my palette. My sketchbook is begun.

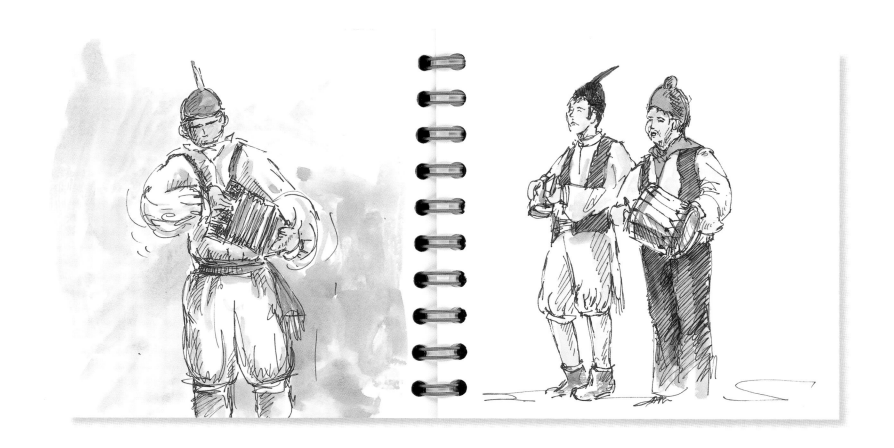

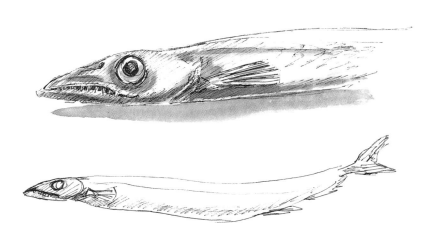

Espada, the deep sea fish unique to Madeira are strange in shape, huge in size and delicious in flavour, especially with fried banana!

I stand in the fish market, getting curious glances as I busily describe these strange fish in pen and ink.

Funchal

Feet accustomed to go, cannot be still PORTUGESE

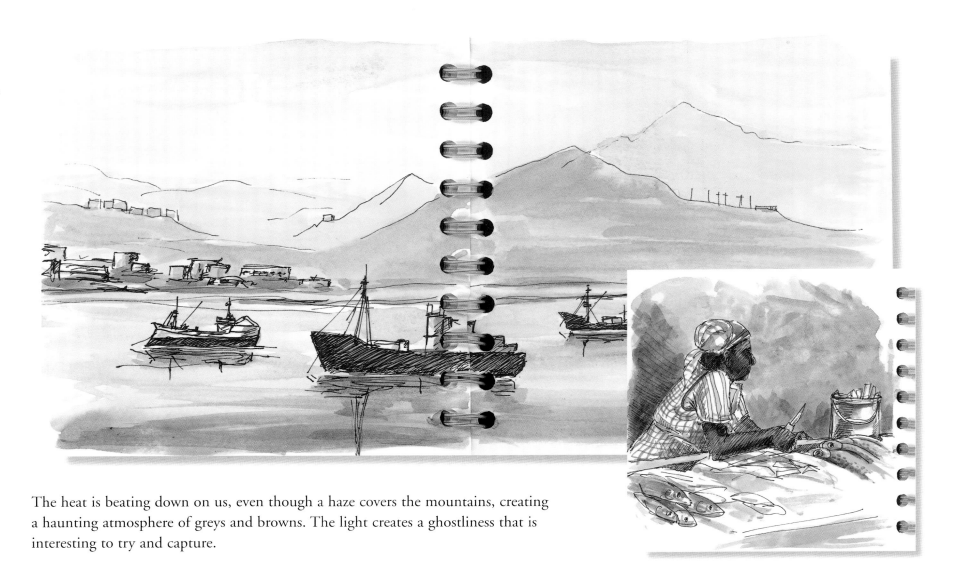

The heat is beating down on us, even though a haze covers the mountains, creating a haunting atmosphere of greys and browns. The light creates a ghostliness that is interesting to try and capture.

Looking out at the desert, it amazes me that anything can live here. Yet I just saw a few oryx shimmering in the distance.

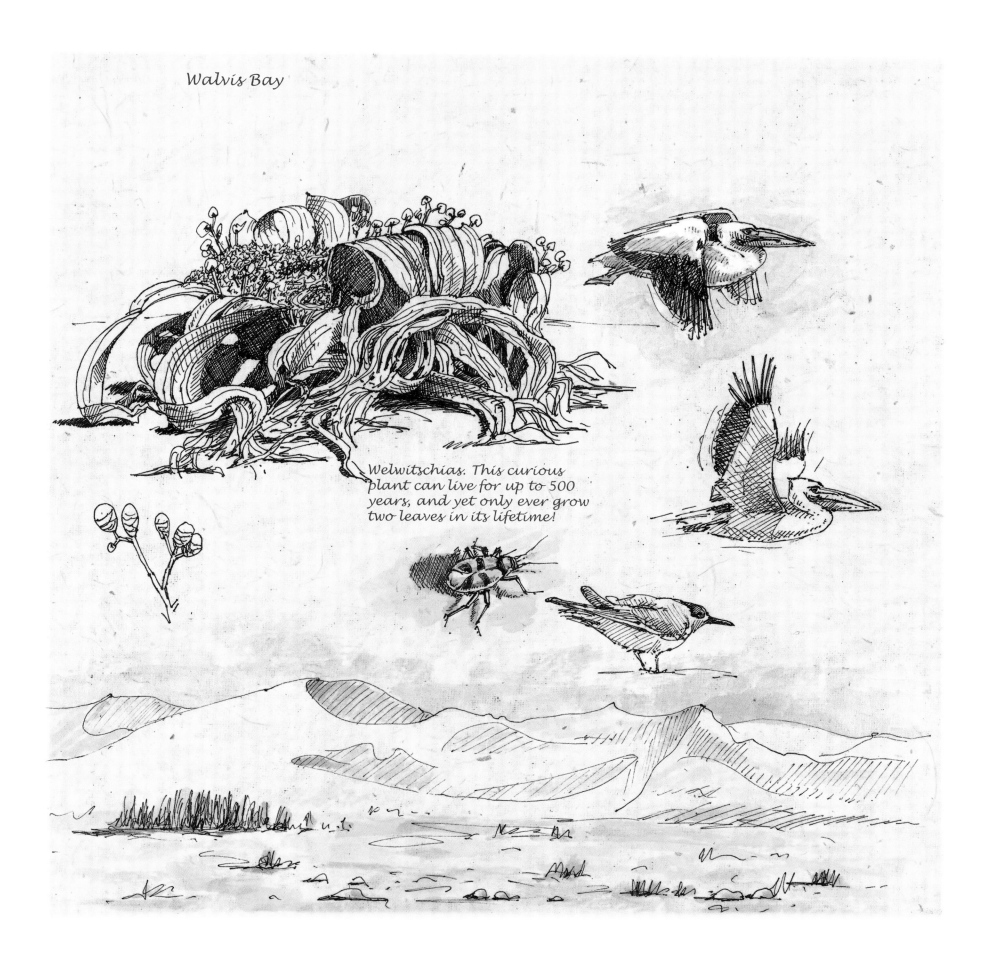

Walvis Bay

Welwitschias. This curious plant can live for up to 500 years, and yet only ever grow two leaves in its lifetime!

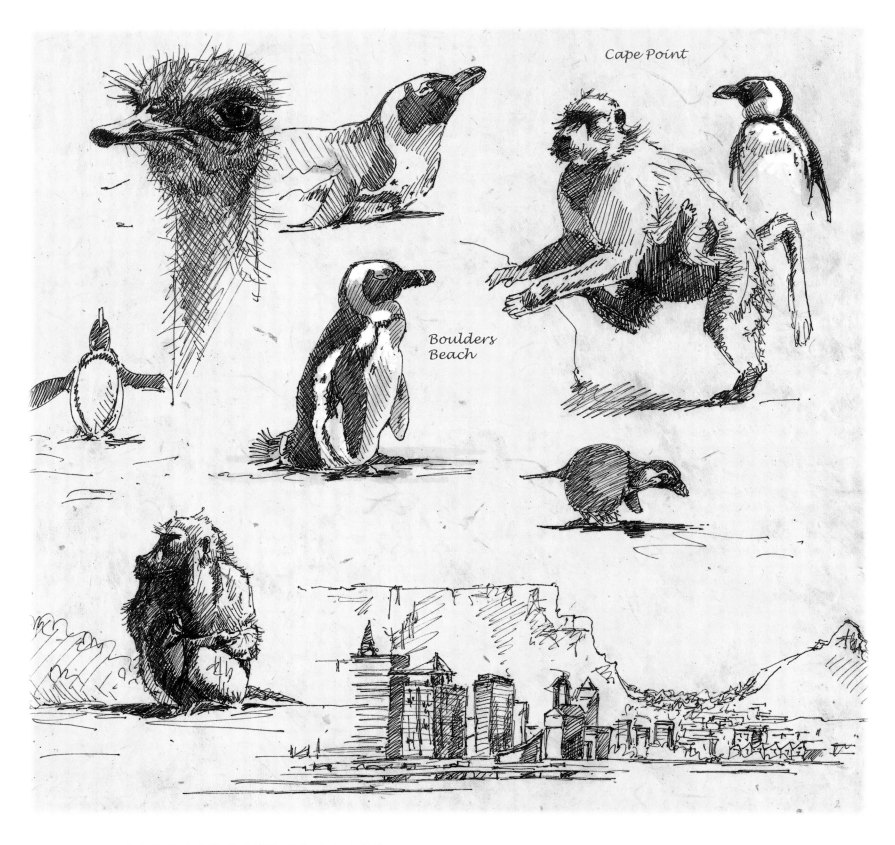

Cape Point

Boulders
Beach

When observing these dapper penguins at
Boulders Beach, I know I can't paint their
pungent smell or the groaning sounds emanating
from these dapper birds. However, I try my best
to capture their movement and behaviour, their
clumsiness on land and contrasting fluidity in
the water – all challenges for my pen!

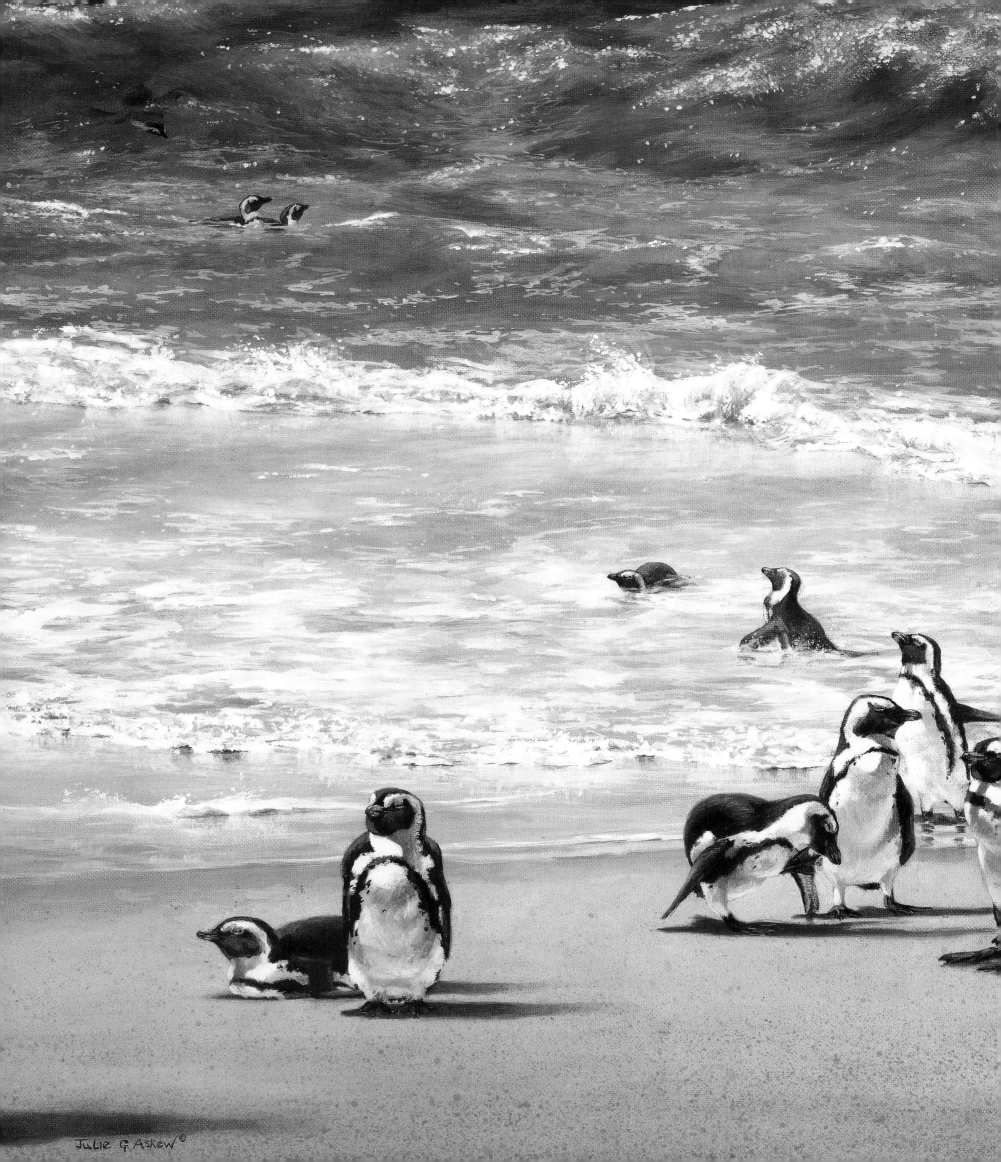

Now in Zululand. The Zulus still have a standard bride price of seven cows

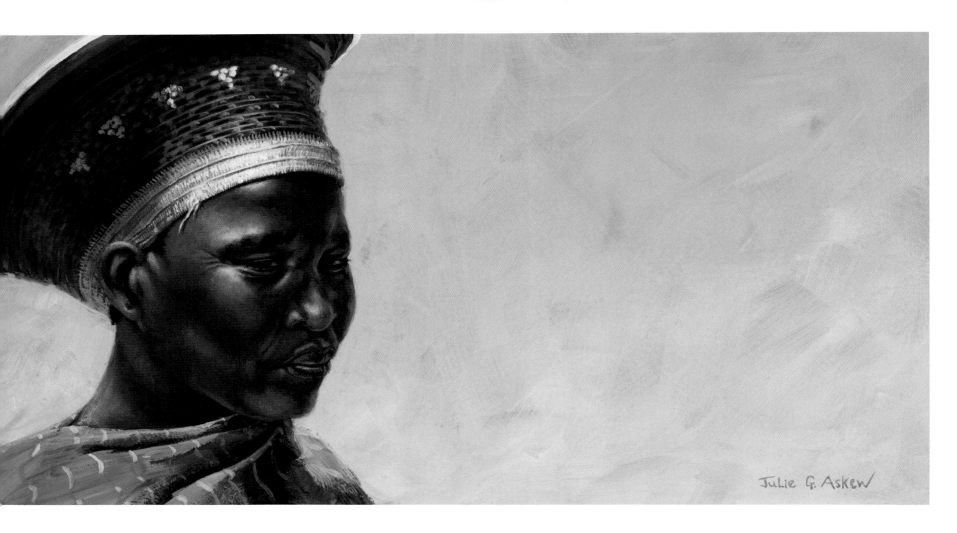

Julie G. Askew

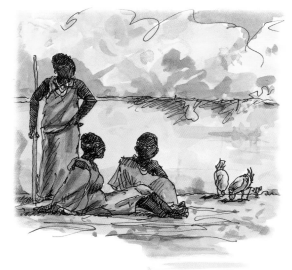

Portraits in different cultures create different colour challenges capturing the different skin tones, as well as anatomical features. African skin has a wonderful rich tone that always looks fantastic against brightly coloured fabrics.

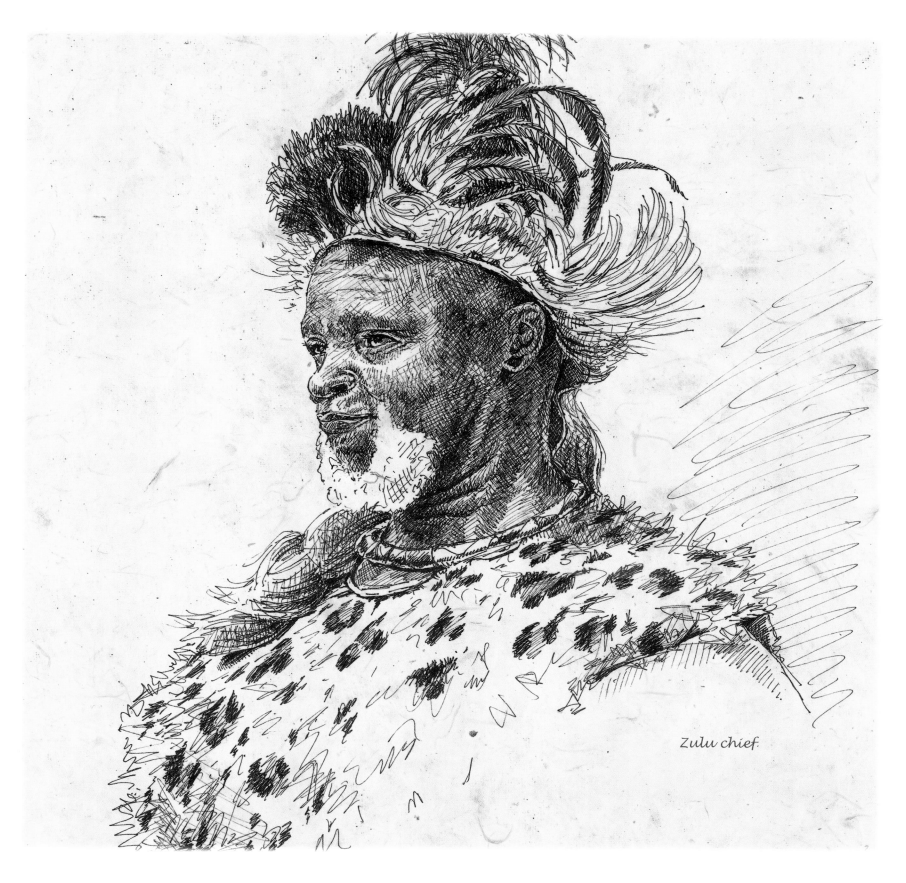

Zulu chief.

What an old man can see whilst seated, a young man cannot see standing SOUTH AFRICA

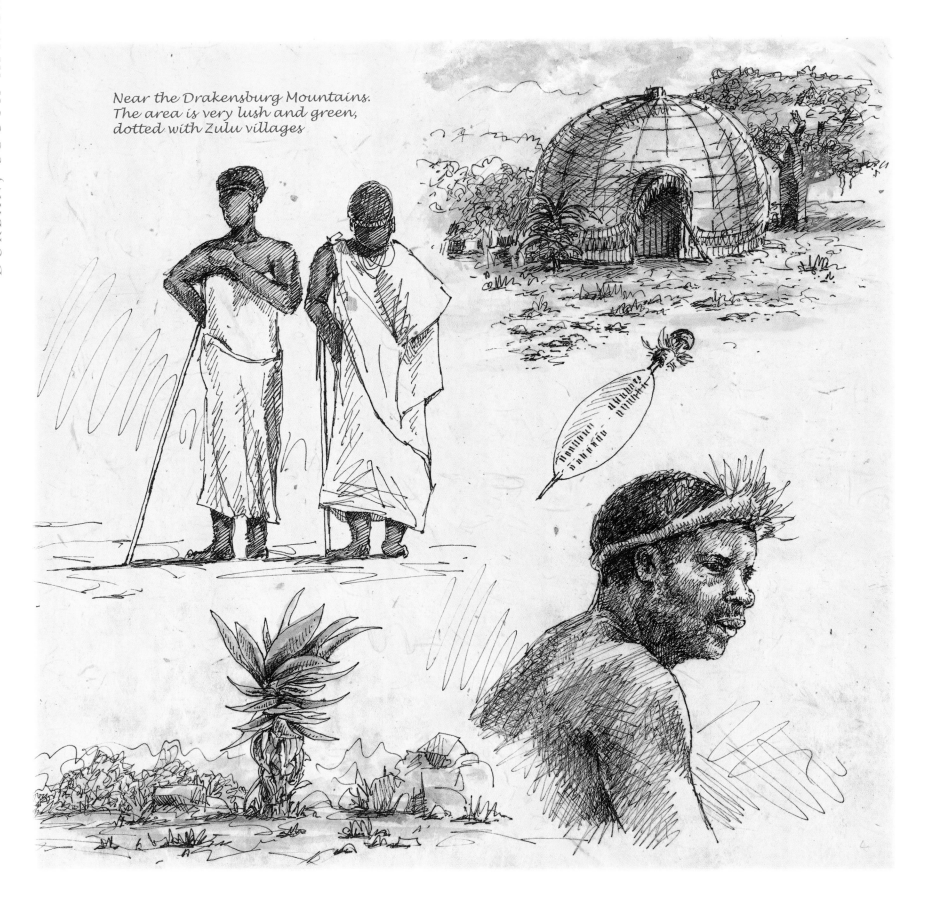

Near the Drakensburg Mountains.
The area is very lush and green,
dotted with Zulu villages

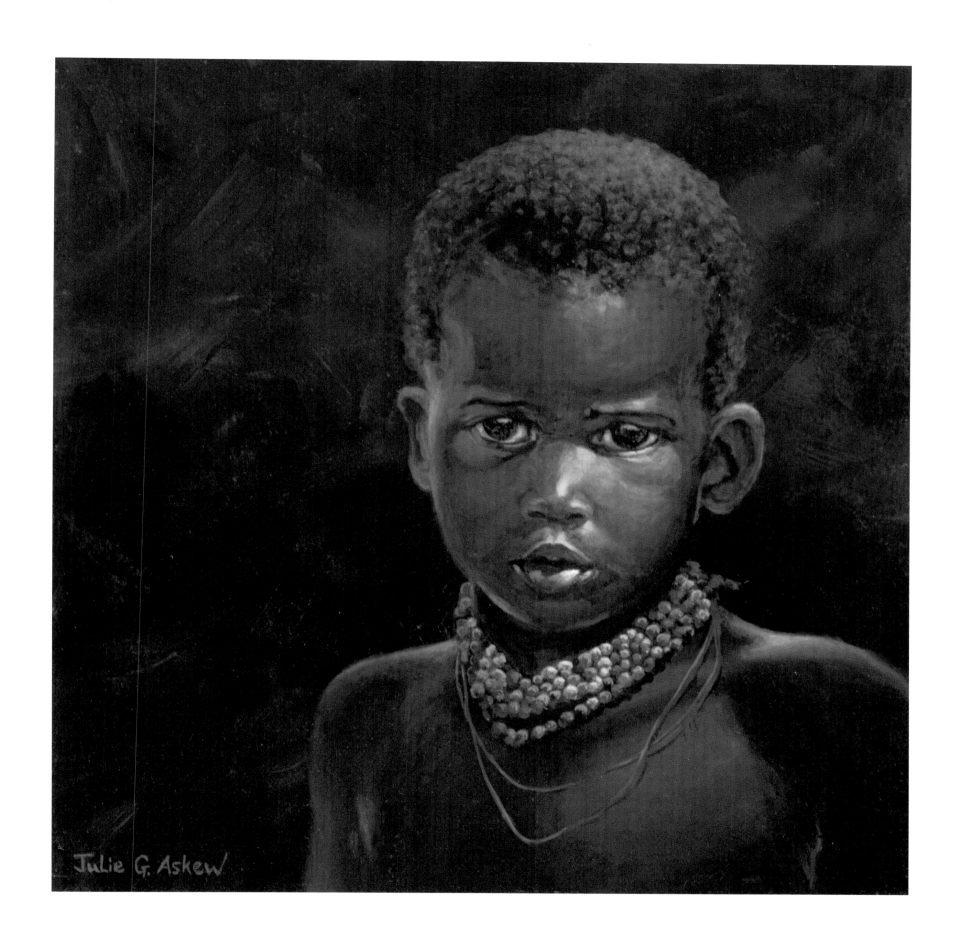

Julie G. Askew

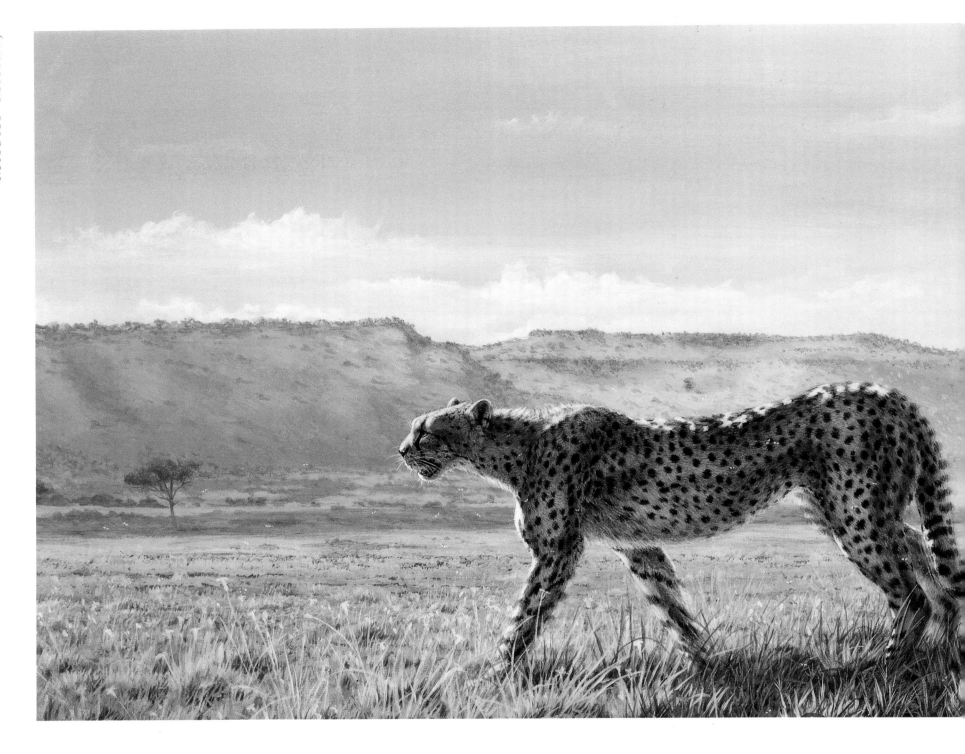

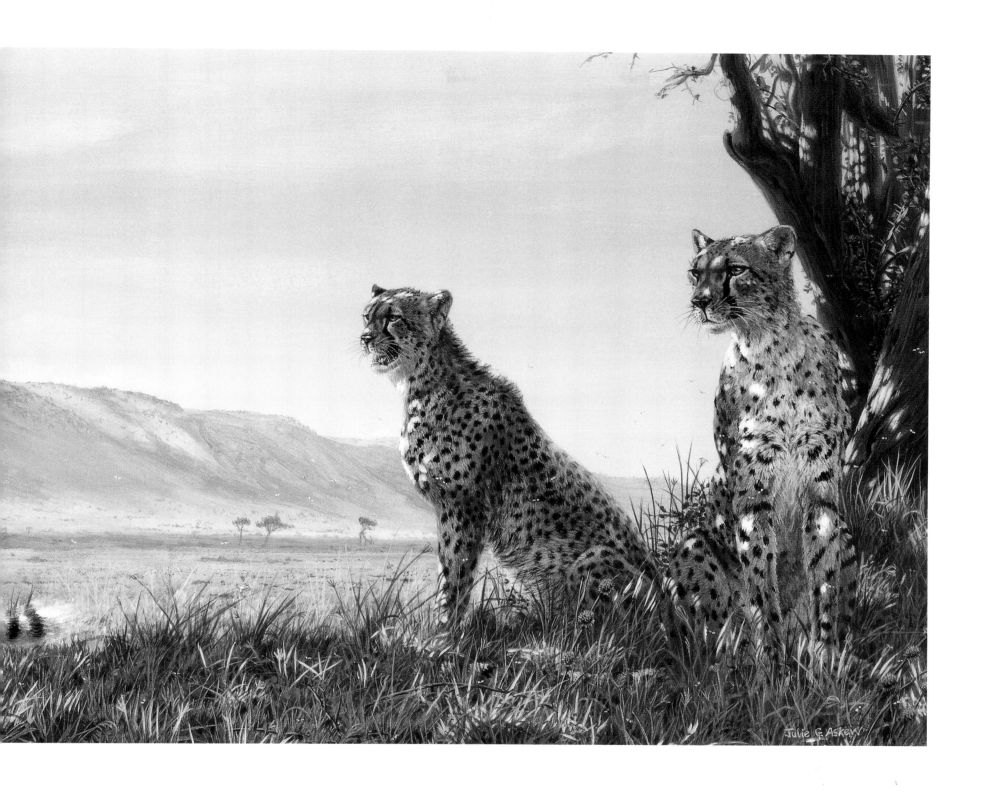

It is incredible how the animals' camouflage works so dramatically and also how it may begin to work artistically. This adult female cheetah and her youngsters stood out in their spotted coats. Then, all of a sudden, they disappeared, the bird-like chirping of the youngsters the only thing giving them away.

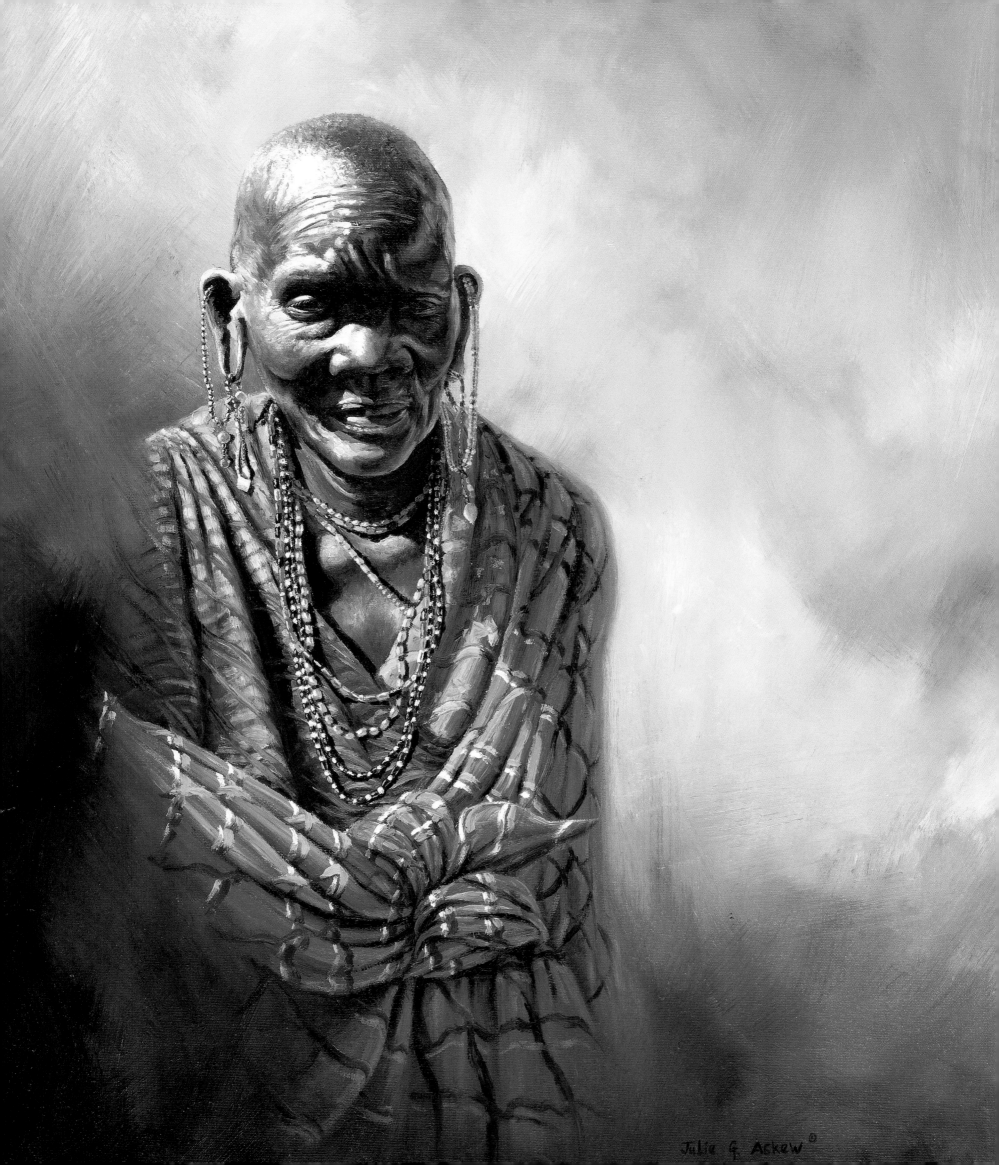

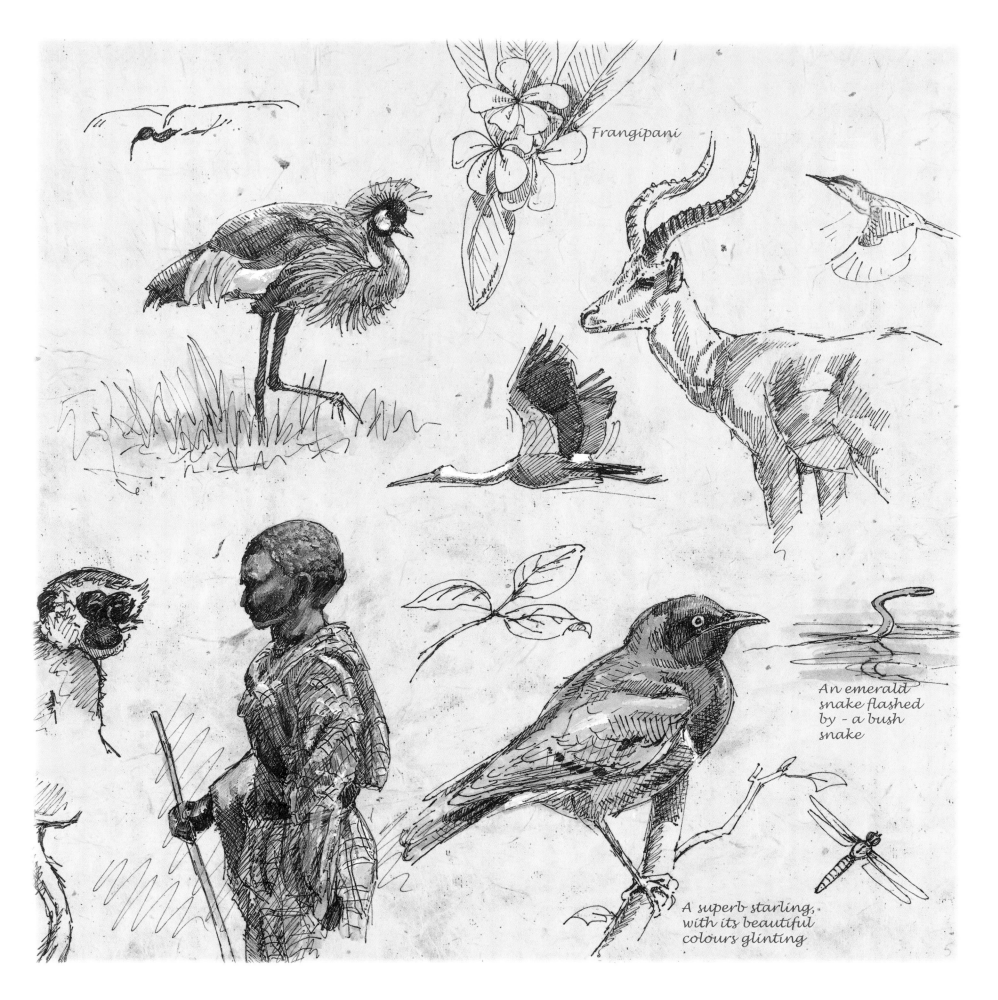

Frangipani

An emerald
snake flashed
by - a bush
snake

A superb starling,
with its beautiful
colours glinting

A son will be what he is taught SWAHILI

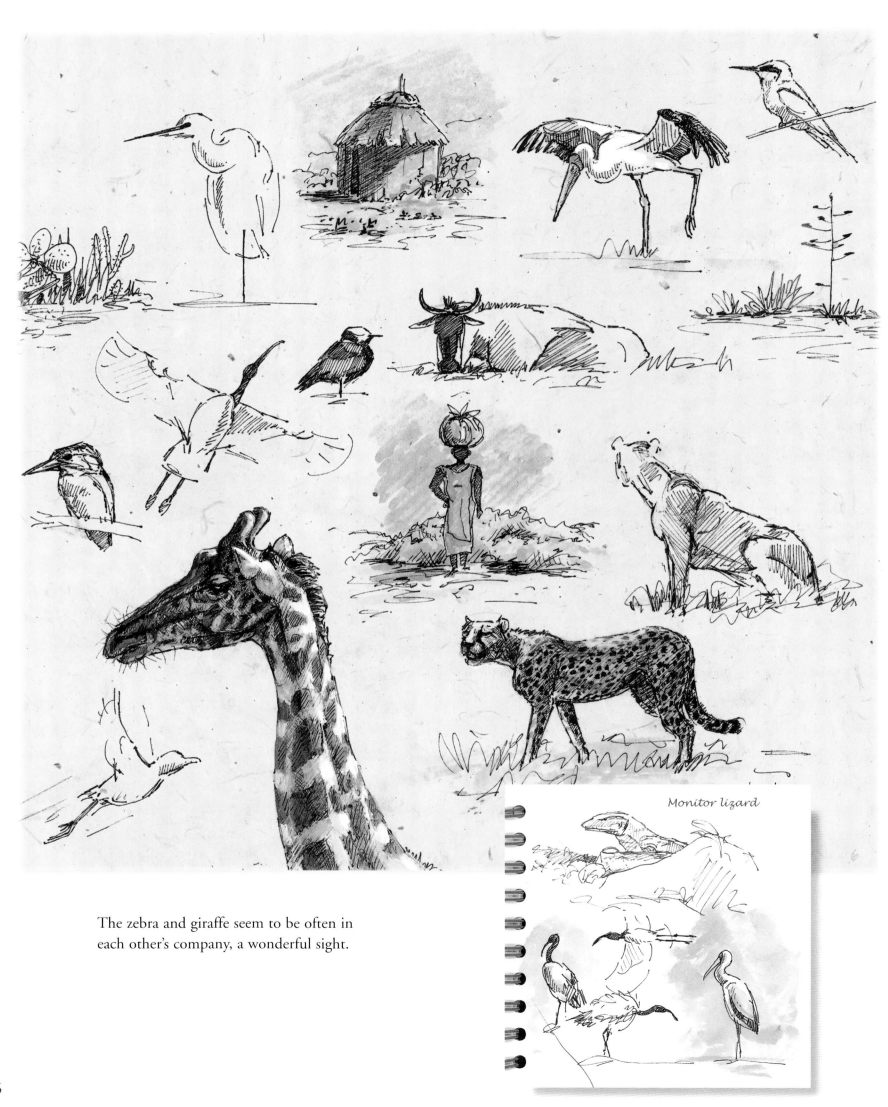

Monitor lizard

The zebra and giraffe seem to be often in
each other's company, a wonderful sight.

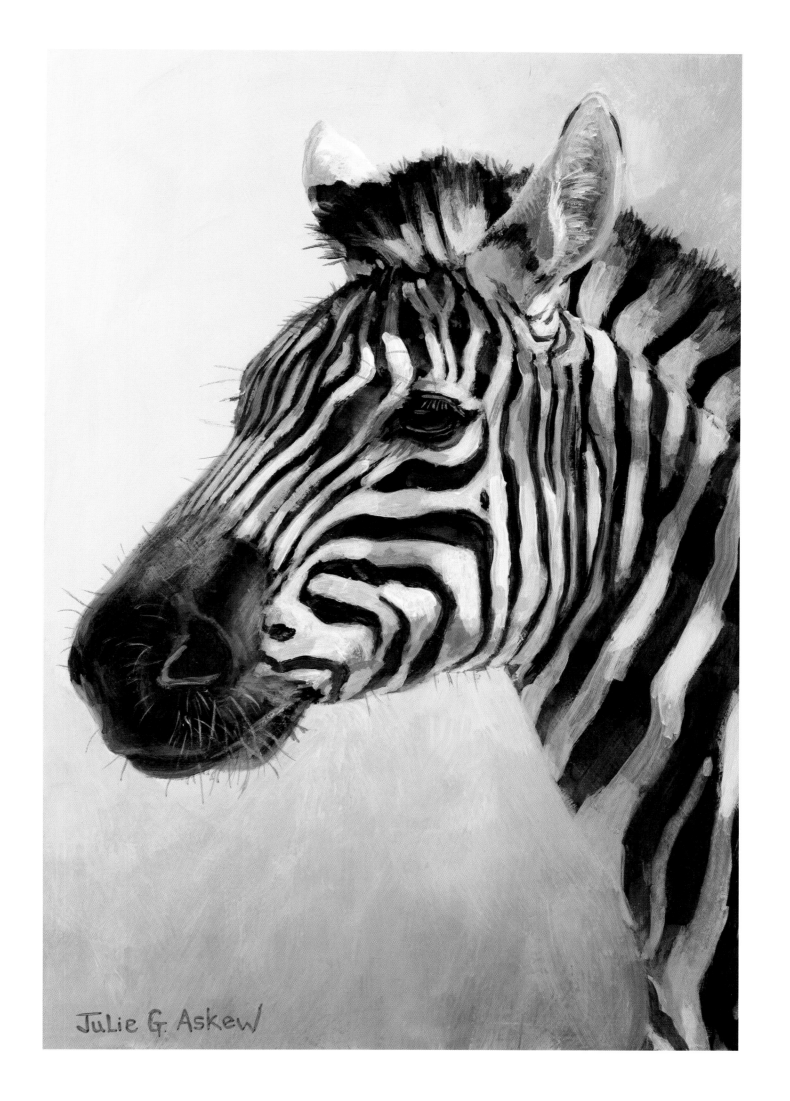

Julie G. Askew

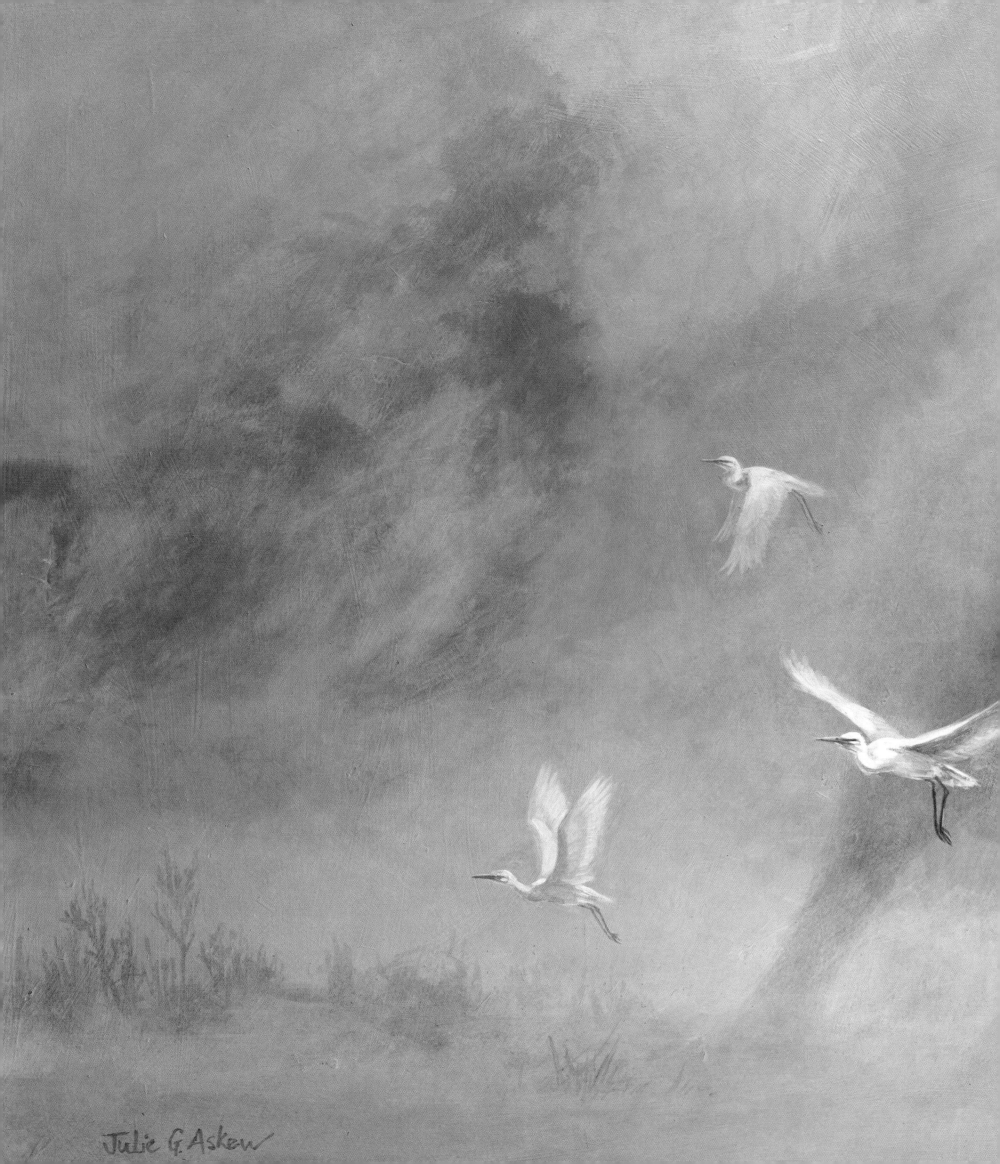

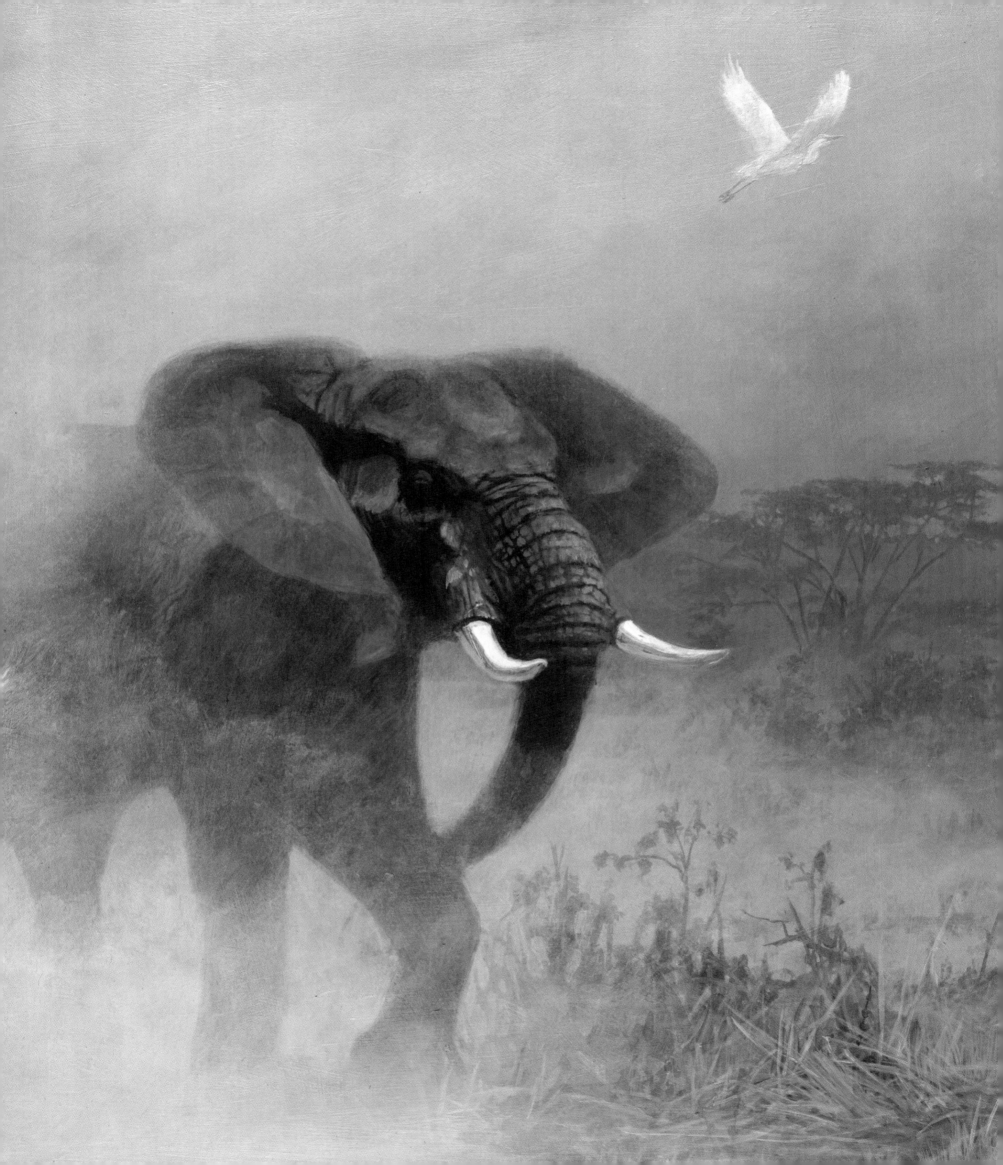

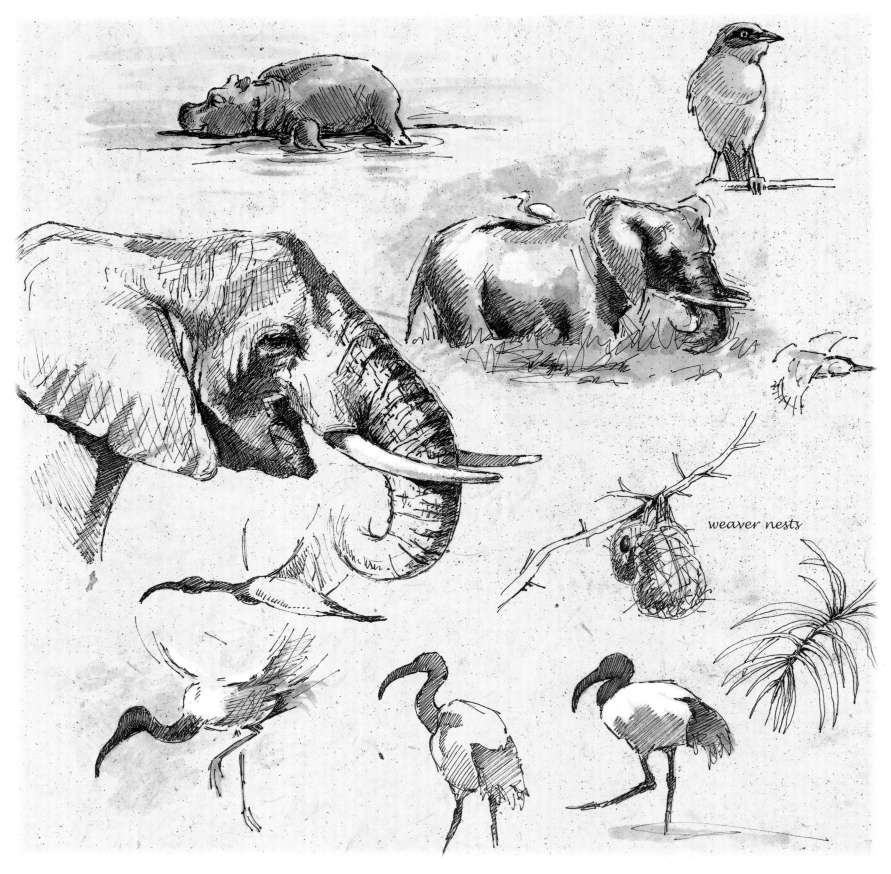

weaver nests

The big bull elephant came thundering out of the marsh, his ears
flapping. As he halted, in a magnificent pose, I rapidly sketched
him before another bull arrived and much waving of heads and
trunks ensued.

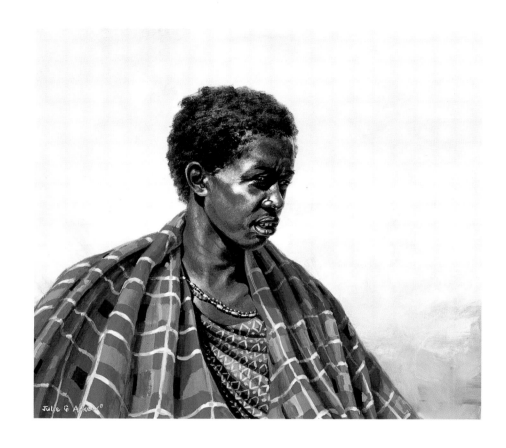

It is not possible to dodge the arrow before it has been thrown MASAI

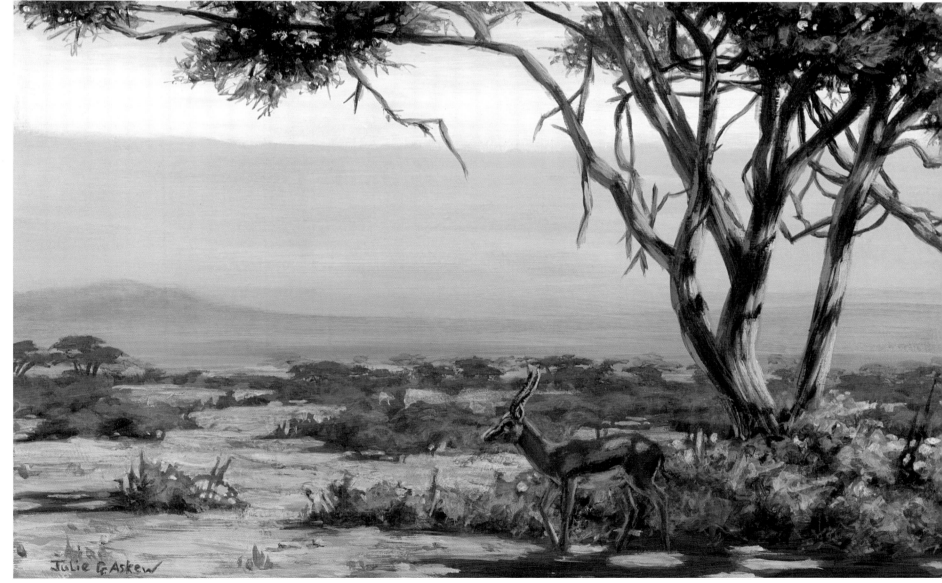

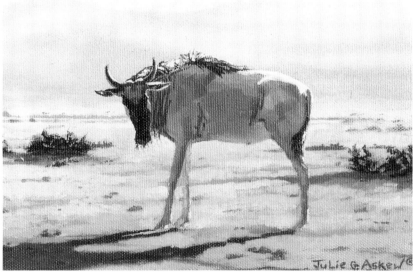

Standing beside the Land Rover, again stuck in mud, the sense of being watched tingles my neck. The warning voice of the driver directs my eyes over to the nearby bushes and I catch sight of the lions, casually watching us in our predicament.

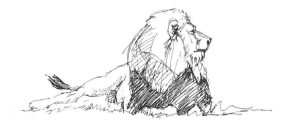

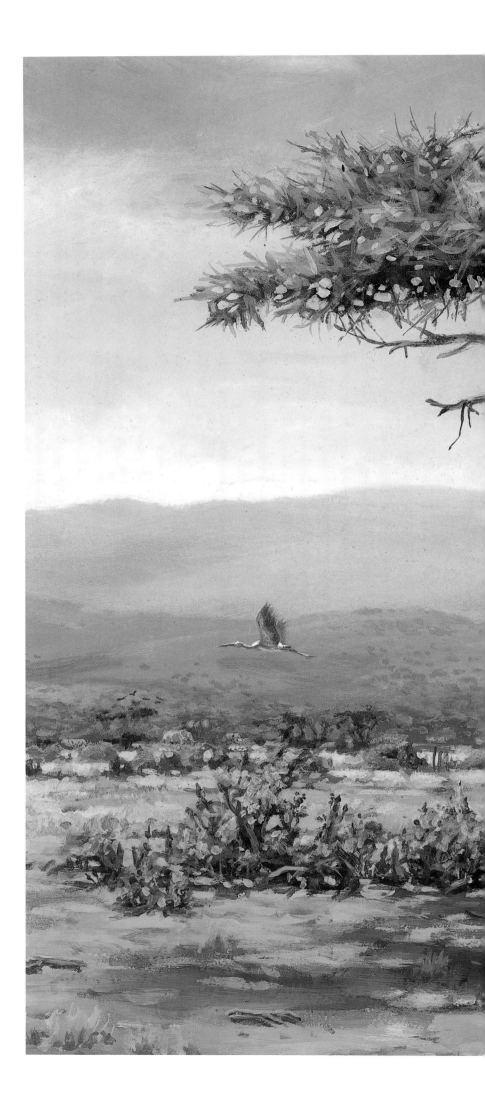

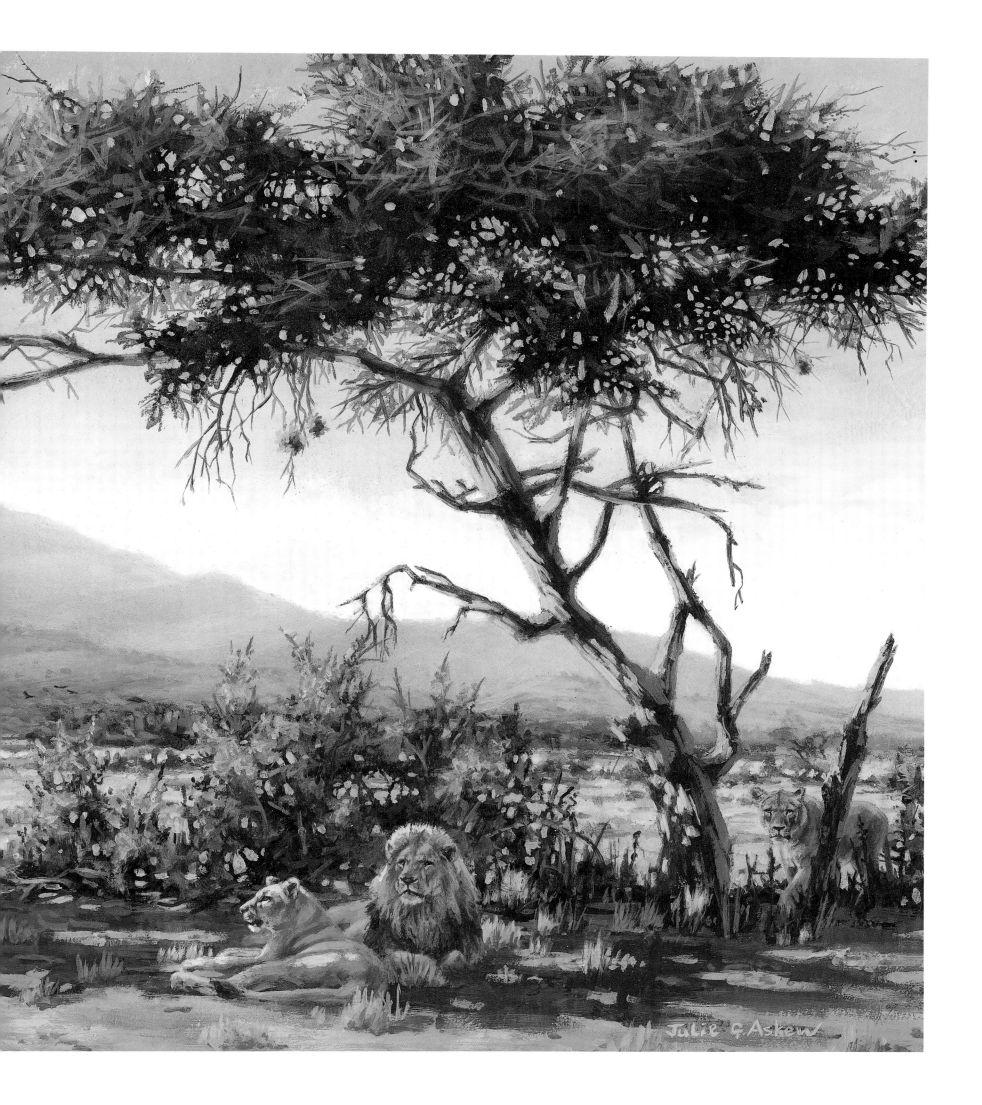

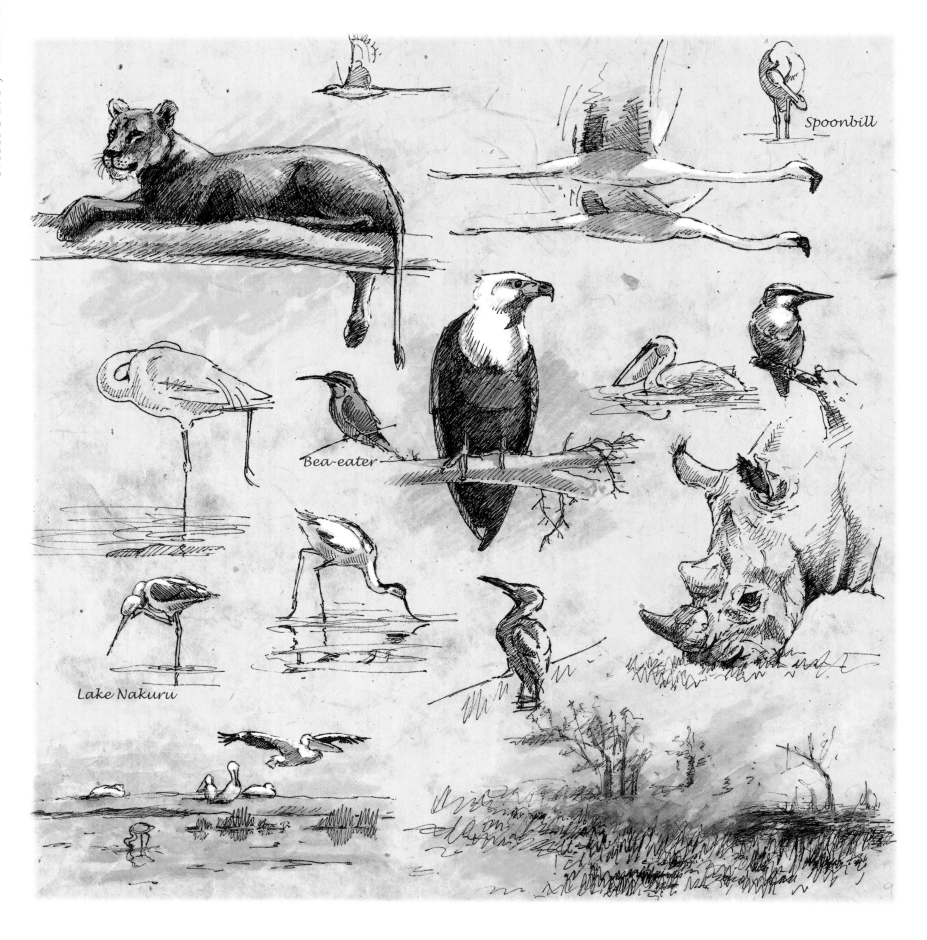

Spoonbill

Bea-eater

Lake Nakuru

Armed only with a twig and considerable apprehension, I join in the beating of a bush fire we'd come across. The heat singes my eyebrows and the smoke blackens my shirt. The flames eat the scrub at an alarming rate and we are helpless to stop its growing advance. Even as my eyes sting with smoke, the drama inspires me with new ideas for paintings.

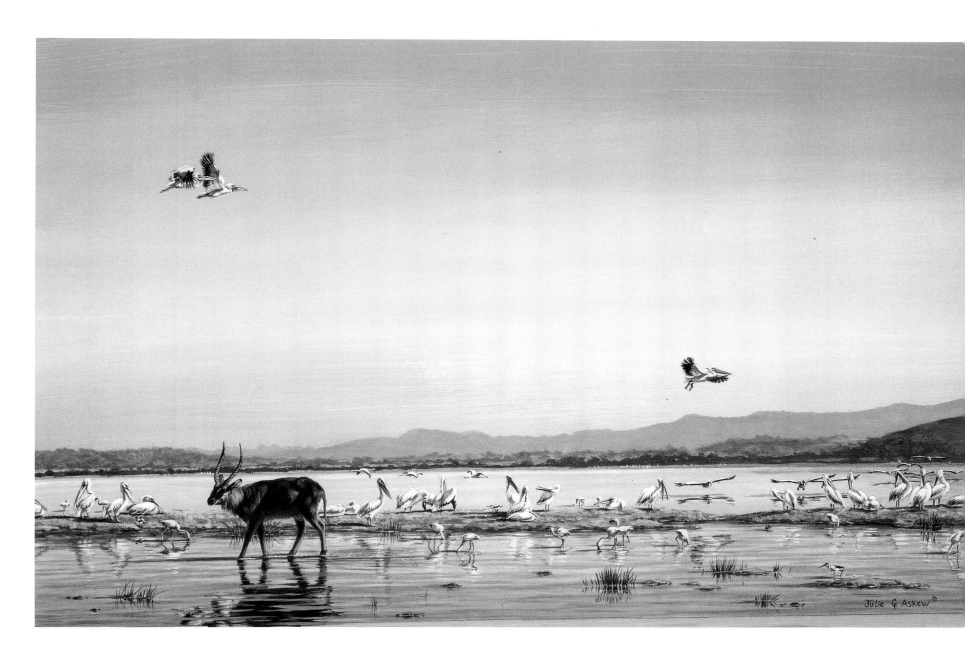

Nakuru glistens in front of me. There are so many birds, such breathtaking light and colour, that I just stare in wonder before finally gripping my pen…

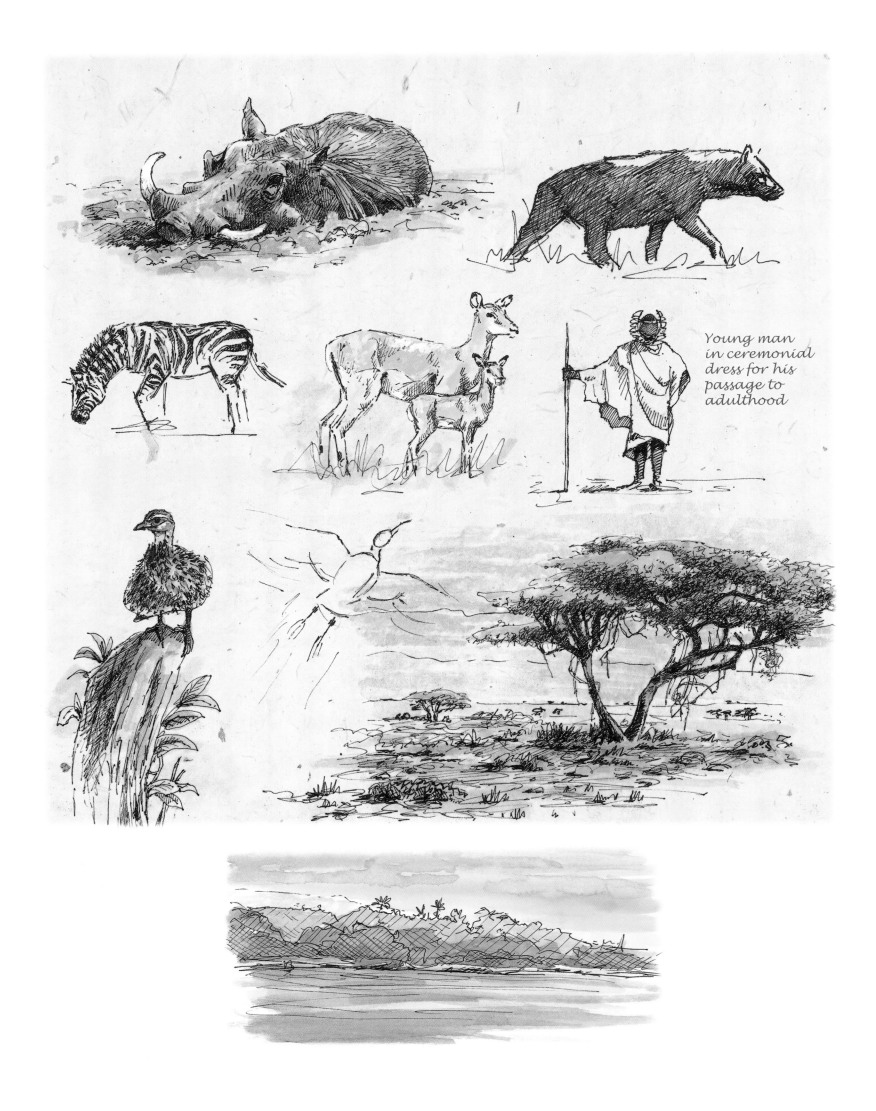

Young man
in ceremonial
dress for his
passage to
adulthood

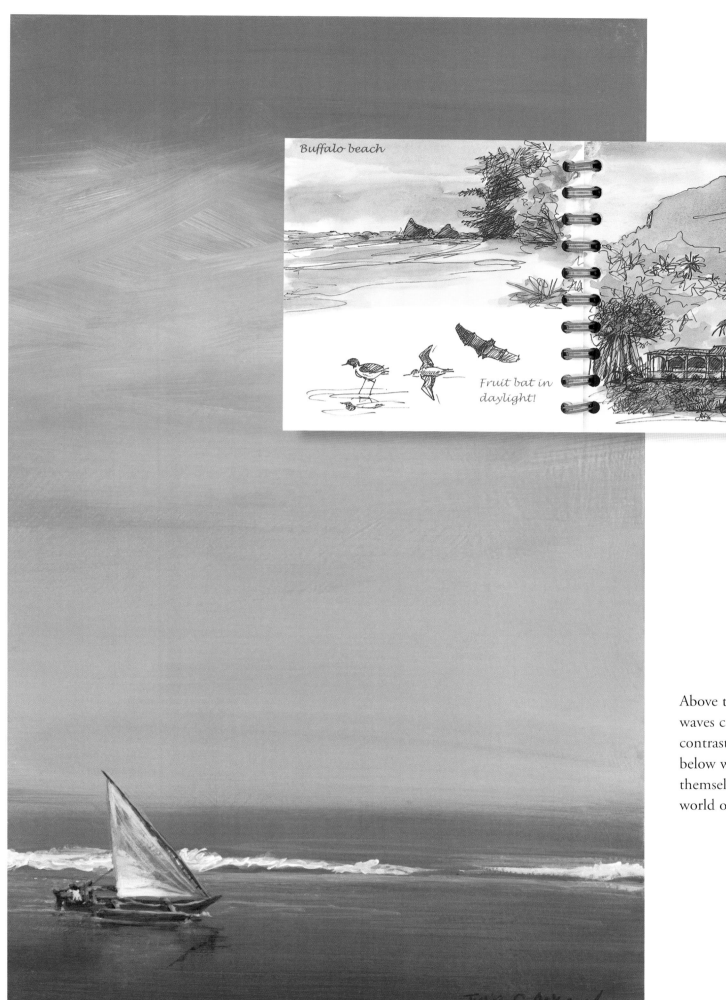

Buffalo beach

Fruit bat in
daylight!

Above the reef the huge
waves crash in warning,
contrasting with the calm
below where fish busy
themselves in their watery
world of blue-tinted light.

Julie G Askew

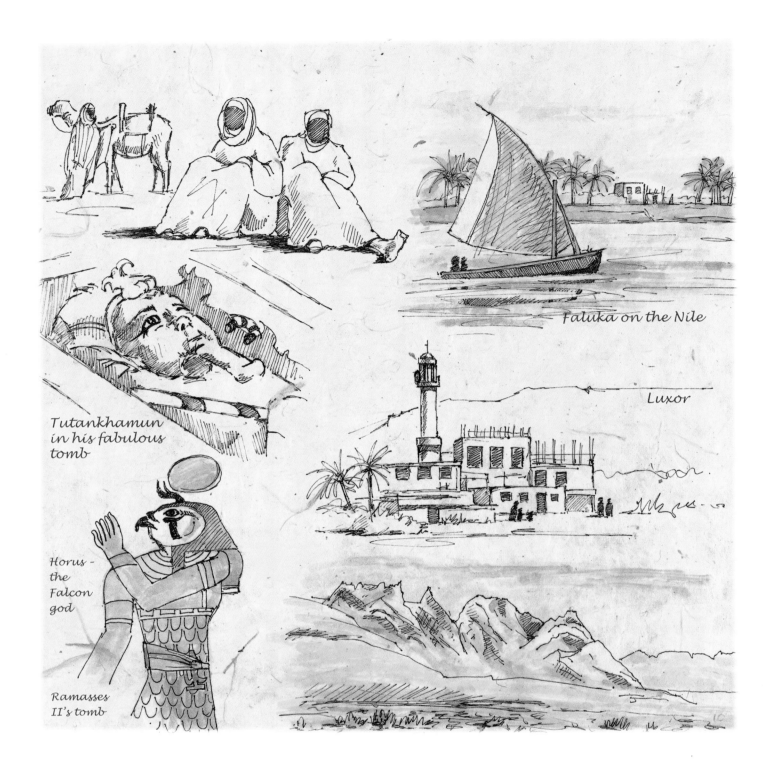

Faluka on the Nile

Luxor

Tutankhamun in his fabulous tomb

Horus – the Falcon god

Ramasses II's tomb

A wise man never takes a step too long for his left leg EGYPT

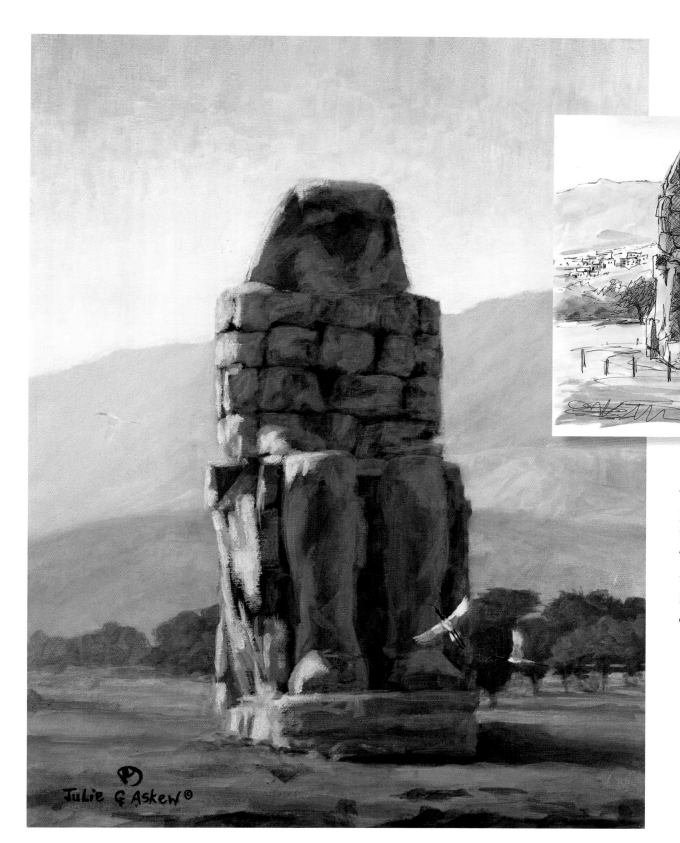

Julie G Askew©

The remaining colours and hieroglyphics in the tombs are breathtaking and awe-inspiring. The carvings are so beautiful and the statues amazing. It is interesting to capture the early craftsmen's art in my own work.

Travelling up the Suez, on my left the land is fertile and lush, full of life. On my right is desert, bleak and empty. The two sides of the canal couldn't contrast more. Ahead, a nuclear submarine and a destroyer guide us through as this becomes an uneasy time – the Gulf War has begun this very day.

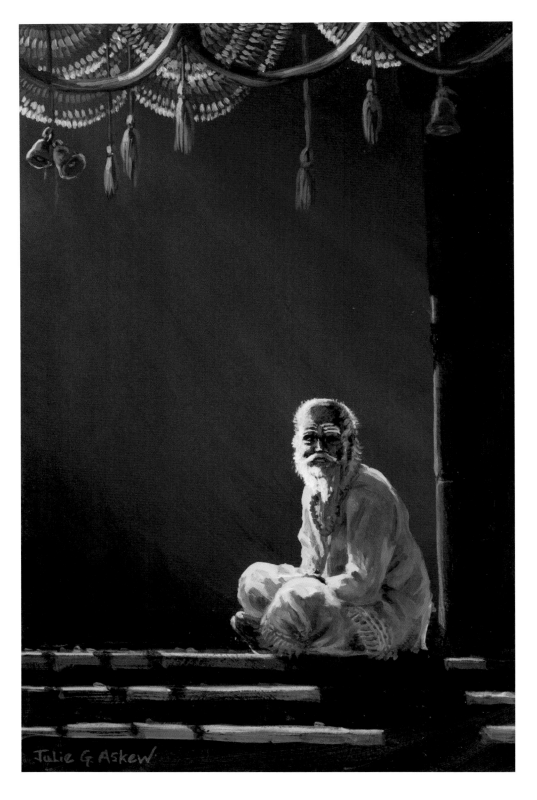

Julie G. Askew

By the bustling marketplace, a brightly-robed holy man rises from his position seated at the temple entrance and respectfully approaches me. 'Ah,' he says, 'You are lucky.' With a toothless smile he holds out a flowered necklace: 'One dollar!' As he returns to the temple I sketch him, noting his humble, yet proud, character and the dramatic colours.

A book is like a garden in the pocket INDIA

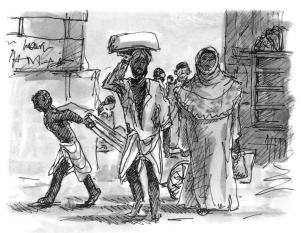

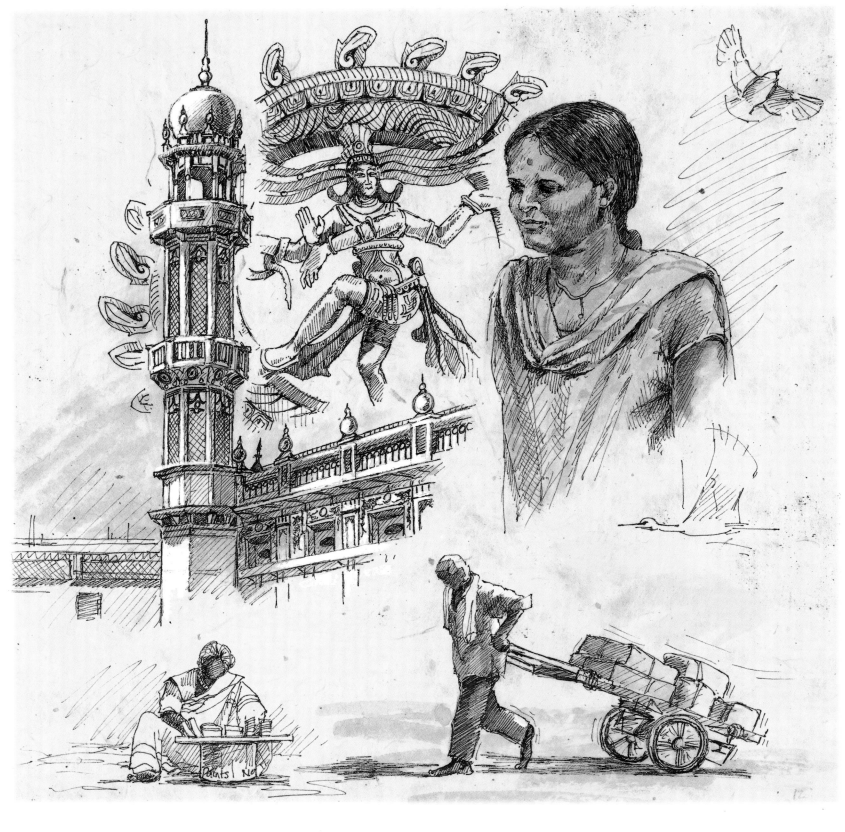

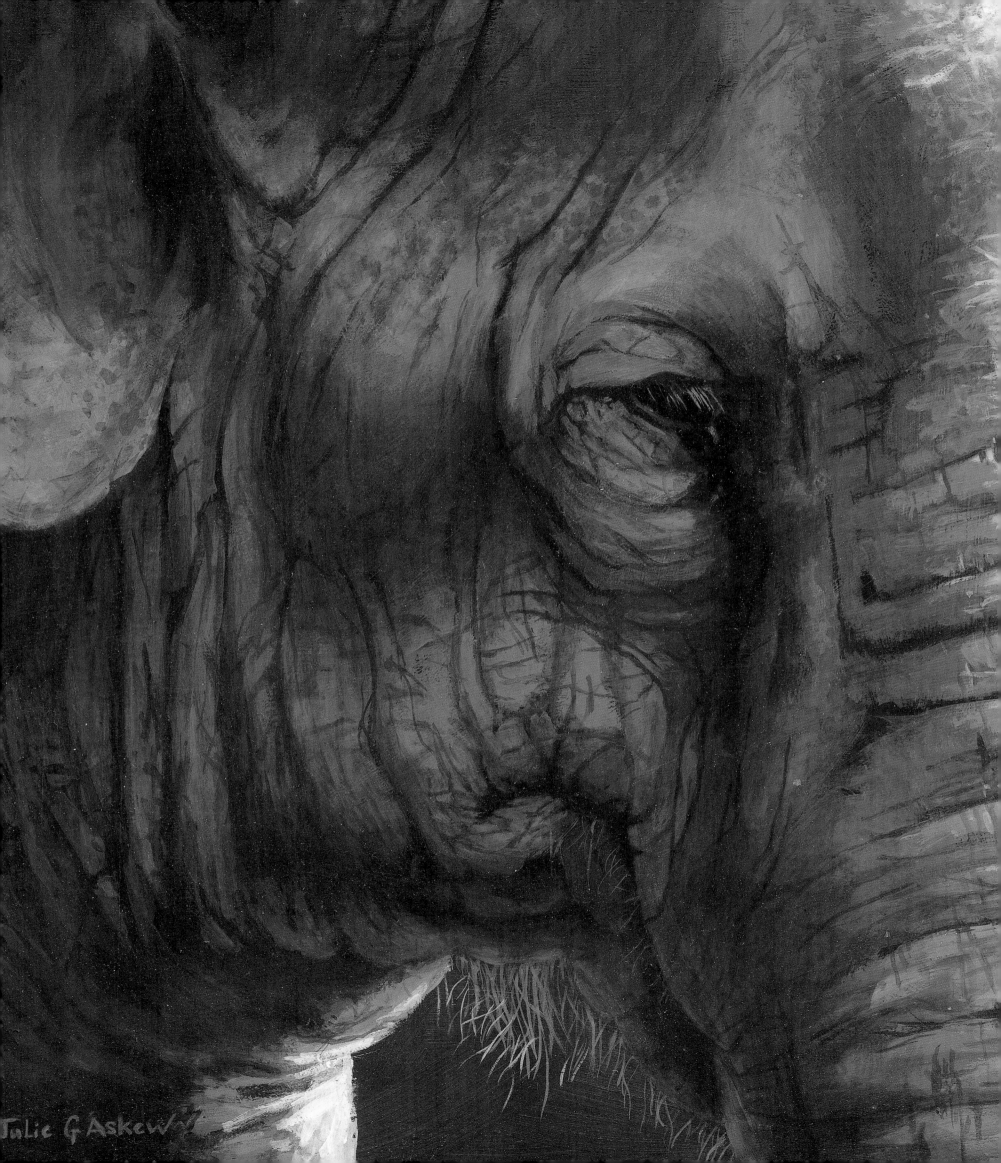

Julie G Askew

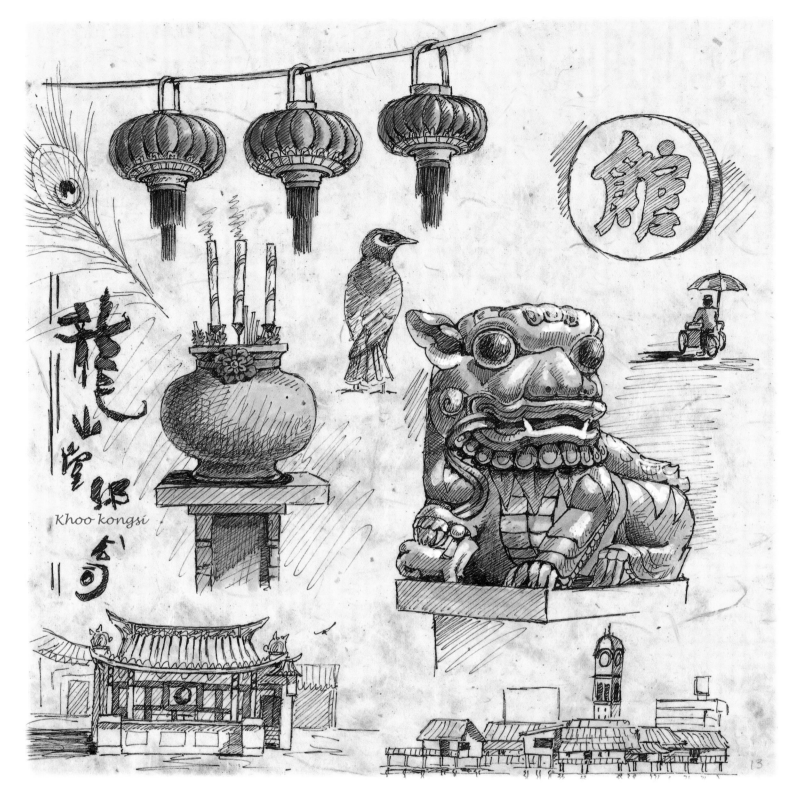

Khoo kongsi

Entering the cool, dark temple in Penang, it takes a while for my eyes to adjust. Only impressions of red and gold pierce the gloom.

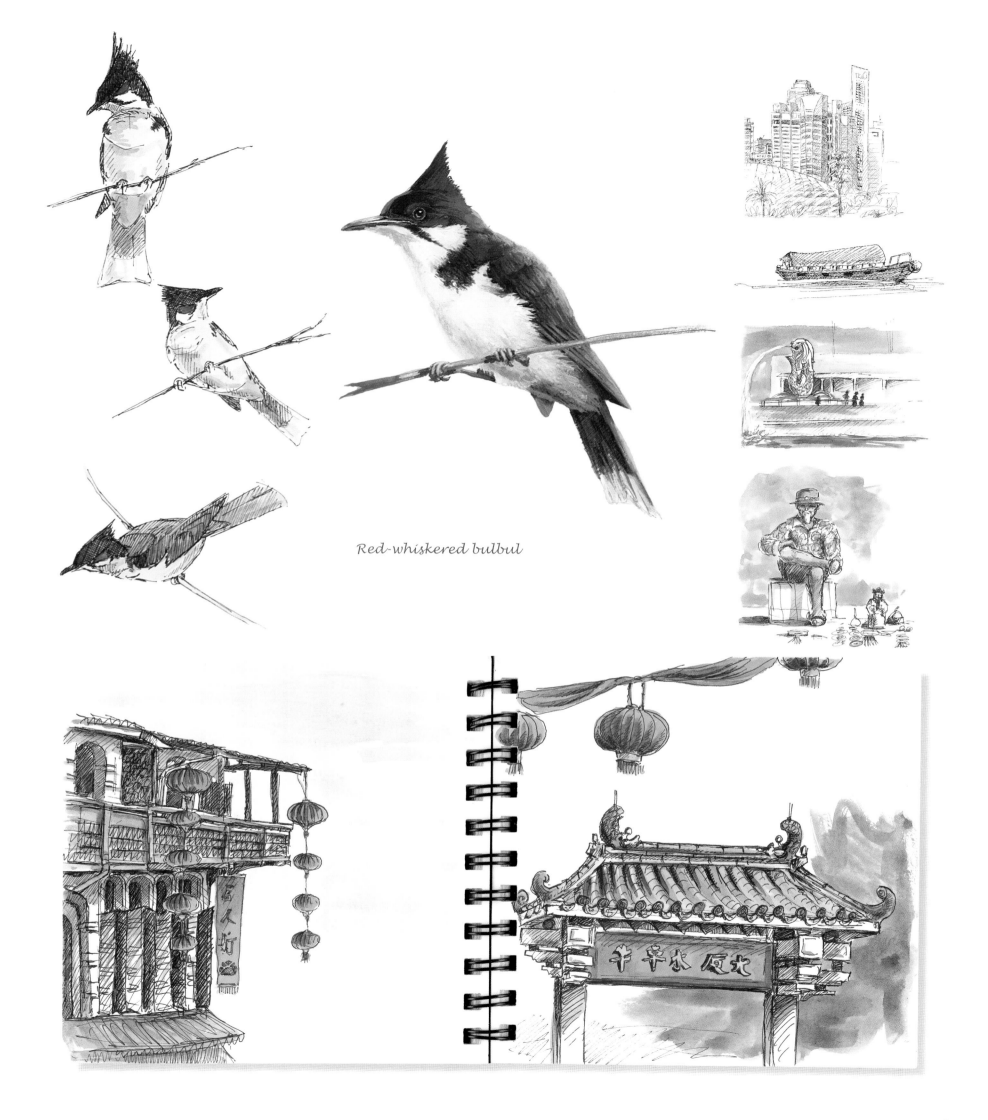

Red-whiskered bulbul

A turtle lays a thousand eggs
without anyone knowing.
When a chicken lays one egg,
the whole country is told ASIA

My overall memory of Borneo is of barefooted children, dodging around the dogs and chickens in a game of chase. Their heart shaped faces are full of smiles, their laughter as bright as the flowers around them.

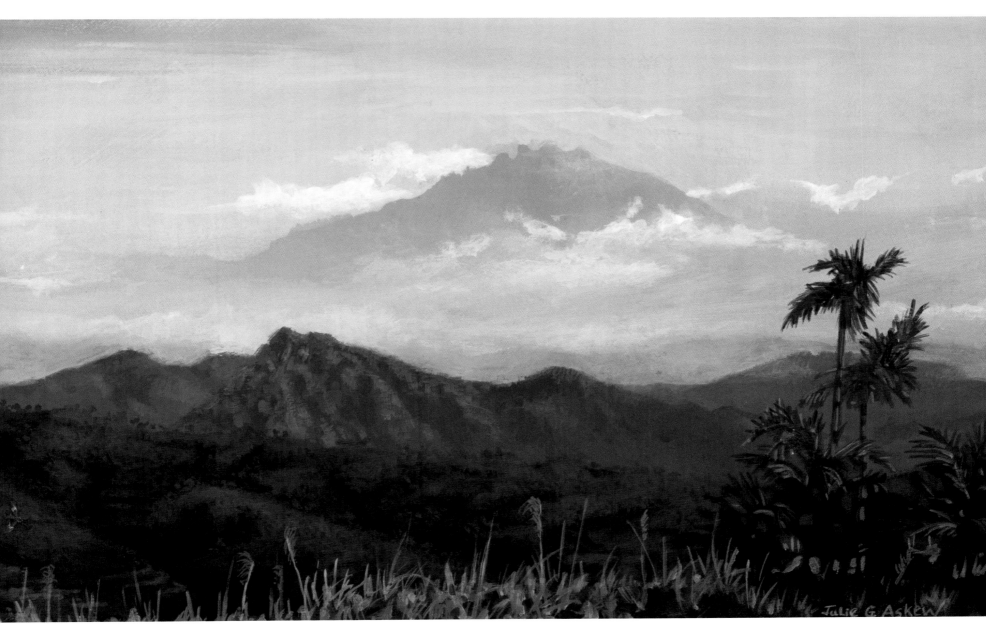

Wherever we stand, we hold the sky... INDONESIA

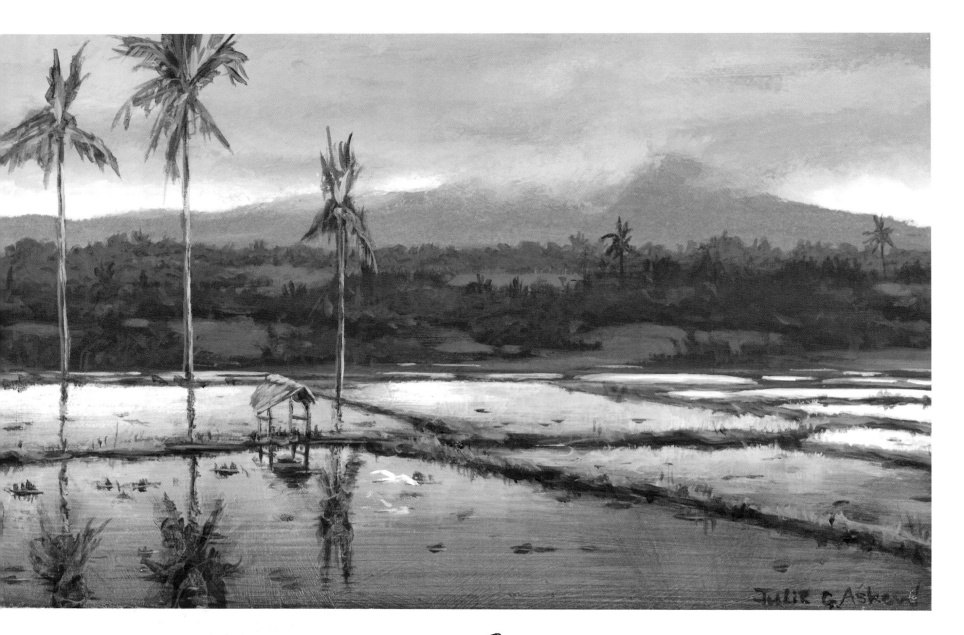

Opposite: Throughout Indonesia, I'm captivated by the fabulous fabrics, the bright colours rippled together in the breeze, the golden threads glistening in the sun. They fit so well with the tropical landscape and create an overall sense of stunning beauty.

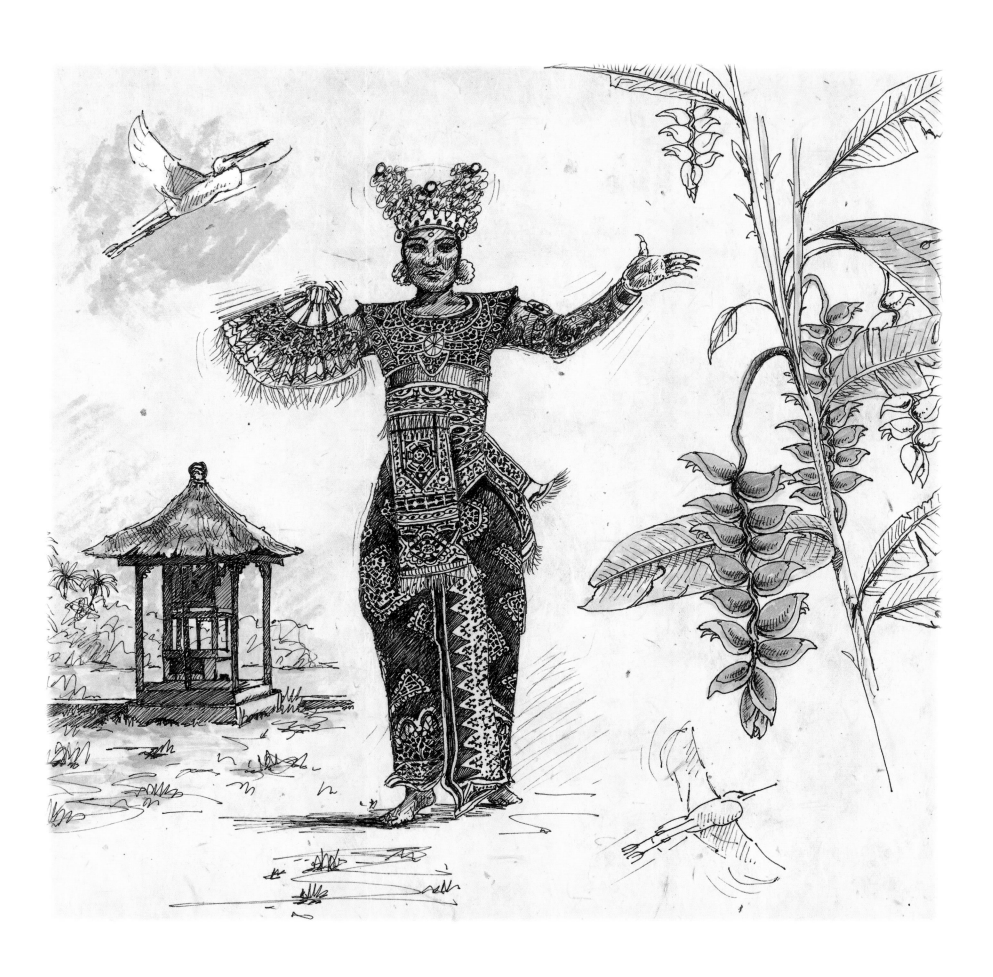

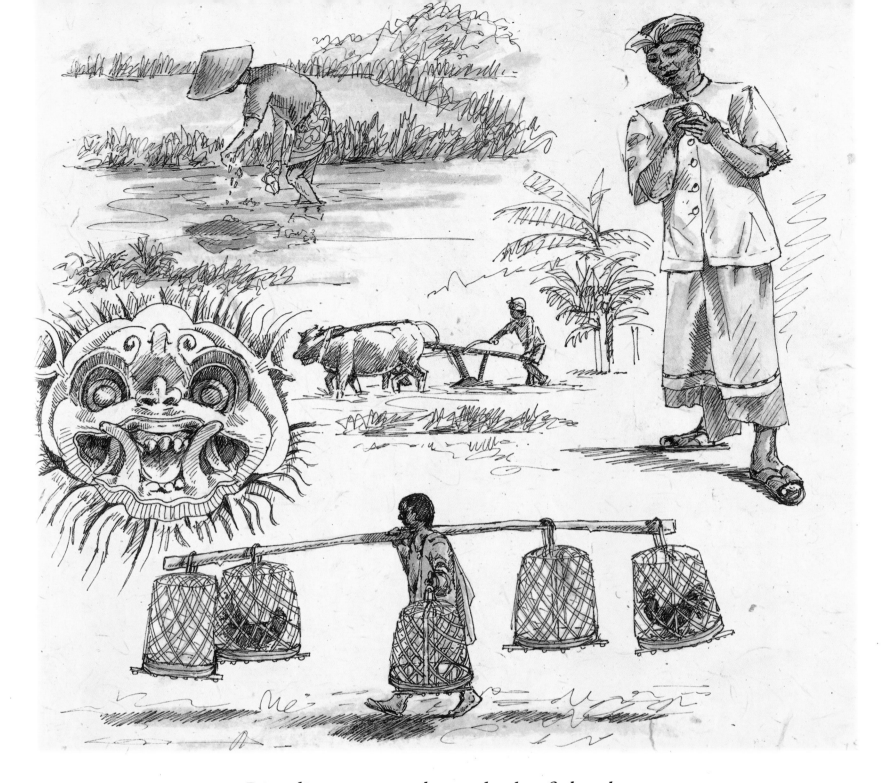

Rippling water shows lack of depth INDONESIA

I see that there is a funeral taking place as I walk through the Balinese village. The shrine's intricate designs and shapes contrast with the houses and the village is melted in the lush landscape. Music emanates from brightly dressed people in a courtyard, drums bang and pipes play in merriment.

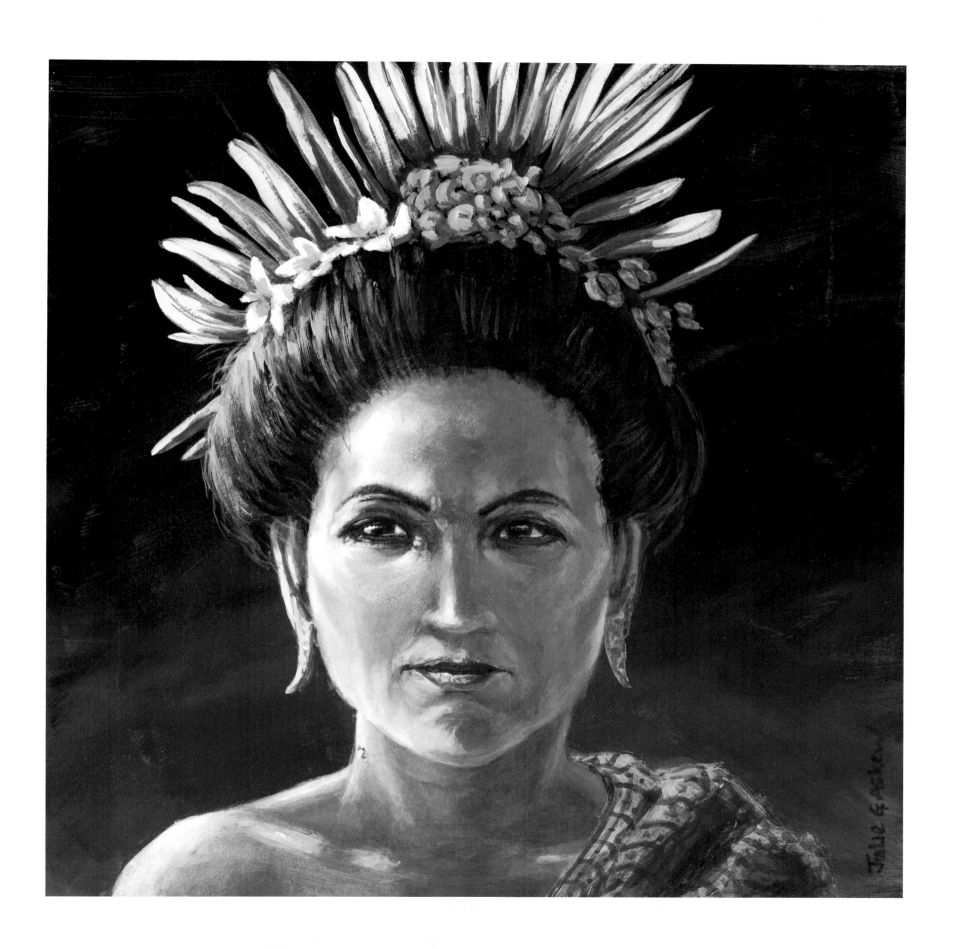

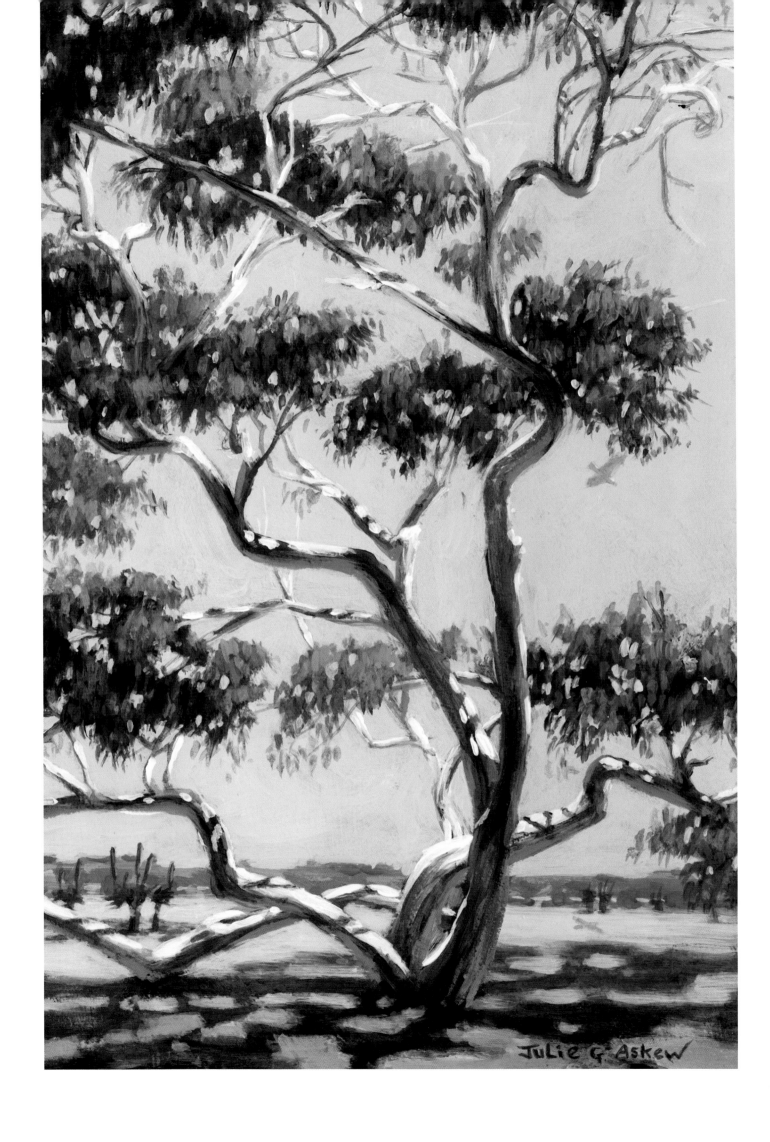

Julie G Askew

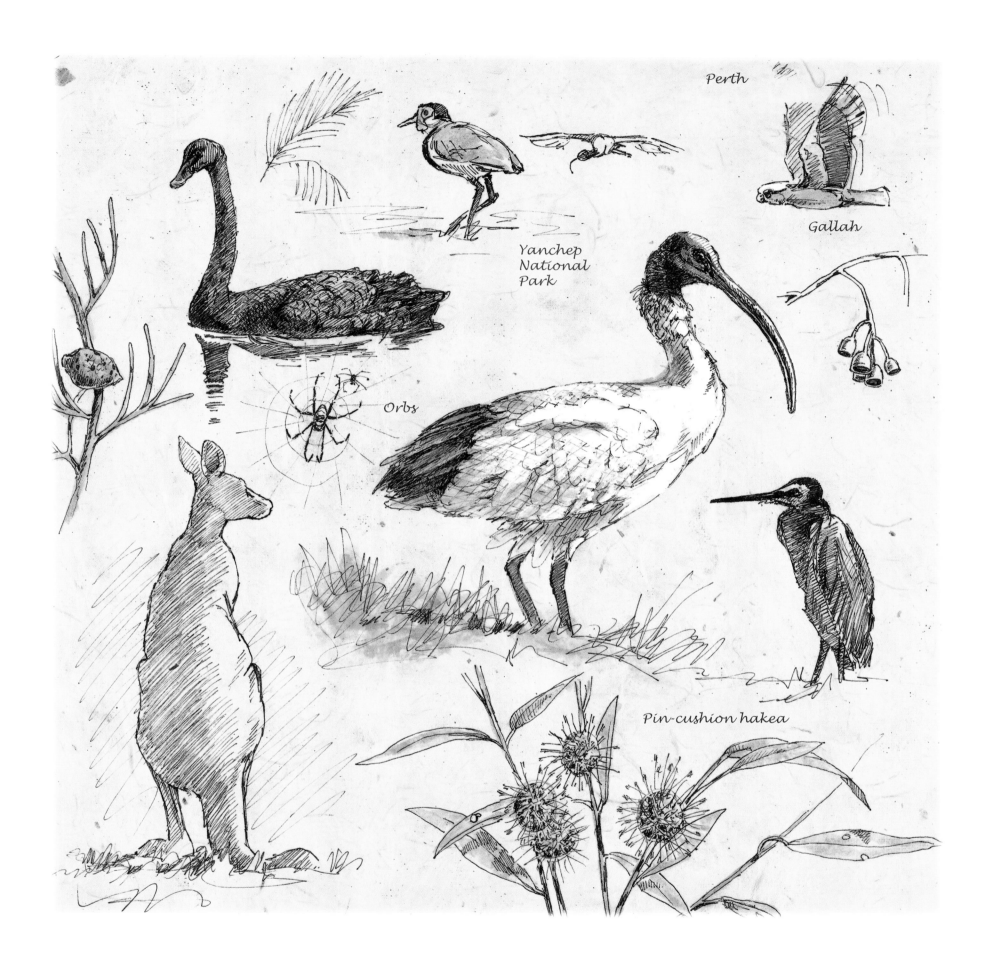

Perth

Gallah

Yanchep
National
Park

Orbs

Pin-cushion hakea

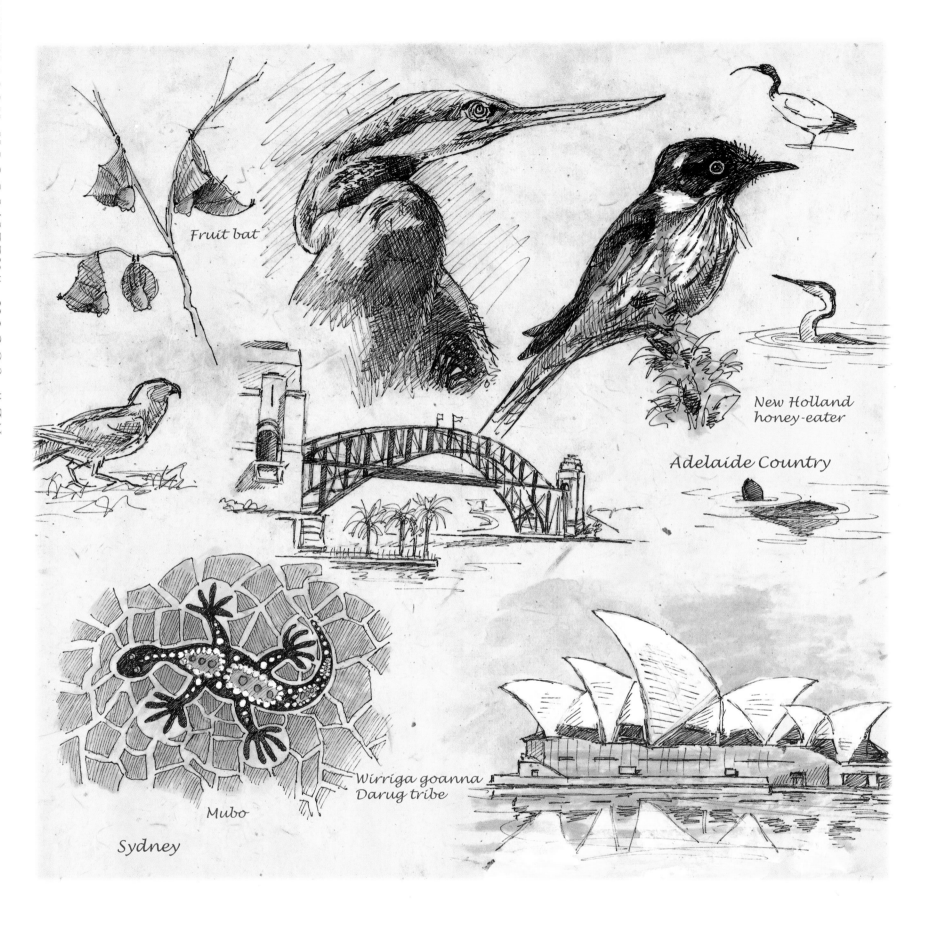

Fruit bat

New Holland
honey-eater

Adelaide Country

Wirriga goanna
Darug tribe

Mubo

Sydney

The heat here is intense, standing in a garden of suburban Adelaide. The constantly chattering birds in the bushes and trees around me are great to sketch, but painting outside in this heat is impossible: both acrylic and watercolour paint dries on the brush before it even reaches the paper.

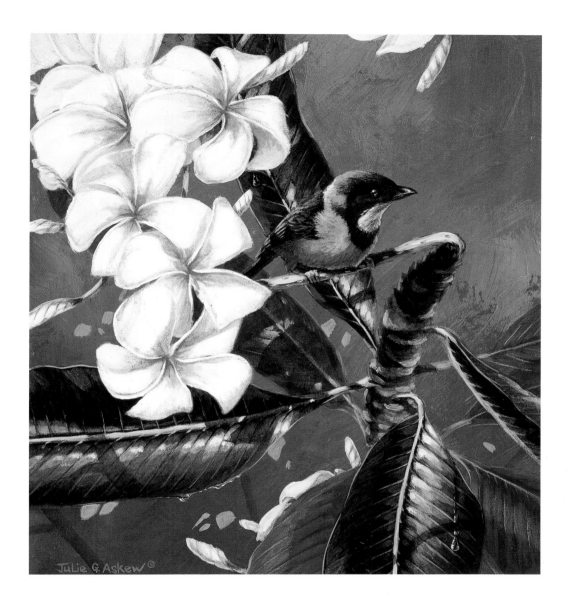

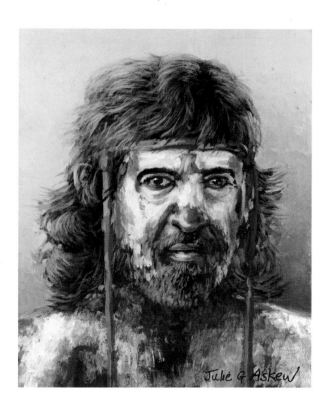

Keep your eyes on the sun and you don't see the shadows... ABORIGINAL

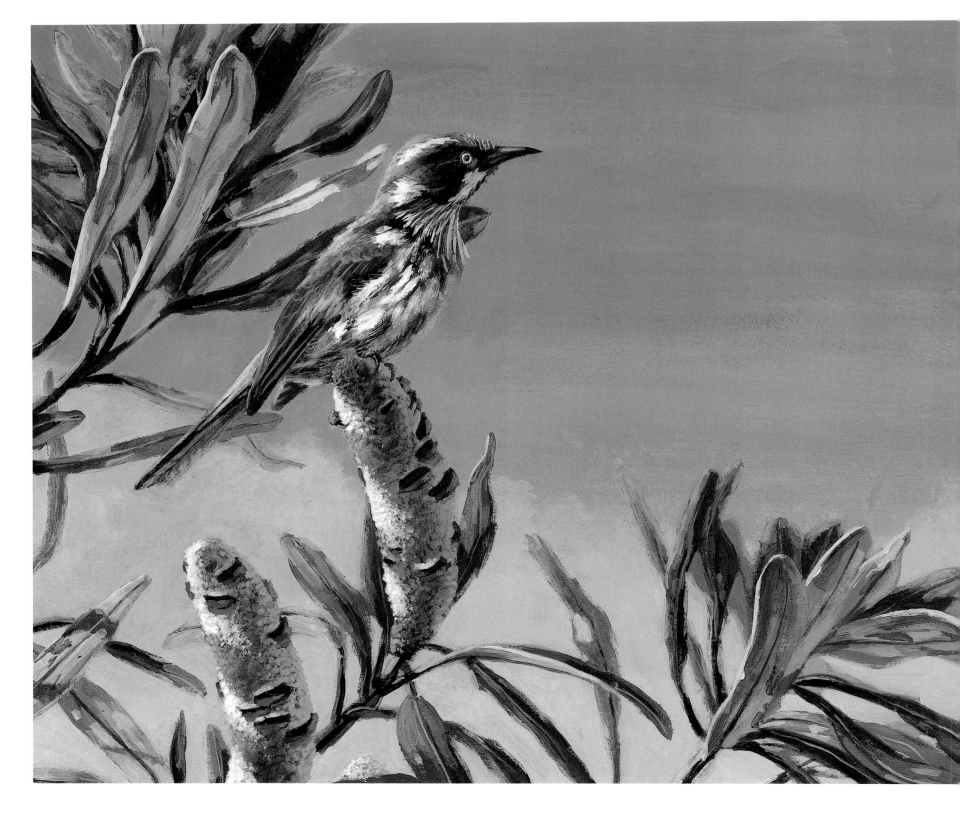

Those who lose dreaming are lost... ABORIGINAL

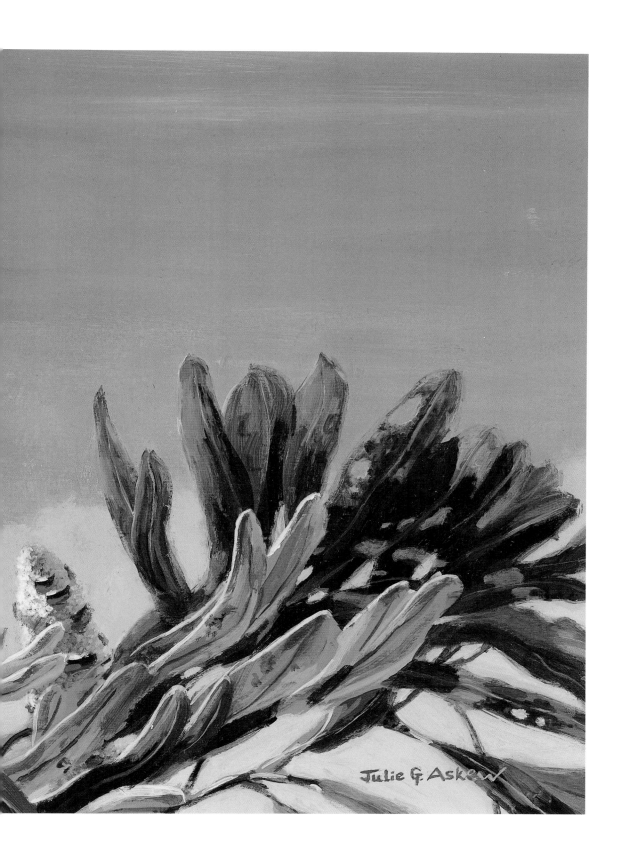

While watching the New Holland honeyeaters, a distinctive laughing call cuts through the still, hot air, giving away another bird's presence. Two kookaburras are in a tree ahead of me; the sight and sound of them gives such a sense of place. I watch and sketch them for a while before they dart off into the scrub.

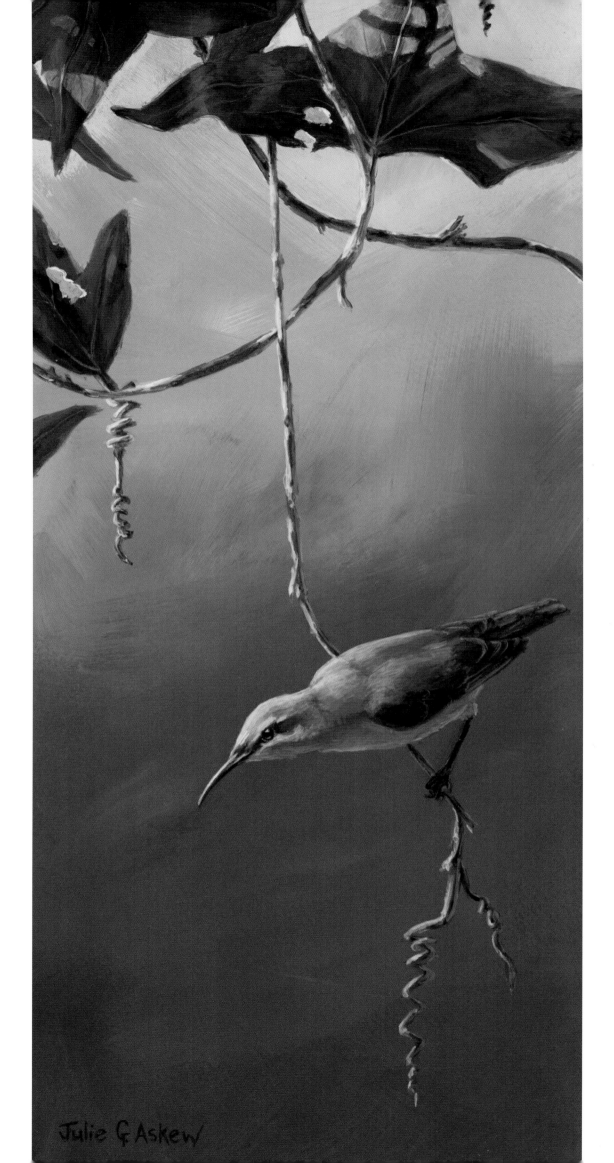

Julie G Askew

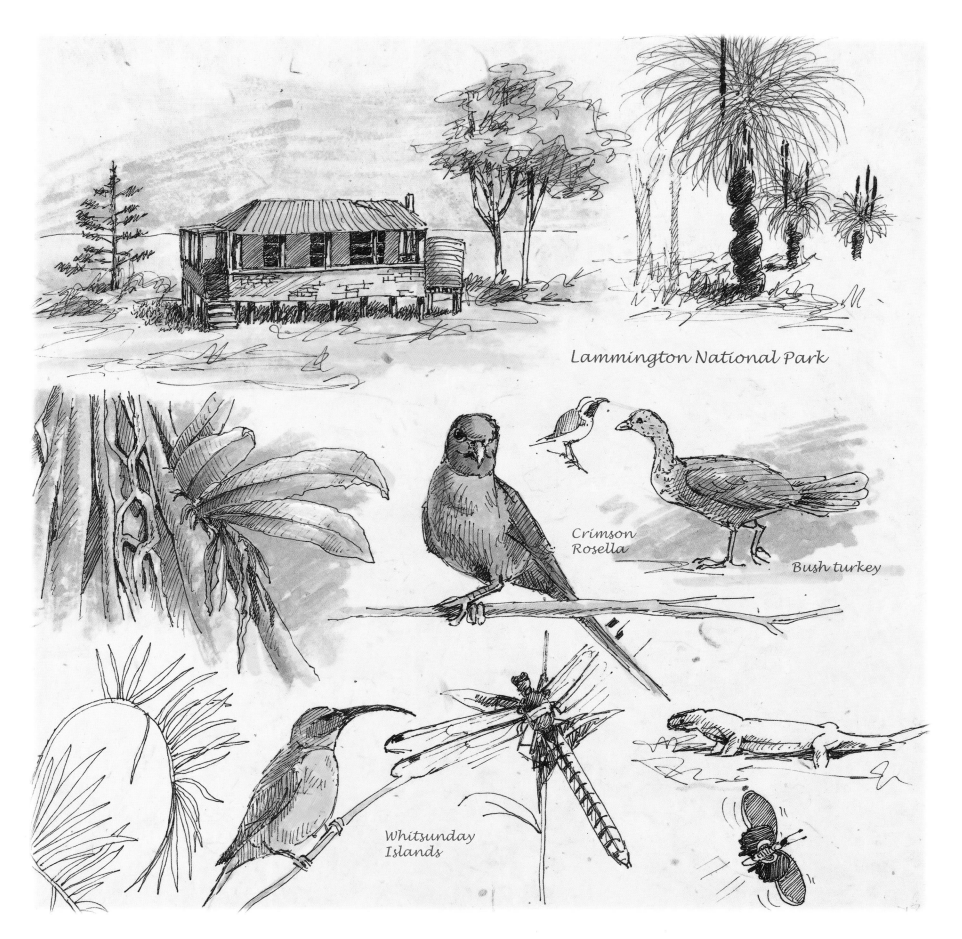

Lammington National Park

Crimson Rosella

Bush turkey

Whitsunday Islands

I climb up a ladder hung through the canopy, passing all manner of leaves in every shade of green. The forest floor recedes below me and the bush turkey that had nibbled my toe a bit earlier awaits my return. Suddenly the leaves clear and the forest opens out before me like a vast green palette.

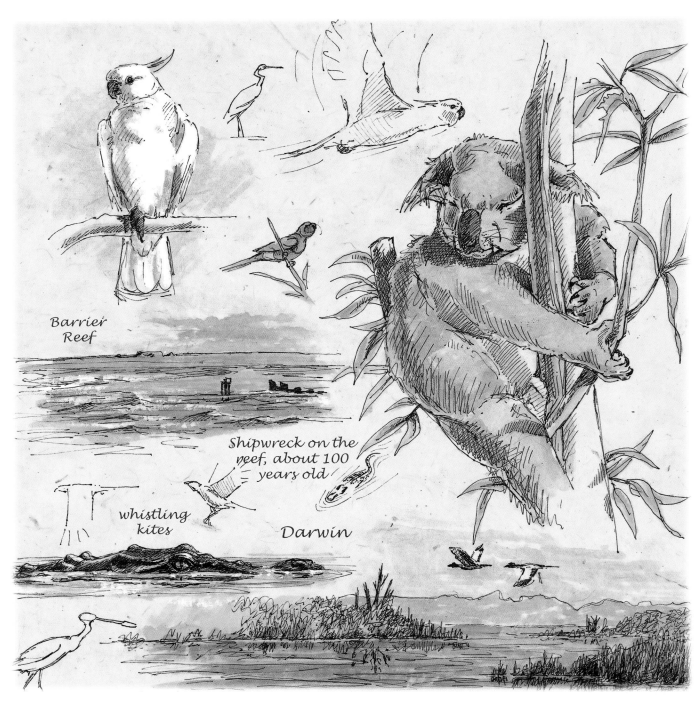

Barrier Reef

Shipwreck on the reef, about 100 years old

whistling kites

Darwin

Opposite: The sulphur-crested cockatoos stand out, startlingly white in the bright sun, and scattered all over the trees like big blooms. The challenge is the paint: white, after all, isn't really white. The choice of colours to create a white-looking bird has to be subtle. Unlike painting snow though, it must not feel cold, so warm pinks in reflected light and purples as well as blue keep the bird warm-looking. Drops of yellow and white create the brightest areas.

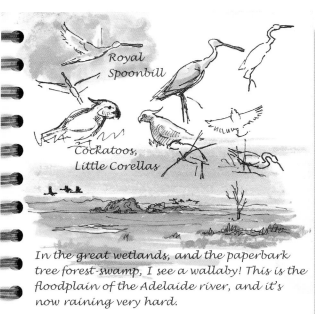

Royal Spoonbill

Cockatoos, Little Corellas

In the great wetlands, and the paperbark tree forest-swamp, I see a wallaby! This is the floodplain of the Adelaide river, and it's now raining very hard.

It really is fantastic having the coast of Australia on this side and the reef on the other, even with the grey skies and misty views.

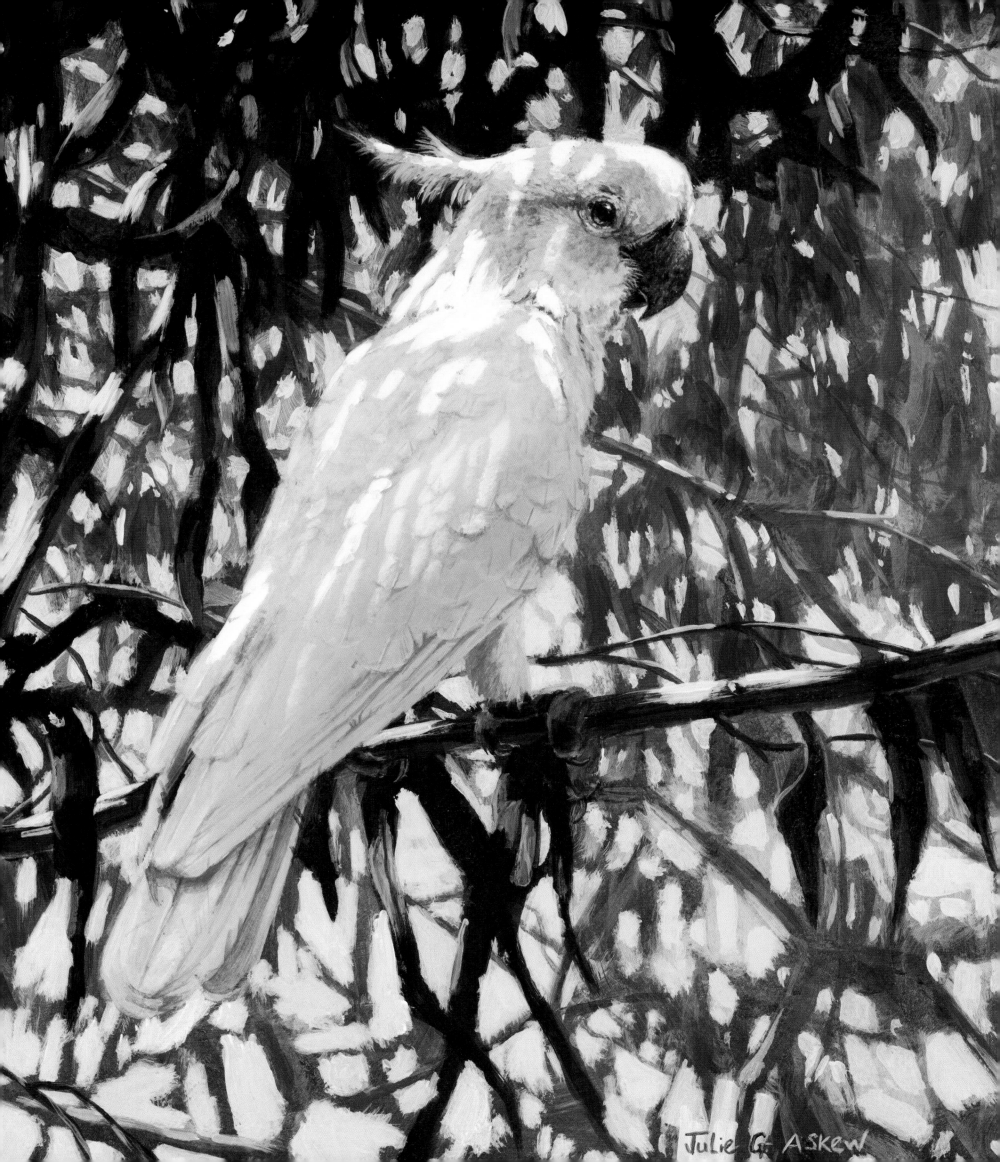
Julie G. Askew

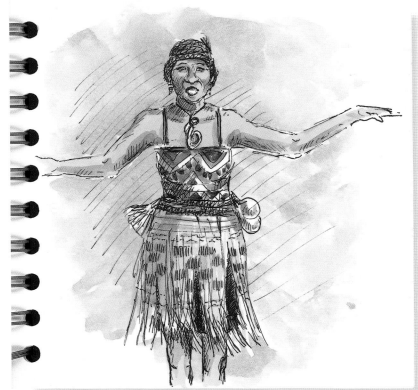

The mud boils away like porridge in Rotorua, spluttering and burping, emanating its sulphur smell. The smell of eggs strangely makes me hungry as I head over to observe the steaming geysers, about to shoot their boiling water into the sky. I sketch quickly, before moving to the leafy ferns that contrast strongly with the mud scenes.

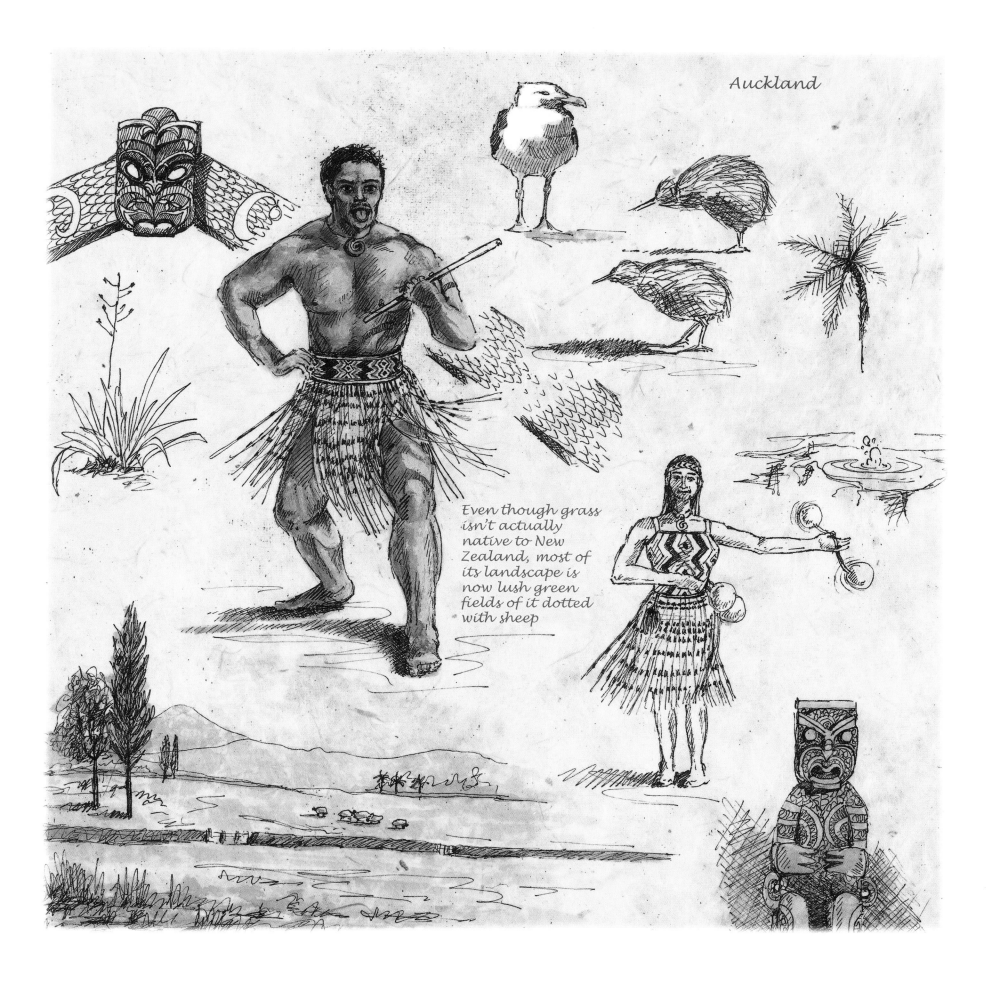

Auckland

Even though grass isn't actually native to New Zealand, most of its landscape is now lush green fields of it dotted with sheep

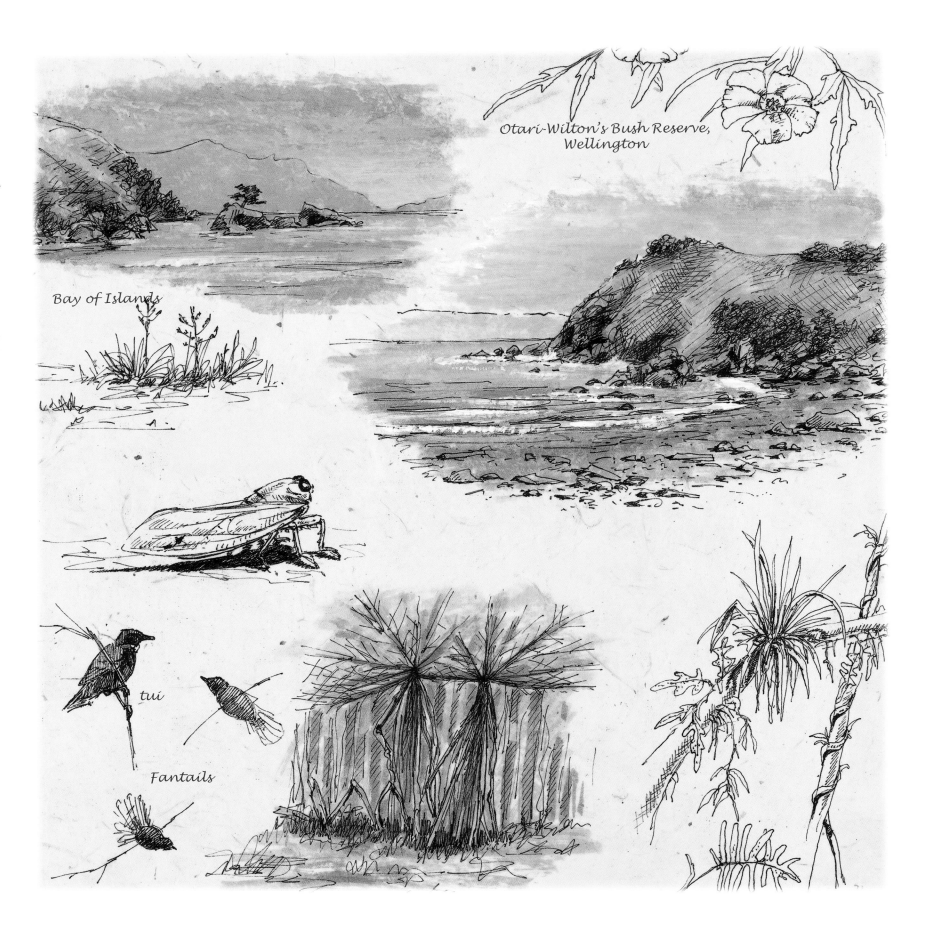

Otari-Wilton's Bush Reserve,
Wellington

Bay of Islands

tui

Fantails

In amongst the giant ferns of the nature reserve, the cicadas' distinctive clicking is intense and ever-present, like a fly buzzing in my head. I try to ignore it and concentrate on sketching the magnificent views.

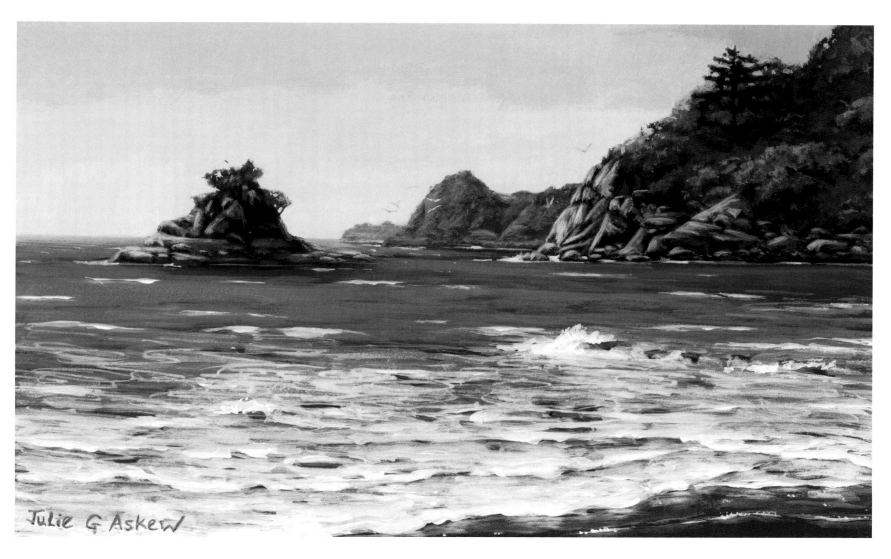

The land is permanent; Man disappears... MAORI

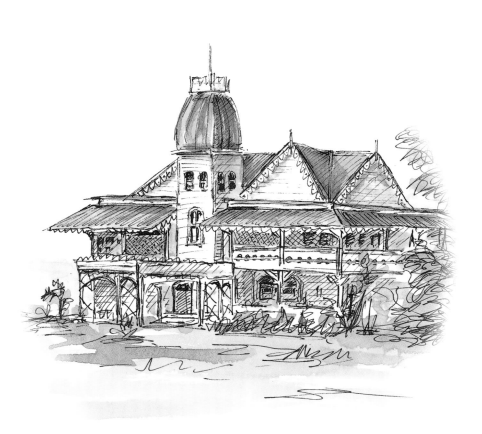

The Royal Palace of the Kingdom of Tonga stands in splendid isolation, a grand wooden building for the King. Just outside its empty grounds though, little pigs run across the roads, around the houses, past the lady selling bananas, under the wooden benches in the local bar…reflecting perfectly the character of these islands!

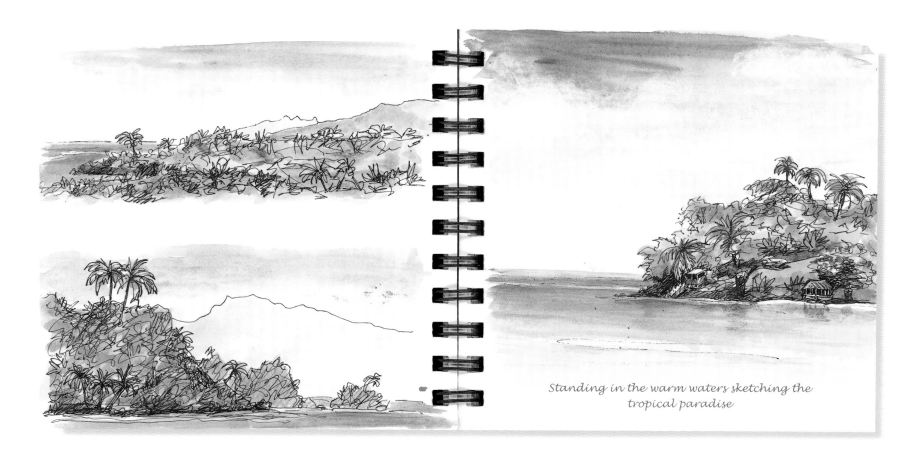

Standing in the warm waters sketching the tropical paradise

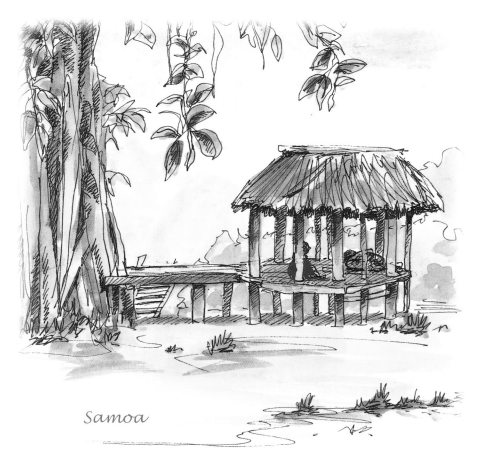

Samoa

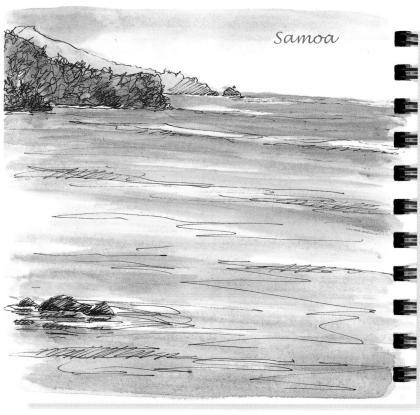

Samoa

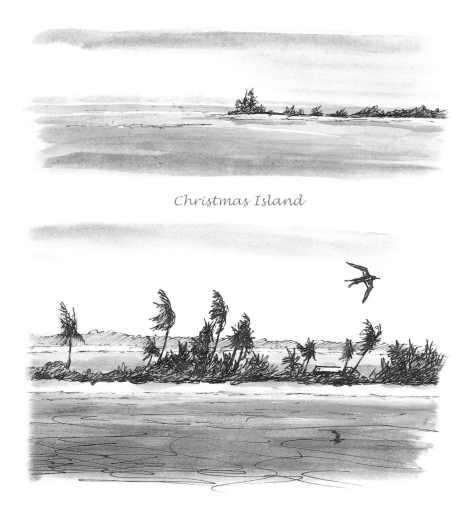

Christmas Island

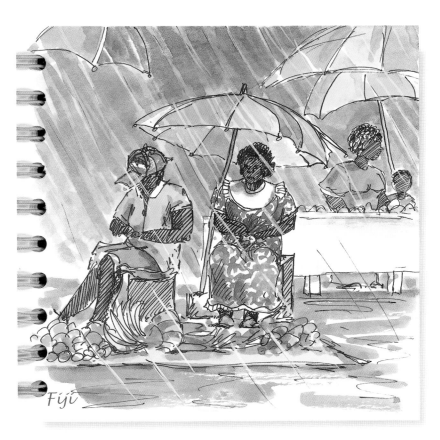

Fiji

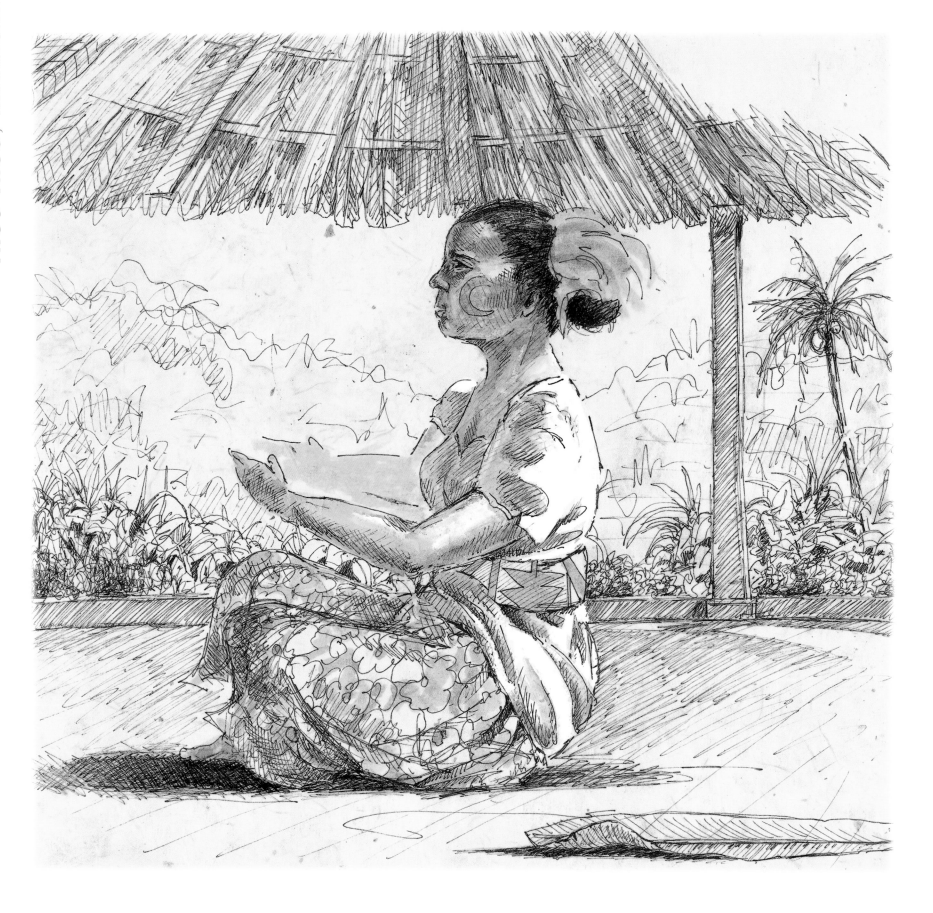

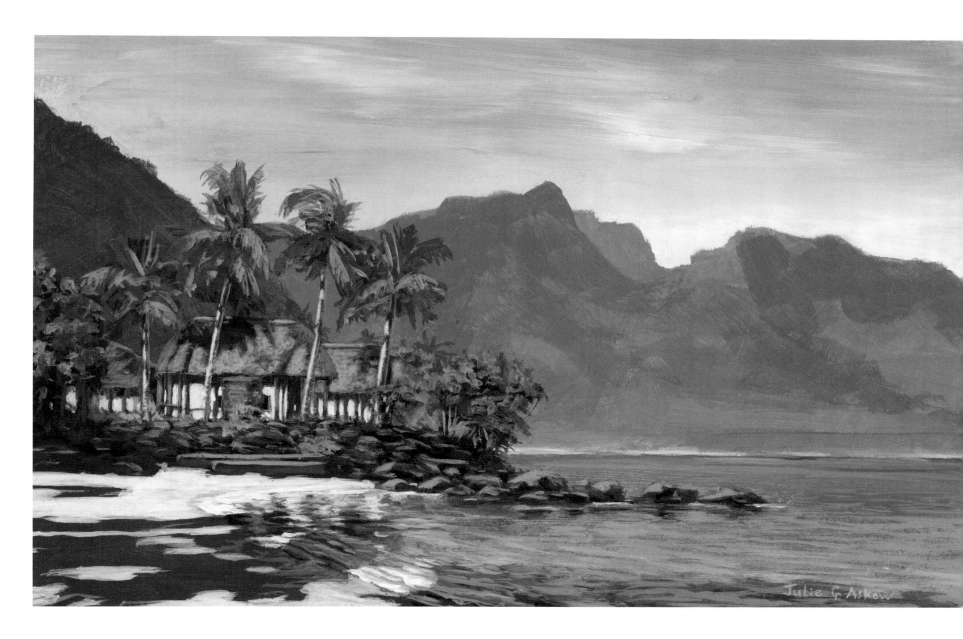

When a mistake is made on land, it can be rectified by the sea SAMOA

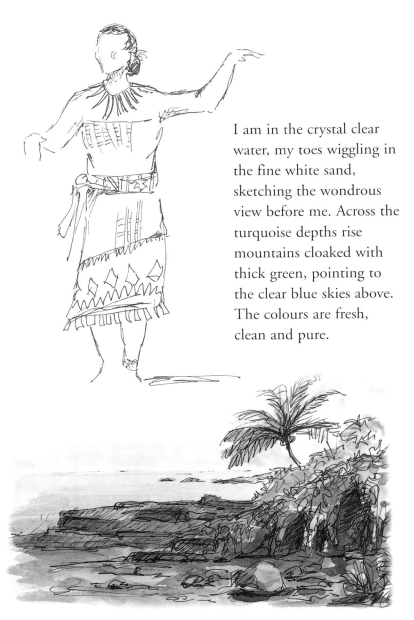

I am in the crystal clear water, my toes wiggling in the fine white sand, sketching the wondrous view before me. Across the turquoise depths rise mountains cloaked with thick green, pointing to the clear blue skies above. The colours are fresh, clean and pure.

The Flower
Pot

To capture the varying greens is interesting as they are so bright that they can look very plastic in paint. Watercolour is an easier medium to achieve the subtlety but then it also makes it harder to keep the freshness.

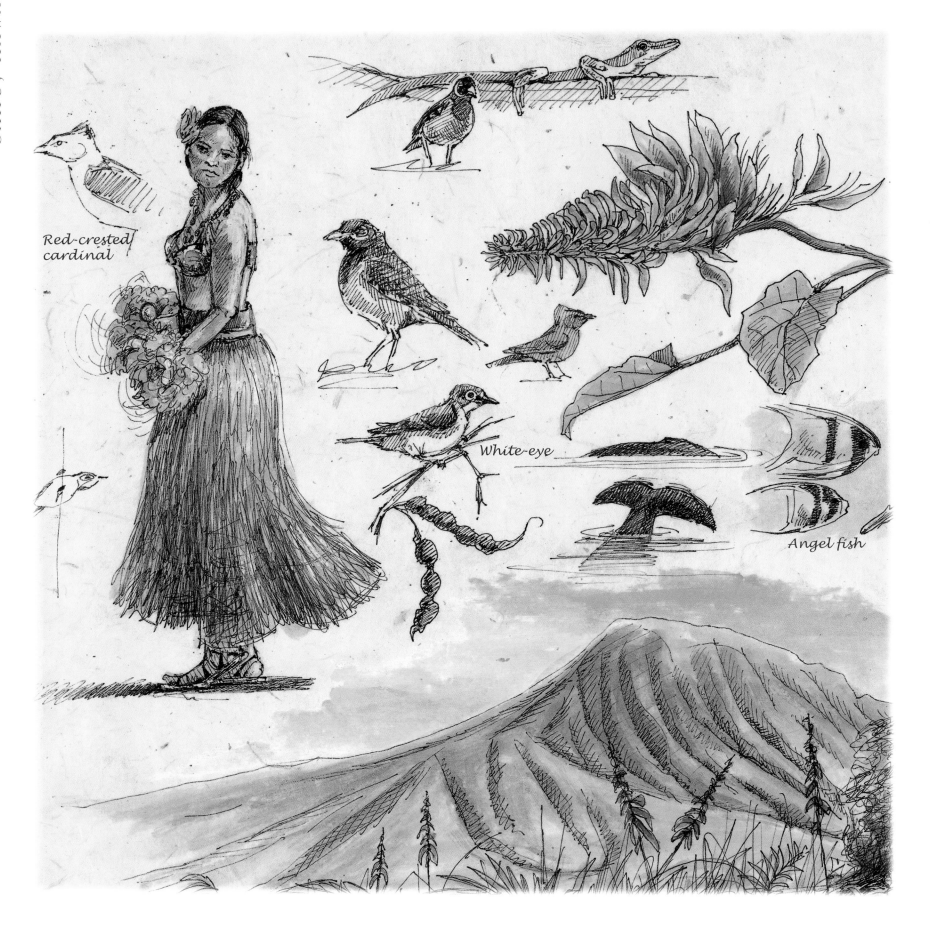

Red-crested cardinal

White-eye

Angel fish

The rain follows the forest HAWAII

The clouds are closing down around the tops of the mountains, creating a dramatic atmosphere and giving the promise of heavy rain. My sketch book will get wet, but at least the ink is waterproof.

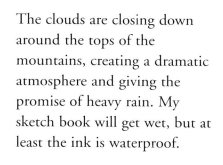

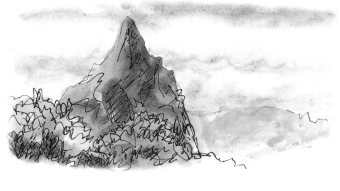

Kokoi nut, like macadaemia.

The candle nut tree (the State tree).

The foliage is getting more lush and tropical in the wetter side of the island, and soon enough yet more clouds have gathered.

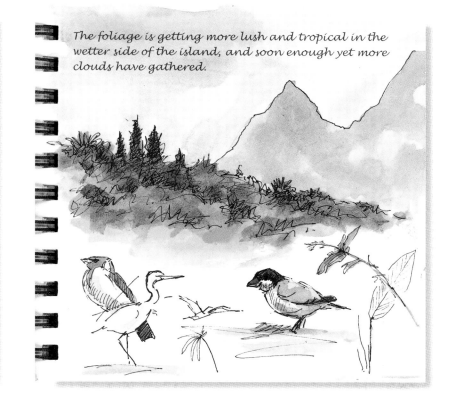

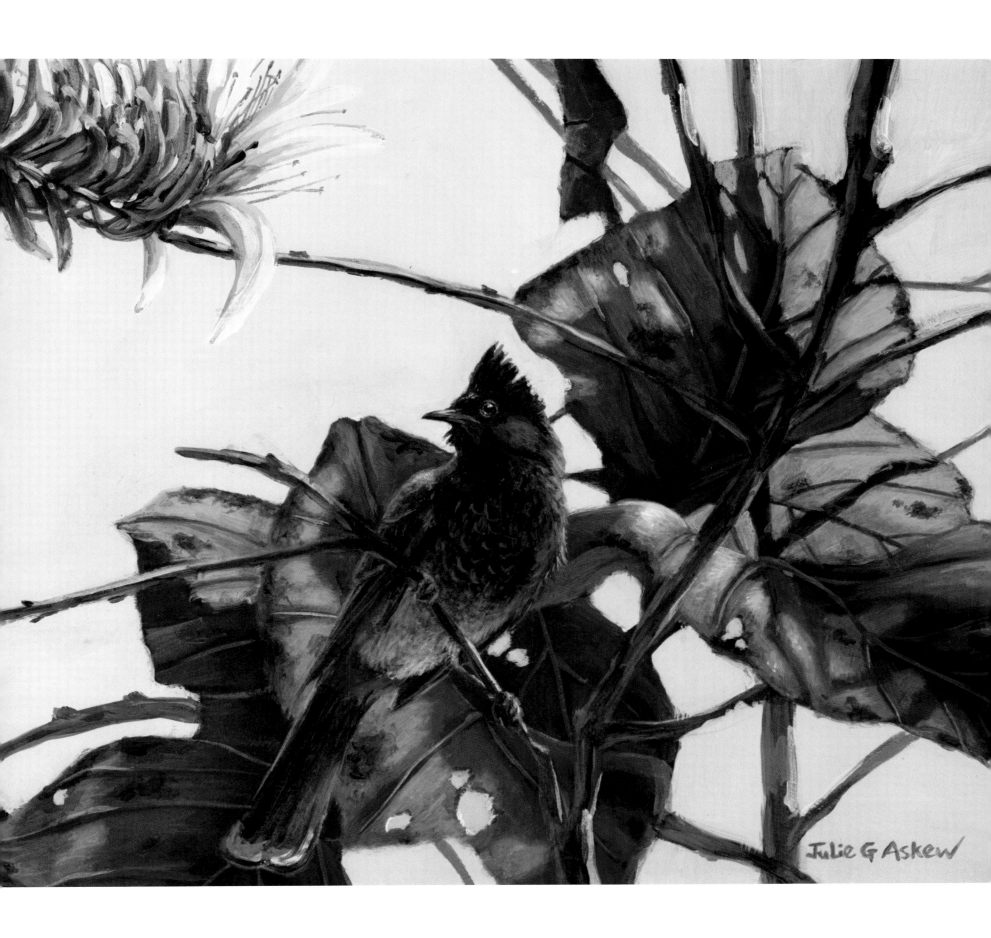

Julie G Askew

From the shore I can look down on the deep blue
ocean and sketch a pod of whales as they enjoy the
calm, warm water.

A coral reef hardens into land HAWAII

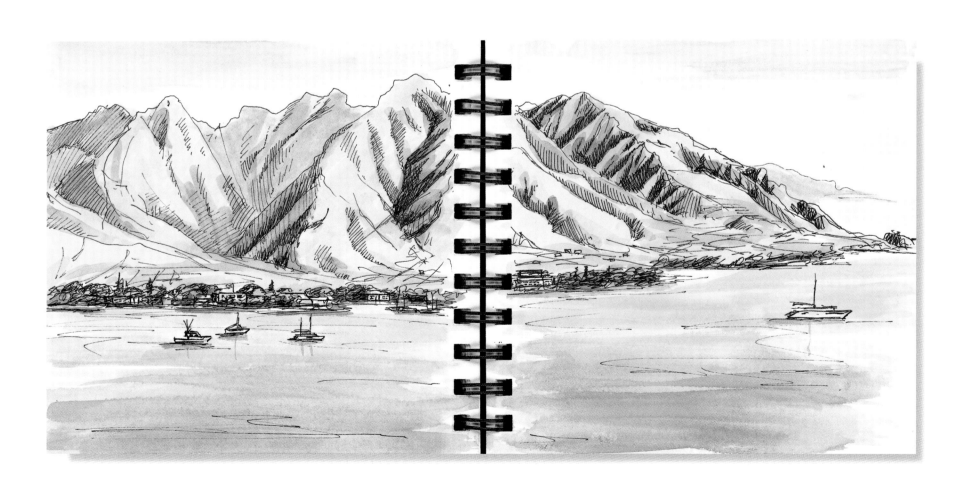

Up above the clouds, going up to 9000 feet!

Being up Mount Haleakala is like being on the moon, so bare and stark. Hard to believe that this is where the Hawaiian goose (the state bird) is native. It is cold and windy and my fingers are freezing, making it hard to control the pen.

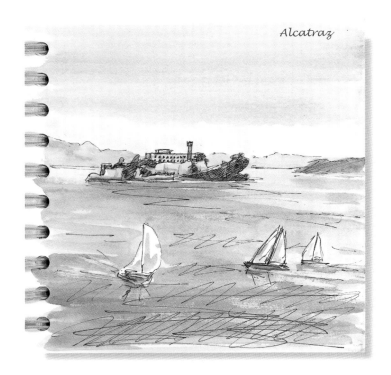

Alcatraz

A dark shadow suddenly strokes the grass near me. The bald eagle glides to a nearby tree, landing on the top to haughtily observe our intrusion of its territory.

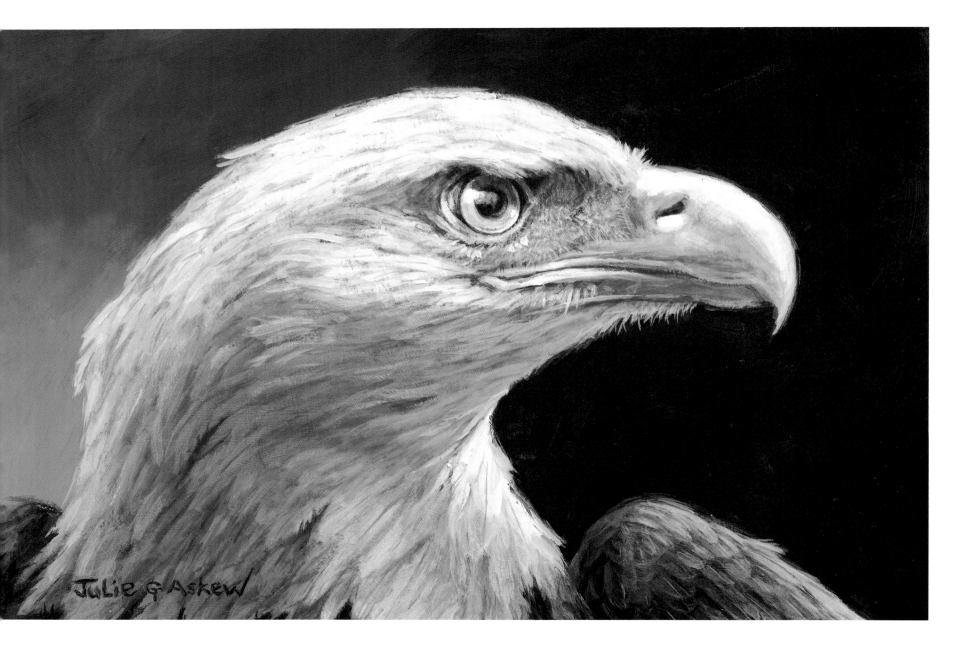

Julie G Askew

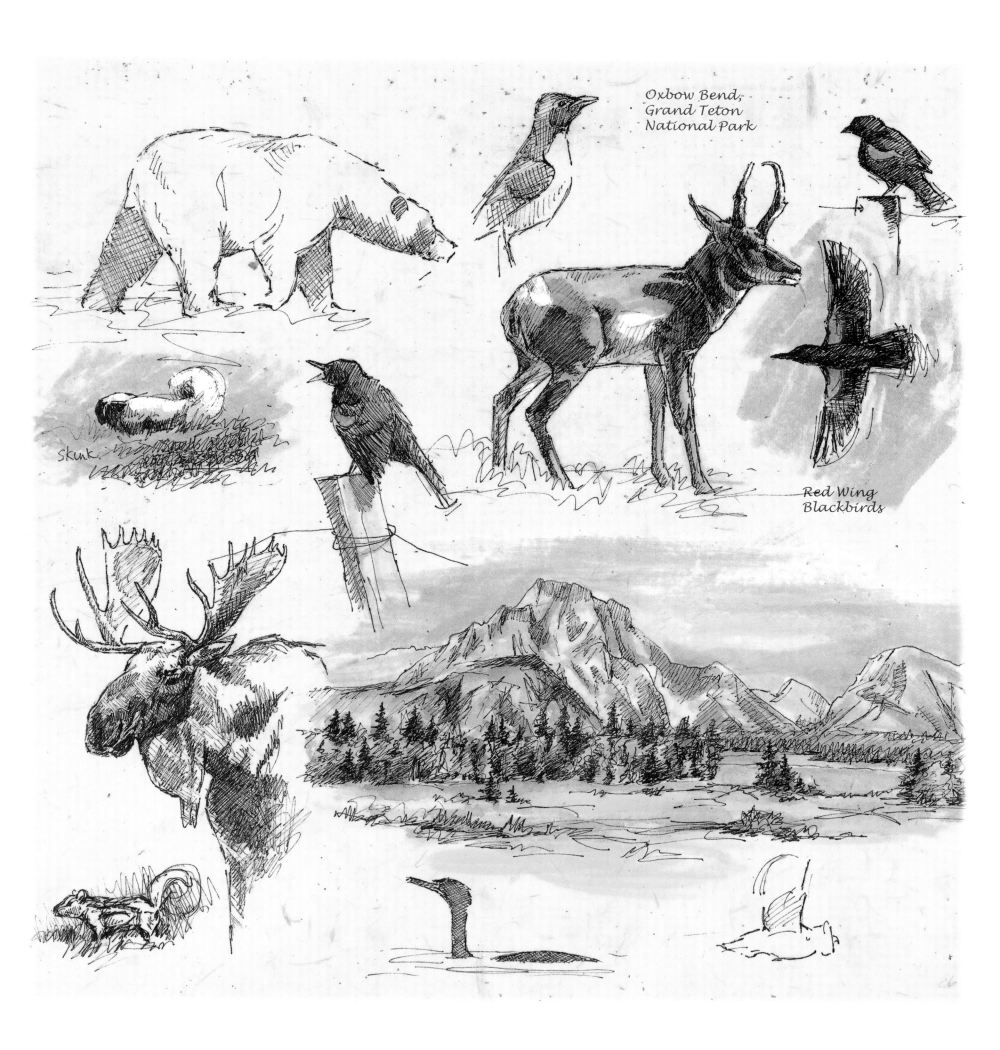

Oxbow Bend,
Grand Teton
National Park

skunk

Red Wing
Blackbirds

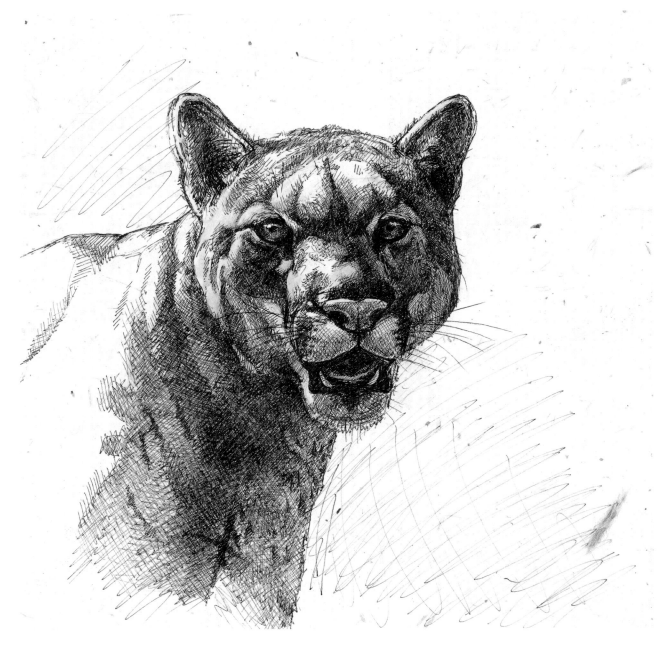

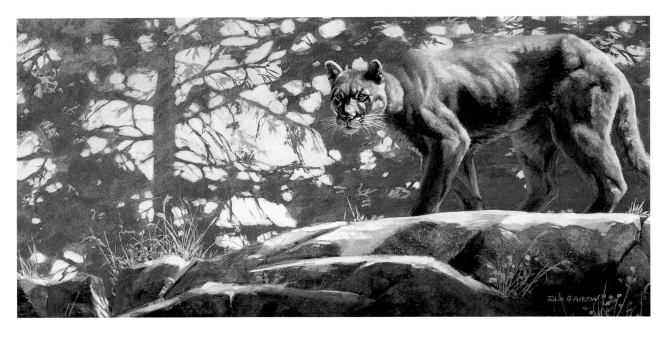

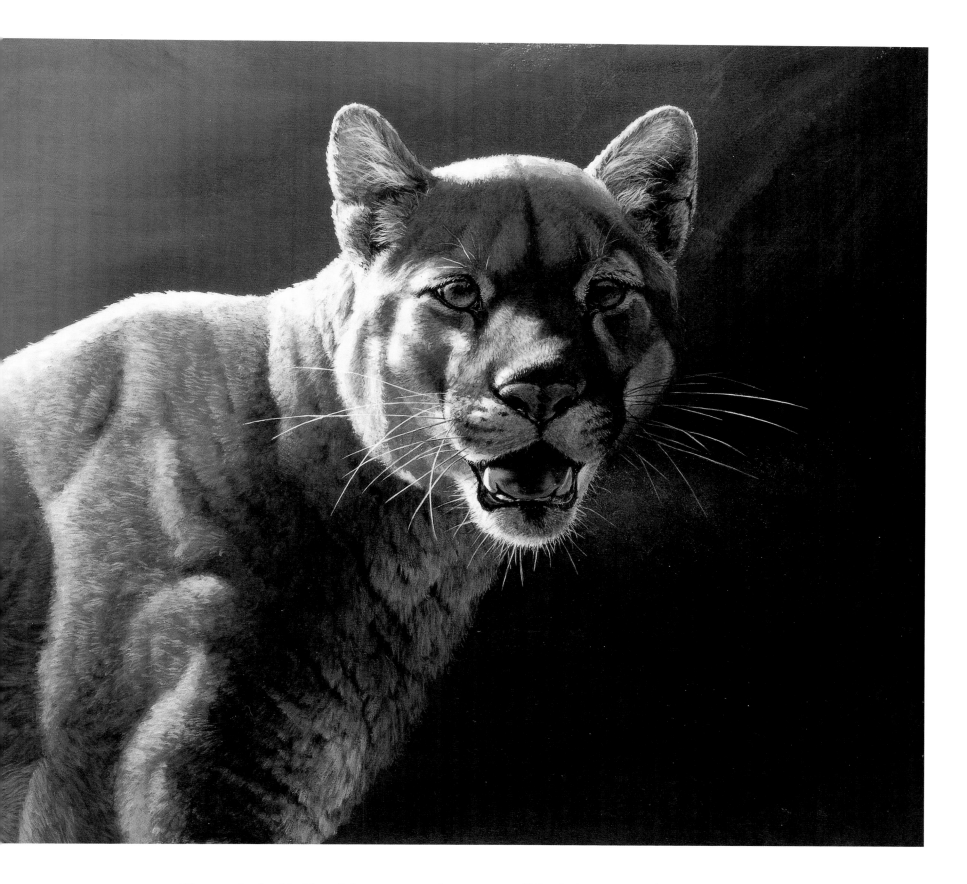

The unmistakeable hiss of the cougar, native to most of North America, sends shivers down the spine as it echoes off the rocks above us. As one, we forget the waterfall that we have come to admire and move rapidly away, bunching together up the path.

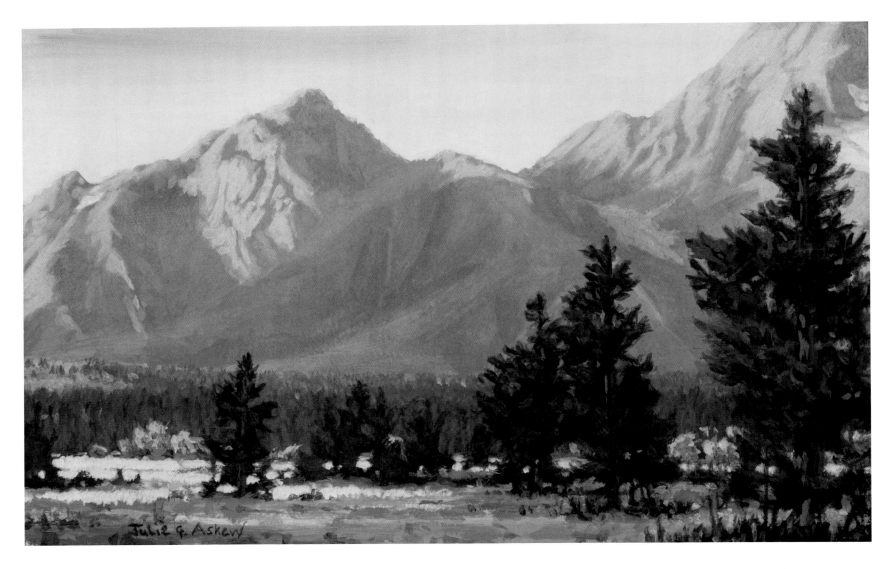

I am lucky to have reached the Tetons at
peak autumn colour. The aspen leaves
fluttering in the breeze. Never have I
seen such bright yellow. It is good to add
purples and violets in shadows when
painting this, to make these yellows
really vivacious and extra bright.

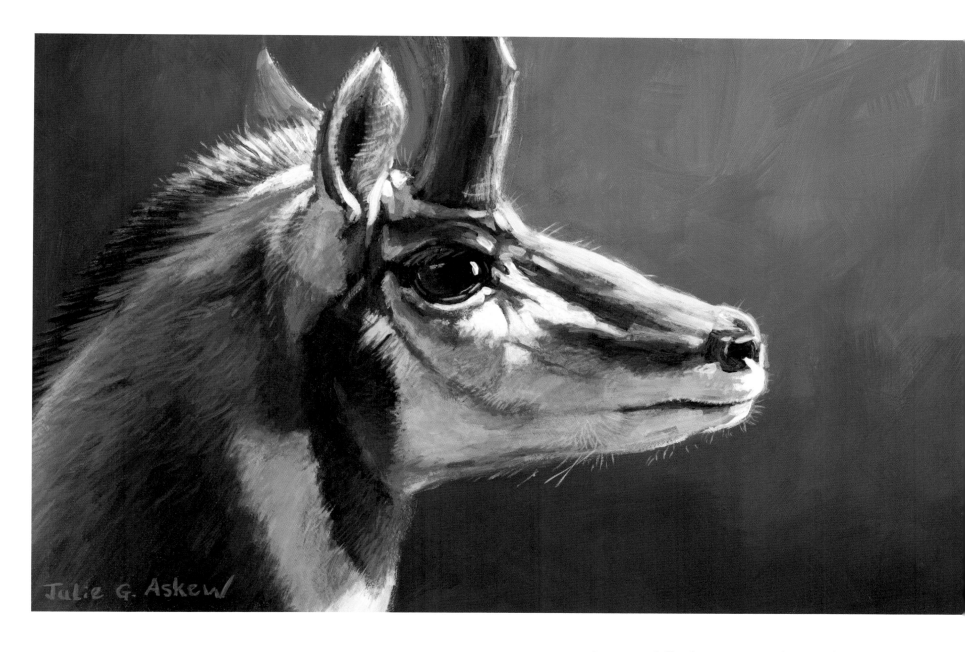

Julie G. Askew

It is very difficult to get a good view of the pronghorn. It's often more a matter of luck than judgement as it dances away from any human presence – and it is the second-fastest land animal in the world!

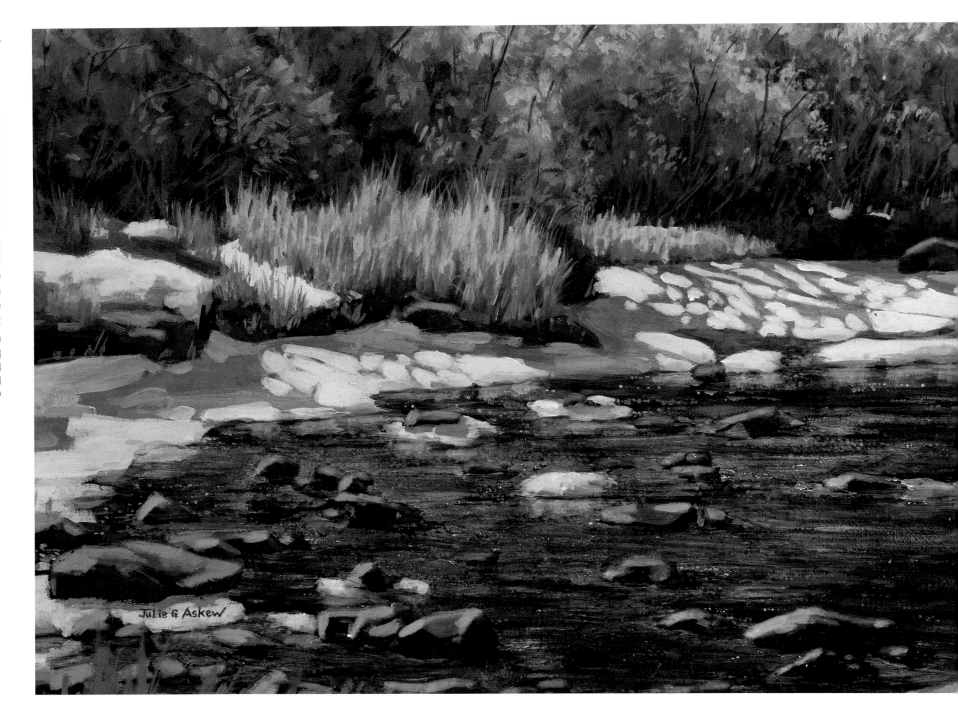

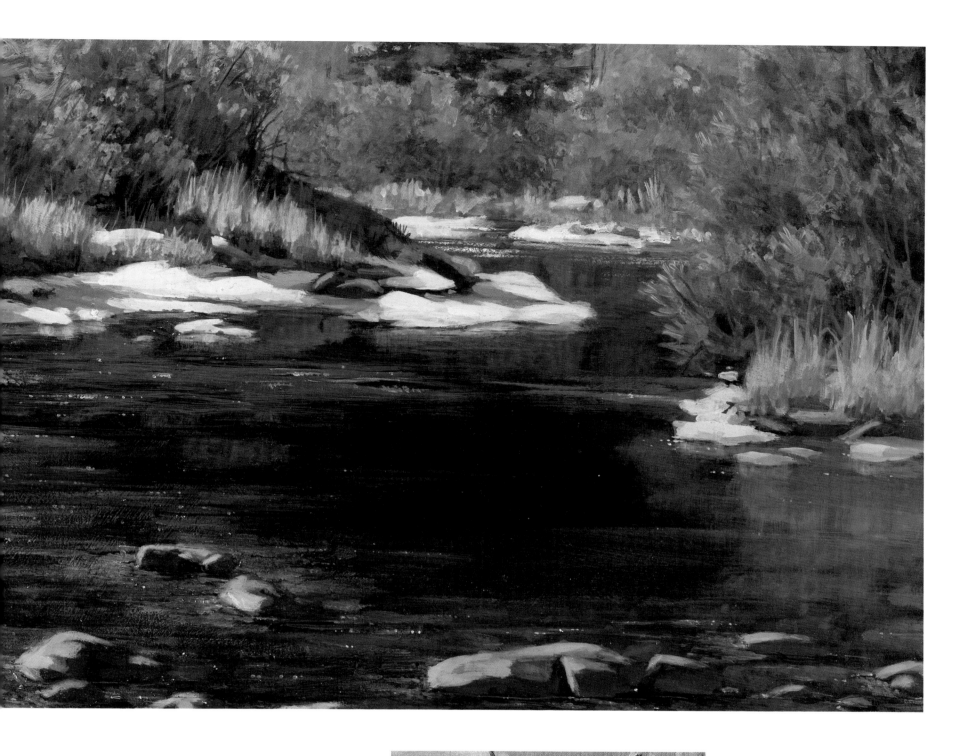

First snow. Although it isn't too cold, the signs of the approaching winter arrive with light snow and iced streams. The added colour and texture enrich the already stunning landscape.

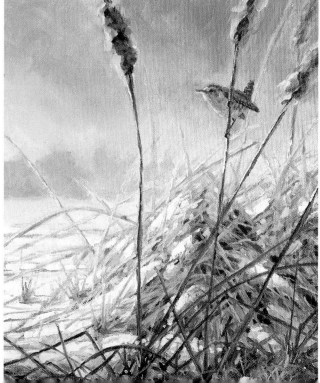

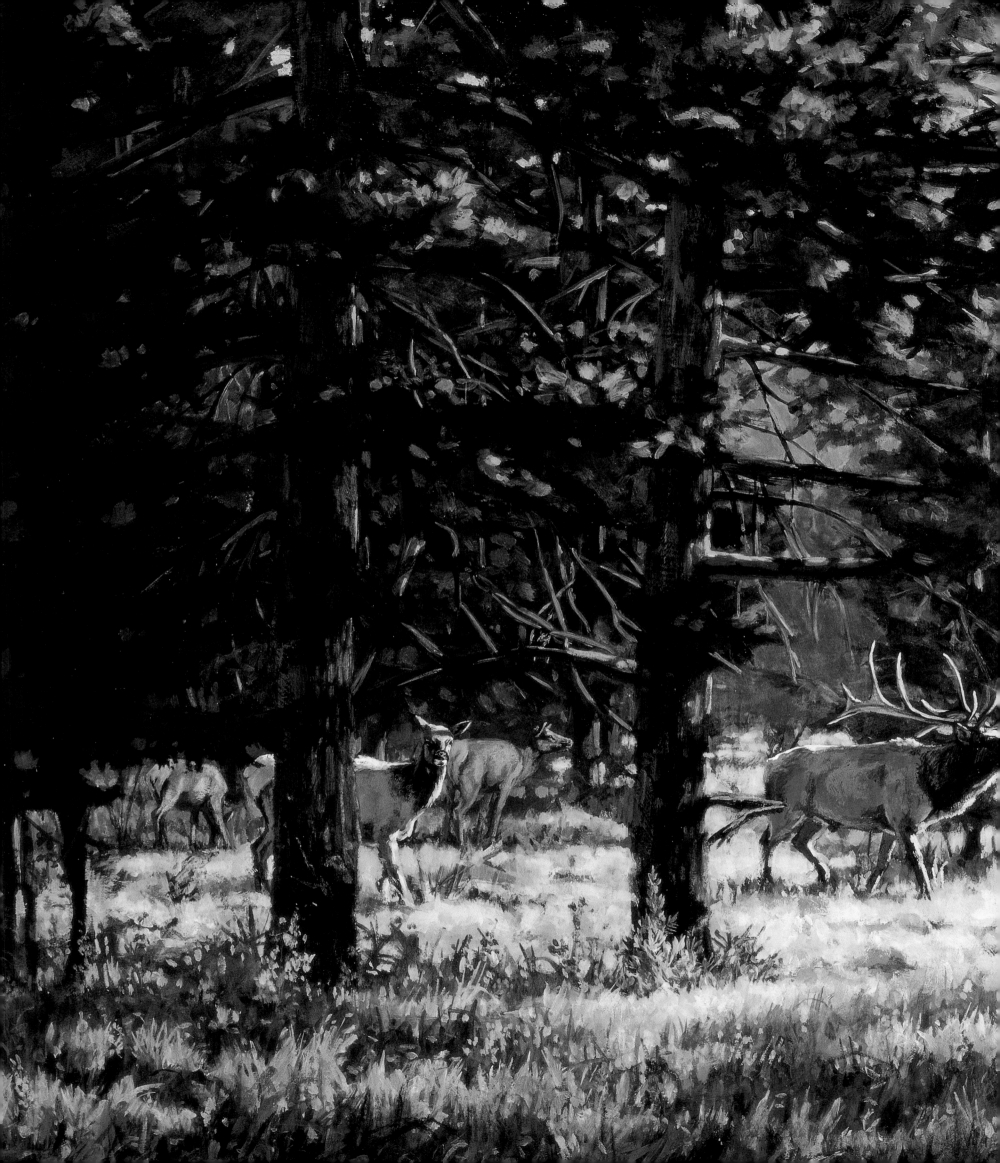

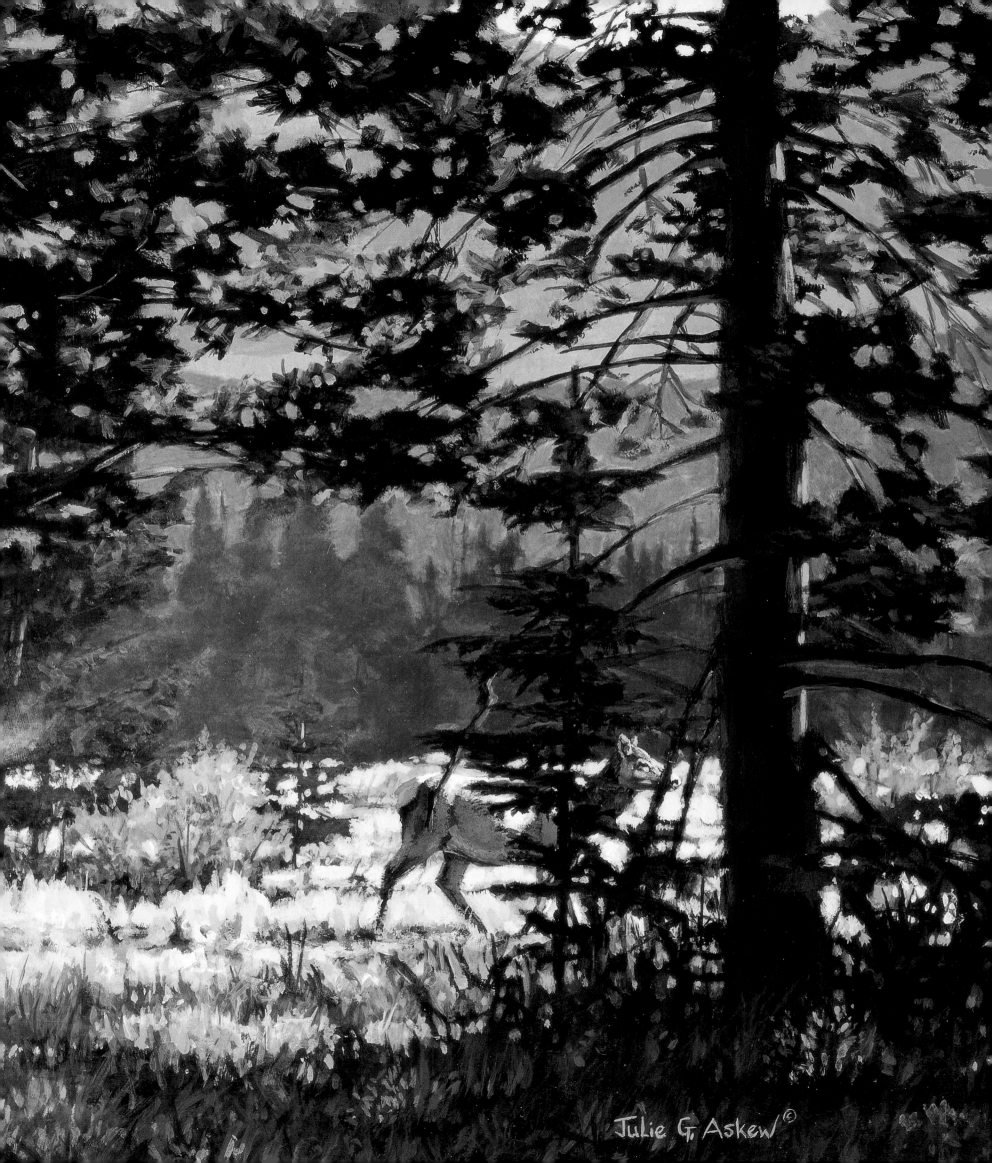

Julie G. Askew

It is a rare privilege to observe wolves in the wild. I have been very fortunate in this respect and have been able to study them closely in the Lamar Valley, Yellowstone. It is fascinating to portray their interaction within the hierarchy of a pack. All aspects of canine behaviour are present, whether they are submissive or dominant, or inquisitive while they patrol their border, or fiercely aggressive when trying to scare off a grizzly bear from their kill.

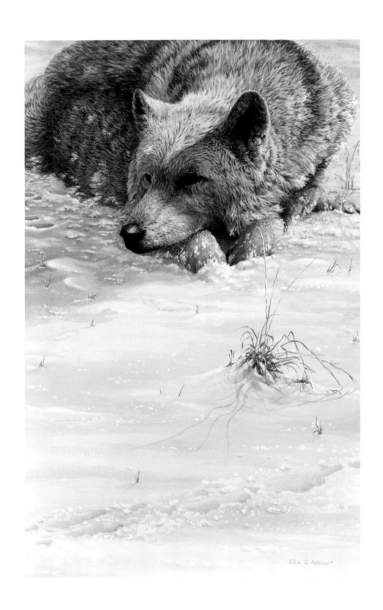

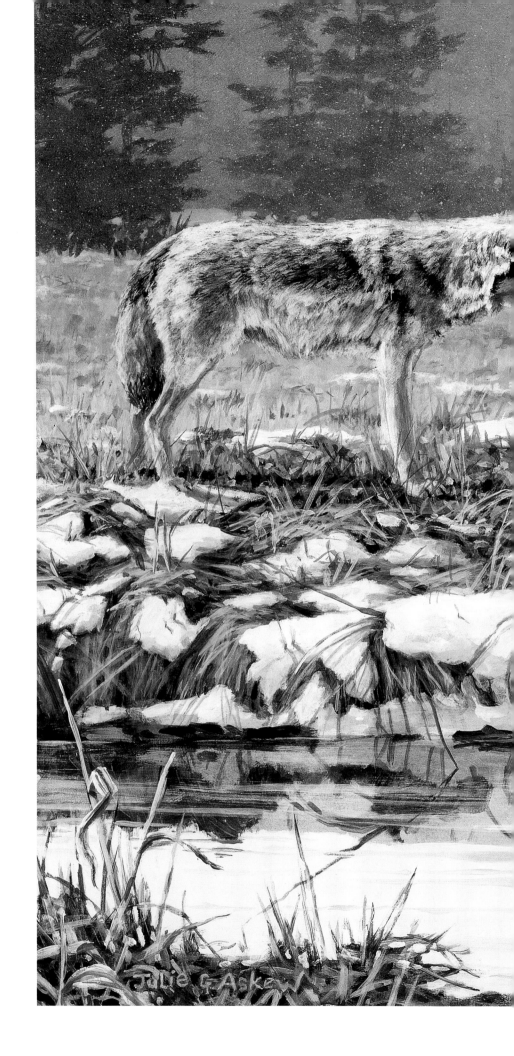

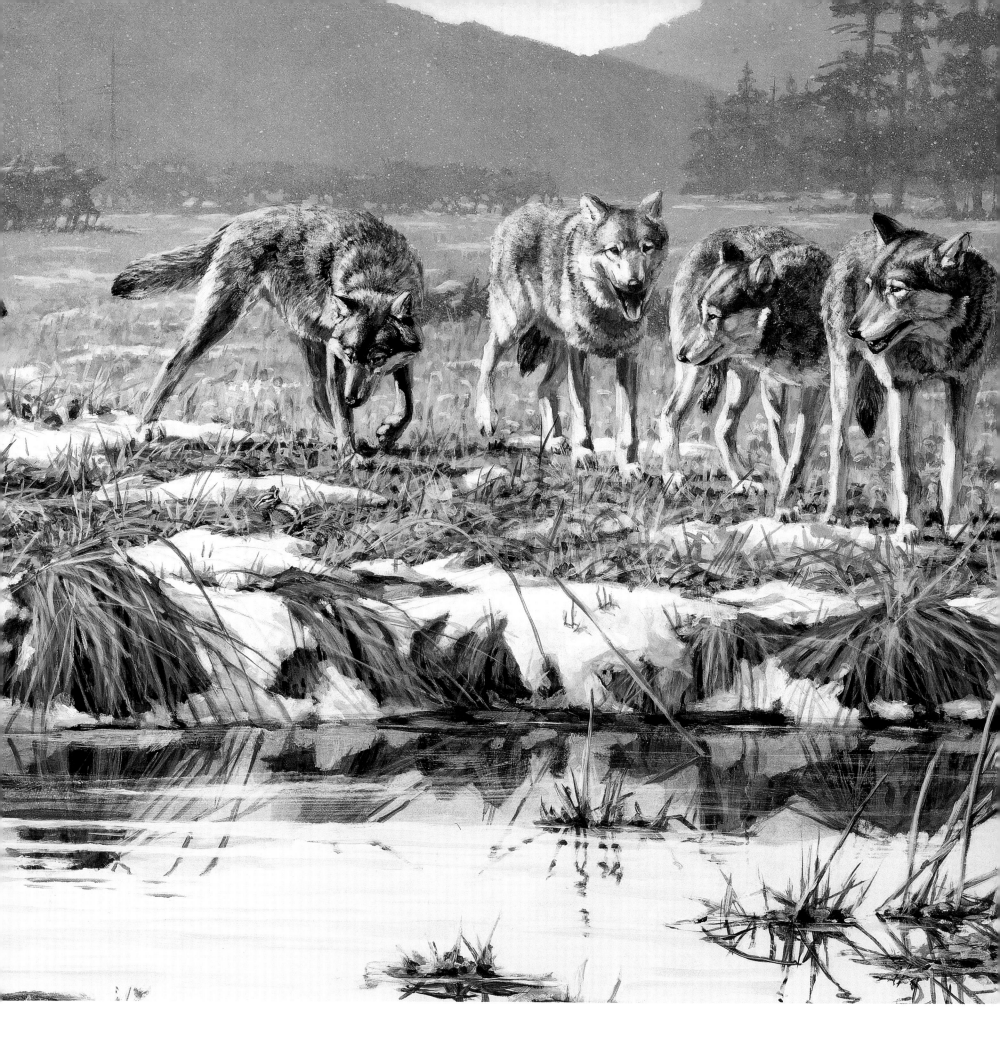

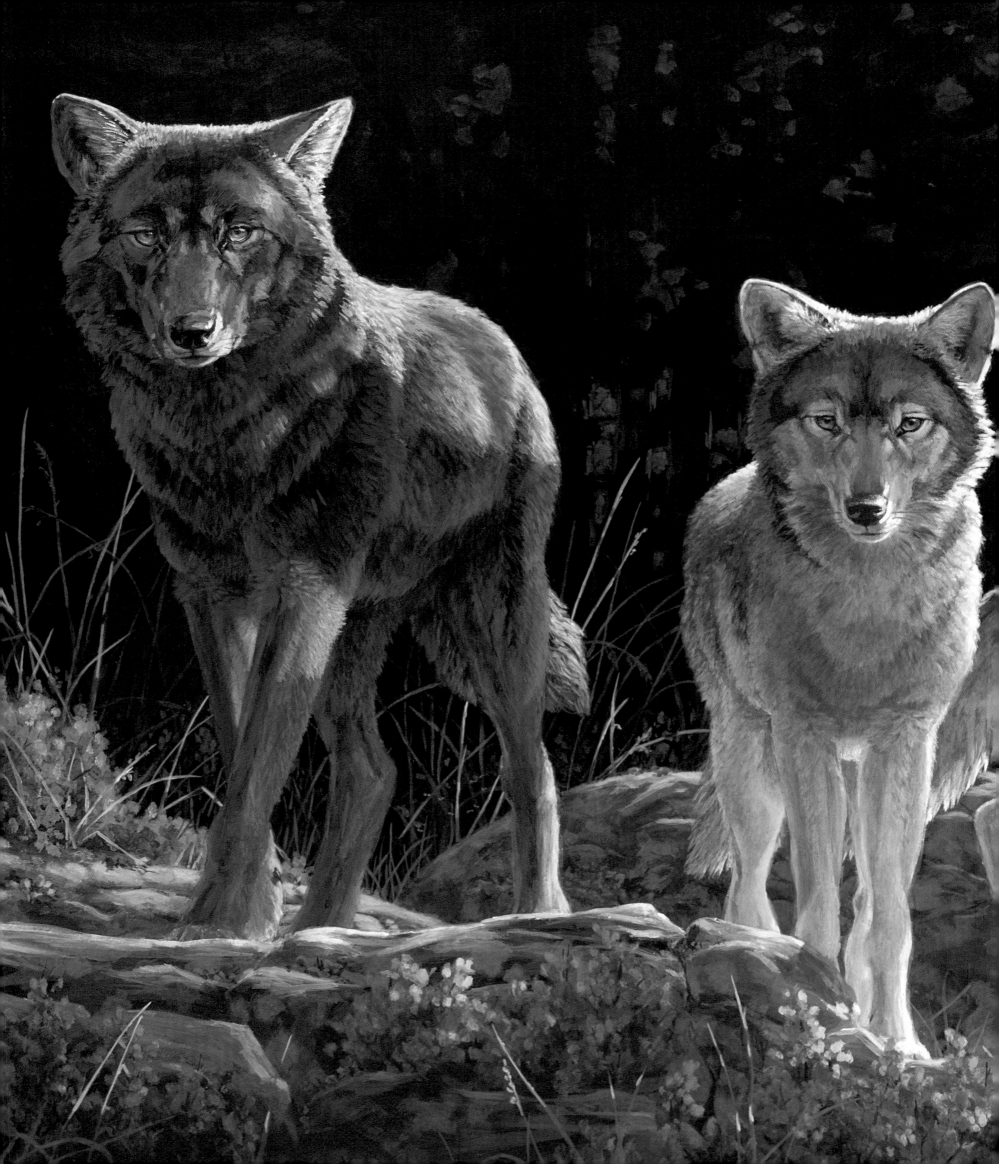

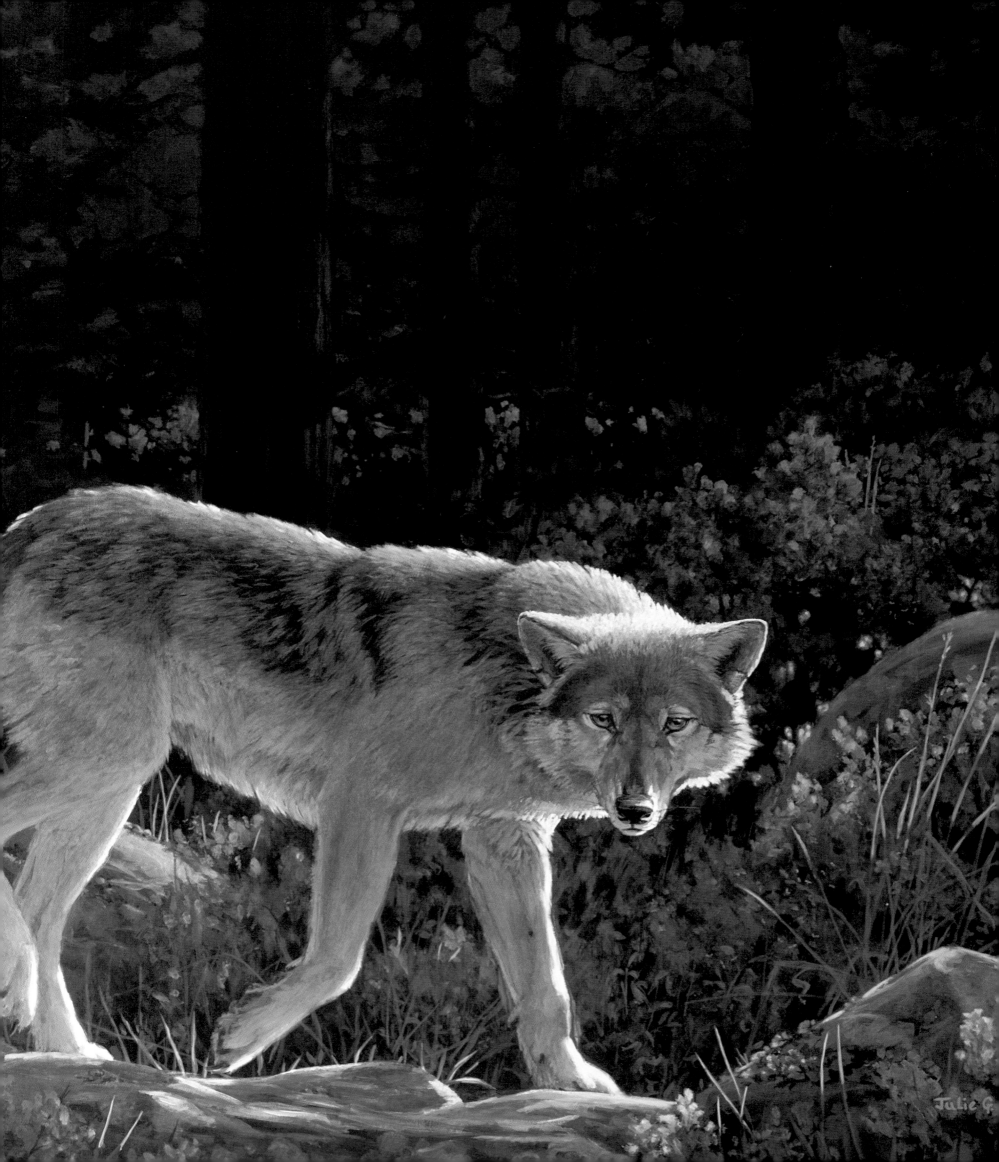

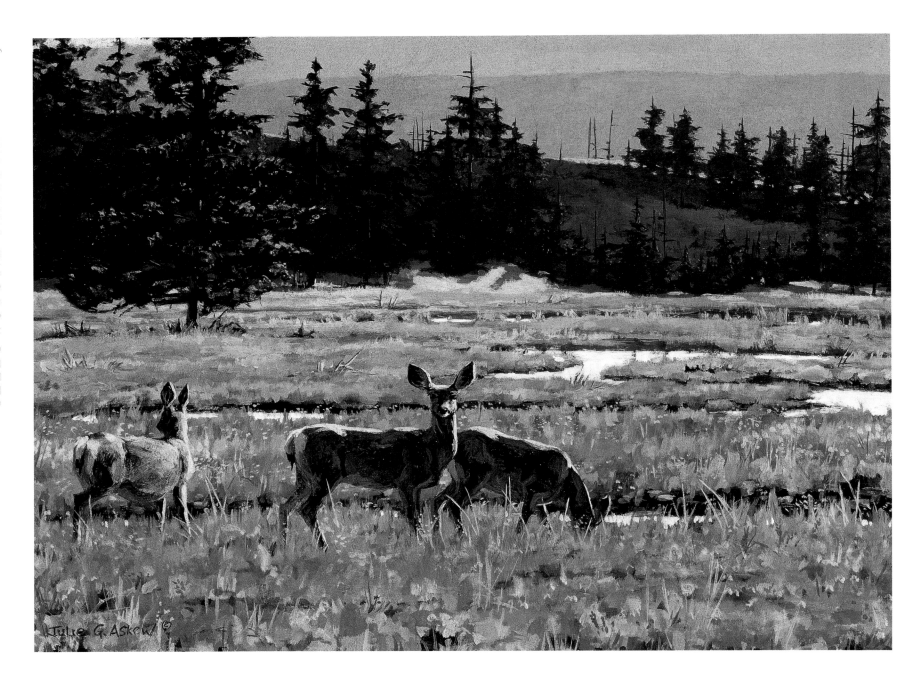

Absorbed as we are by the view of the elk, bugling and
clashing their antlers amid the beautifully sunlit grass
and trees, I don't at first register the shaking of the trees
around us. When it really can't be ignored any longer,
realisation dawns: trees don't shake themselves – a bear
must be rather closer than is usually advised. A rapid
departure suddenly seems vital!

Listen or your tongue will keep deaf NATIVE AMERICAN

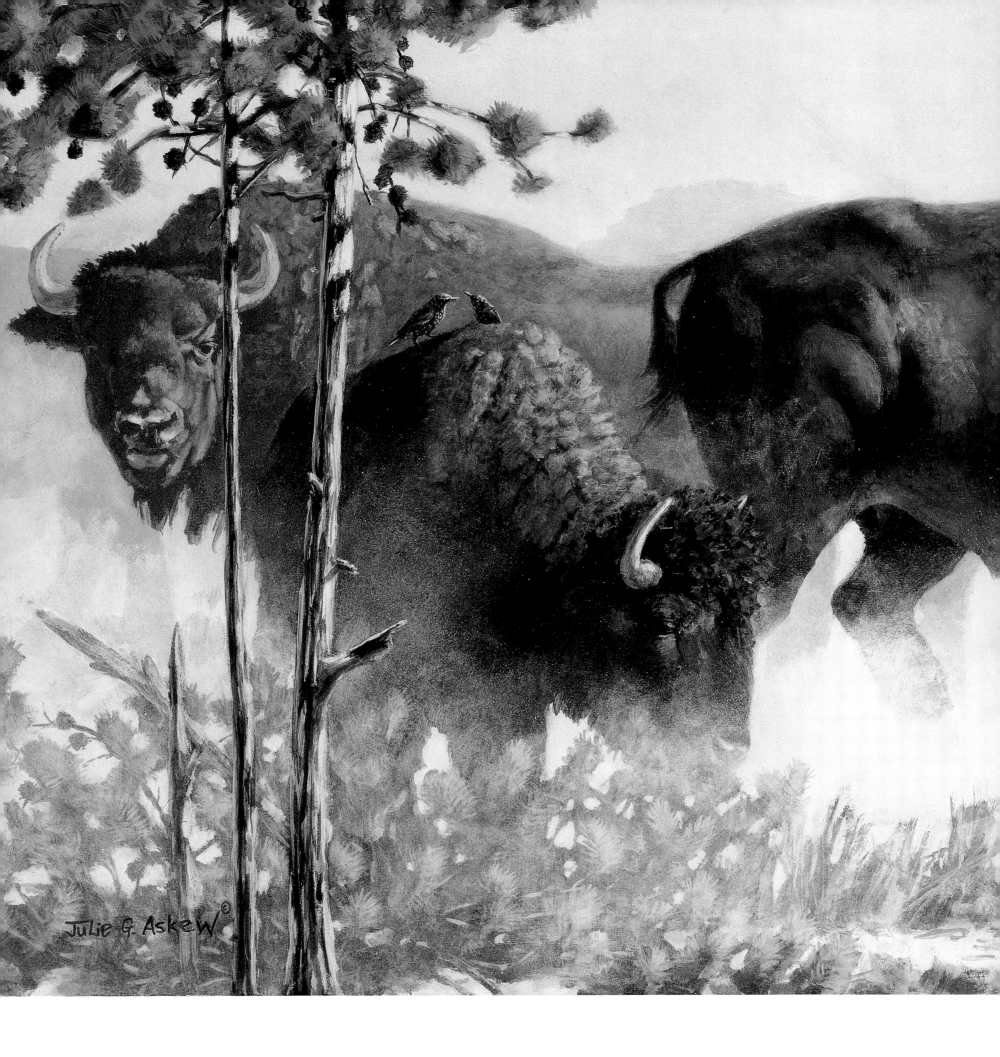

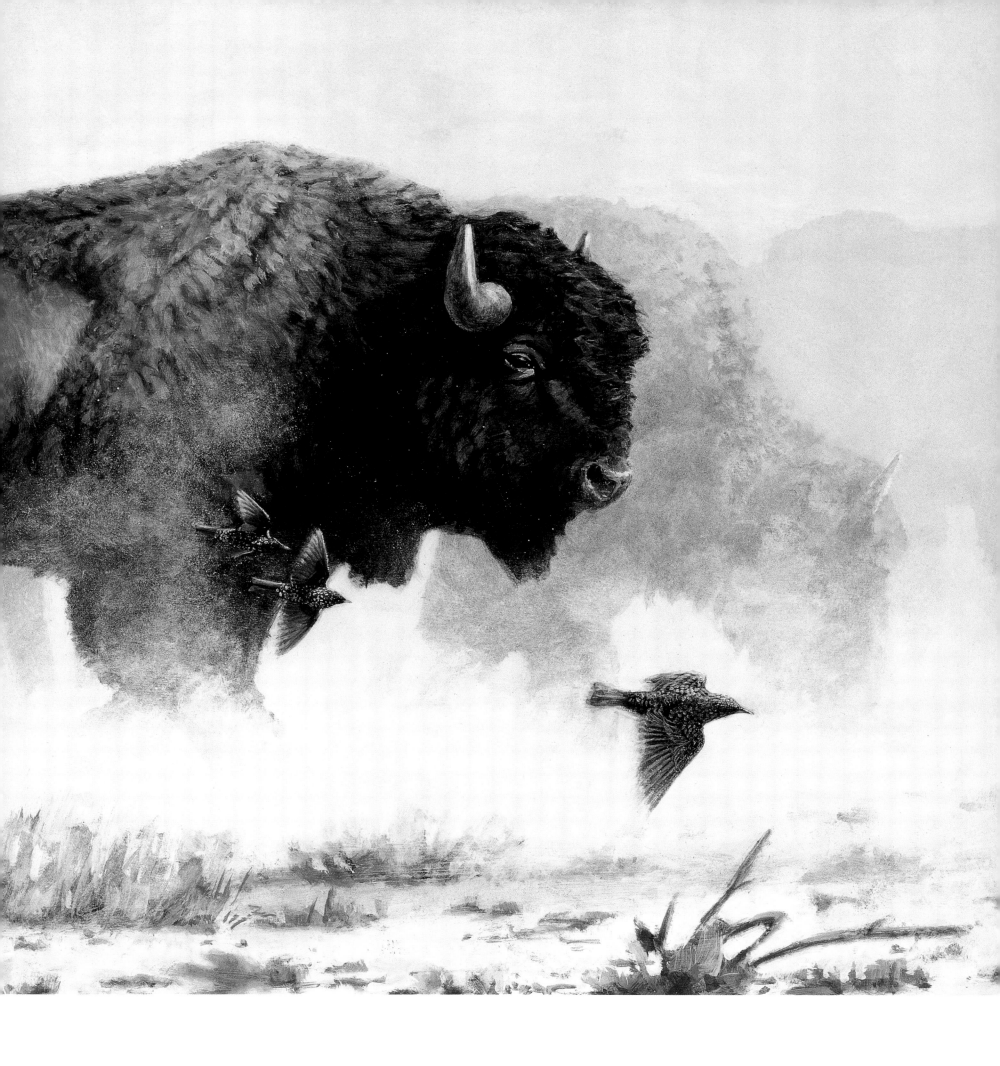

Paco

Robin

Our first teacher is our own heart SIOUX

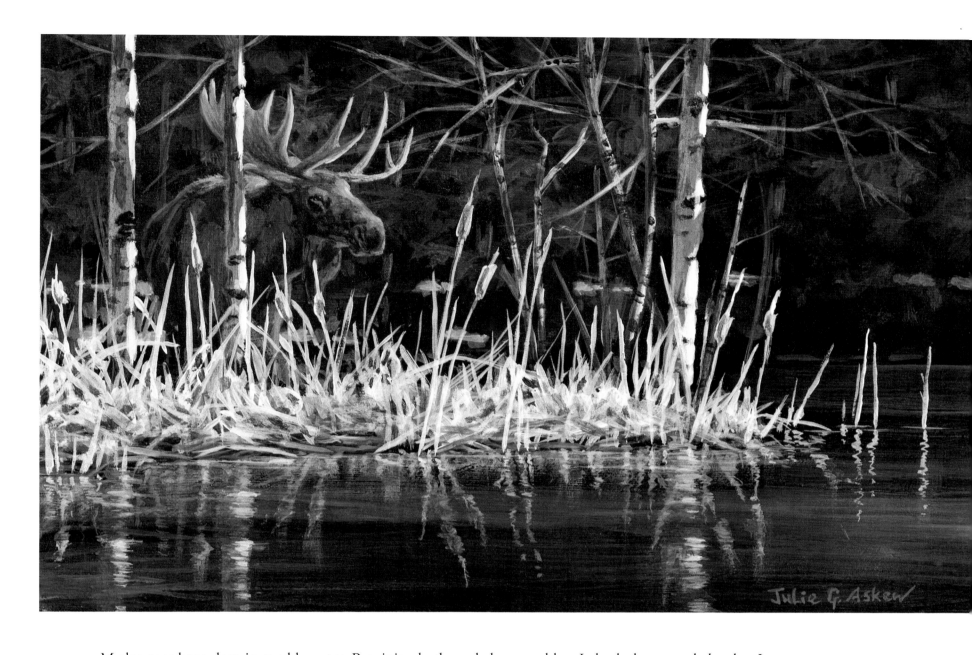

My leg goes knee-deep in muddy water. Regaining both my balance and leg, I check the ground ahead as I move forward. I suddenly come upon a huge bull moose, eye to eye and closer than we are both comfortable with. I slowly back off, hoping the ground stays firm.

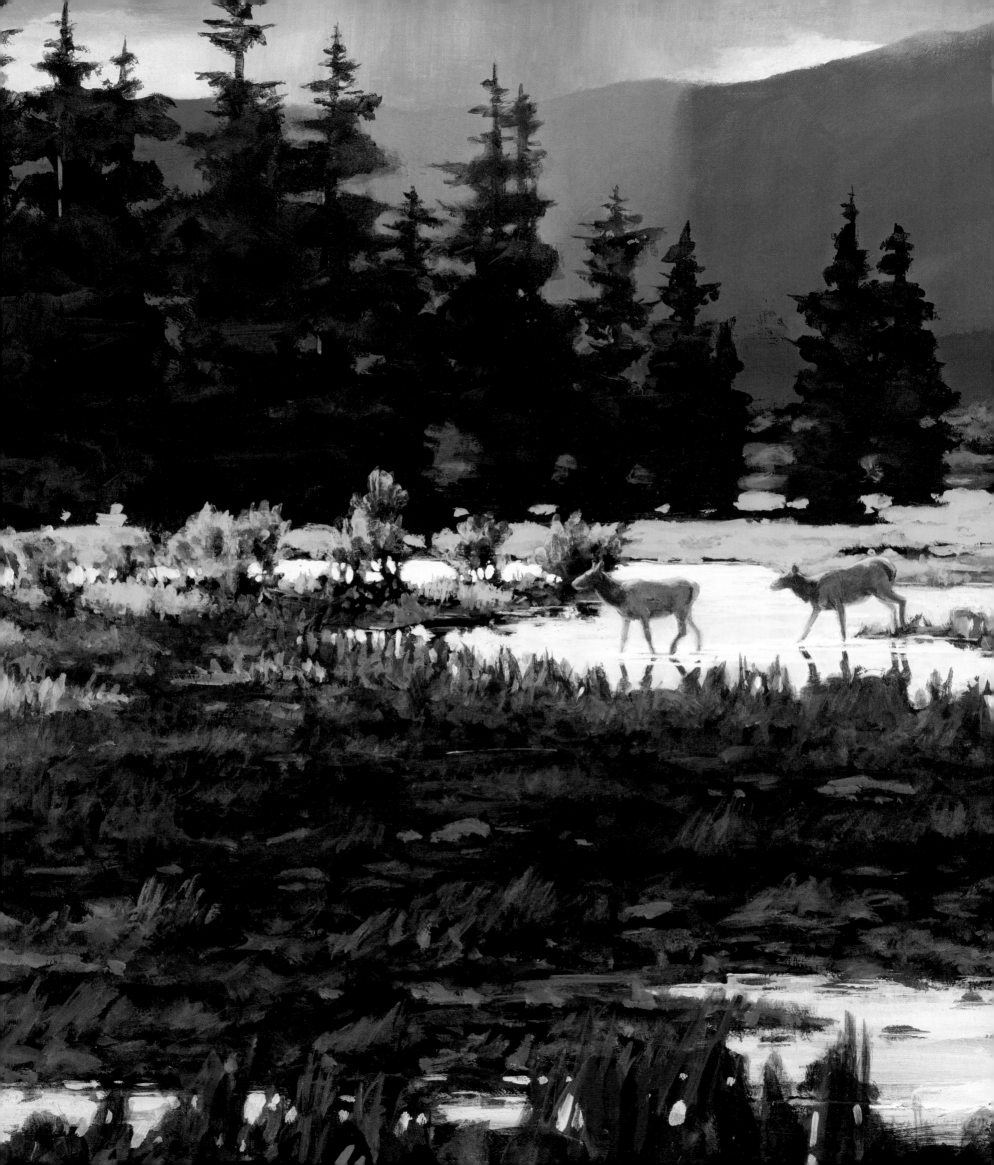

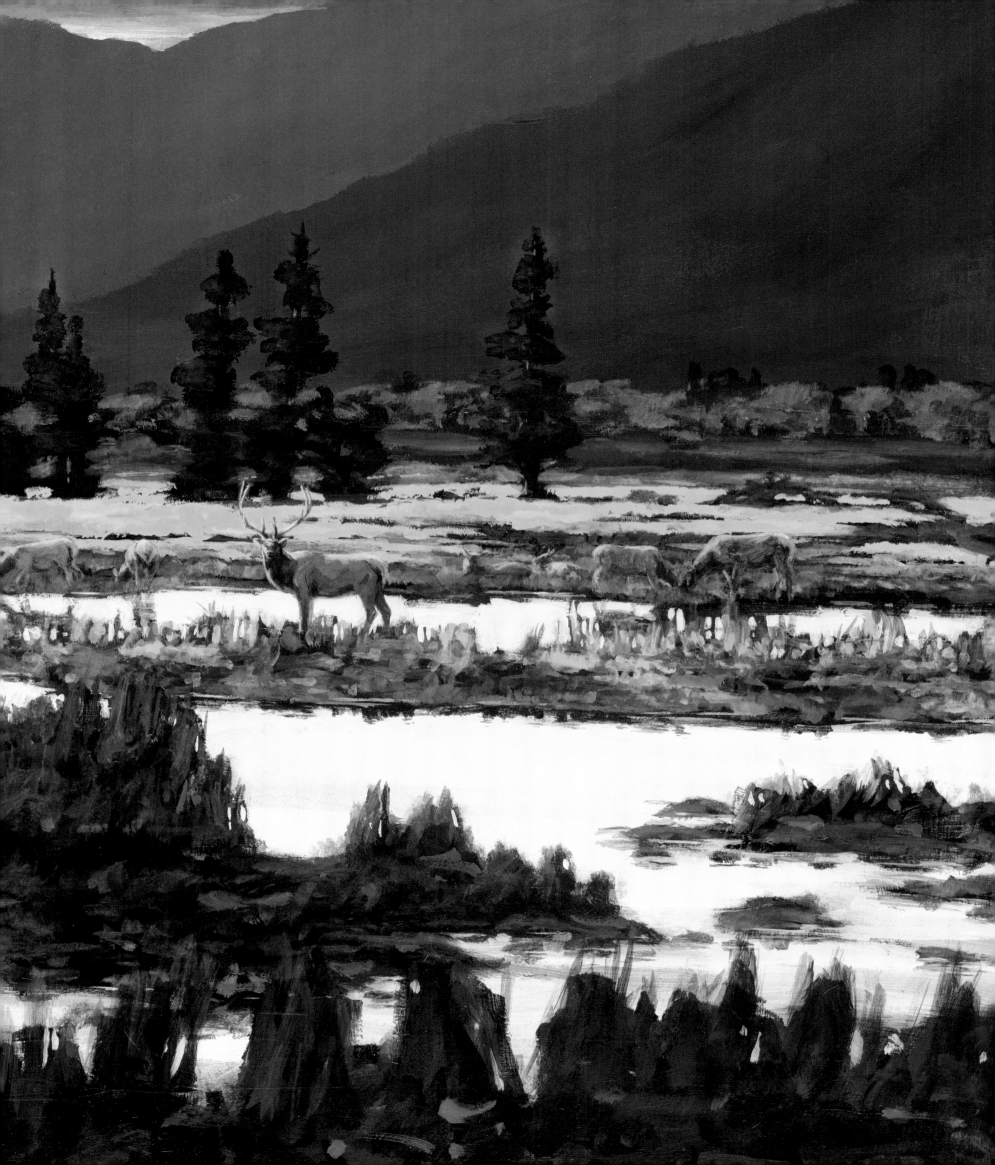

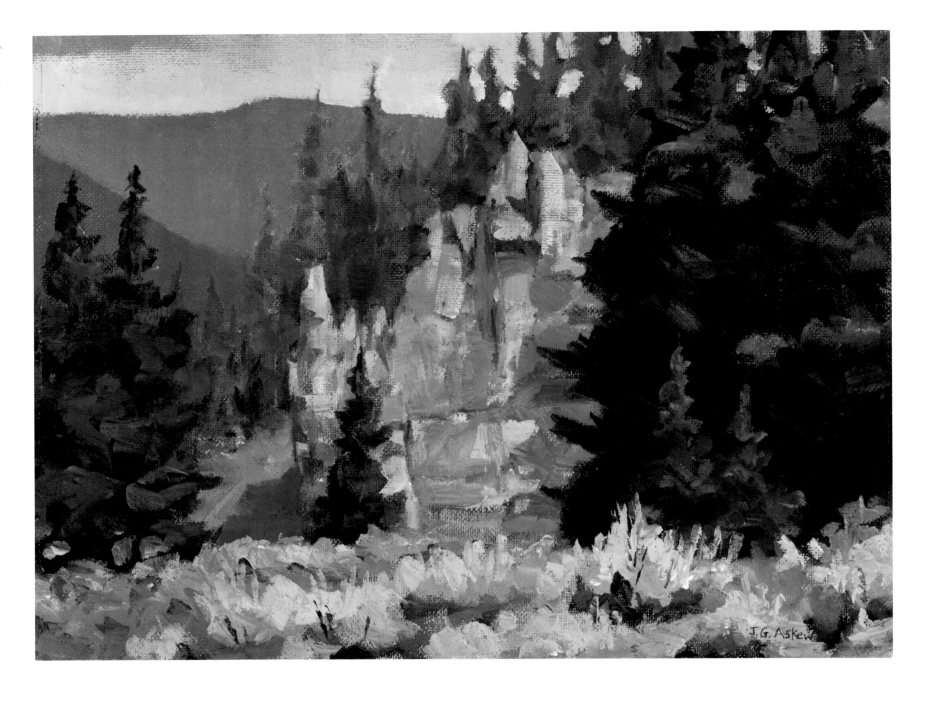

Plein-air painting in the Gallatin Canyon. I can hear
the sound of the river as it ripples along by the cliffs
and sense the stillness of the trees pointing skywards.
The colour tones range from sage green and burnt
browns to pinks, dusky purples, ochres and blues.
There is such a joy of putting paint onto the canvas
out here. It commands my attention. Every glance
holds new inspiration.

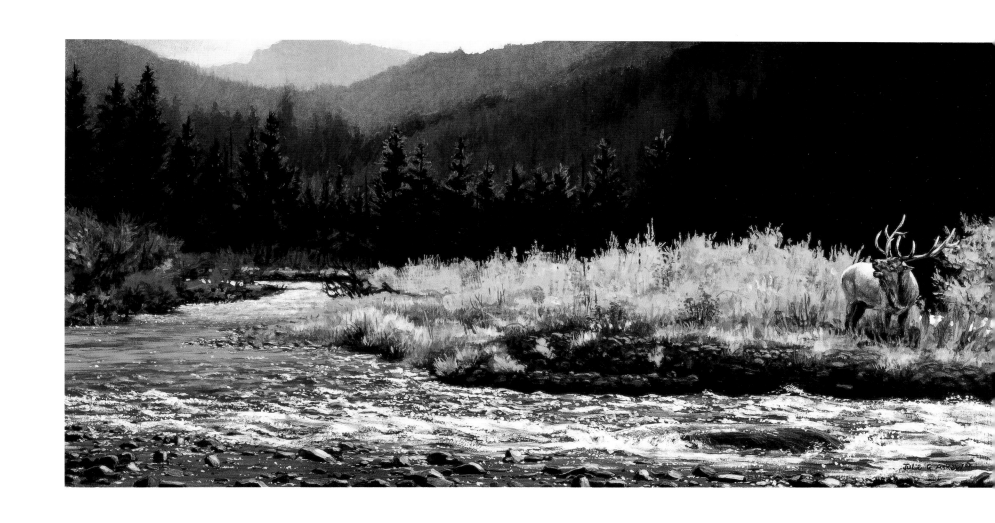

The plants are our brothers and sisters; they talk to us, and if we listen we can hear them Native American

It is interesting to paint light on dark. In the Mid West there are lots of trees, and the technique I use means firstly I block in the dark areas. Then the shape is revealed by painting in the lighter background on top. This gives a random feel to the shapes. It is necessary to remember to paint the back of the tree showing through in areas, giving depth, and also to show some reflected light on the trunk. I usually use a toned purple for this.

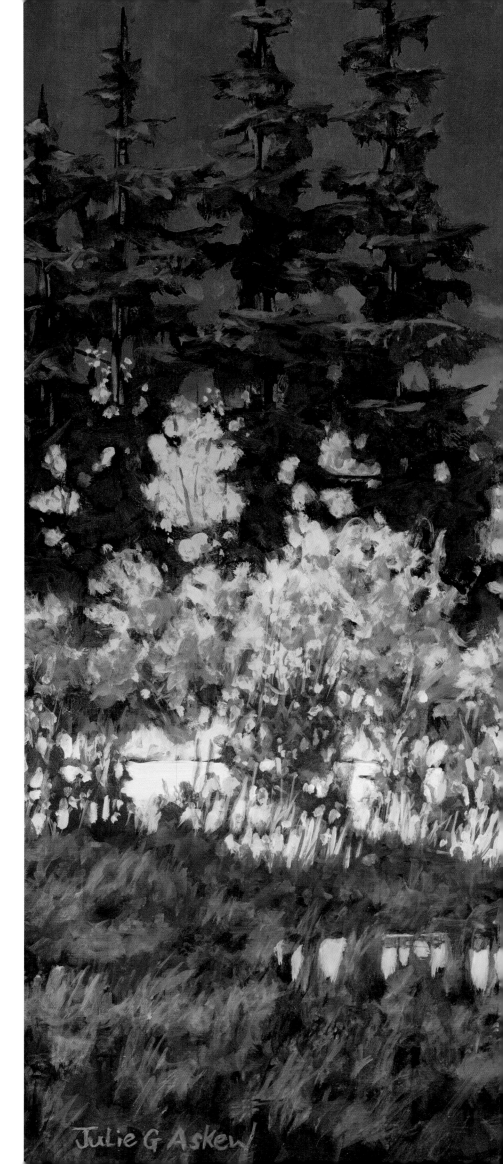

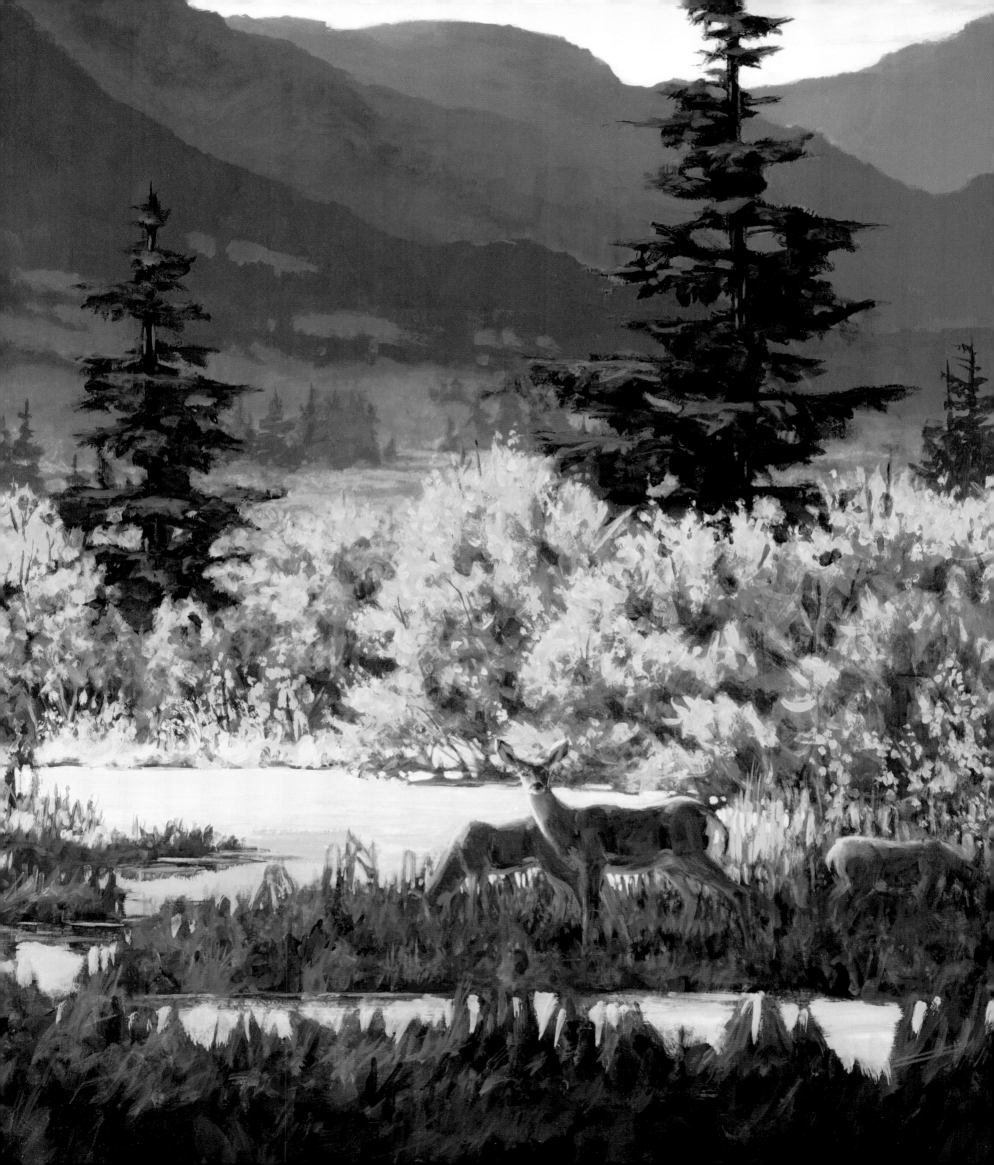

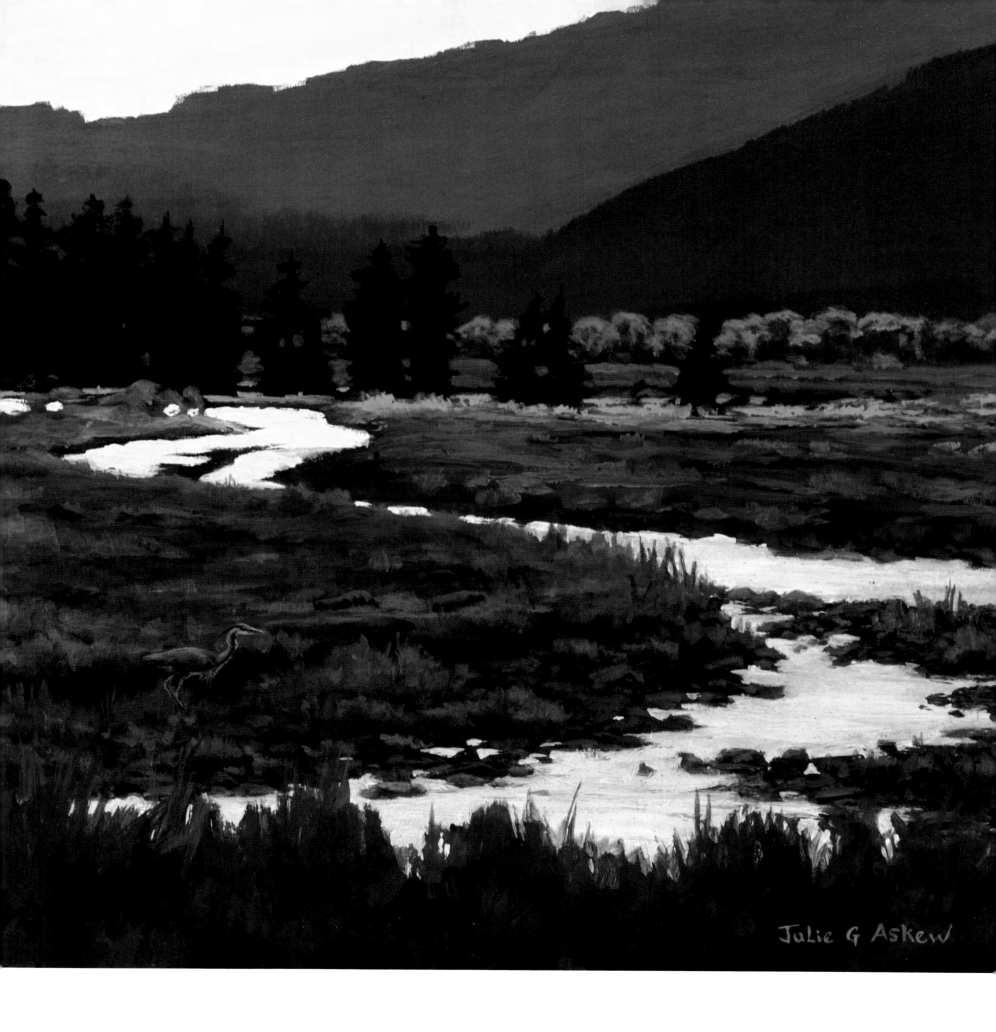

Julie G Askew

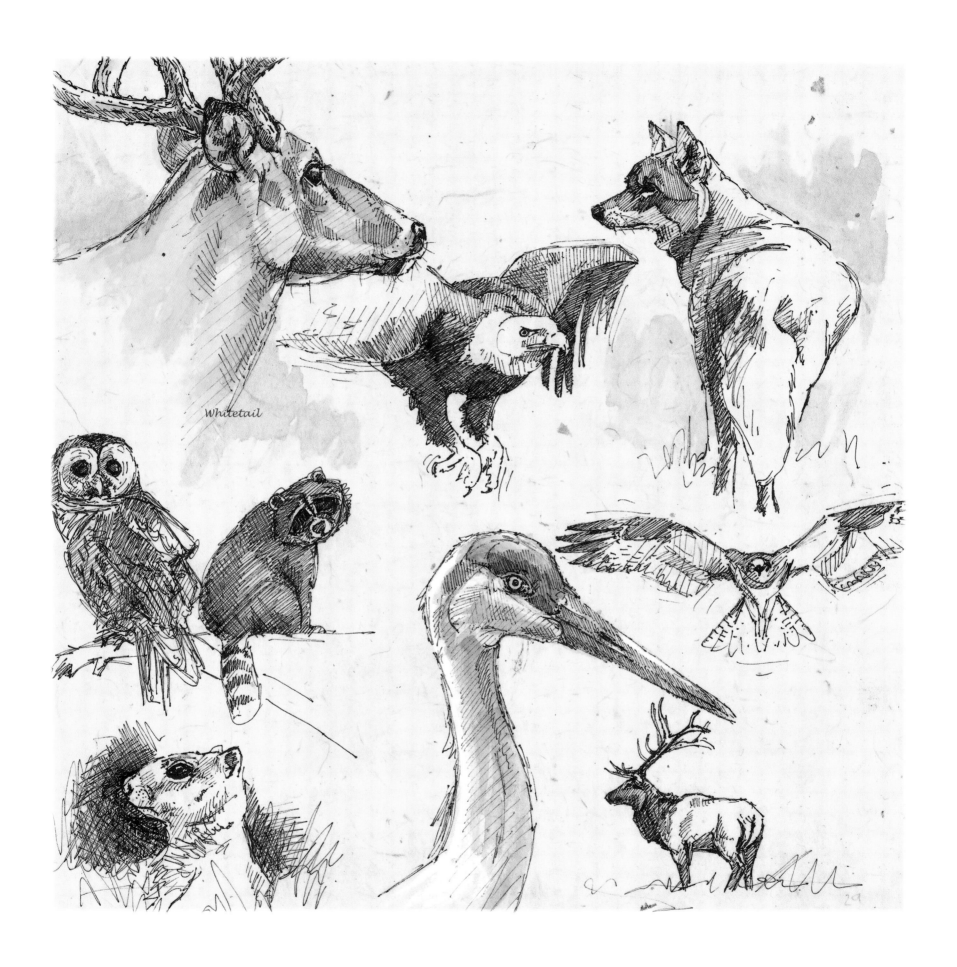

Whitetail

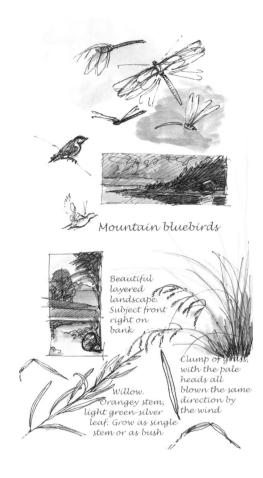

Mountain bluebirds

Beautiful layered landscape. Subject front right on bank

Willow. Orangey stem, light green-silver leaf. Grow as single stem or as bush

Clump of grass, with the pale heads all blown the same direction by the wind

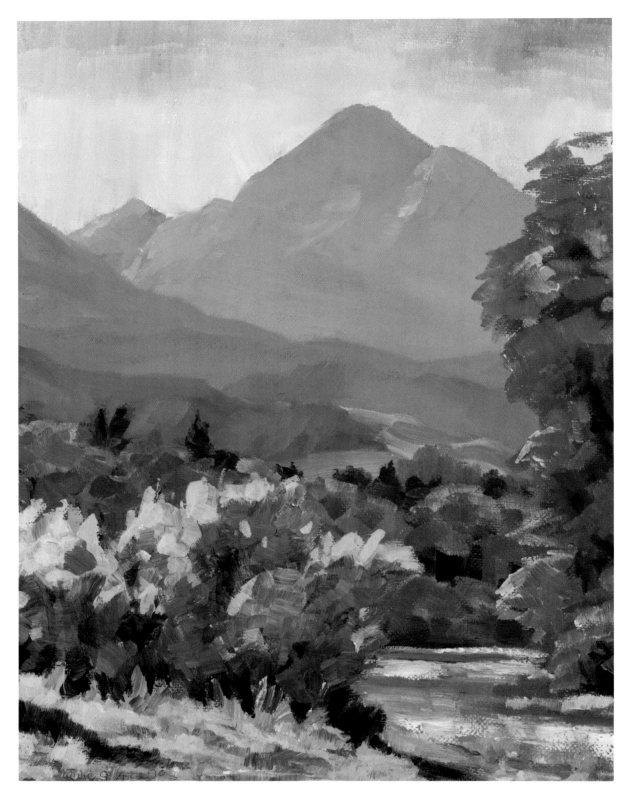

I am balanced by the side of the water in the early morning. One leg of the easel is sinking into the river bed. The light is glorious and the air fresh. All around me are potential plein-air compositions. The Yellowstone river sparkles and gurgles as I settle my eye on a view.

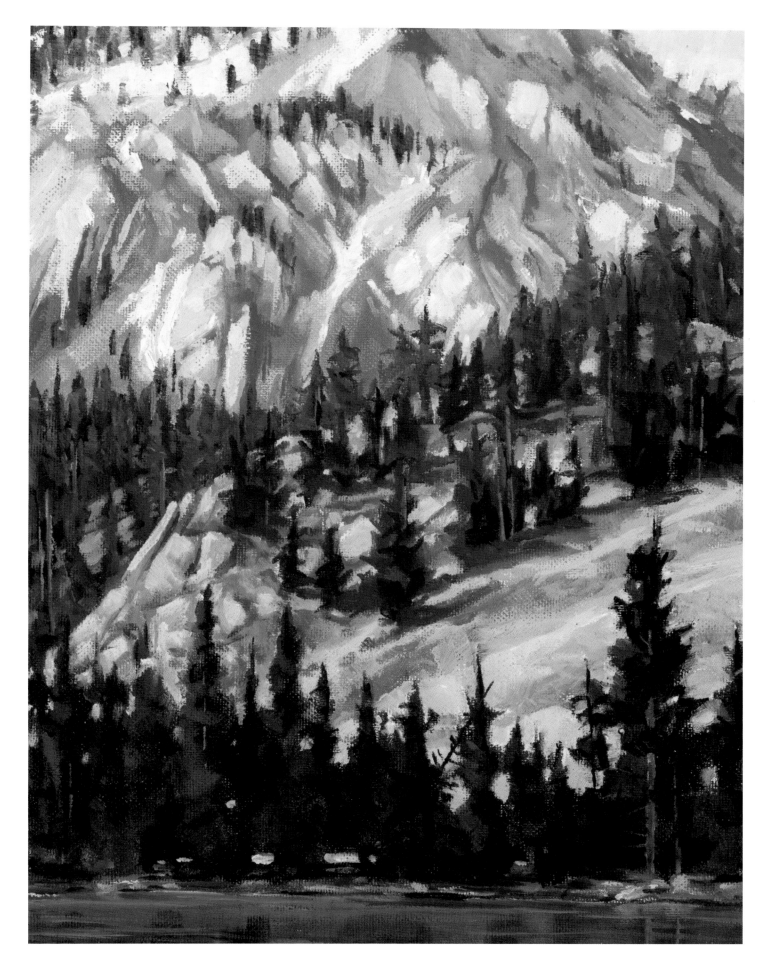

Up at Fairy Lake. Blue paint has somehow gotten all over my fingerless gloves. It is freezing cold. I am painting as fast as possible. Fresh cougar tracks in the snow and a passing blue jay are the only distractions…

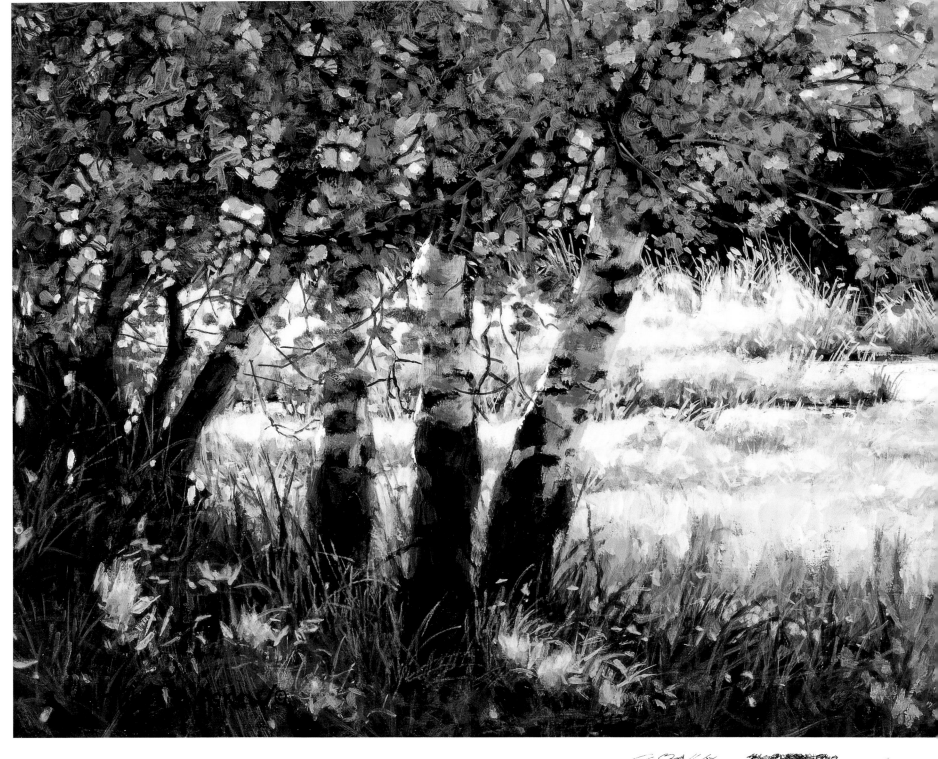

A frog does not drink up the water in which it lives SIOUX

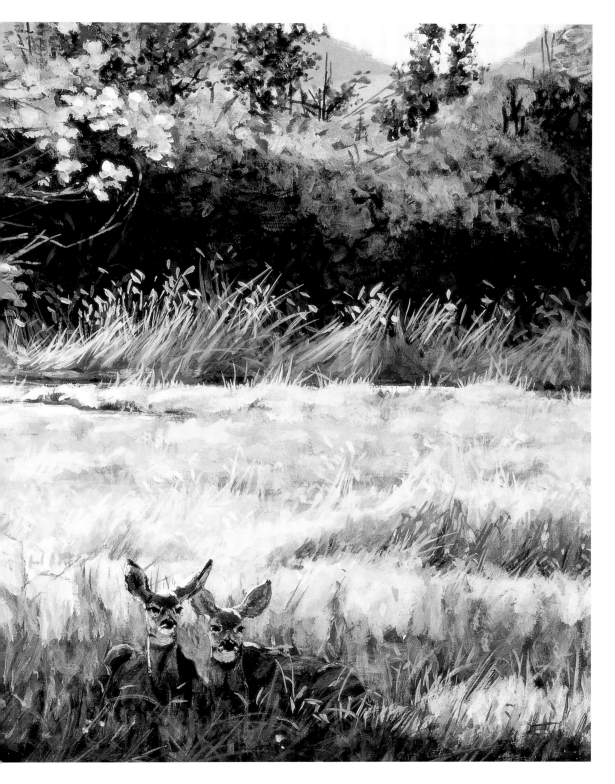

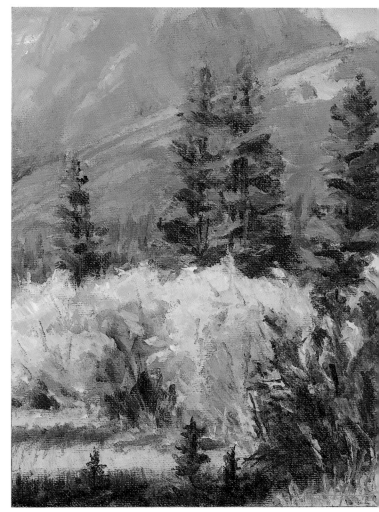

Driving up to the Crazy Mountains on a dirt track, the dust is kicking up as it hasn't rained for a long time. It is a wonderful area. The grass is bright ochre, the aspens flutter their leaves. Golden eagles have an eyrie on a nearby rocky outcrop and I can see them soaring high above. Mule deer are in abundance and whitetails wave their tails as they depart, as if in apology.

Every drive I undertake is like a small safari and it quickly tunes the eyes to observe and spot the slightest movement...is that an ear flicking over there?

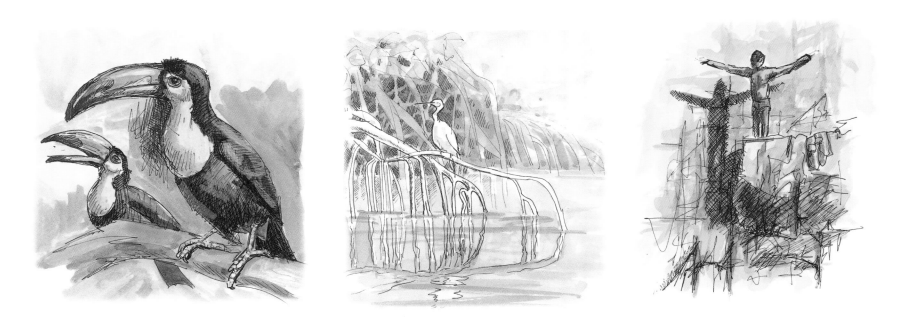

A person born to be a flower pot will not go beyond the porch MEXICAN

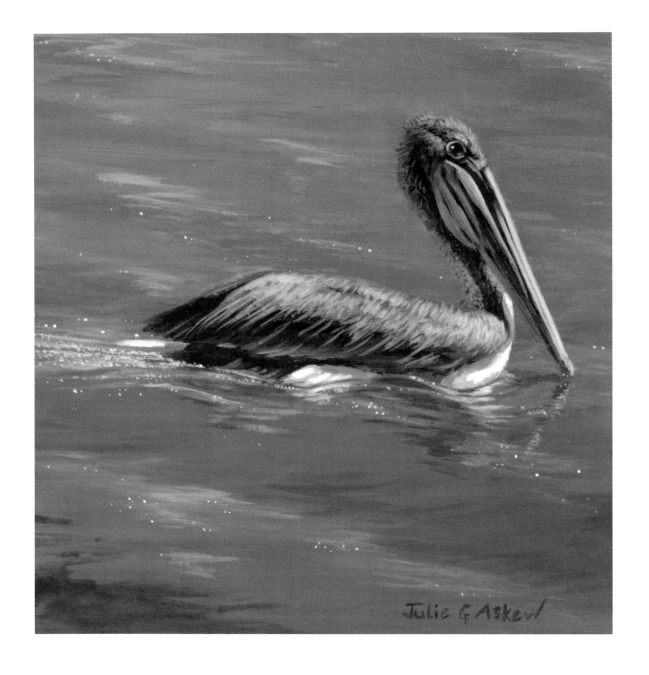

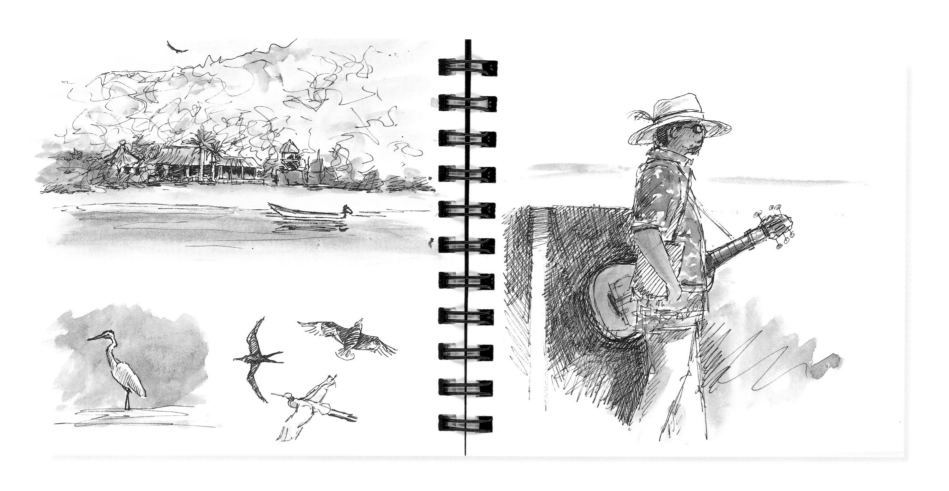

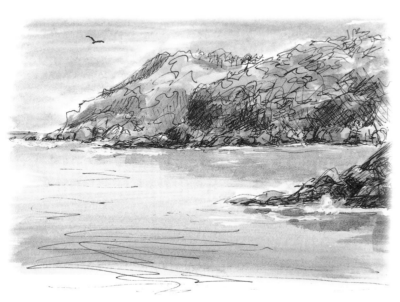

The pace is slow here. Life is pleasant. Strong, burnt colours dominate the skyline as the sun sets.

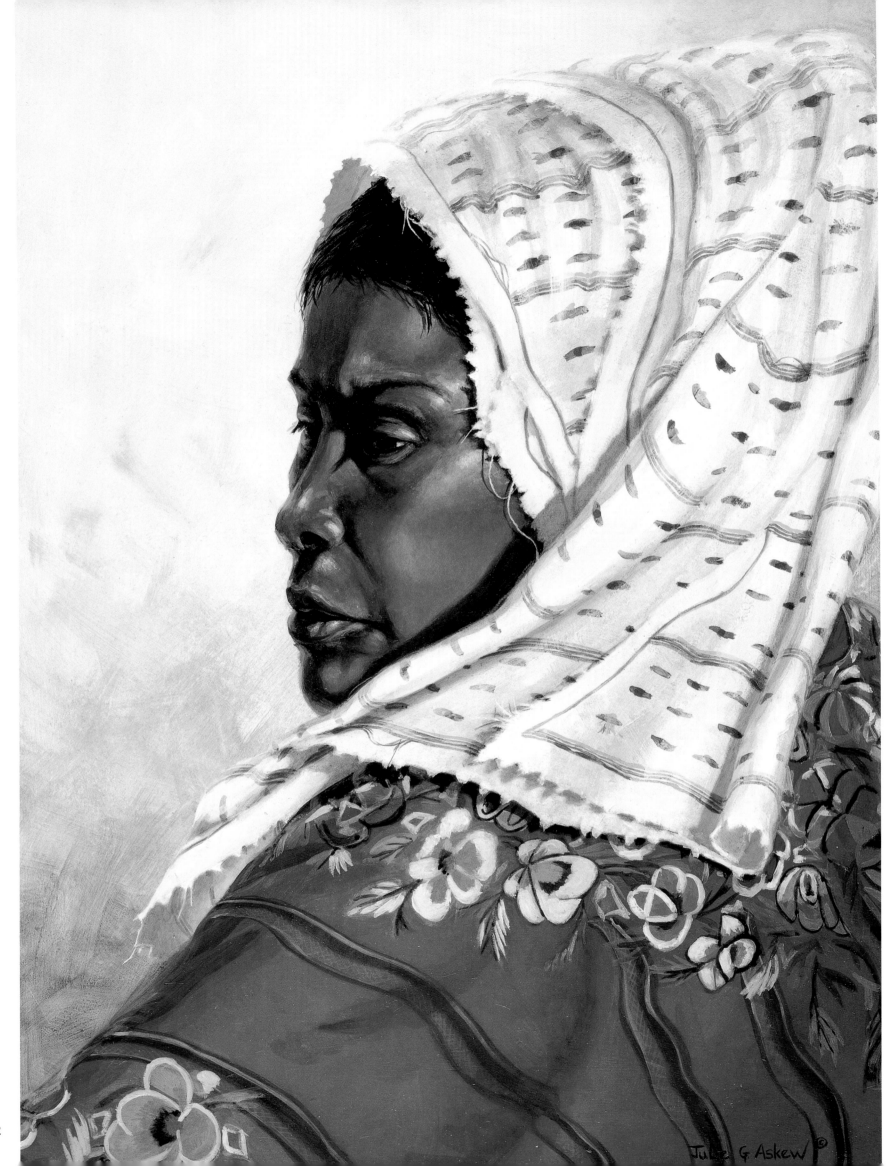

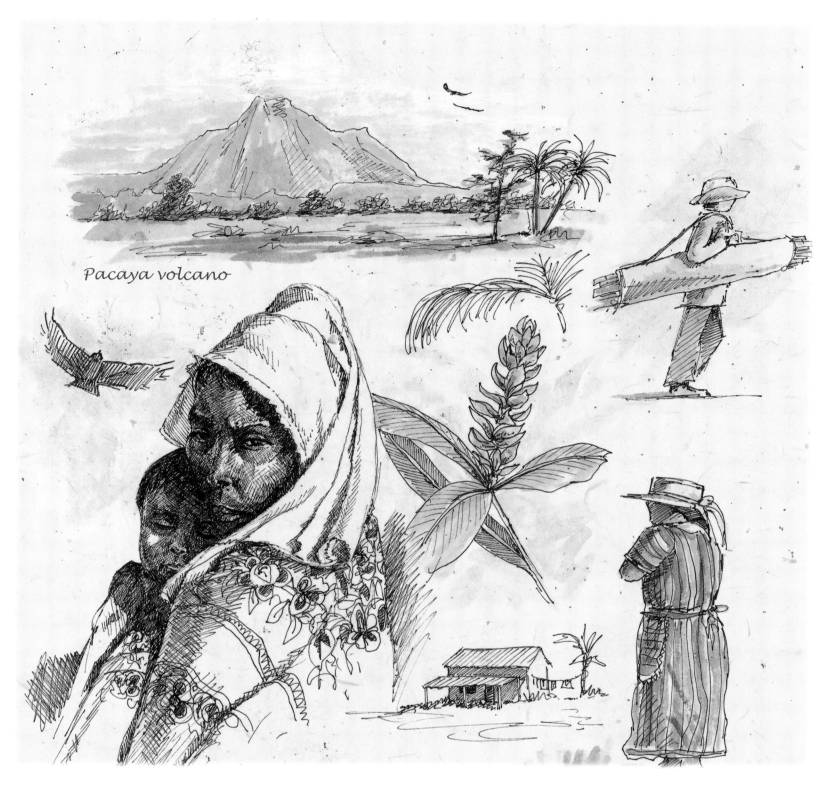

Pacaya volcano

Everyone is the age of their heart GUATEMALA

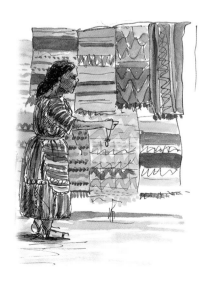

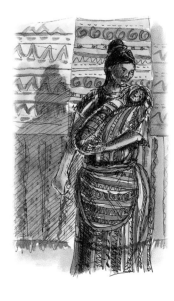

The volcanoes rise dramatically, like great cones on the skyline. Mount Pacaya is still active. The strong features of these people inspire me immensely, as does their mix of colours in the materials – so evocative of this part of the world.

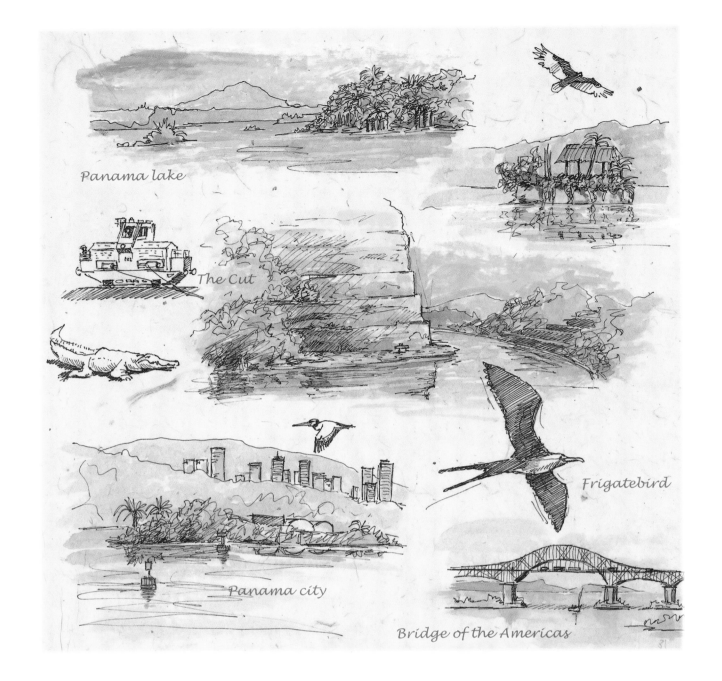

Panama lake

The Cut

Frigatebird

Panama city

Bridge of the Americas

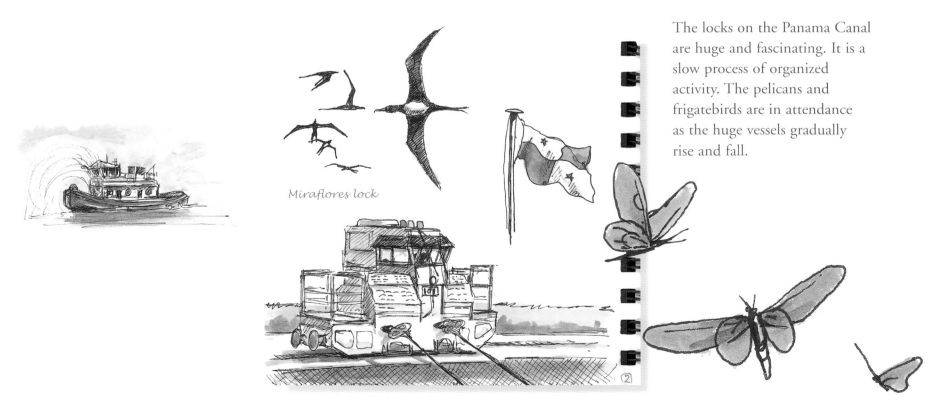

Miraflores lock

The locks on the Panama Canal are huge and fascinating. It is a slow process of organized activity. The pelicans and frigatebirds are in attendance as the huge vessels gradually rise and fall.

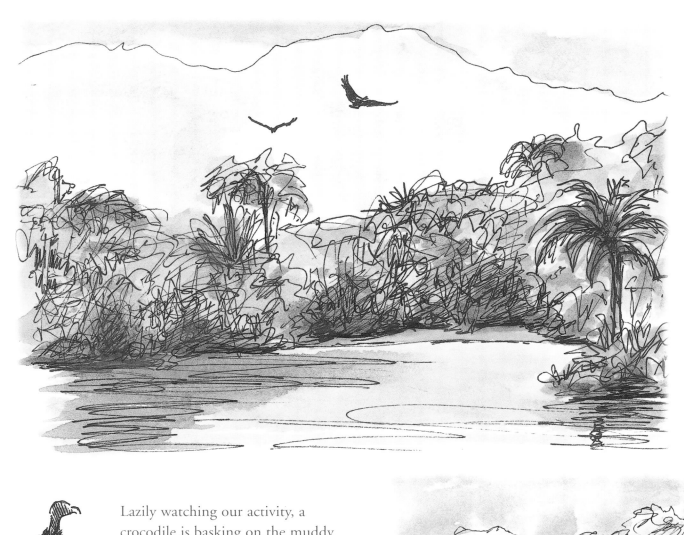

Lazily watching our activity, a crocodile is basking on the muddy bank. The jungle around it is deceptively quiet. Black vultures circle overhead, effortlessly wheeling round and round. Trying to show an impression of the detailed foliage without drawing every line and shadow is proving to be a challenge.

Frigatebirds are prehistoric-looking huge creatures. These long, angular, fork-tailed birds terrorise any seabird in range, in the hopes of getting it to disgorge or drop food. True pirates of the coast. As they swoop and soar above me, they come so close I have to stop sketching and just watch, sure that if I had a fish I would be in trouble too!

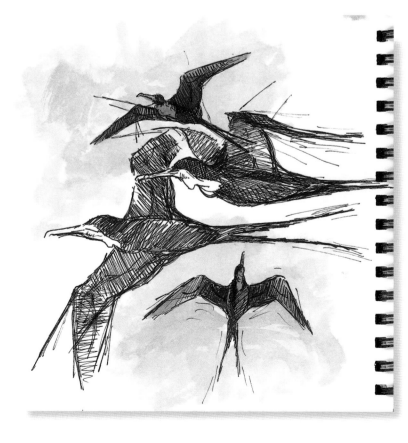

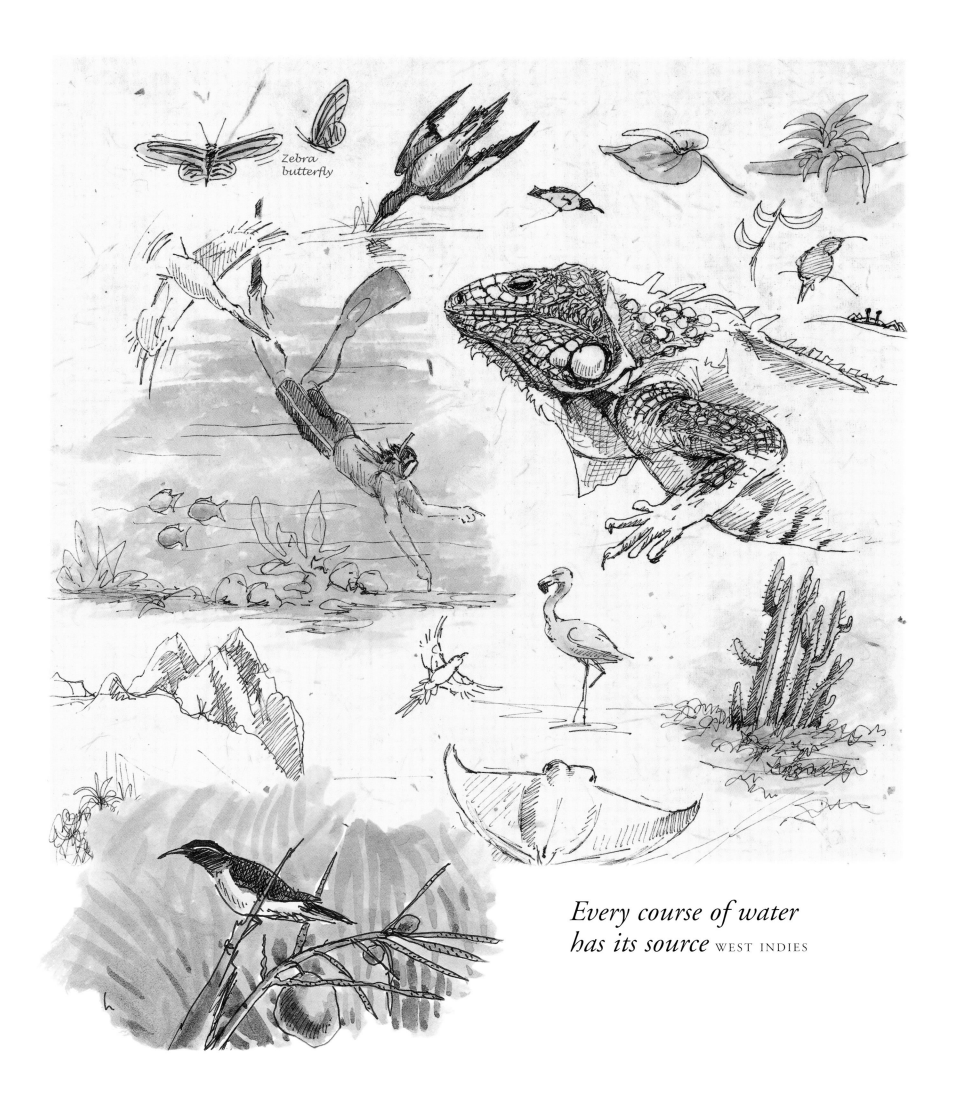

Zebra
butterfly

*Every course of water
has its source* WEST INDIES

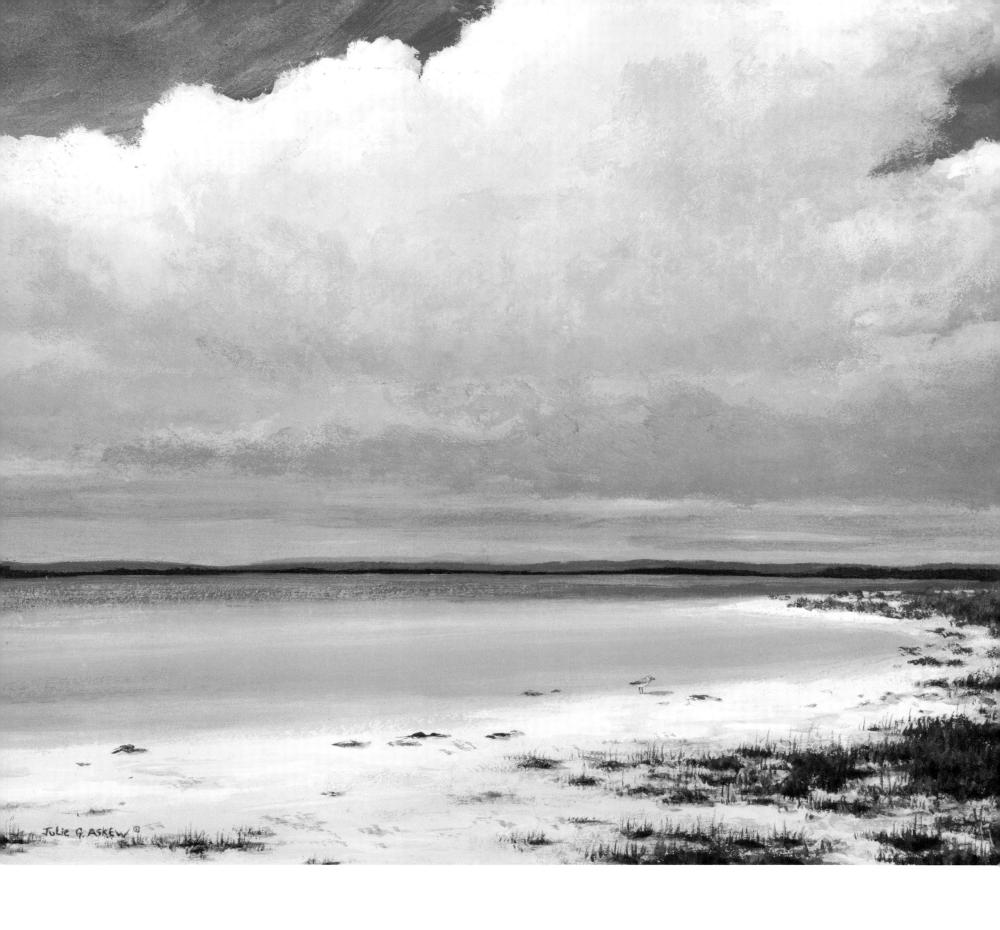

Julie G. Askew

I like watching pelicans fishing, diving from the blue sky like arrows, cutting through the turquoise water that stretches over from Isla Margarita to the coastline of mainland Venezuela.

The Spice Isle tickles my sense of smell as various spices are wafted in my general direction – the exotic aromas of nutmeg, cinnamon, saffron, cloves, bay leaves and balls of raw chocolate are particularly strong. Various bottles with floating contents are to be seen everywhere, rum with an assortment of additions it seems. All in a setting of lush foliage covered mountains, bird song and humid heat.

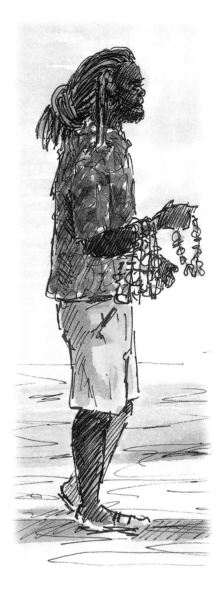

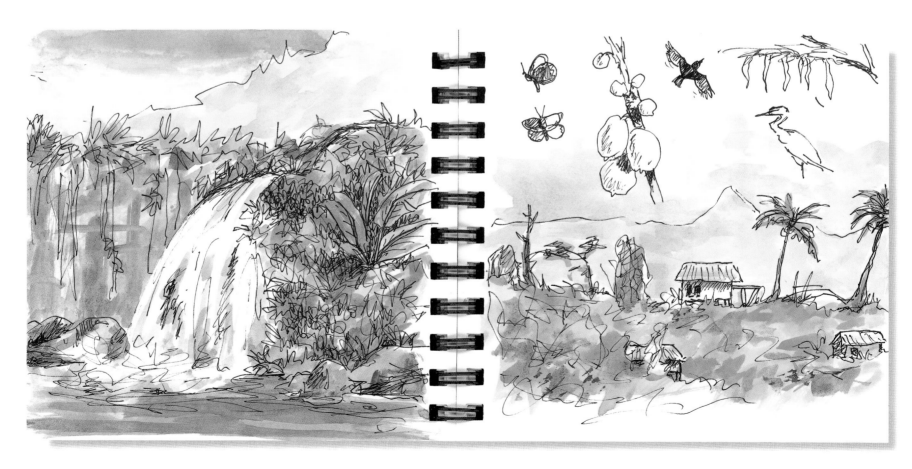

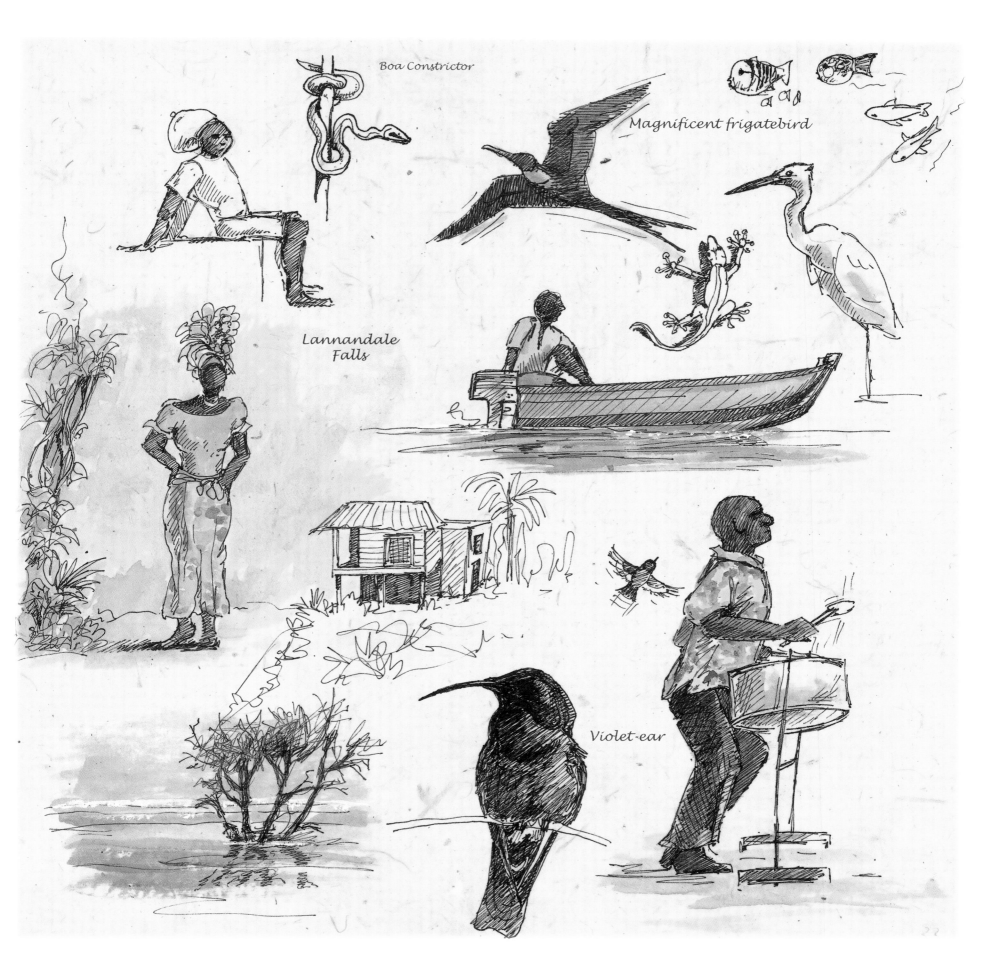

Boa Constrictor

Magnificent frigatebird

Lannandale
Falls

Violet-ear

If you don't have a horse, ride a cow CARIBBEAN

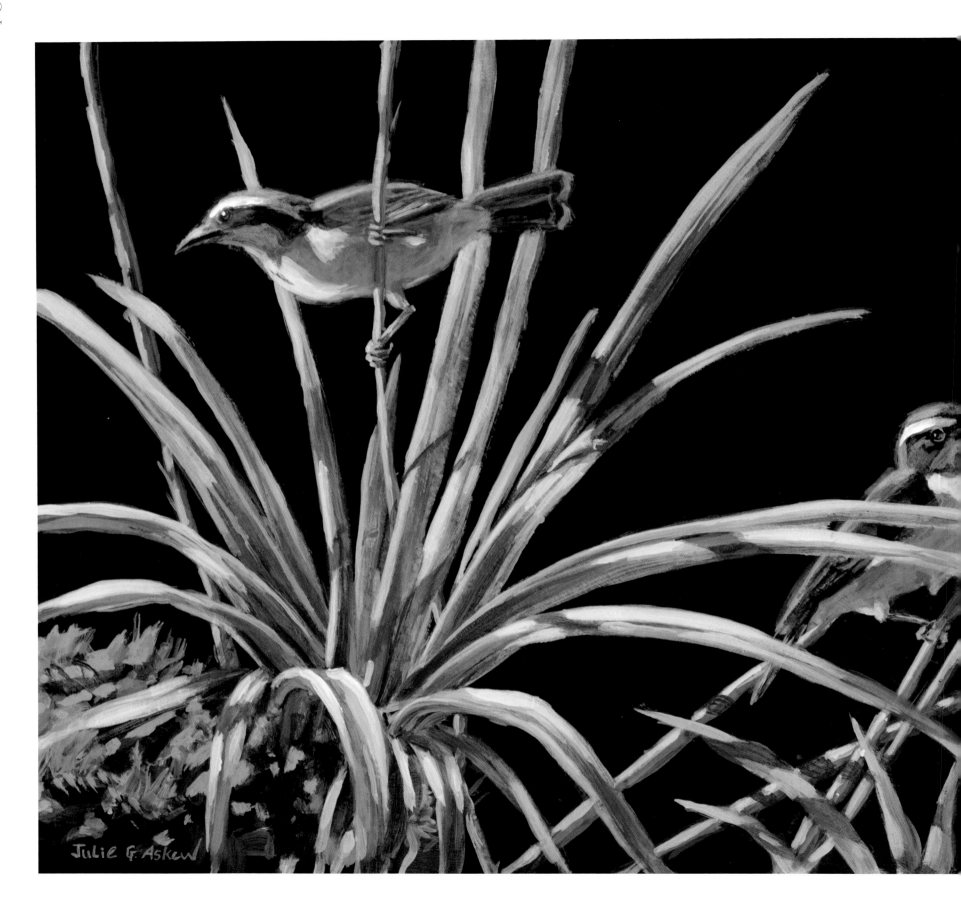

The Main Ridge Reserve is the oldest protected rainforest in the world, secured in 1776 by Soame Jenyns, Member of Parliament for Cambridge. What a privilege, what wildlife! Bananaquits are chattering noisily. The brave little birds come delightfully close. Various hummingbirds are shooting around like flashing jewels, their speedy wings buzzing. Motmots with their long, funny tails and a host of multicoloured other birds in amongst the leaves and flowers. It takes a while to absorb them before I can concentrate on sketching.

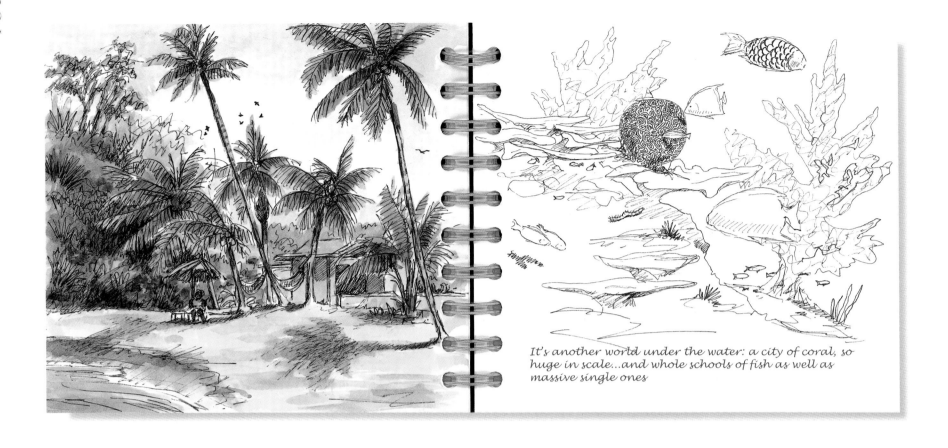

It's another world under the water: a city of coral, so huge in scale…and whole schools of fish as well as massive single ones

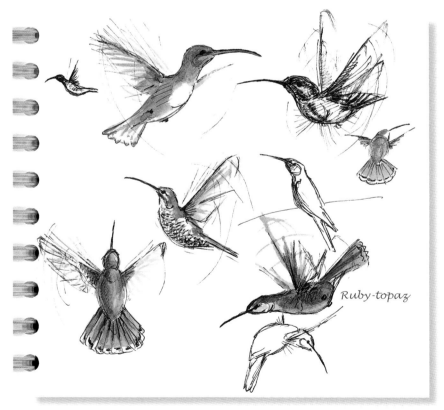

Ruby-topaz

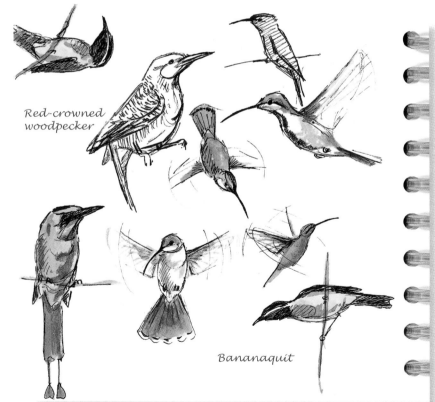

Red-crowned woodpecker

Bananaquit

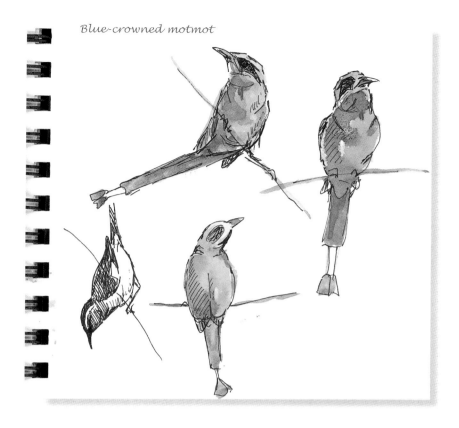

Blue-crowned motmot

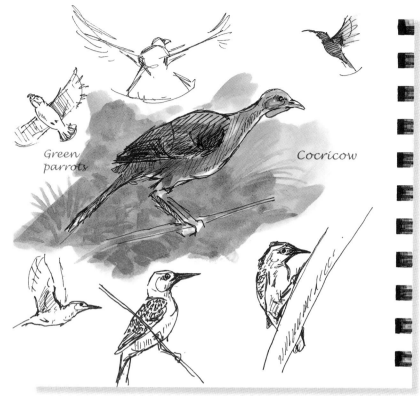

Green parrots

Cocricow

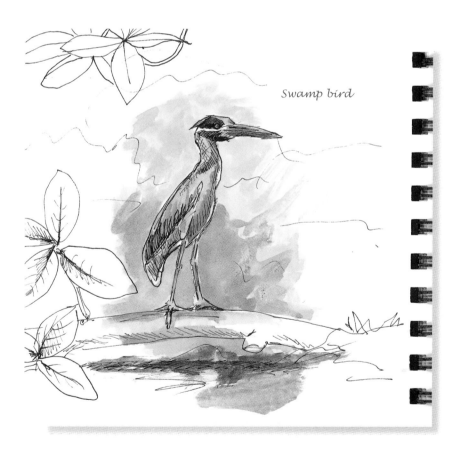

Swamp bird

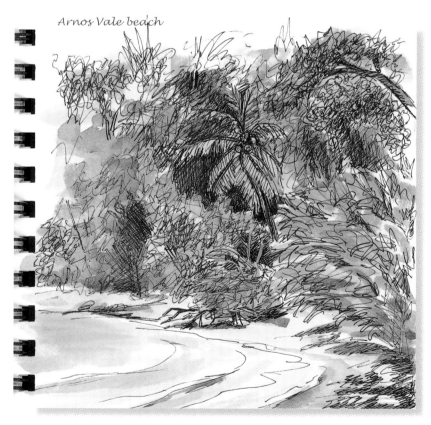

Arnos Vale beach

A turtle looms out of the sandy water and into clear view, passing gracefully under me, very close. It's so entirely in its element that it makes me feel clumsy and out of place.

Bathsheba

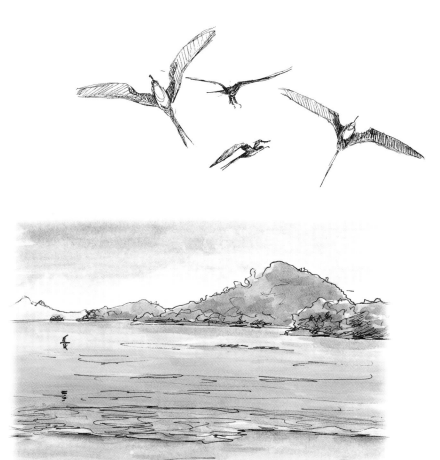

Sitting on the sand, sipping lemonade under a gently waving palm tree. As the sun goes down there's nobody else around except one solitary dove.

Rat Island at sunset

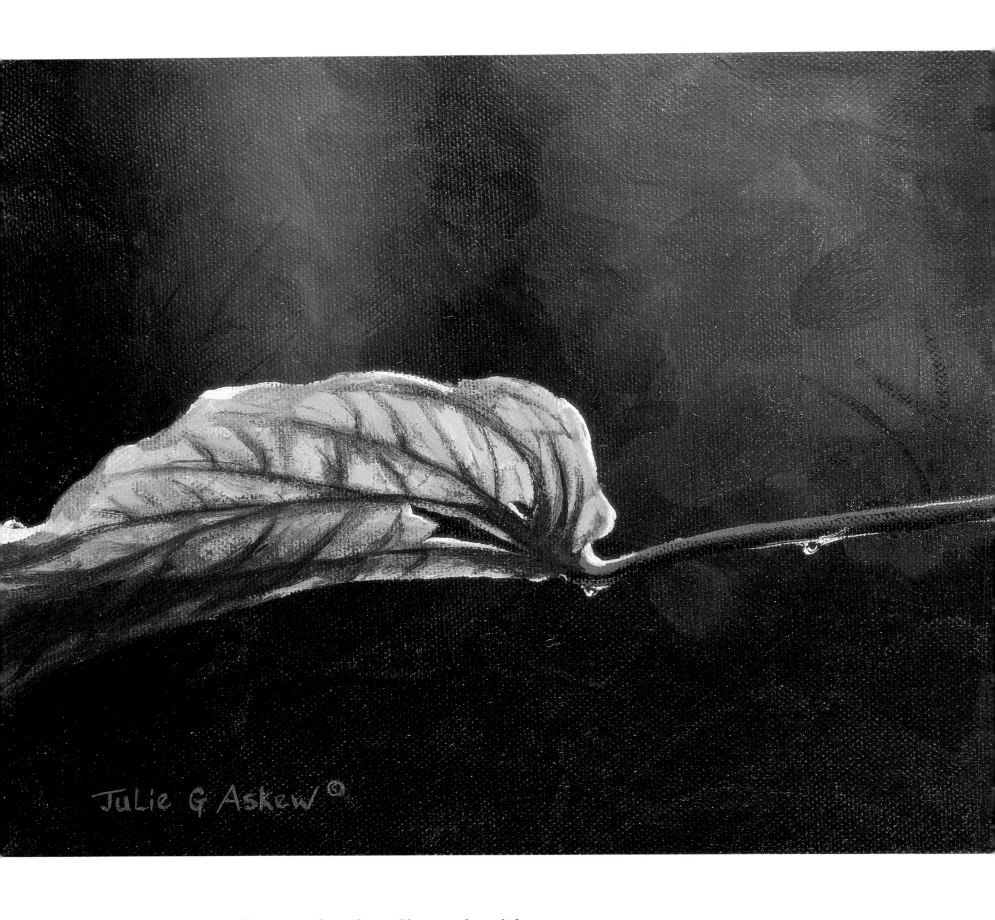

Julie G Askew ©

A talkative bird will not build a nest CARIBBEAN

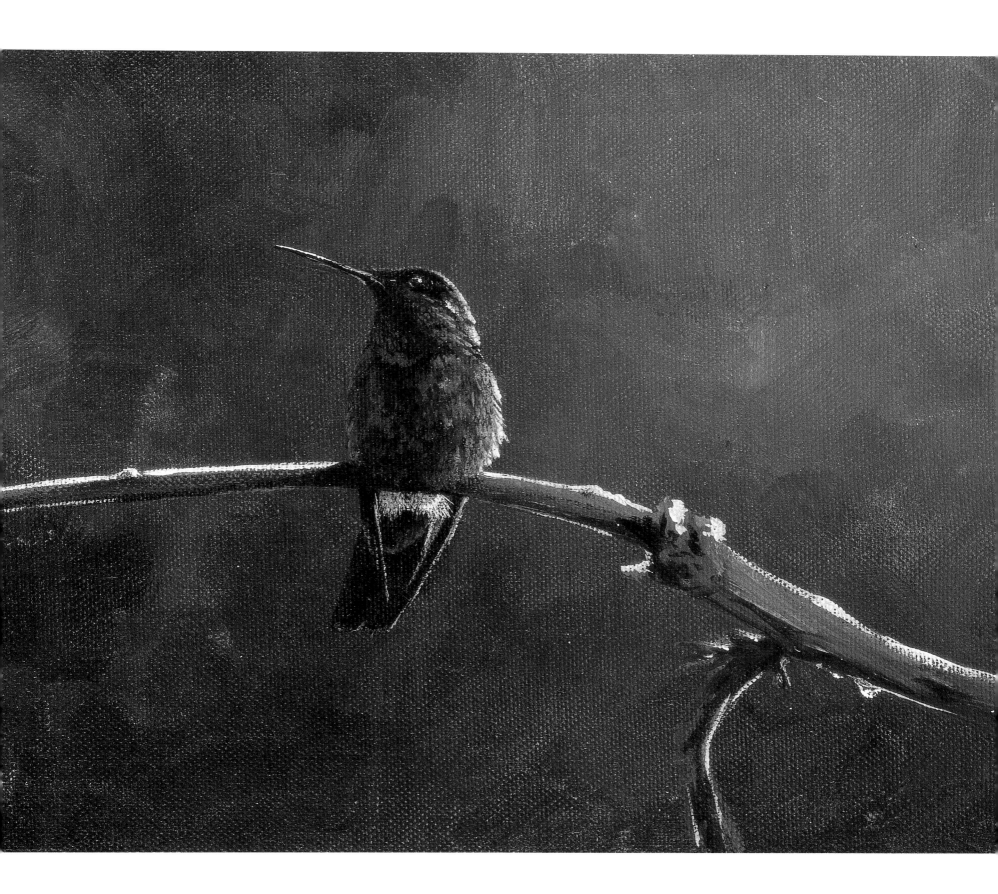

The clouds open and throw down a torrent of water. I'm sheltering under a palm tree, watching it stop as suddenly as it began. Like a tap, on and off. Now the sun is again burning bright and I venture back out into its hot embrace.

The dense jungle foliage drips from the cone-shaped mountains. The flame trees stand out in stark contrast to the lush greens which surround them.

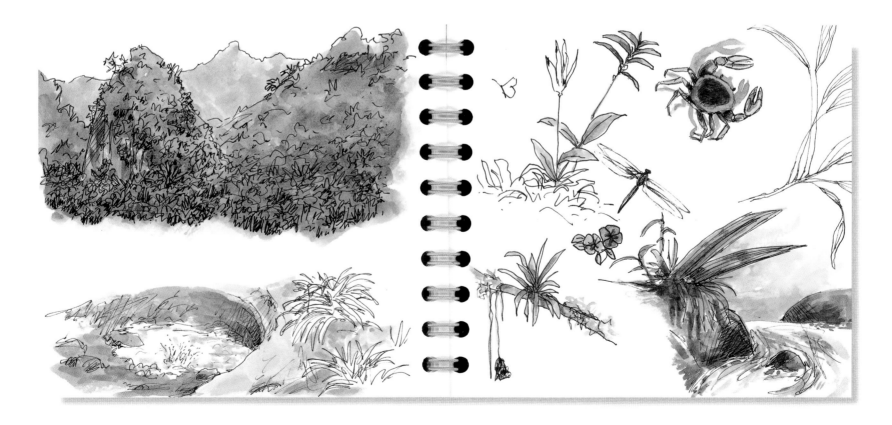

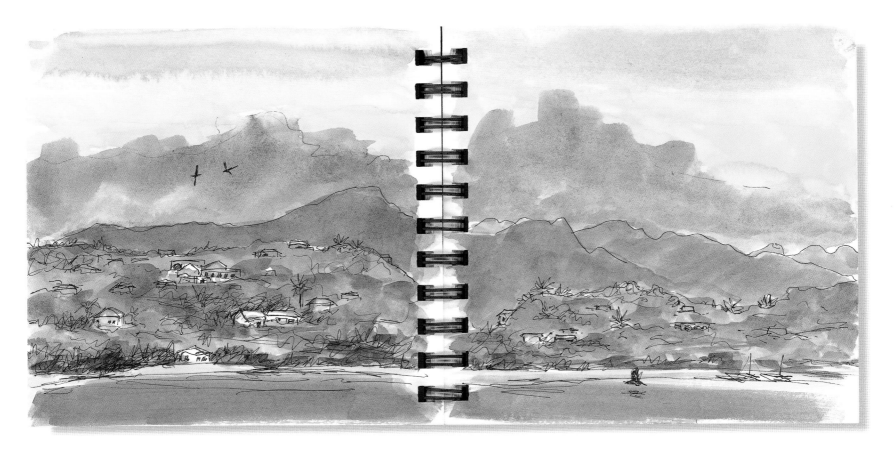

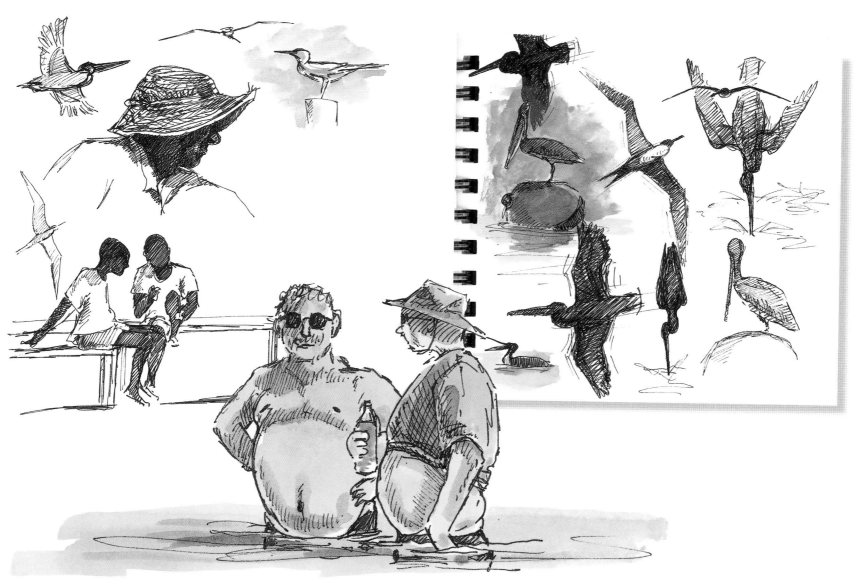

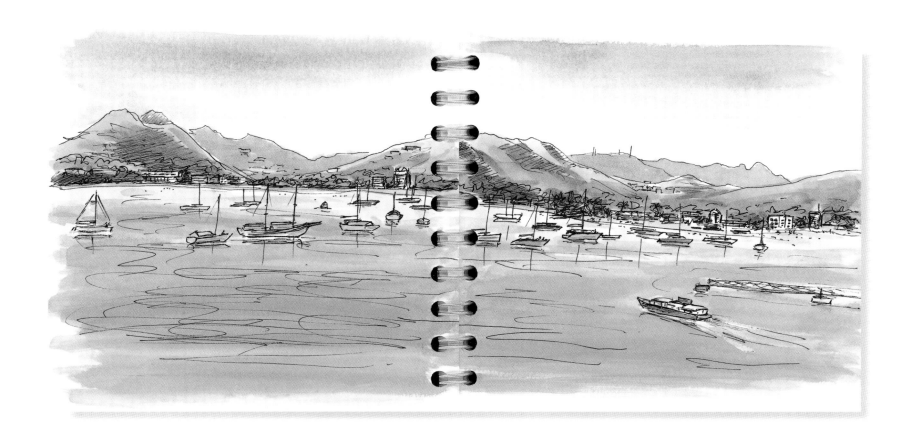

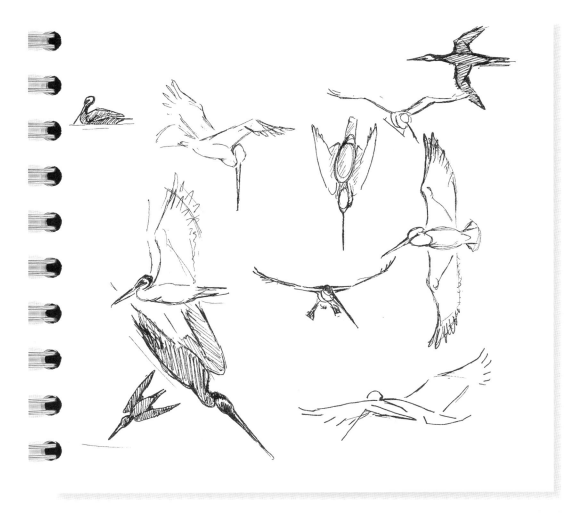

I come out of the crystal clear water back into intense heat. Two steps onto the white sandy beach, I sit, grab my sketchbook and draw the pelicans still diving into the water before me, right where I've just been one instant before. The dripping salty water soon dries on the sketchbook...

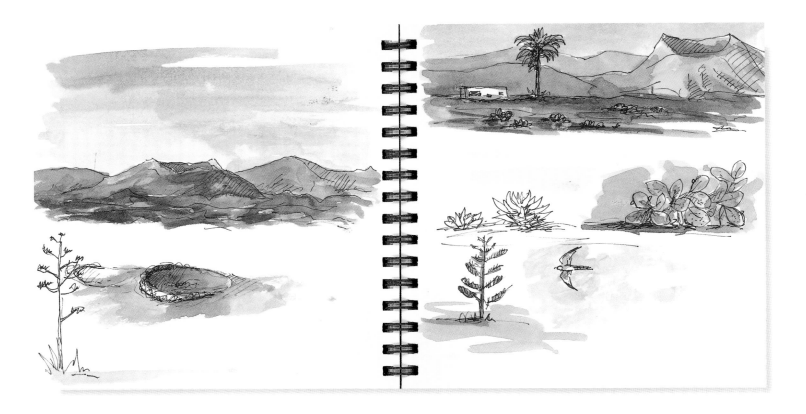

I am surrounded by whales and dolphins. A respectful distance isn't even possible as they surface right beside the boat! I can only imagine their vastness under the water. I just sketch the brief shapes that emerge before me.

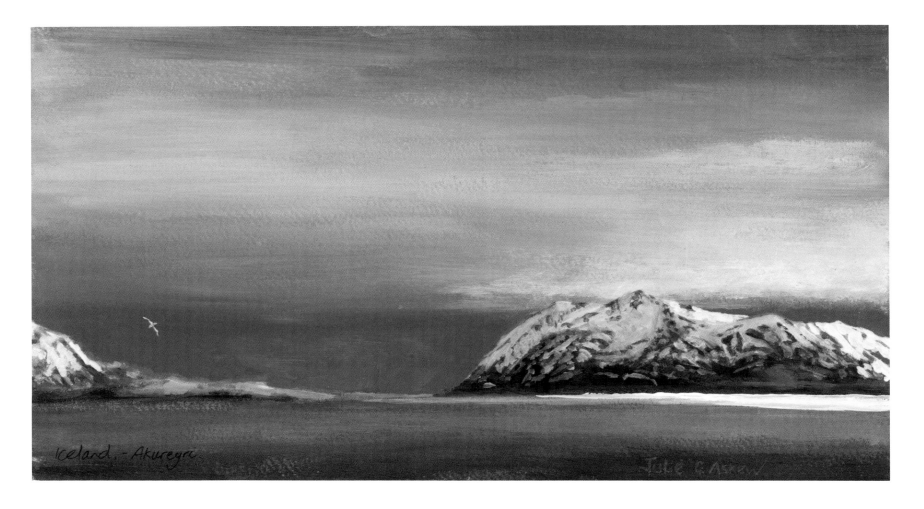

Iceland, - Akureyri

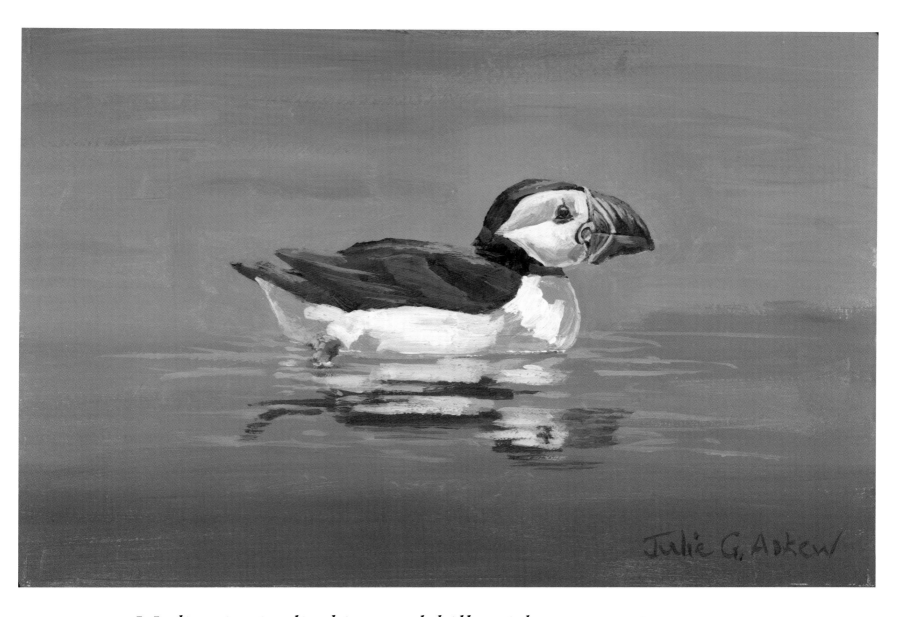

Julie G. Askew

Mediocrity is climbing molehills without sweating ICELAND

Godafoss Falls

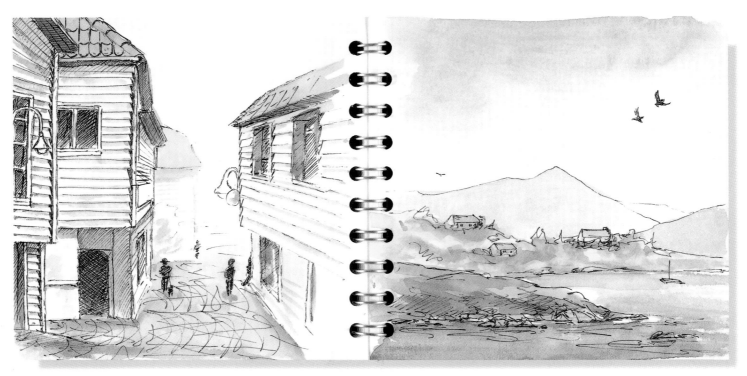

The wooden buildings are quite a feature of the towns of Norway. Buildings present different challenges to sketch. Perspective is very obvious and needs extra care, taking a little longer than a mountain or a bird to depict.

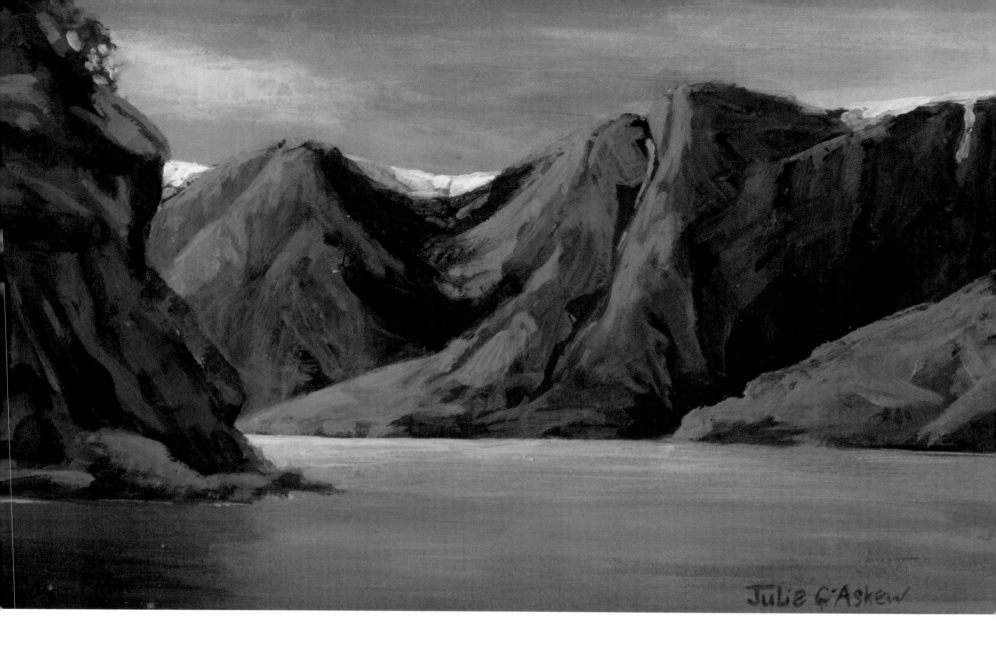

Julie G Askew

Flåm

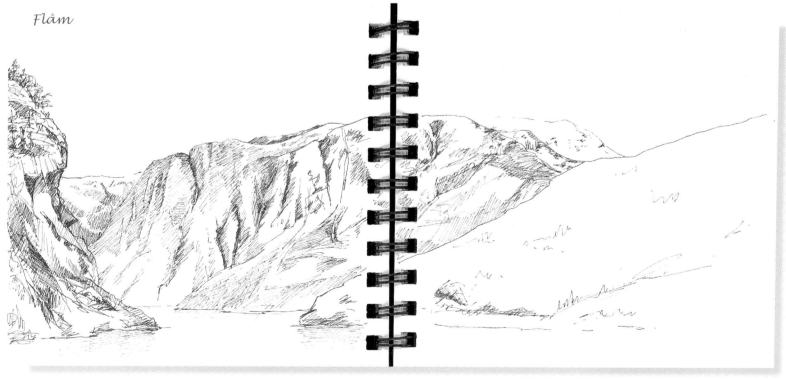

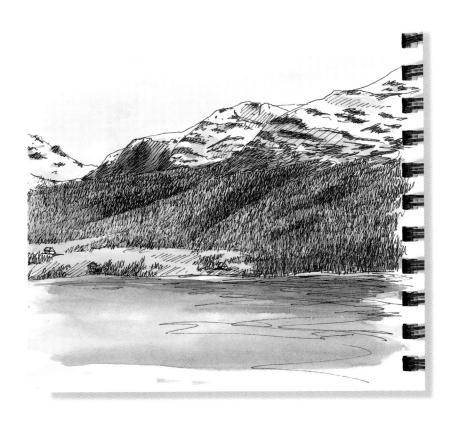

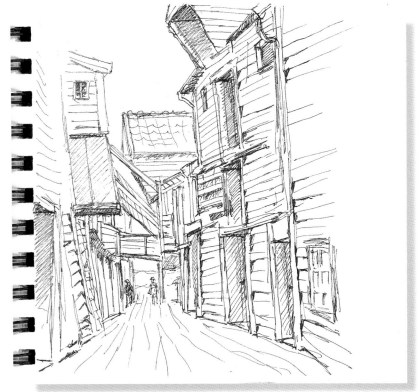

Mountains have always fascinated me. To capture the special mountain atmosphere is a challenge for any painter. They raise majestically from the valley floor. The meadows are full of sweet grass and spring flowers. In Bergen the rain mists down on the old wooden buildings and I have to stand under an arch to sketch them.

whale steaks *leopard fish* *salmon*

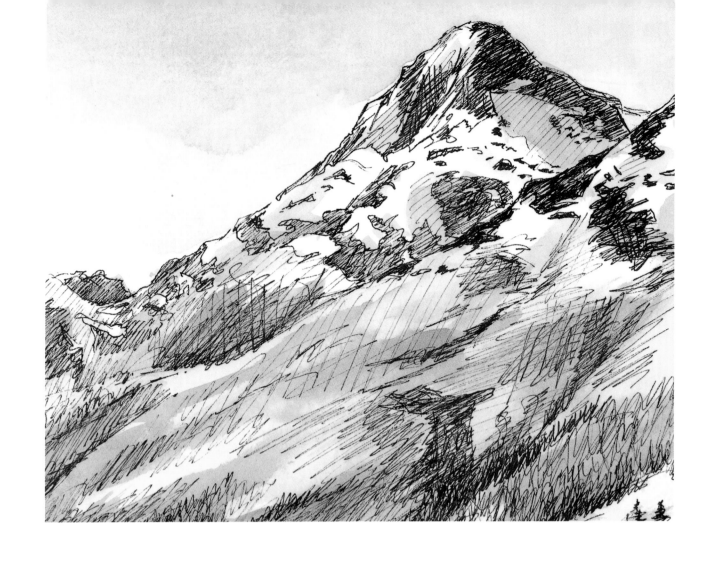

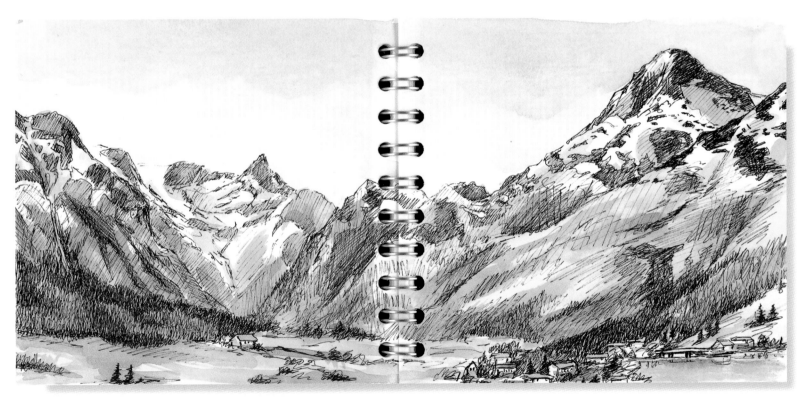

Afterthought is good, but forethought is better Norway

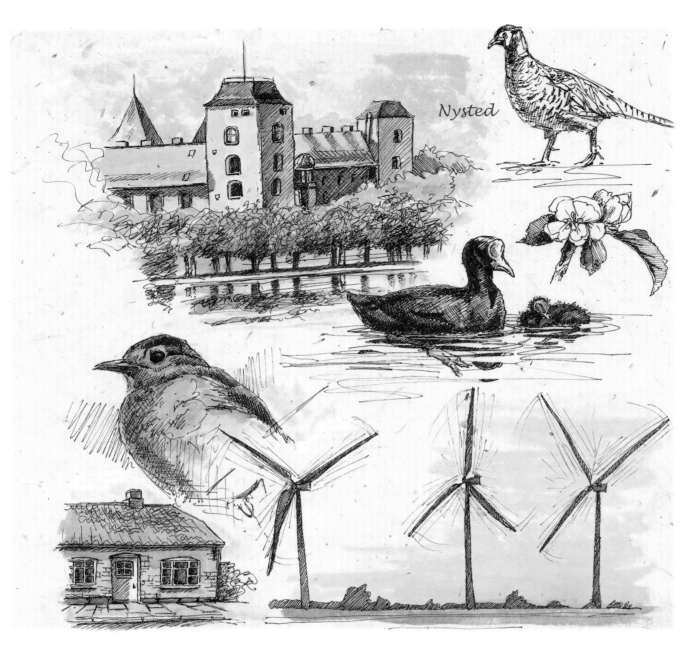

Nysted

Julie G. Askew ©

Perched on her rock, gazing out to sea, the bronze Little Mermaid ignores both me and the hordes that visit her. Copenhagen rises behind her with its curly spires that always catch my eye.

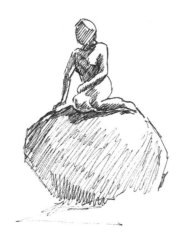

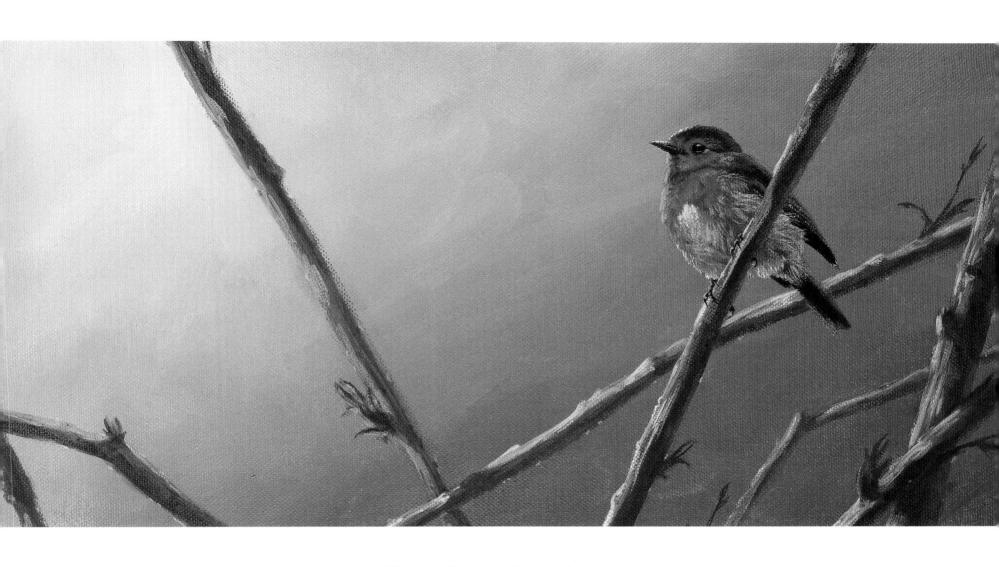

Many small creeks make a big river DENMARK

Faaborg festival
opening

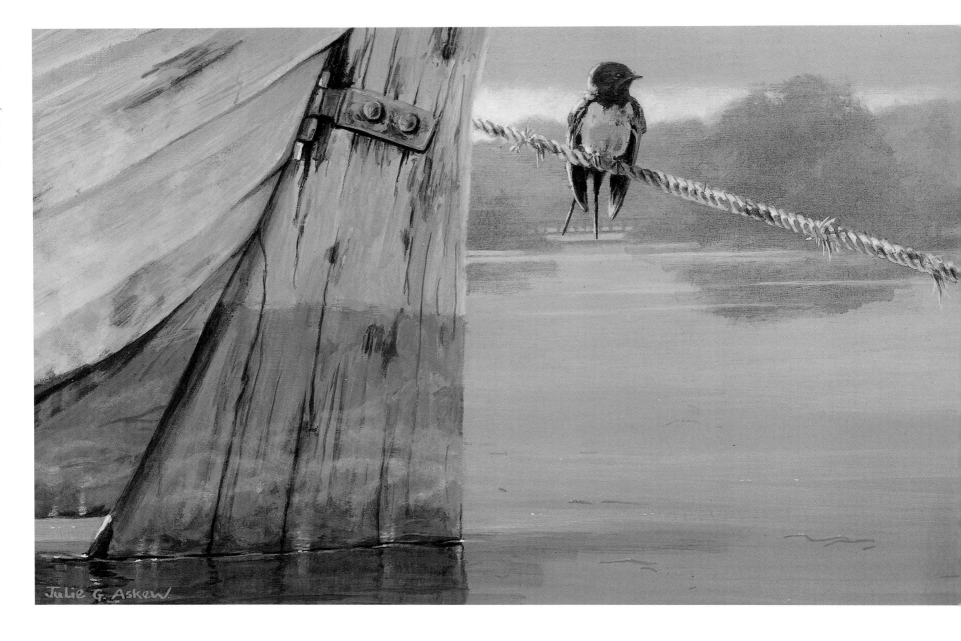

The little harbour is a hive of activity. Boats old and new, sailing yachts gliding in and fisher boats chugging out. Darting amongst them are the swallows, chattering as they busy themselves collecting insects for their young who are waiting in nests under the jettys. Despite all the bustle, there is a tranquility and slow pace of life, the atmosphere I try to capture when portraying Nysted.

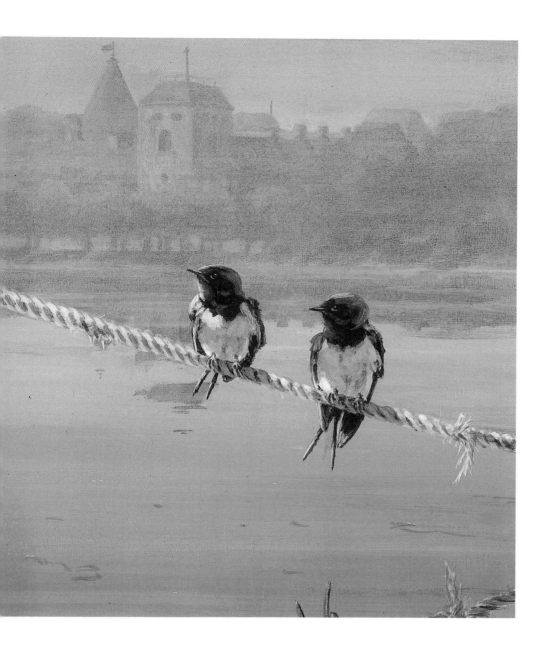

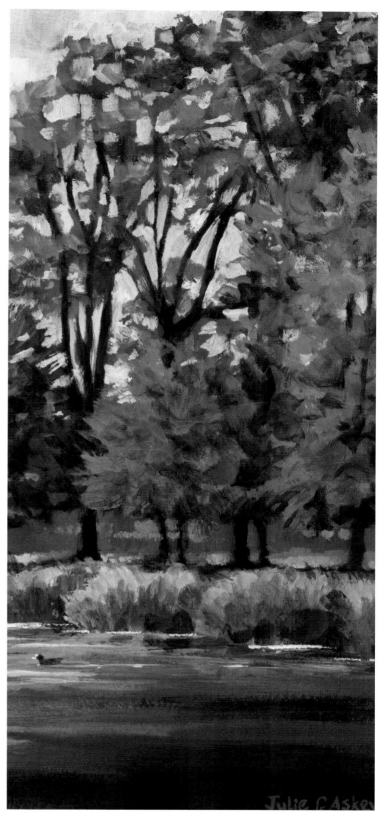

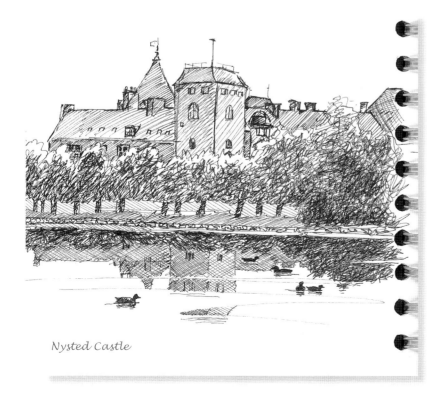

Nysted Castle

The basis for my plein-air painting is the light catching the tree tops, casting dark shadows and a strip of bright light on the grass. The shadows change constantly but now, at mid-afternoon, it is just right. Distant bells are playing a folk tune that rings out over the village.

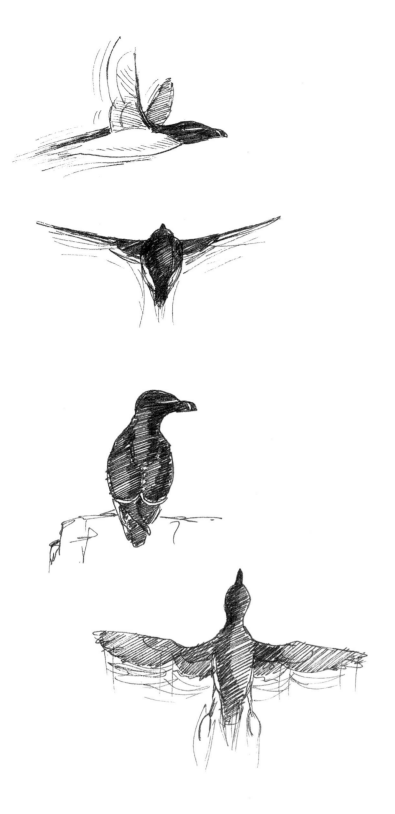

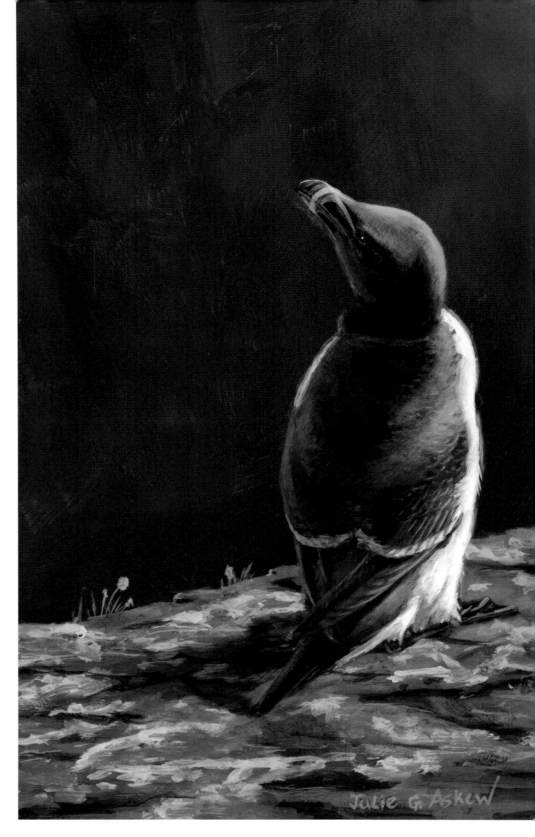

The streamlined shapes and oily feathers of razorbills contrast with the rough rocks. The wonderful colours of both grab my attention.

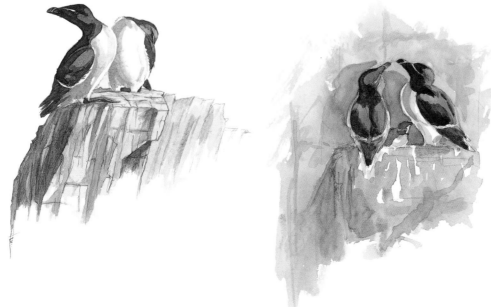

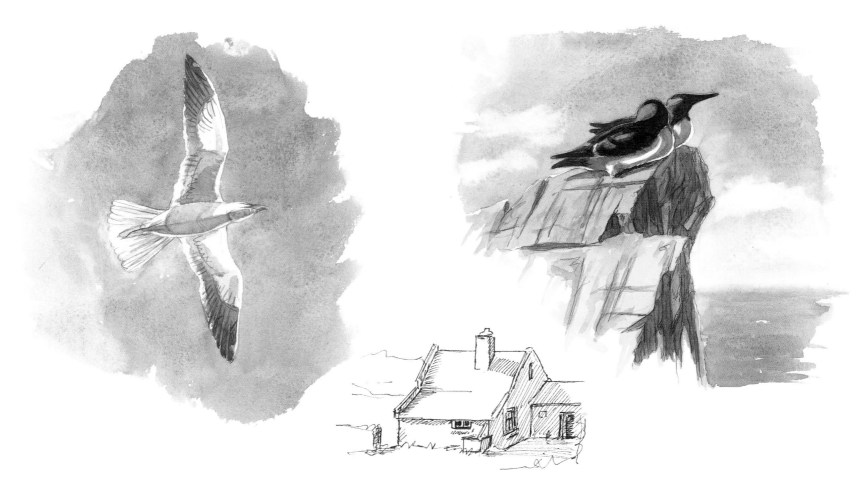

A bad farmer's hedge is full of gaps WALES

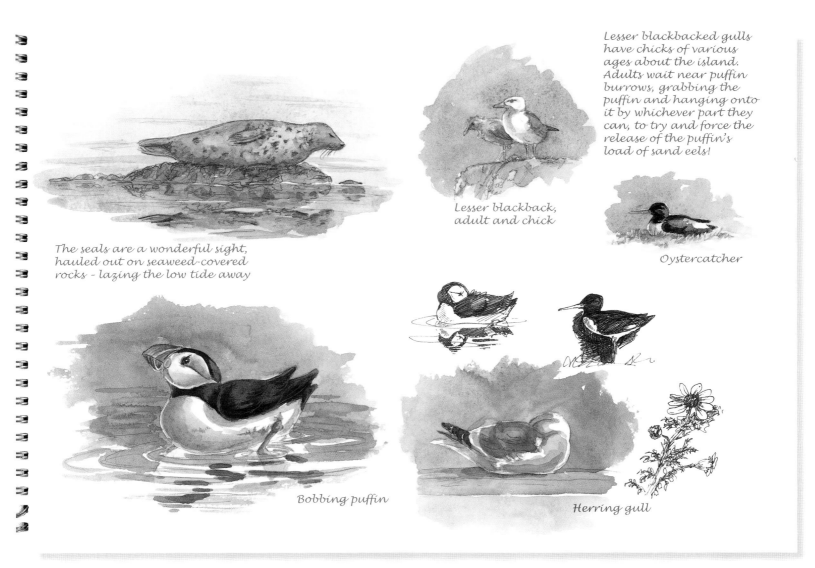

Lesser blackbacked gulls have chicks of various ages about the island. Adults wait near puffin burrows, grabbing the puffin and hanging onto it by whichever part they can, to try and force the release of the puffin's load of sand eels!

Lesser blackback, adult and chick

Oystercatcher

The seals are a wonderful sight, hauled out on seaweed-covered rocks - lazing the low tide away

Bobbing puffin

Herring gull

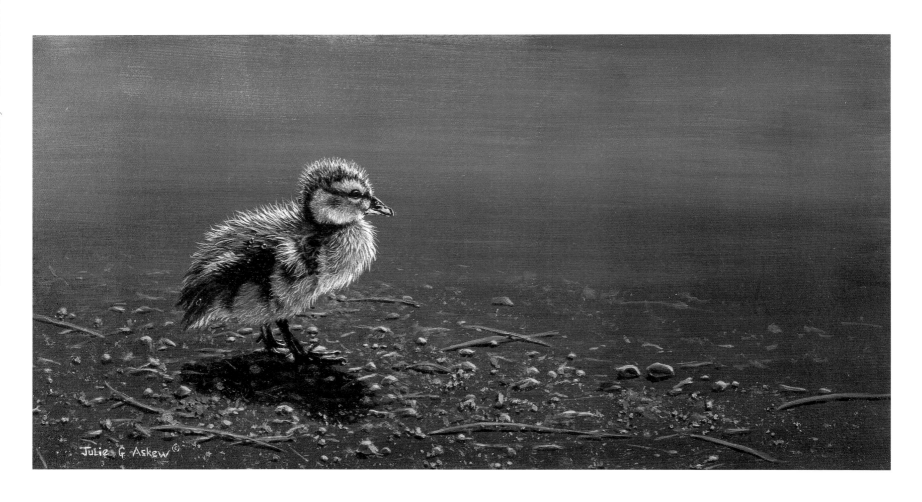

A bird in the hand is worth two in the bush ENGLAND

It is dark as I drive. Suddenly like a vision, the ghostly shape of a barn owl glides alongside, keeping speed with the car. It is one of those wonderful wildlife moments that burns its way into your memory for later reference.

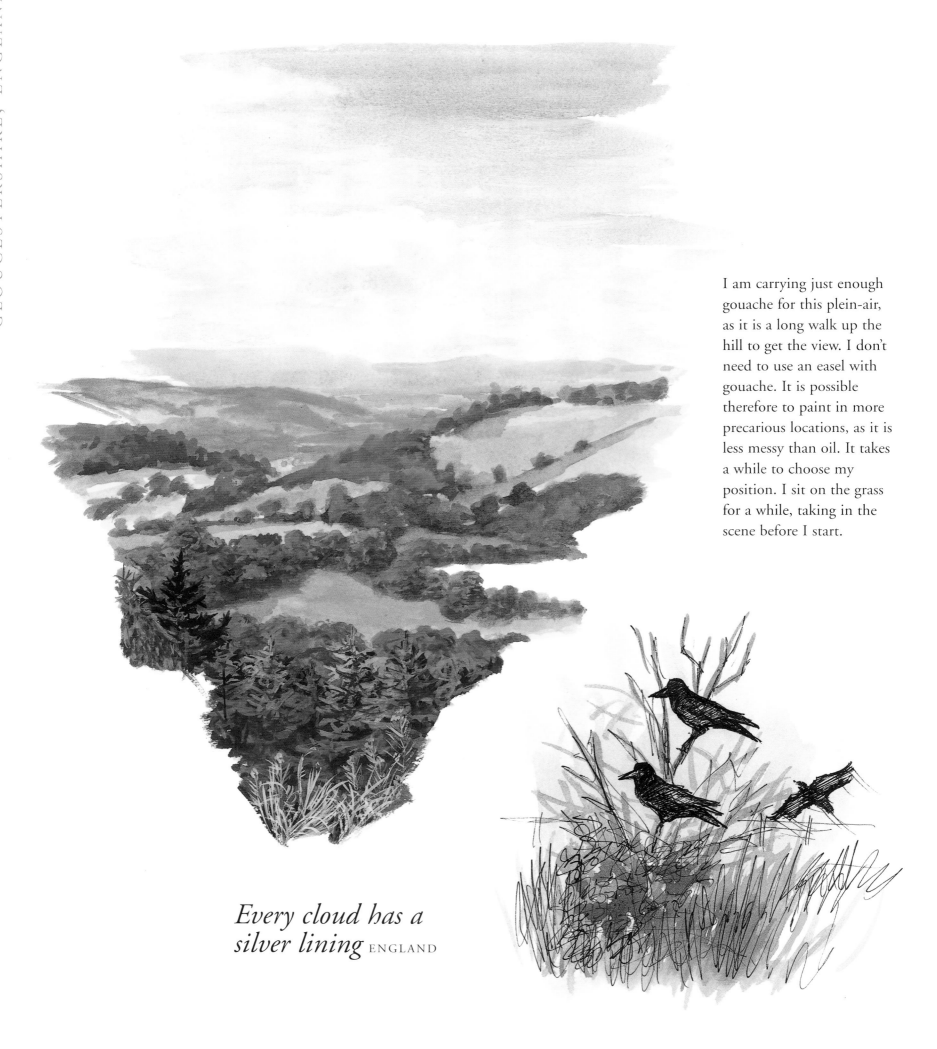

I am carrying just enough gouache for this plein-air, as it is a long walk up the hill to get the view. I don't need to use an easel with gouache. It is possible therefore to paint in more precarious locations, as it is less messy than oil. It takes a while to choose my position. I sit on the grass for a while, taking in the scene before I start.

Every cloud has a silver lining ENGLAND

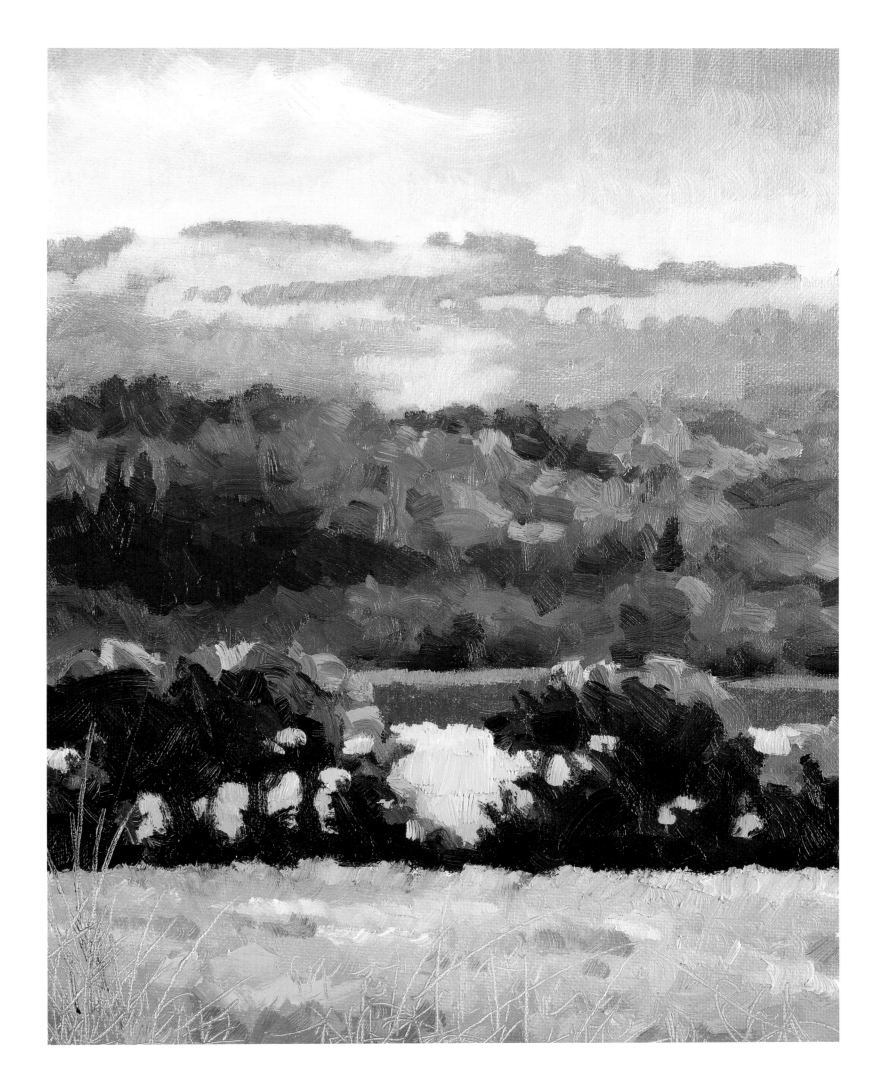

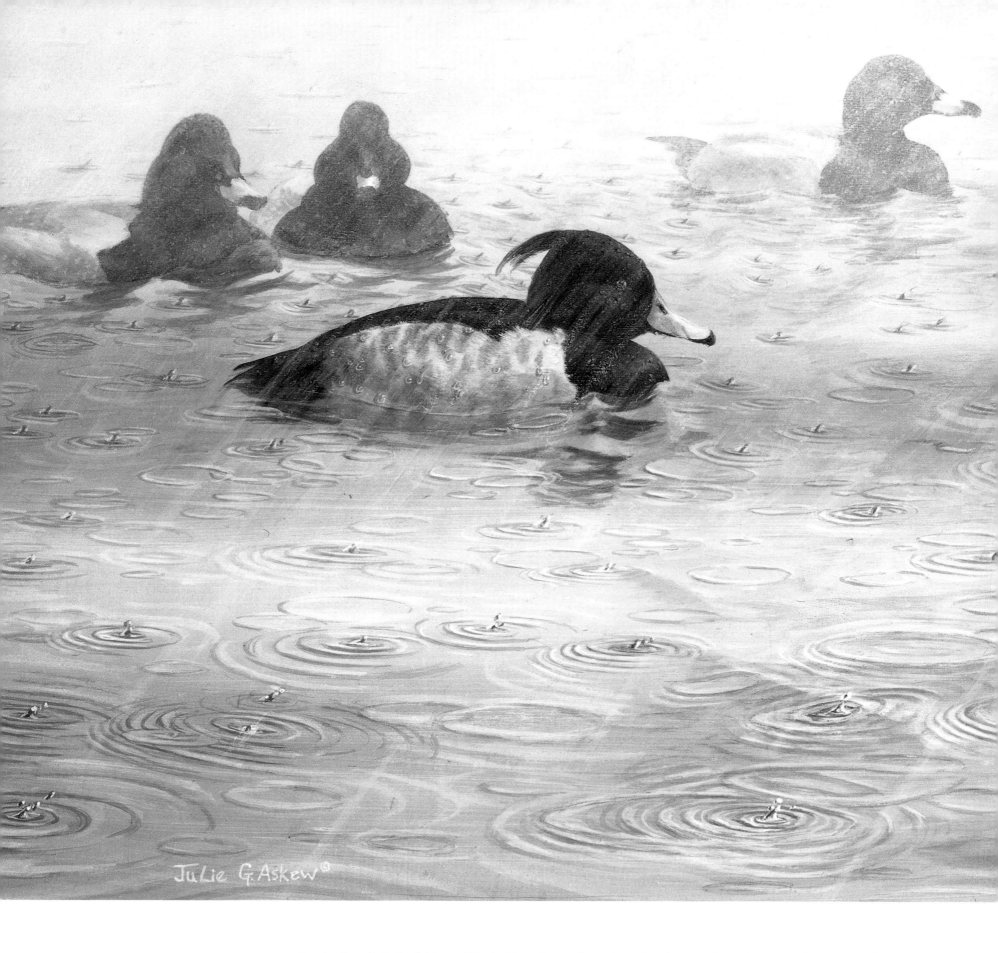

In the South Lake hide at Slimbridge, I am observing the view as the rain pours down outside. Although these aren't particularly pleasant conditions, they do give me the opportunity to observe the ducks' behaviour and to try and capture the flat light of such a November day.

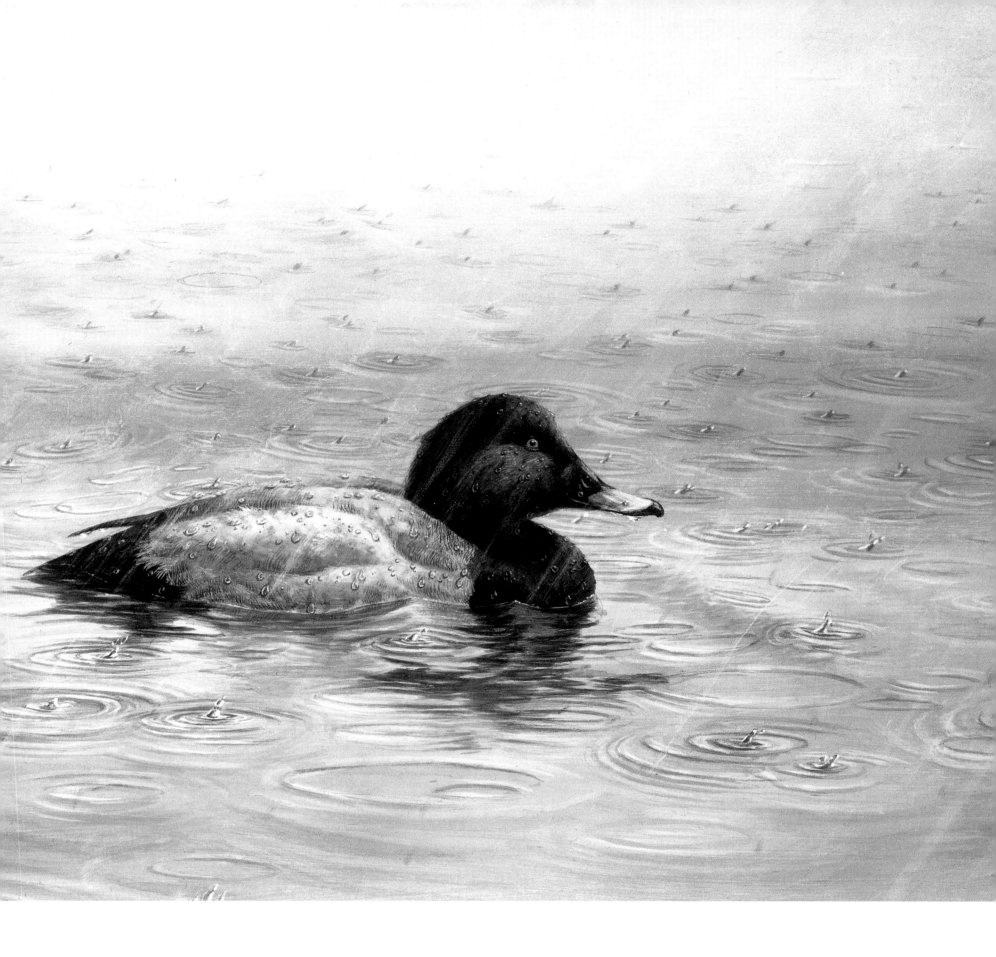

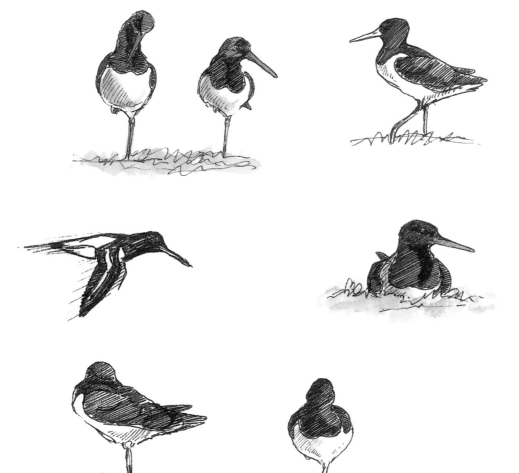

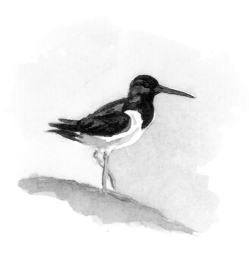

It is wonderful to look at the shapes of birds. They are basically quite simple forms. Subtle changes in beak curve can denote a whole different species. As I sit here, surrounded by birds, it is hugely enjoyable. My pen is still busy, as yet another sketchbook runs out of pages…

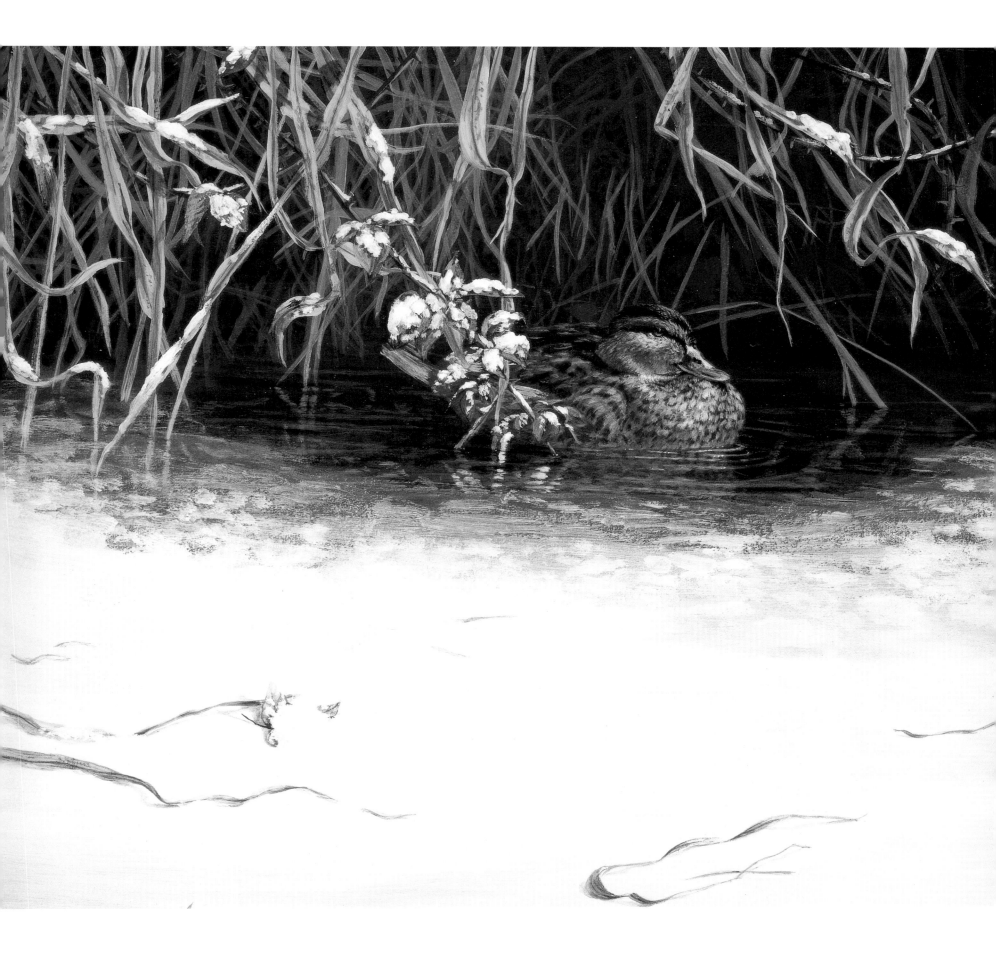

Artist's note

To me, the basis for any painting is observational drawing. Whether you use pencil or start drawing directly with paint, you can't paint well based on a bad drawing. Until you have mastered your craft sufficiently, the work created around this basis will struggle, no matter how wonderful your brushwork.

There are no shortcuts! It takes practice like anything else. One of the most rewarding forms of observational drawing is sketching. Progress can be felt through the pen or pencil; it becomes more fluid as you go.

As you observe, you develop a memory for shape. It is this development that enables you to capture the lines of a bird as it flies by or a lynx as it flashes before you.

I work in pen, leaving no room for error and forcing myself to go with my instinct. The less I think about it, the easier I find it. If you work in pencil, the temptation to lean on the crutch of an eraser

Sketching in Tobago

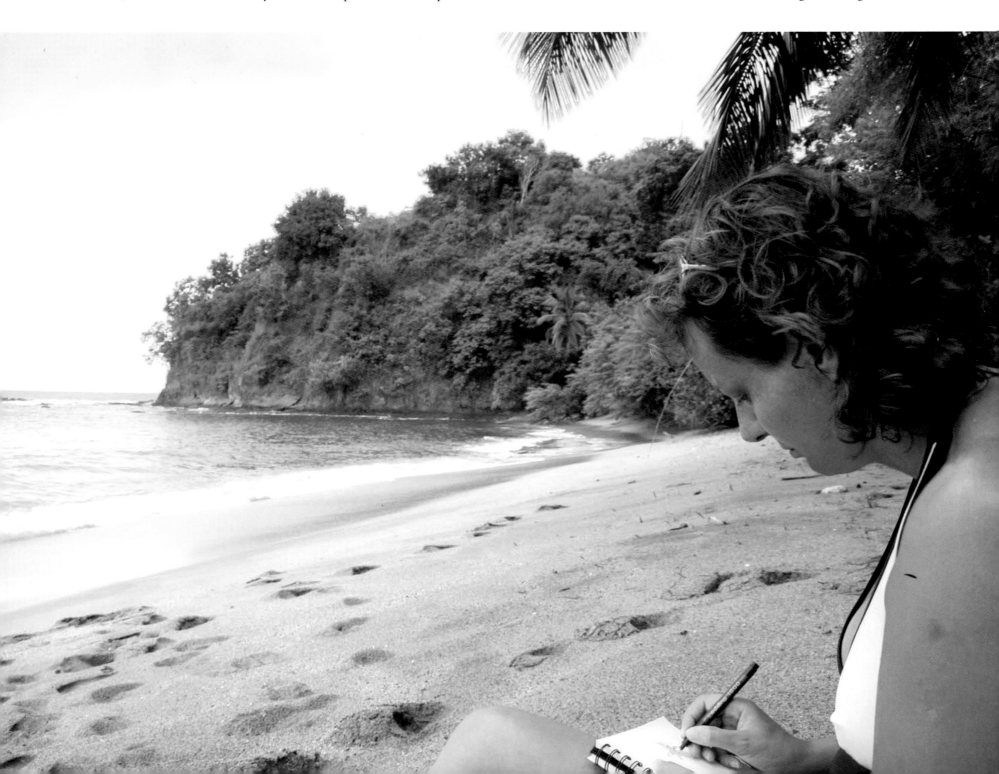

can get in the way of the flow, and the bird flying by has also flown from your memory once you have rubbed out your error and are ready to start again.

My colour in the sketchbooks is usually watercolour, added at the moment of creation or at the first opportunity if I am on the move. Subject matter is just whatever is there. People, buildings, wildlife or landscape. When I am sketching, it is the shapes that matter. Capturing a line, a tilt of a head or the angle of a mountain.

Sometimes I will sketch particular subjects with a complete painting in mind. In these situations I will note atmosphere and light and often do a thumbnail sketch of a composition if it shows itself. I will then try to capture as much of a subject as possible in simple shape, making note of the behaviour that the pose may indicate. This could affect the composition or story of the final painting.

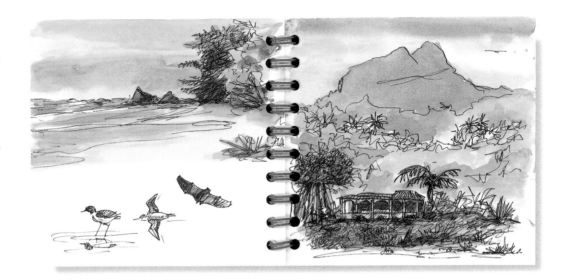

A sketch will take you mentally back to that moment, far more than a photograph would. Sketching is therefore not only good for developing drawing skills; it sets you up with useful reference material.

My paintings begin with an idea. I will only paint what I have observed in life, and potential paintings are everywhere. Ideas are constantly showing themselves although as with most things, ninety percent of those ideas never get painted, as others are always taking their place.

It must be remembered that you need to do thorough research on your subject matter. For example; if you are painting an elk in autumn, will it have its rack yet? What colour stage will the plants be in, and have you put the right species in the right place? Is the elk in proportion to the landscape and have you got your animal anatomy correct? Does the light fit on both elk and landscape? What time of day is it and is it constant throughout? Thorough knowledge of what you are painting is vital.

My advice would be: if you haven't ever seen it in life – don't paint it!

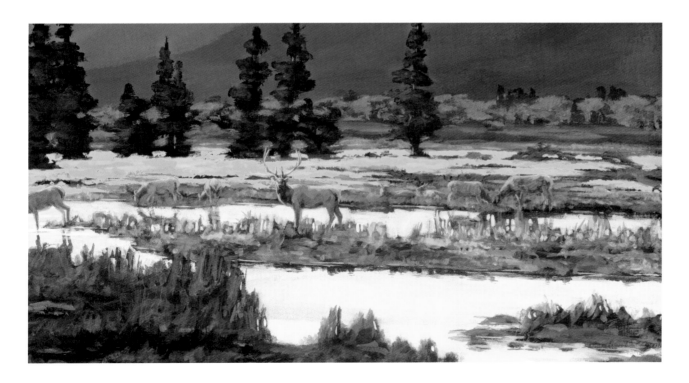

For me, the most important part of a painting is the light and colour. The same subject's colours change dramatically if you move the light direction around. Light gives the emotion to the picture: drama or tranquility. It is both the atmosphere and colour key to the painting. It tells the artist where the shadows will fall and can change the feel of an entire composition.

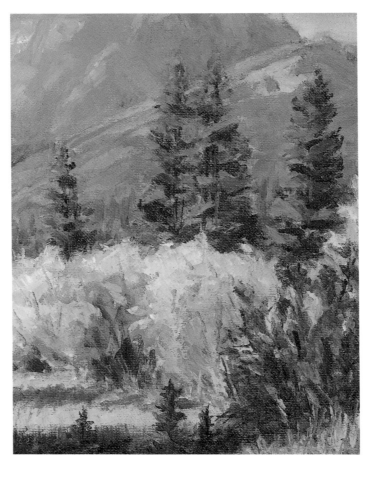

For acrylic paintings, I usually prepare a few boards at once and then, selecting the one whose size and shape fits, I will give it a wash of ochre and umber as a base colour. This startling orange effect glows through the painting.

To lay down my dark colours and basic composition, I use a mix of umber and cobalt to map in the subjects and get a feel for the piece. Laying down a few bright tones, I can then see if the piece will work.

From this point on, my mind is occupied with the paint. The texture, the brushwork and form. I try to sculpt on the board, translating 3D images onto a 2D surface.

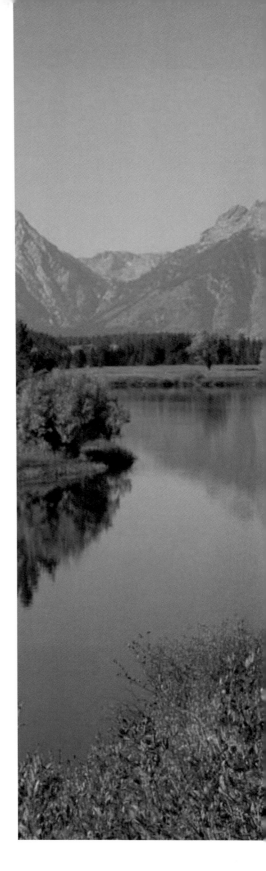

I have included in this book some plein-air paintings, traditionally done in oils. To my good fortune, I was first introduced to this technique by the late great Paco Young.

I believe plein-air painting is the best technique for developing landscape painting, as it has a wonderful freedom and honesty about it. You need paint for no longer than two hours in the field. After this time, the light will have changed so much that you will be altering what you have already achieved. This is not a long time in oils and demands a fresh, fast approach. Plein-air paintings can stand alone or can work as a basis for a larger studio piece.

I strive to portray the stunning beauty that is all around us, if we take the time to look. I am fortunate to be able to travel far and wide, but looking out of any window anywhere one can enjoy something as simple as the light catching the turn of a leaf. Appreciation is a step towards preservation. Our natural world is disappearing at an alarming rate – if we destroy it, we destroy ourselves. A lovely couple said to me once, 'We will buy your book for our granddaughter. When she has grown up, some of what you have portrayed will not exist anymore.'

My painted journey in this book depicts some of our planet's great diversity. There is a fantastic world out there. Go. Observe. Preserve. Paint!

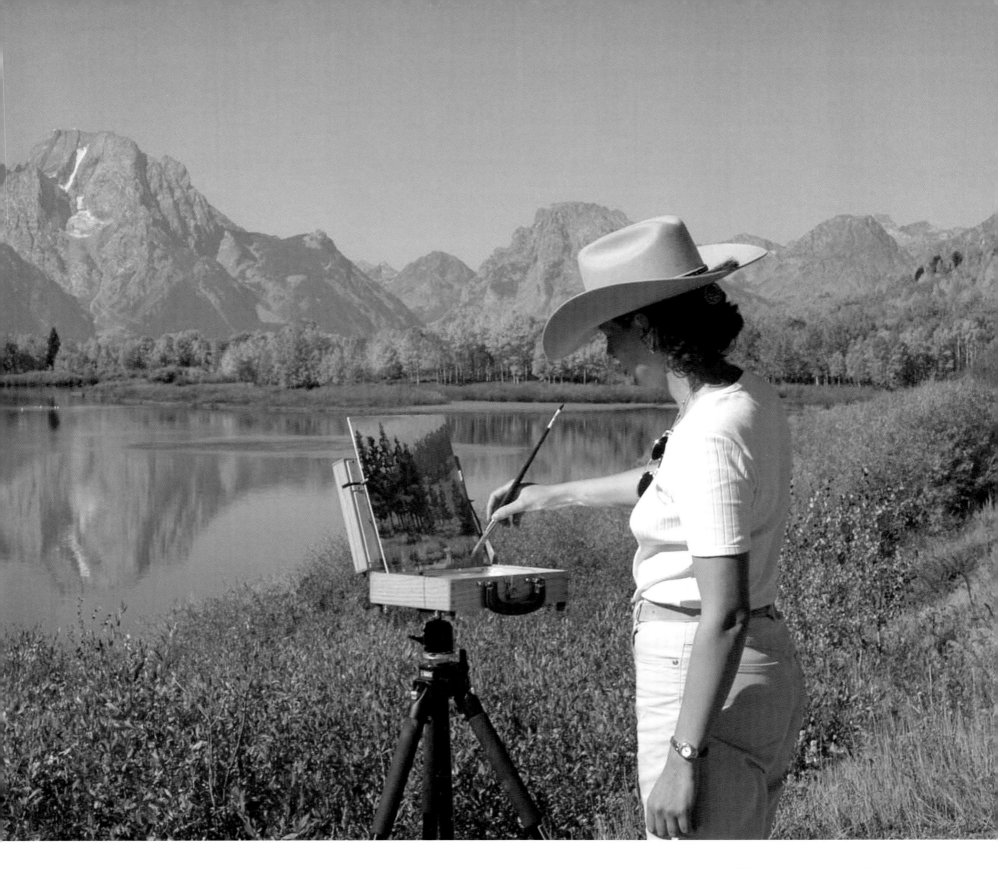

Plein-air painting at Oxbow
Bend, Wyoming.

We are all visitors to this time, this place, we are just passing through. Our purpose is to observe, learn, grow and love, and then we return home ABORIGINAL

Paintings list

About the artist

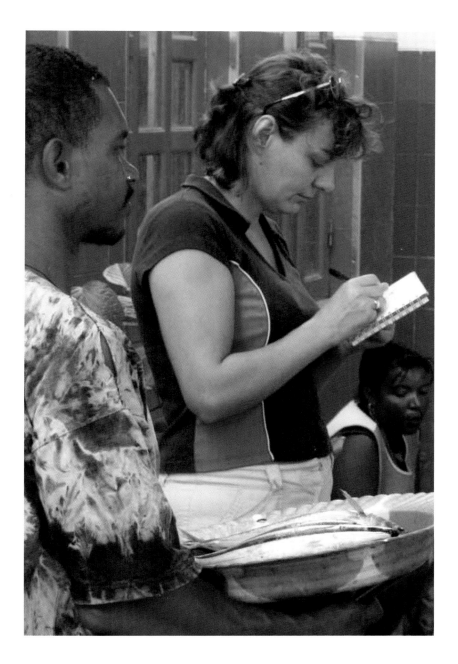

Being a graduate of Scientific Illustration (BA Hon. Middlesex University) has given Julie the important grounding in anatomy and understanding of the subject from inside out.

Da Vinci and Dürer were amongst the first artists to realize the importance of anatomical knowledge and studies from life. Following their example has been the ideal basis upon which Julie has formed her own work.

Her fascination of the natural world has always married with her need to describe it. It wasn't though until she came across a book with Robert Bateman's work (which became a prized possession), that she realized this could be her life.

From that point, the work of North American and Canadian painters began to attract her attention, and a whole world of artists and subjects opened to her. With stubborn determination she decided that she wanted to be part of it.

Since *Born Free*, Africa has always attracted her too, even as a young child when she had no idea where it was. So, upon winning a National Urban Wildlife Photography competition and using the prize money (which was intended for equipment) to take her to Kenya, her eyes were opened and dreams cemented. Julie's first one-woman show on African and European wildlife sold out and she knew she was on the right track.

A workshop with John Seerey-Lester and Alan Hunt gave her some much needed direction on composition, the importance of landscape and a huge inspirational boost.

The next few years were spent moving from illustration to painting and developing her own style. Her choice of material changed in the process. Trained in pure watercolour, she added white gouache to give her work more body. Still in need of texture she moved to acrylics and oils, working dark to light instead of light to dark and so obtaining the possibility of glazing and working layers.

The opportunity to attend another Seerey-Lester workshop arose, this time in Montana, USA. With delight she headed off to join the Beartooth School of Art which was to change her work forever.

Having always been of the principal never to paint what she hasn't observed live, she finally saw the American wildlife and landscape that she had only admired in paintings and knew she had found her greatest inspiration. The workshop introduced Julie to the late Paco Young, who she is proud to call both mentor and friend. Paco's fantastic painting style and plein-air approach combined with the grandeur of Montana blew her

away. The area became her main source of inspiration and most frequent travel destination.

Despite her young age, Julie is already considered one of England's leading wildlife artists. She was 'Best Selling Artist' at Sotheby's last Wildlife auction and was invited to become an annual Artist in Residence at the Nature in Art Museum, UK, as well as having work in the museum's permanent collection. Her limited edition prints are much in demand and sell worldwide.

She is represented in the UK by the Tryon Gallery, London and in the USA by Frameworks Gallery, Montana. She is an elected member of the Society of Animal Artists, USA and of Artists for Conservation, USA.

Julie has travelled the world extensively for many years and has done workshops and given lectures all over, encouraging all ages and abilities to sketch and paint. With her studio often being in different exotic parts of the world, her pile of sketchbooks grows higher and her brush works ever faster.

159

**Julie Askew
Fine Art Prints**

Please visit
www.julieaskew.com

 The Tryon Galleries

We are very pleased to be associated with
Julie Askew and her outstanding work.

Tryon Gallery
7 Bury Street
London SW1Y 6AL

www.tryon.co.uk
info@tryon.co.uk
020 7839 8083
020 7839 8085

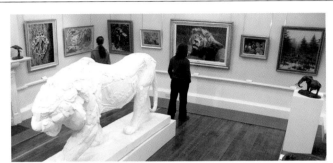

NATURE IN ART
WALLSWORTH HALL
A38, TWIGWORTH,
GLOUCESTER GL2 9PA
TEL: 01452 731422
www.nature-in-art.org.uk
director@nature-in-art.org.uk

 Artists for Conservation™
Supporting Nature through Art

'The Artists for Conservation Foundation (AFC) is a
non-profit, international artist collective with a mission to
support wildlife and habitat conservation, biodiversity,
sustainability and environmental education through art that
celebrates our natural heritage.'

'The AFC is pleased to have Julie Askew as a Signature Member.'

JEFFREY WHITING - Artist (Canada)
President & Founder - Artists for Conservation

The Society Of Animal Artists

The Society of Animal Artists is an international association of artists
working in the genre of animal art. Patricia Allen Bott and Guido Borghi
founded the Society in 1960 and today there are 460 members. We are
very proud to have Julie Askew as one of our members.

LESLIE DELGYER, President
Society of Animal Artists, USA

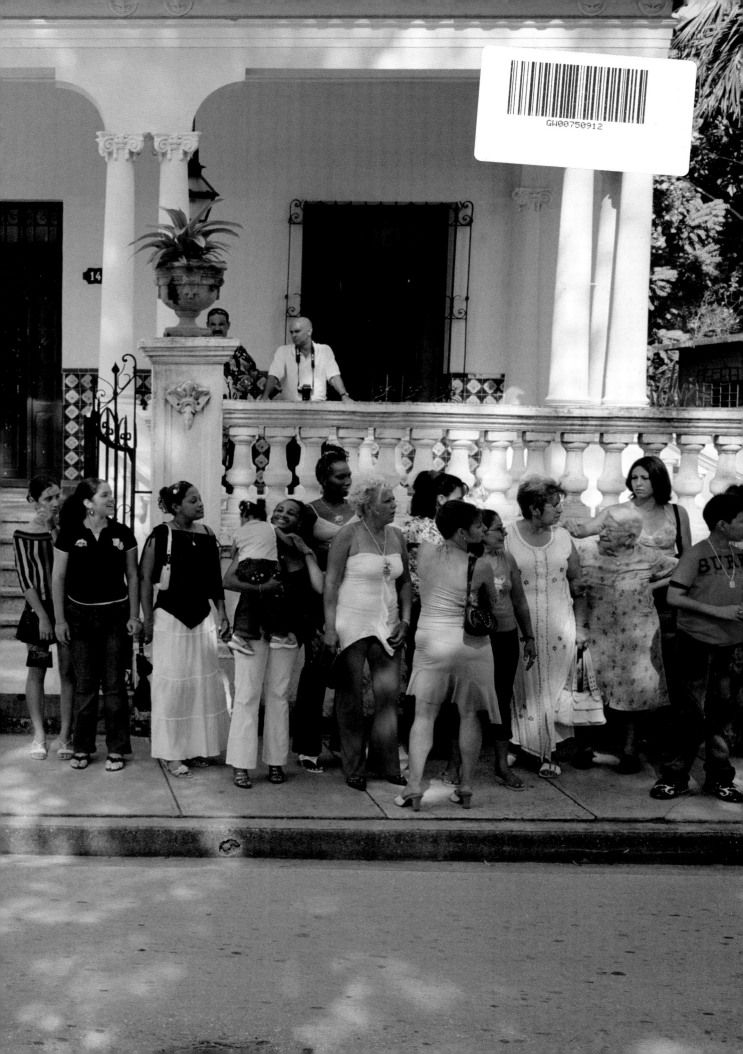

CLIVE FROST

CUBA

CUBANAS Y CUBANOS

The Revolution is not intimidated by attacks. The Revolution is not weakened by attacks. On the contrary, it waxes and gains strength, for this is the Revolution of a valiant, fighting people.

With another people, another people lacking the virtues of the Cuban people, it would not even be worthwhile having started this struggle, but when one has a people like this to count on, one not only begins but achieves and goes on to total victory.

The people fear that the death of one of their leaders would be failure for the Revolution. What I am about to tell the people of Cuba today is that this is not true. What I am going to tell the people of Cuba is that revolutions cannot depend upon one man. The fate of a nation cannot depend on one man.

It is time for the United States to rethink its approach to the Cuban government and the Cuban people. Current policies towards Cuba have clearly not achieved their objectives.

Today, the United States maintains the embargo despite the absence of an obvious national security threat and against nearly unanimous international opposition. There is no better example of the ineffectiveness of unilateral sanctions than the case of Cuba.

The real cost is the influence that the United States has lost by voluntarily isolating itself from Cuba during an important moment of transition. Far from providing leverage, U.S. policies threaten to make the United States virtually irrelevant to the future of Cuba.

La Revolución no se acobarda frente al ataque. La Revolución no se debilita frente al ataque, sino que se crece, que se hace más fuerte, porque esta es la Revolución de un pueblo valiente y peleador.

Con otro pueblo que no fuese éste, con otro pueblo que no tuviese las virtudes del cubano, no valdría la pena siquiera haber comenzado esta lucha. Pero cuando se cuenta con un pueblo como éste, no sólo se comienza, sino que se prosigue y se continúa hasta la victoria total.

Teme el pueblo que la muerte de uno de sus líderes pueda ser el fracaso de la Revolución. Y lo que yo le voy a decir al pueblo de Cuba hoy es que no. Lo que voy a decir al pueblo de Cuba es que las revoluciones no pueden depender de un hombre, que el destino de los pueblos no puede depender de un hombre.

4 de Diciembre de 2008
Carta enviada por líderes comerciales de los EE.UU. al presidente electo
Barack Obama

Ha llegado la hora de que los Estados Unidos reconsideren su posición con respecto al gobierno y pueblo cubano. Está claro que las políticas actuales profesadas hacia Cuba no han logrado sus objetivos.

Hasta la presente, los Estados Unidos siguen manteniendo el embargo impuesto a Cuba a pesar de la clara ausencia de cualquier tipo de amenaza para la seguridad nacional y enfrentándose de forma persistente a una oposición internacional que se muestra casi unánime a un levantamiento del mismo. No hay mejor ejemplo de lo ineficaz que resultan unas sanciones unilaterales que el caso del embargo a Cuba.

El coste real es la influencia que los Estados Unidos han perdido aislándose voluntariamente de Cuba durante un período de transición tan importante como éste. En lugar de hacer presión, la política demostrada por los EE.UU. amenaza con convertir a los propios Estados Unidos en una nación prácticamente irrelevante para el futuro de Cuba.

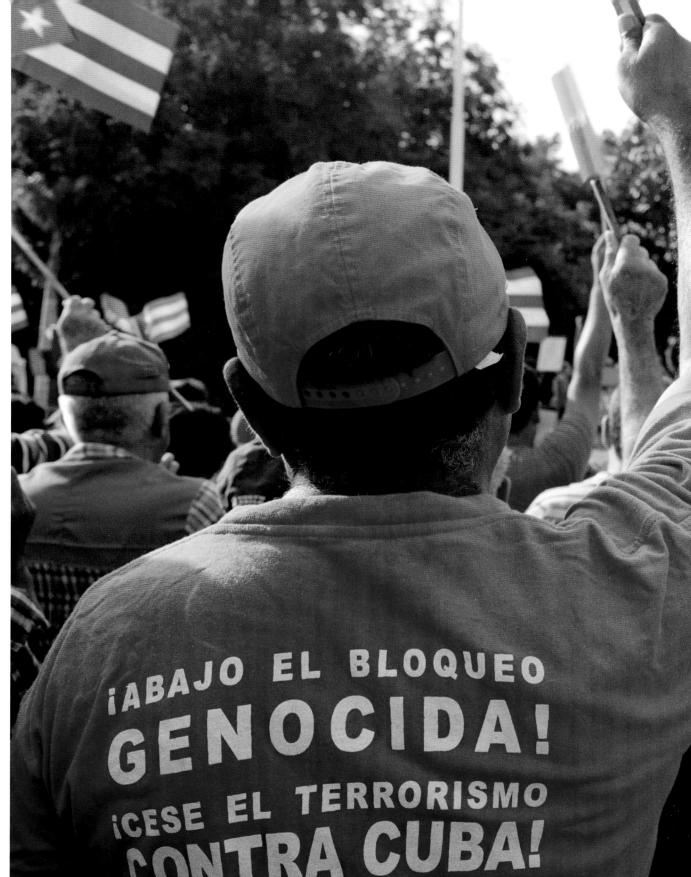

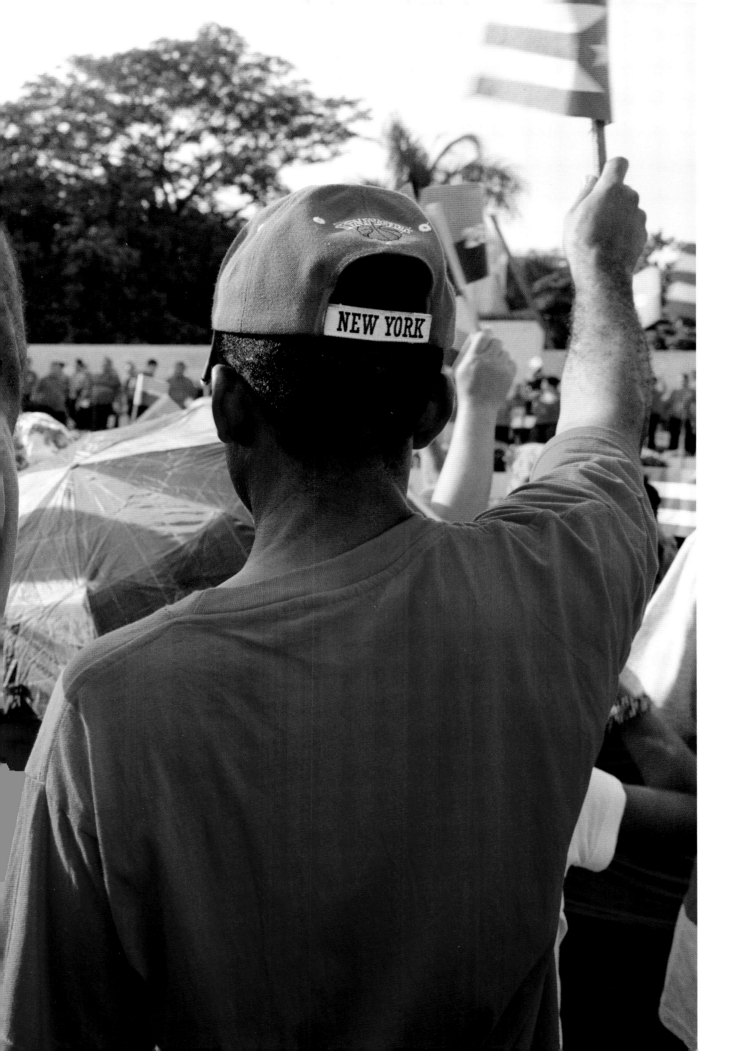

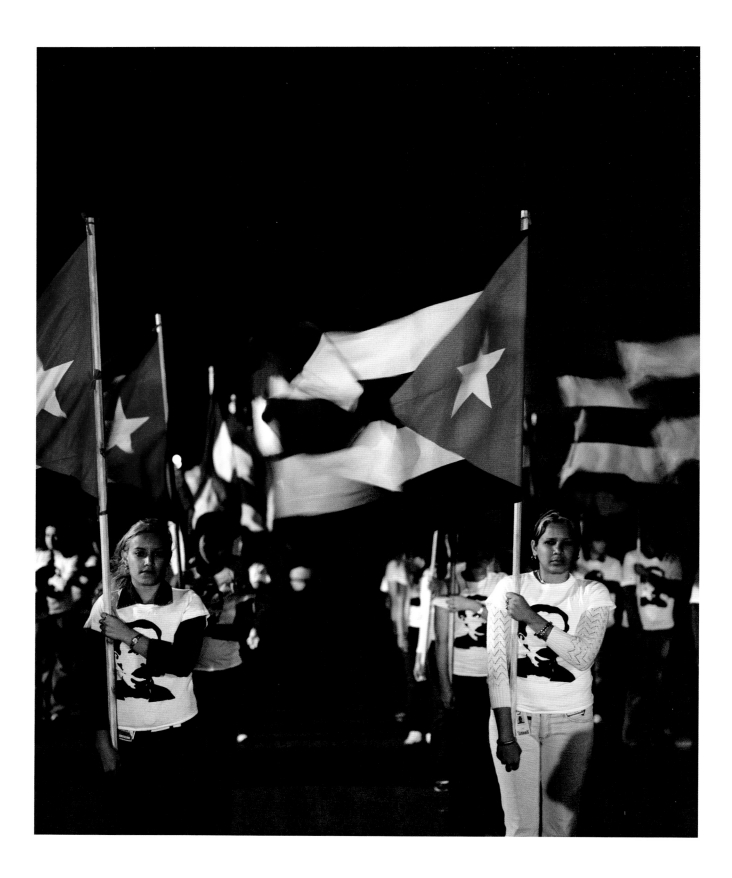

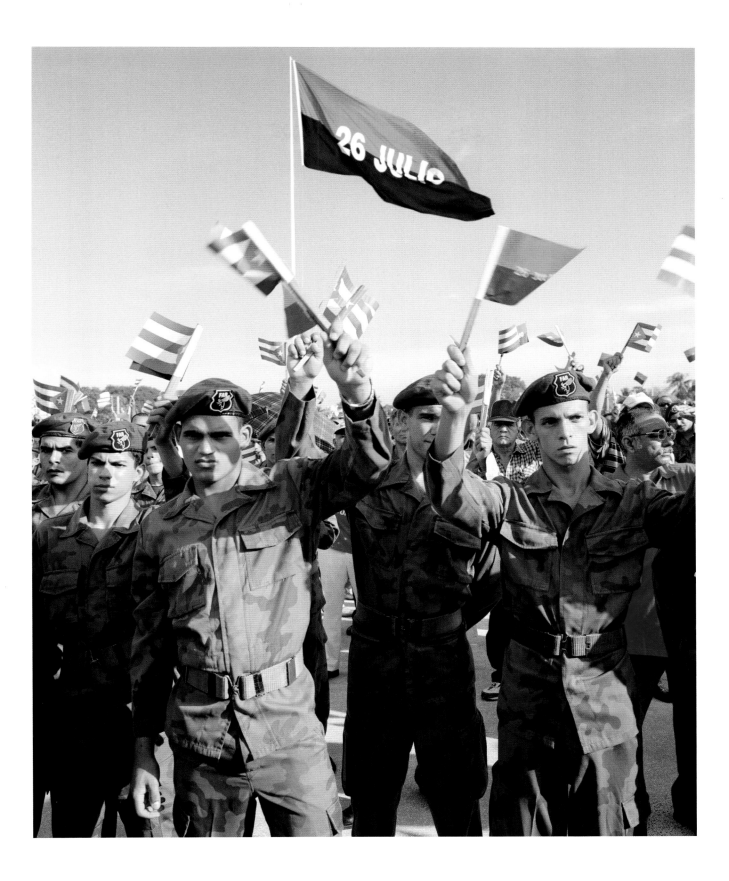

26th July celebrations
Acto por el 26 de Julio
Plaza de la Patria, Bayamo, Granma

Mural in La Rampa
Mural en La Rampa
Vedado, Habana

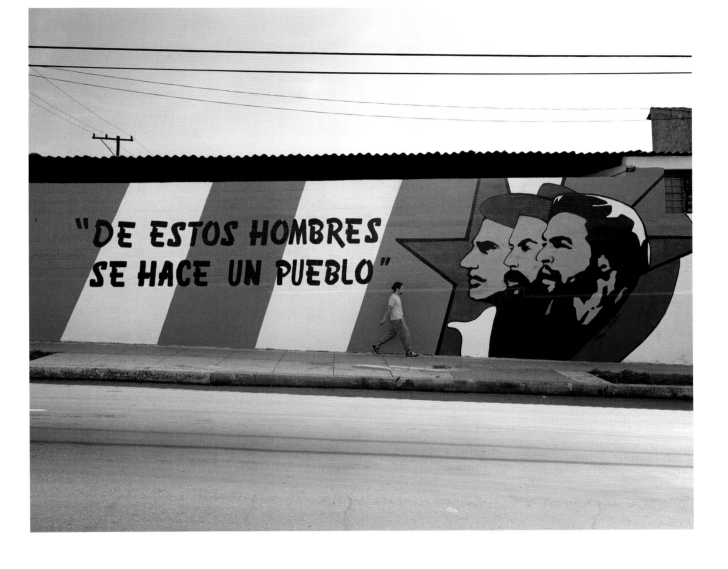

Mural in Avenue G
Mural en Avenidad G
Vedado, Habana

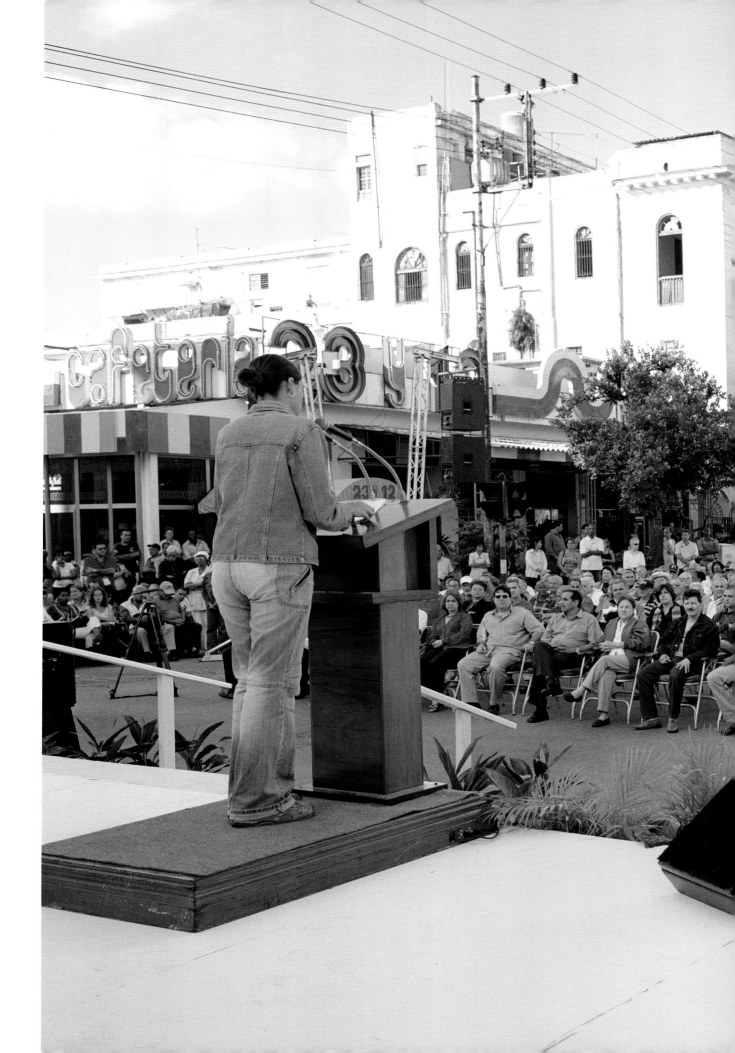

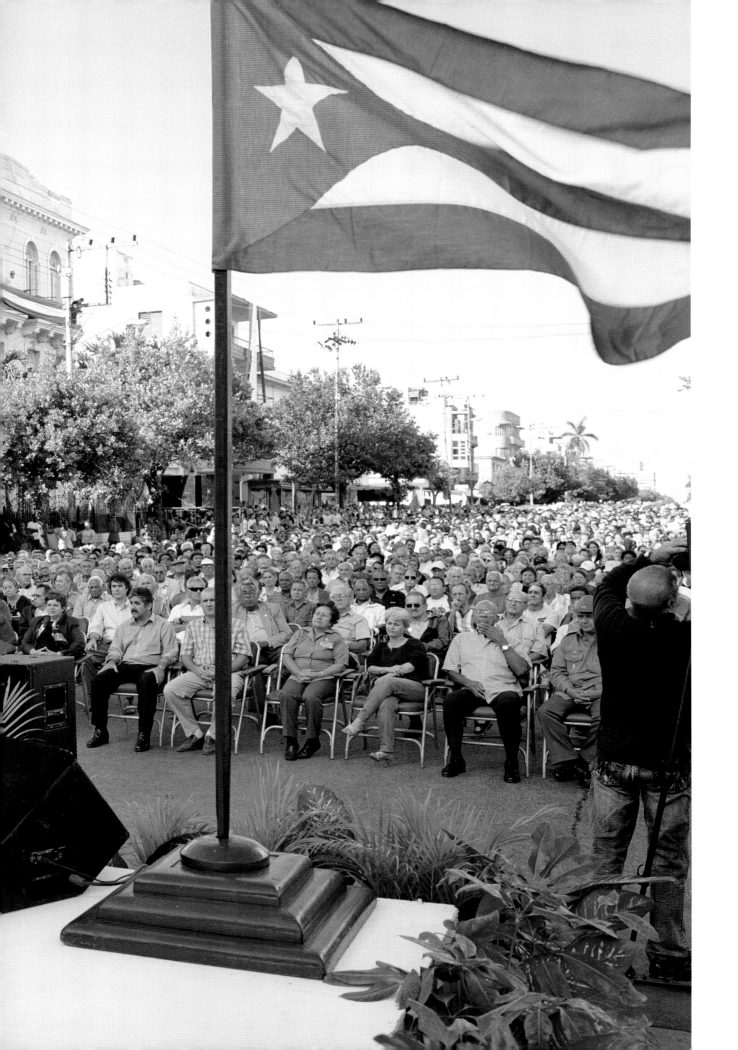

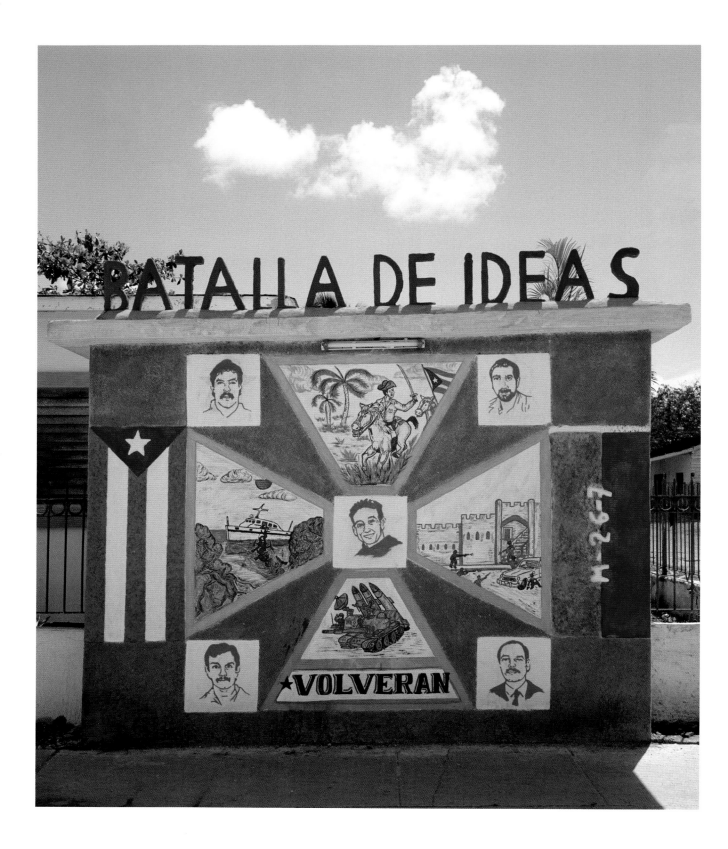

The Russian Embassy
Embajada de Rusia
5 Avenida, Miramar, Habana

Cubanos
An essay by Stephen Smith

One of the unfailing charms of travel, I'm sure you'll agree, is to frame a view of your destination in the screen of your camera and exclaim, 'How picturesque!' Who hasn't been proud to show their slides to the neighbours or the Rotary Club, with a sly boast of 'This little place we found was so scenic'? Well, visitors to Cuba, and seasoned armchair travellers alike, will already know that nowhere on earth is more photogenic than the largest island in the Caribbean. Or rather, if it *can* be bettered by another eye-catching spot, then such a place has so far eluded generations of gifted photographers, including Clive Frost, the man responsible for the present portfolio.

I say that holiday snaps are one of the delights of the tripper, and yet I personally share the view of the writer Geoff Dyer, author of a much admired book about photography (*The Ongoing Moment*) that I can't actually be bothered to take any pictures myself. I know my place, and my limitations. Indeed, poring over photographic images of Cuba as good as Frost's, I feel honour bound to throw in the towel, or rather the pen, on behalf of words, in the face of overwhelming competition from the visual medium. It's not that literature has failed to make a go of Cuba - far from it. No time is wasted that is spent with Graham Greene's prescient entertainment *'Our Man in Havana'*, nor on the books of Cuban novelists young and old, G Cabrera Infante and Pedro Juan Gutierrez. Non-fiction holds its own, too, with Hugh Thomas's masterly history, *'Cuba'*, as well as at least one travelogue that modesty prevents me from mentioning (though I'm prepared to come round and sign a copy for you, if you insist). But you have only to consider the landmarks that the visual arts have achieved in Cuba to realise no fair-minded judge would find in favour of the page rather than the photographic plate.

Iconic is a much-bandied term, but perhaps it's not inappropriate in the case of Korda's study of Che Guevara, a man who has inspired hero-worship in everyone from revolutionaries to advertising agencies. His is arguably the most famous portrait ever committed to developing fluid. That beret, that 'tache, that intense, thousand-yard gaze (or is it a thousand *years*?), Korda, once plain Alberto Diaz Gutierrez, had made his living from fashion and glamour shots before the revolution. In March 1960, he was taking pictures of Castro during a speech when his attention was drawn to Guevara, and he captured the image that has covered up the damp in a million undergraduate bedsits. 'The Heroic Guerrilla,' the photographer called it. When The Victoria and Albert Museum in London staged an exhibition centred on it a few years ago, there were claims that it had been reproduced more than any other image in photography. 'To the camera, Che's eyes glow; they coax, entice, and mesmerize.' So rhapsodised no less an authority than Henri Cartier-Bresson, when he considered Korda's unwitting sitter.

Other terrific pictures survive of this period, less celebrated perhaps, but well worth seeking out in their resting place on the postcard-racks of old Havana. In the somehow ennobling context of black and white photography, Fidel and his merry men are seen hacking their way through the Sierra Maestra mountains en route to victory; or else they are attending to their toilet in camp, or - best of all - enjoying a game of pitch and putt in their military fatigues! Another poignant slide shows Castro admiring the Lincoln monument in Washington, in the days before the Cuban missile crisis and the United States economic embargo. Into this one image may be read so much of what went wrong between the two nations on either side of the Florida Straights. And indeed it would be easy, in these days of the one-click, icon-shorthand of the worldwide web, to allow Cuba's very strong visual signature (a cigar, a voluptuous American automobile, a man with a beard) to substitute for a more complicated and nuanced narrative. Clive Frost's photographs can speak for themselves, of course, but if I might venture a line of commentary, it would be simply to observe that they dodge clichés of Cuba in favour of recording moments in the lives of ordinary Cubans - the *cubanos* of his title.

This set me thinking about some of the Cuban moments that I managed to commit to memory - albeit to the archive of the mind rather than the pristine cache of the memory-stick. Perhaps unsurprisingly, these are often associated in the mind's eye with photographic documents of Cuba, which, as I say, can be overwhelming.

The mental scrapbook falls open at random, on the head-and-shoulders likenesses of famous guests which line the walls of the Hotel Nacional. That's the imposing Moorish pile overlooking the Malecon, the seaside strip of Havana. The publicity stills covering the dark wood of the hotel's El Golfo bar transport the toper back in time, to an epoch when the Cuban capital was the glamorous playground of Hollywood royalty and American tycoons: before Castro came to power, the Mob thought nothing of flying Sinatra into town just to play a show. The last time I sipped a daiquiri in this impeccably panelled Tardis, though, I found that newer stars had joined the firmament of visitors, our own Naomi Campbell and Kate Moss among them. There, too, was the tousle-haired troubadour Robert Plant - or he was there in spirit, memorialised by the coaster on which he had reflexively, or defensively, scribbled the address of his management company. But the display case which showed off these once-unspoilt trophies was no match for the penetrating tropical sun, nor the ambient salt of the wave-tossed Malecon. And so the distinguished Brits who had stayed under the Nacional's turreted roof had joined the many other faded glories of the city.

I think of pictures from an exhibition, or rather relics from a museum, the *Museo de la Revolución*. What stays

Cubanos
Un ensayo por Stephen Smith

Los viajes tienen ciertos encantos que nunca fallan a la cita. Uno de ellos —y seguro que estarán de acuerdo— es captar una vista en la pantalla de la cámara y exclamar: "¡Qué pintoresco!" ¿Quién no ha sentido satisfacción al mostrar sus fotografías a los vecinos o en el Club Rotario y decir, con cierto orgullo: "Este lugar que encontramos era precioso"? Pues bien, tanto quienes visitan Cuba como los avezados viajeros de salón sabrán que ningún lugar de este planeta es más fotogénico que la mayor isla del Caribe. O más bien, si es que hay un sitio que *pueda* superar a este rincón asombroso, hasta ahora ha escapado a generaciones de fotógrafos de talento, incluido Clive Frost, el responsable de la presente colección.

Afirmo que las instantáneas de las vacaciones son uno de los placeres del viajero y, sin embargo, comparto la opinión del escritor Geoff Dyer, autor de un celebrado libro sobre fotografía ('*The Ongoing Moment*'): lo cierto es que no me molesto en tomar fotos. Conozco mi parcela y mis limitaciones. De hecho, al examinar minuciosamente imágenes fotográficas de Cuba tan buenas como las de Frost, me siento obligado a tirar la toalla, o más bien la pluma, en nombre de las palabras, rindiéndome ante la abrumadora competencia del medio visual. No es que la literatura haya fracasado al cantarle a Cuba, lejos estamos de eso. El tiempo consagrado a la lectura de '*Our Man in Havana*', el clarividente "entretenimiento" de Graham Greene, no es tiempo perdido, como tampoco lo es el dedicado a libros de novelistas cubanos —jóvenes y viejos— como Guillermo Cabrera Infante y Pedro Juan Gutiérrez. La literatura ensayística tampoco se queda atrás con '*Cuba*', la magistral historia de Hugh Thomas, como tampoco la de al menos un cronista que la modestia me impide mencionar (aunque, si insiste, estoy dispuesto a acercarme y firmarle un ejemplar). Pero sólo tienen que considerar los hitos que las artes visuales han logrado en Cuba para darse cuenta de que ningún juez justo fallaría a favor de la página escrita en detrimento de la placa fotográfica.

El término icónico ha sido empleado hasta la saciedad, pero tal vez no resulte inapropiado aplicarlo al estudio que Korda hizo del Che Guevara, un hombre que ha inspirado el culto al héroe en todo el mundo, desde revolucionarios hasta agencias de publicidad. Es tal vez el retrato más famoso que haya sido sometido a líquido para revelar. Esa boina, ese talante, esa mirada intensa que se proyecta a mil metros (¿o mil *años*?) fue captada por Korda, o Alberto Díaz Gutiérrez como sencillamente alguna vez se llamó, quien se había ganado la vida haciendo fotos de moda y farándula antes de la revolución. En marzo de 1960, mientras tomaba fotografías de Castro durante un discurso, se sintió atraído por la presencia de Guevara y capturó la imagen

que ha cubierto la mancha de humedad en millones de habitaciones de estudiantes universitarios. "El Guerrillero Heroico", lo llamó el fotógrafo. Cuando el Museo Victoria y Alberto presentó en Londres una exposición centrada en él hace unos años, se afirmó que ese retrato había sido reproducido más que cualquier otra imagen en la historia de la fotografía. "Para la cámara, los ojos del Che brillan, persuaden, seducen y cautivan". Así habló una autoridad de la talla de Henri Cartier-Bresson, al razonar sobre el modelo involuntario de Korda.

De este período sobreviven otras fotos espléndidas, tal vez menos celebradas, pero que merece la pena rebuscar en los estantes de postales de La Habana Vieja. En el contexto de algún modo ennoblecedor de la fotografía en blanco y negro, Fidel y sus hombres se ven alegres avanzando a través de la montañas de la Sierra Maestra en su camino a la victoria, o bien ocupándose de su aseo personal en el campamento, o mejor aún, ¡disfrutando de un juego de *pitch and putt* en su uniforme de faena! Otra conmovedora fotografía muestra a Castro admirando el Memorial de Lincoln en Washington, en los días anteriores a la crisis de los misiles de Cuba y al embargo económico de los Estados Unidos. En esta imagen puede leerse mucho de aquello que quedó truncado entre las dos naciones ubicadas a ambos lados del Estrecho de la Florida. Y ciertamente sería fácil, en estos días del clic y de la taquigrafía icónica de la red mundial, dejar que la sólida firma visual de Cuba (un habano, un voluptuoso coche estadounidense, un hombre con barba) sustituya una narración más compleja y matizada. Las fotografías de Clive Frost pueden hablar por sí mismas, desde luego, pero si se me permite un comentario, sería simplemente para observar que evitan los clichés de Cuba a favor del registro de momentos de la vida de la gente de a pie, de los cubanos, título de su muestra.

Esto me hizo pensar en algunos de los momentos cubanos que pude grabar en la memoria — en el archivo de la mente, no en el caché de la prístina Memoria USB. Tal vez, legítimamente, estos momentos a menudo se asocian en el ojo de la mente con documentos fotográficos de Cuba, que, como digo, pueden ser abrumadores.

El bloc de notas mental se abre al azar, en los retratos faciales de invitados famosos que adornan las paredes del hotel Nacional. Esa es la imponente fuente morisca con vistas al Malecón, la franja costera de La Habana. La publicidad que aún cubre la oscura madera del bar del hotel El Golfo, transporta al visitante al pasado, a una época en que la capital cubana era sinónimo de *glamour*, el parque de diversiones de los príncipes de Hollywood y los magnates estadounidenses: antes de que Castro llegara al poder, para la Mafia no era nada del otro mundo traer a Sinatra a la ciudad para un único espectáculo. Sin embargo, la última vez que me tomé un

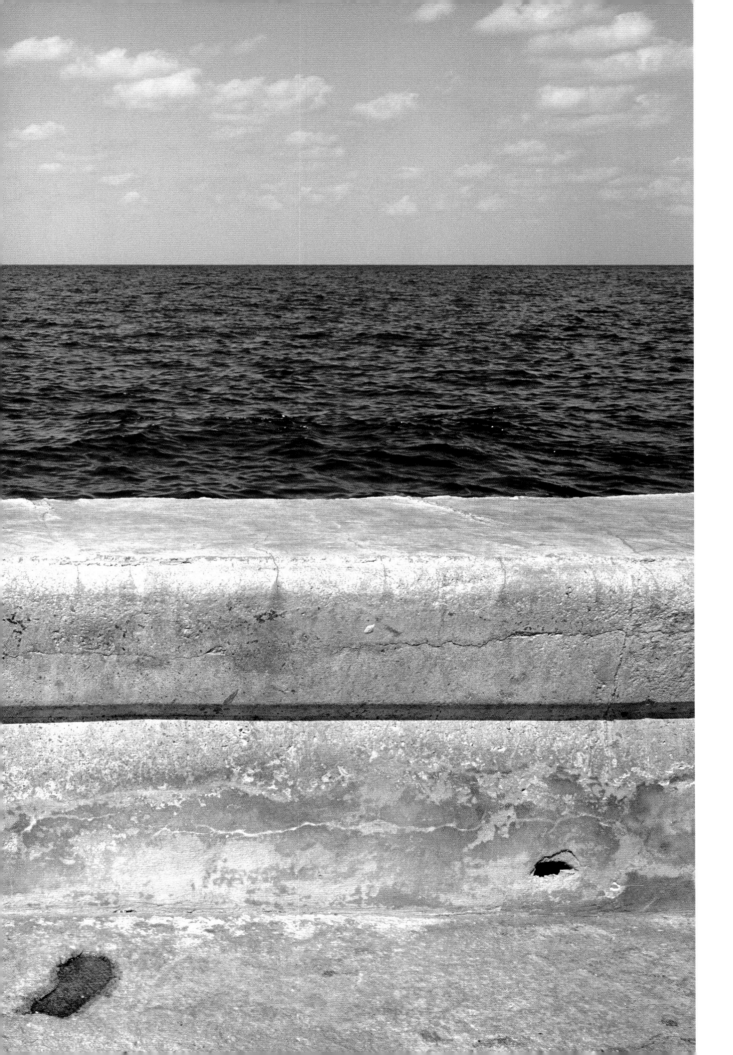

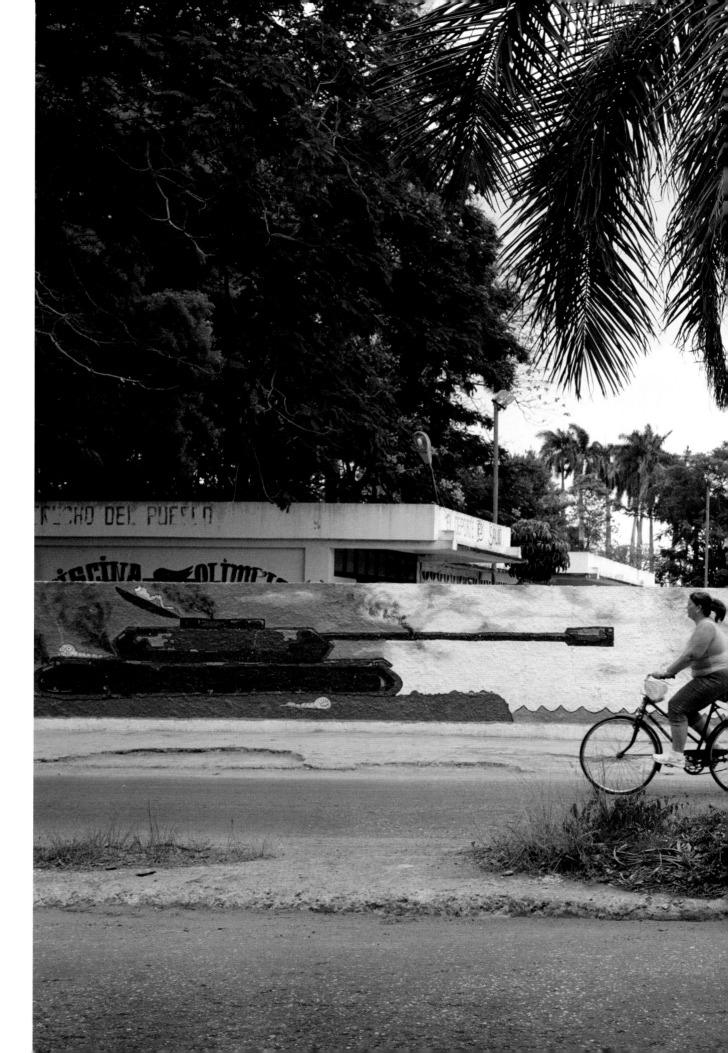

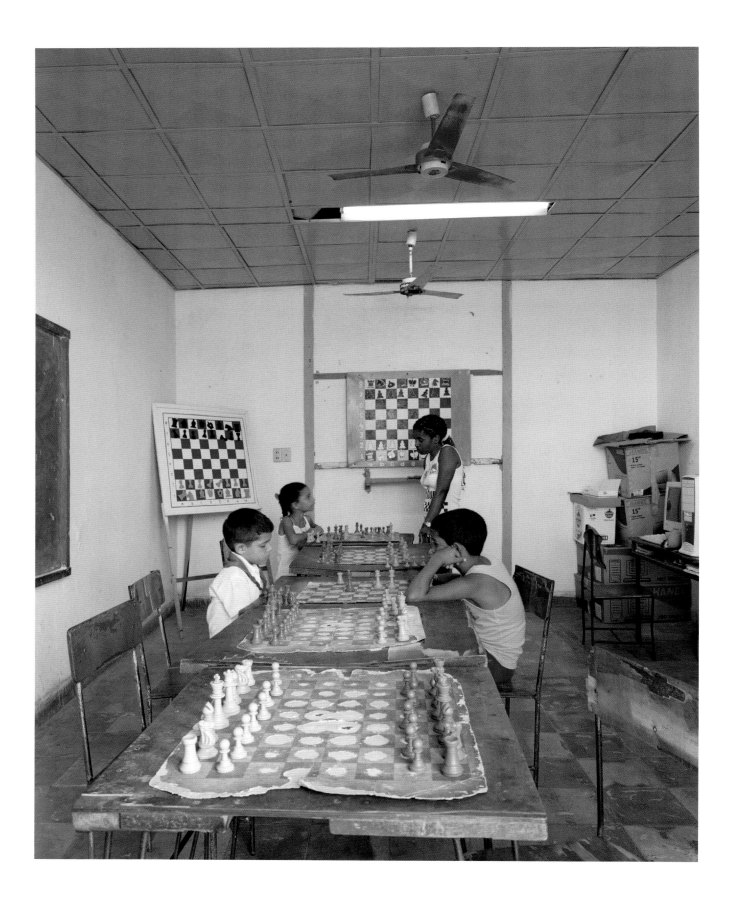

Above / Superior
Yamiraisi Boudet Gónzalez
Teacher and students, chess school
Maestra y estudiantes, Academia
de Ajédrez
Trinidad, Sancti Spiritus

Dinorah Hernández
Teacher and students, the Máximo Gómez
Baez primary school
Maestra y alumnos, Escuela Primaria
Máximo Gómez Baez
Km 17 carretera La Coloma, Pinar del Rio

University students
Estudiantes de la Universidad
Hermanos Saiz Montes de Oca, Pinar del Río

**February 2008 – 6th International Congress
of Higher Education**
Febrero 2008 - 6to Congreso Internacional
de Educación Superior
Teatro Karl Marx, Playa, Habana

Art School
Escuela de Artes Plásticas
(Martín Morua, Antonio Maceo, Tolstoy,
Abraham Lincoln, Carlos Manuel de Céspedes,
José Martí)
Marianao, Habana

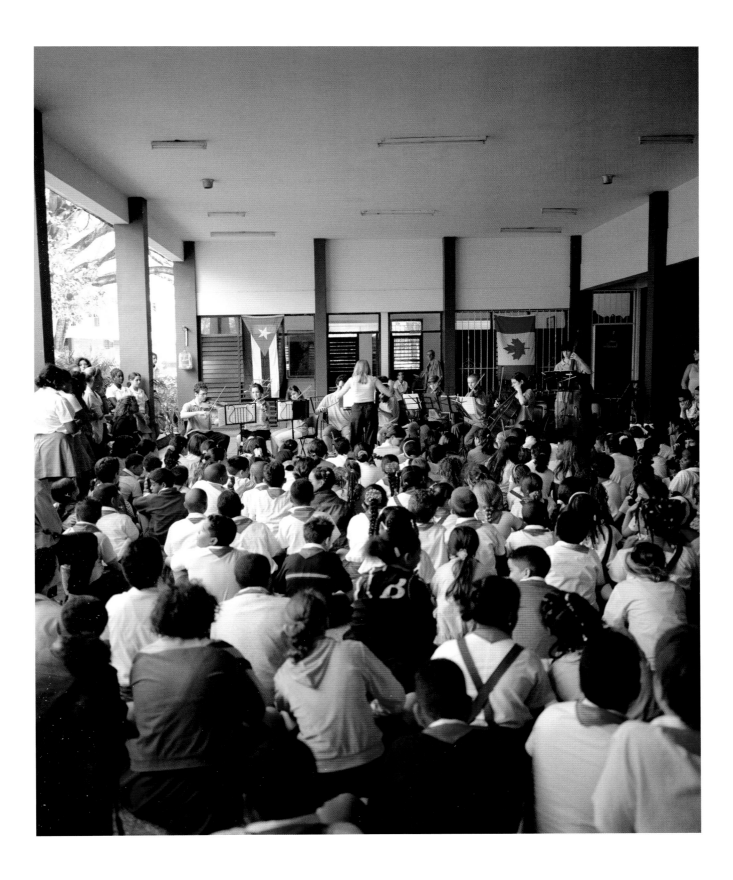

Alejandro Caturla School of Music
Escuela de Musica Alejandro Caturla
Marianao, Habana

Gustavo Izquierdo Library
Biblioteca Gustavo Izquierdo
Trinidad, Sancti Spiritus

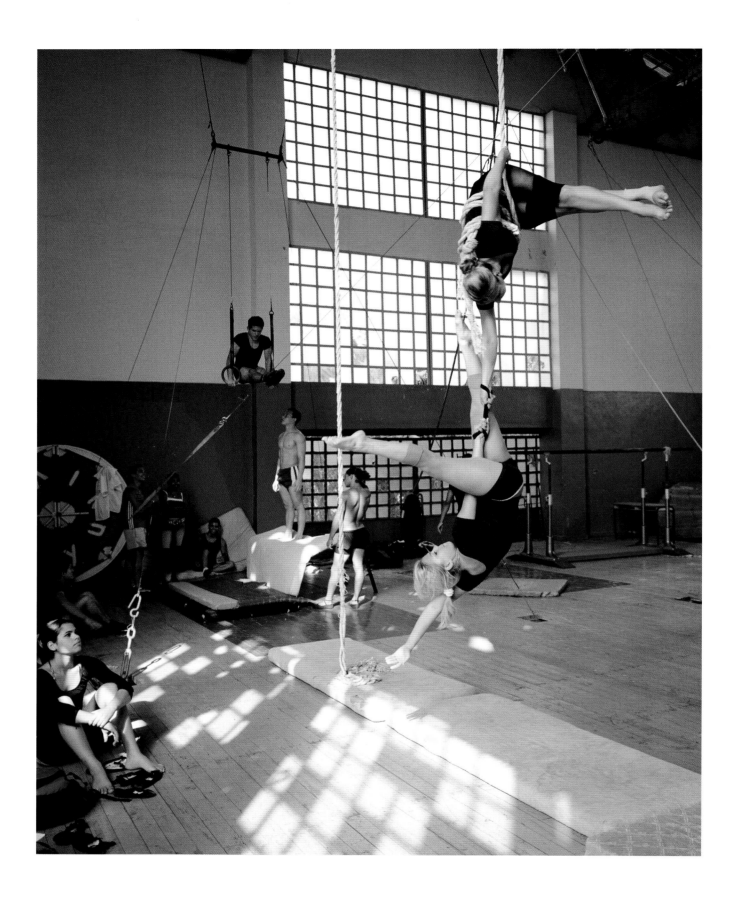

National School of Contemporary Dance
Escuela Nacional de Danza
Playa, Habana

National Ballet School
Escuela Nacional de Ballet
Habana Vieja

Dancers, Cabaret Tropicana
Bailarinas, Cabaret Tropicana
Marianao, Habana

with me are the venerated keepsakes and familiars of Fidel and the boys, such as Castro's old denim laundry bag - crudely worked with the monogram 'FC' - which was also used by his brother Raul 'when their laundry was done at Jesus Montane's house'. Another incongruous souvenir of the struggle was a 'frying pan snatched from the enemy and used at the La Plata headquarters.'

I think of favourite buildings and scenes of Cuba, as if they were the glossy leaves of a coffee table book. There's the view from the roof of the Hotel Ambos Mundos, where Hemingway wrote *'For Whom the Bell Tolls'*. You can see across the bay of Havana to the towering Christ of Casablana, in the east of the city. There's a patched-up cargo boat in the bay. The crew of this tramp steamer will be looking forward to shore leave in the stews and speakeasies of Havana, which still reveal themselves to the savvy matelot.

There is the art deco Bacardi building (b. 1930), the base of the rum dynasty which was once one of the great powers in Cuba. The distillers regularly dabbled in the island's torrid politics. In Hugh Thomas's commentary on a presidential election from the bad old days of 1952, he offers a marvellously backhanded compliment to the rum-makers' preferred candidate, one Carlos Hevia. 'Hevia was now forty-eight, an engineer,' notes Thomas, 'and, though closely connected with the Bacardi Rum Company, believed to be honest.' (Perhaps too honest: he lost to Batista, Castro's spectacularly light-fingered predecessor.) The company apparently commissioned its headquarters while drunk on power, or perhaps its own wares. There are exuberant mosaics of nymphs and goddesses, each spilling a cornucopia. The imperious Bacardi logo, a bat covering the globe with its wingspan, appears at the pinnacle of a minaret, which itself stands proud from the building. There are Moorish battlements, as on the Hotel Nacional. Tiles represent waves - the waters surrounding Cuba - while other friezes depict flowers of green and gold, an idealised version of the sugar cane from which Bacardi's riches and influence sprang. You might have thought that the dynasty would have resisted *la revolución*. On the contrary, the senior management - perhaps sensing the way the wind was blowing from the vantage of their lofty ramparts - generously offered to pay a year's taxes *in advance* to the all-conquering but cash-strapped Castro. But a man's days are like grass, as the psalms teach us, or perhaps that should be cane-husks. The Bacardi clan and the government got on the wrong side of each other; the grog-makers deserted Cuba and their own splendid offices. These are now occupied by the more prosaic concern of a travel agent's.

Overlooked by the Bacardi building, the very streets of the old capital are named, not for the important men of the distant colonial power in Madrid, nor on the basis of some utilitarian grid principle, but after spectacles which made a lasting impression on the people of the city. Damas is so called because of the pretty girls who used to disport themselves on its balconies; Refugio is the somewhat mocking name of a street where a beautiful *mulatta* gave shelter to Governor Ricafort in the 1830s; Obispo takes its name from the bishop who used to pace up and down on this thoroughfare, lost in thought or prayer. At the pizzerias on Obispo now, there is something like a hole-in-the-wall franchise for locals: stand in the street by a hatch and you may be lucky enough to be served a slice of Margherita. Also on Obispo, a wiry man may walk past with a parrot on his shoulder. You think, if they were starting Havana from scratch today, this might be dubbed Pizza Street, or the Avenue of the Parrots.

I recall the last day I spent in Havana with my friend Julietta, rattling around in her new car, which needless to say was very old, an antique Ford. She said, 'I don't know how you British ever fitted into these cars, they're so tiny.' It was decrepit, and the passenger door could only be closed very gingerly, or else it might fall off. We had lunch in Chinatown, at the excellent Chan Li Po on Campanario: lobster chop suey for two cost the equivalent of £2. The waitresses all wore tight black tops and leggings, with their name tags sewn onto their behinds. Our waitress was Yanit, a particularly curvy *cubana*. 'I wish I had a *culo* like hers,' sighed Julietta scandalously. The restaurant was full, with a line down the street by the time we left, and almost all of the patrons were Cuban.

In the vast, air-conditioned lobby of the Habana Libre, we bought boxes of chocolates from the hard-currency *tienda*. The top floors of the hotel were commandeered by Fidel and Che in the days after 'the revolution triumphed', and pressed into service as the ministerial offices of the new government. In the home of the superannuated American roadster, it was a huge radiator grille of a place, fittingly enough. The sweets were a gift for Hilda, my old landlady in Havana. She was still living in the same apartment building, at 25 y O, but she'd moved to the fresher climes of a higher floor. Her view still took in the statue of the Carmen virgin, rising from the wonderful Spanish church of the *barrio*, but now Hilda could also see the distant cupola of the Capitolio. This grand edifice looks exactly like the Capitol in Washington on which it was modelled - except that it doesn't, not really, levitating as it does over the flaking stuccoed rooftops of old Havana. Hilda didn't seem to have changed at all, in the nearly 10 years since I had last seen her. She patted my hips and said with pleasure 'Gordo!' It is meant to be a compliment to say to anyone, 'How fat you are!', a few inches on the waist representing worldly success and ease, enough food to eat. She didn't have a man friend, Hilda said. 'They're more trouble than they're worth!' Instead, she had the company of a handsome budgerigar, a birthday present from a Canadian who had also lodged with her, and another pair of fancy birds. In addition there was Nico, her grown-up son, who still lived at home. He was on his way out to work. I reminded Nico of his effective if halting English - phrases like 'police-*man*' and the

daiquirí en esta máquina del tiempo de paneles impecables, encontré que estrellas más noveles se habían sumado al firmamento de visitantes, nuestra propia Naomi Campbell y Kate Moss entre ellas. Estaba allí también el trovador de cabellera larga y revuelta Robert Plant, o estaba allí en espíritu, grabado en el posavasos en el que había garabateado, por reflejo o, quién sabe si para protegerse, la dirección de su compañía gestora. Sin embargo, la vitrina que exhibía estos trofeos que por un tiempo conservaron su belleza original no podía rivalizar con el penetrante sol tropical, ni con el salitre de un Malecón castigado por las olas. Y así, los distinguidos británicos que habían permanecido bajo el techo de torreones del Nacional se habían sumado a las muchas otras glorias deslustradas de la ciudad.

Pienso en fotografías de una exposición, o más bien reliquias de un museo: el Museo de la Revolución. Lo que retengo son los venerados recuerdos de Fidel y los muchachos, como la vieja bolsa vaquera para la ropa sucia que llevaba Castro, con el monograma "FC" ásperamente inscrito, que también utilizaba su hermano Raúl "cuando les lavaban la ropa en casa de Jesús Montano". Otro recuerdo incongruente de la guerra fue una "sartén arrebatada al enemigo que se utilizaba en el cuartel general de La Plata".

Pienso en escenas y edificios favoritos de Cuba, como si fueran las hojas brillantes de un libro de mesa de café. Ahí está la vista desde la azotea del hotel Ambos Mundos, donde Hemingway escribió *'For Whom the Bell Tolls'*. Podemos ver, al otro lado de la bahía de La Habana, el imponente Cristo de Casablanca, al este de la ciudad. Hay un remendado barco de carga en la bahía. La tripulación de este buque de vapor vagabundo estará aguardando el permiso para bajar a tierra, presta a abalanzarse sobre los guisos y bares clandestinos de La Habana, que siguen seduciendo a los avispados marineros.

Ahí está el edificio *art deco* de Bacardí (1930), la base de la dinastía del ron que alguna vez fue una de las grandes fuerzas motrices de Cuba. Los destiladores tenían escarceos regulares con la tórrida política de la isla. En un comentario sobre las elecciones presidenciales de los malos viejos tiempos de 1952, Hugh Thomas nos ofrece un cumplido, maravillosamente enrevesado, del candidato preferido de los fabricantes de ron, un tal Carlos Hevia. "Hevia ya cumplió los cuarenta y ocho, un ingeniero —señala Thomas— y, aunque está estrechamente relacionado con Ron Bacardí y Compañía, se piensa que es honrado". (Tal vez demasiado honrado: perdió en contra del predecesor de Castro, Batista, de uñas espectacularmente largas). Al parecer, la empresa, ebria de poder, puso a su servicio su casa matriz, o tal vez sus propios productos. Hay exuberantes mosaicos de ninfas y diosas, cada una con un cuerno de la abundancia derramándose. El imperial logotipo de Bacardí, un murciélago que cubre el mundo con su

envergadura, aparece en la punta de un minarete, que a su vez se yergue orgulloso sobre el edificio. Hay almenas moriscas, como en el hotel Nacional. Hay azulejos que figuran olas —las aguas que rodean Cuba— mientras que otros frisos representan flores de color verde y oro, una versión idealizada de la caña de azúcar, de donde surgieron las riquezas y la influencia de Bacardí. Puede que usted haya pensado que la dinastía ha resistido a la revolución. Todo lo contrario, la alta gerencia —tal vez al darse cuenta de la dirección del viento desde la perspectiva de sus nobles murallas— se ofreció generosamente a pagar los impuestos de un año *por anticipado* a un Castro conquistador, aunque corto de dinero. Pero los días de un hombre son como la hierba, como nos enseñan los salmos, o tal vez deberíamos decir como corteza de caña. El clan Bacardí y el gobierno se situaron en bandos opuestos; los fabricantes de ron desertaron de Cuba y de sus espléndidas oficinas, que ahora ocupa una empresa más prosaica: una agencia de viajes.

Dominadas por el edificio Bacardí, las calles de la antigua capital llevan nombres, no de los varones importantes del remoto poder colonial de Madrid —ni basados en el principio utilitario de la cuadrícula—, sino de aspectos que dejaron una impresión duradera en la gente de la ciudad. La calle Damas se llama así por las muchachas bonitas que solían asomarse desde sus balcones; Refugio es el nombre un tanto burlón de una calle donde una bella mulata dio cobijo al Gobernador Ricafort en la década de 1830; Obispo toma su nombre del obispo que solía pasearse de arriba abajo en esta vía, perdido en sus pensamientos o en la oración. Hoy en día, en las pizzerías de Obispo hay algo así como agujeros en la pared para los locales: quédese parado en la calle cerca de una ventanilla y es posible que tenga la suerte de que le sirvan una porción de Margarita. También en Obispo, puede que un hombre enjuto pase caminando con un loro sobre el hombro. Si en estos tiempos construyeran La Habana desde cero, esta vía podría ser bautizada con el nombre de calle Pizza o avenida de los Loros.

Recuerdo el último día que pasé en La Habana con mi amiga Julietta, traqueteando en su coche nuevo, que, huelga decir, estaba muy entrado en años: un Ford clásico. Me dijo, "No entiendo cómo ustedes los británicos cabían en estas máquinas, son tan pequeñas..." Era vetusto y la puerta sólo podía cerrarse con suma cautela, o de lo contrario podía desmoronarse. Almorzamos en el Barrio Chino, en el excelente Chan Li Po de la calle Campanario. El *chop suey* de langosta para dos cuesta el equivalente a 2 libras. Todas las camareras llevaban *tops* y mallas negras y ajustadas, con etiquetas con su nombre cosidas en las nalgas. Nuestra camarera se llamaba Yanit, una curvilínea cubana. "Me gustaría tener un culo como el de ella", suspiró Julietta escandalosamente. El restaurante estaba lleno; había una fila en la calle cuando nos marchamos y casi todos los clientes eran cubanos.

Hony Gónzalez Álvarez and Rubén Díaz Daubar
Teachers, the House of Tango
Profesores, Casa de Tango
Neptuno, Centro Habana

2007 Carnival
Carnaval 2007
Santiago de Cuba

Marriage Palace
Palacio de Matrimonios
Holguin

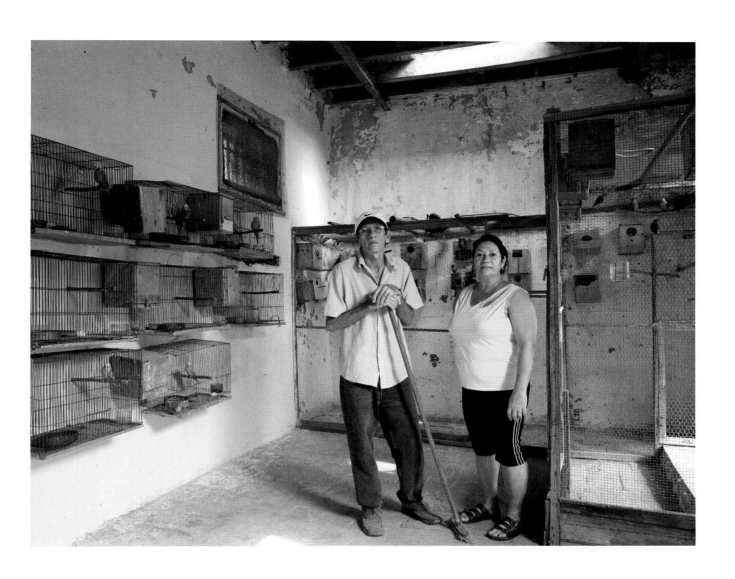

Frank Gónzalez and Maibel Sánchez
Exotic birdbreeders
Criadores de Aves Exóticas
Centro Habana

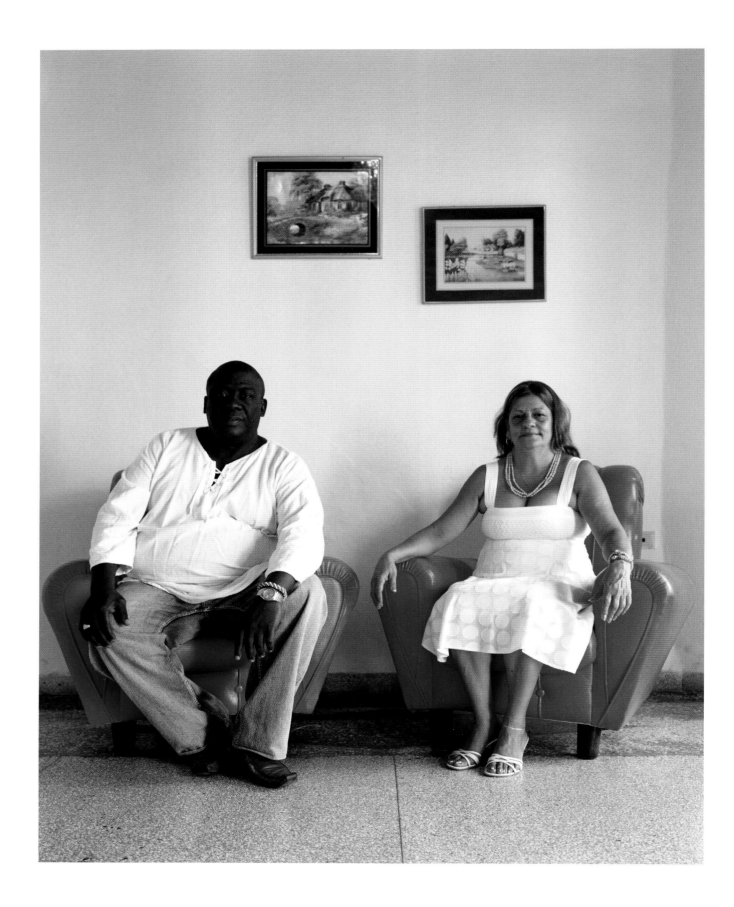

Jorge Padrón and Aidee López Alonso
Babalawo and Director of Marqués de Atares
dance company
Babalawo y Director de la Comparsa
Marqués de Atares
Cerro, Habana

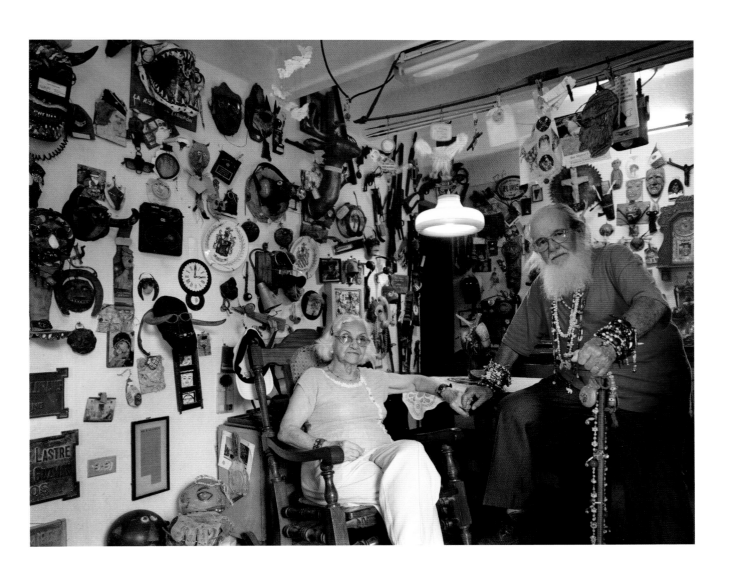

Next page / Página siguiente

María Rivero, Armando Isas and Alvenis Isas
Coffee farmers
Campesinos Cafetaleros
Puerto Rico III Frente, Santiago de Cuba

Hector Gallo and María Emilia Nuñez
Artists
Artistas
Alamar, Habana del Este

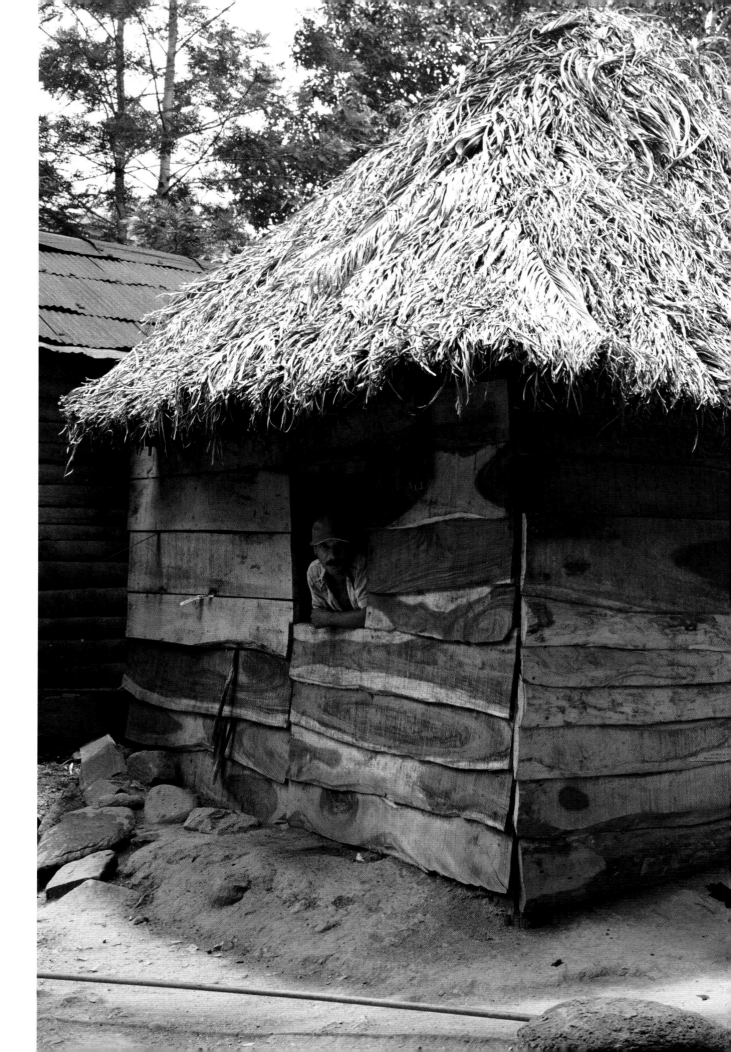

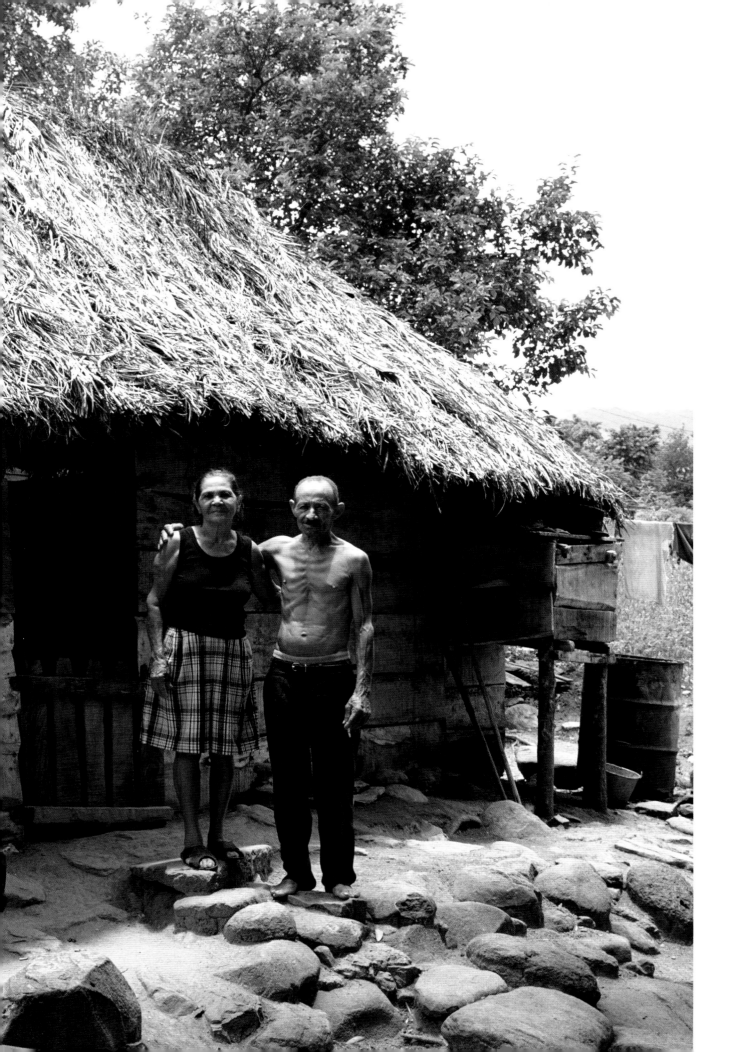

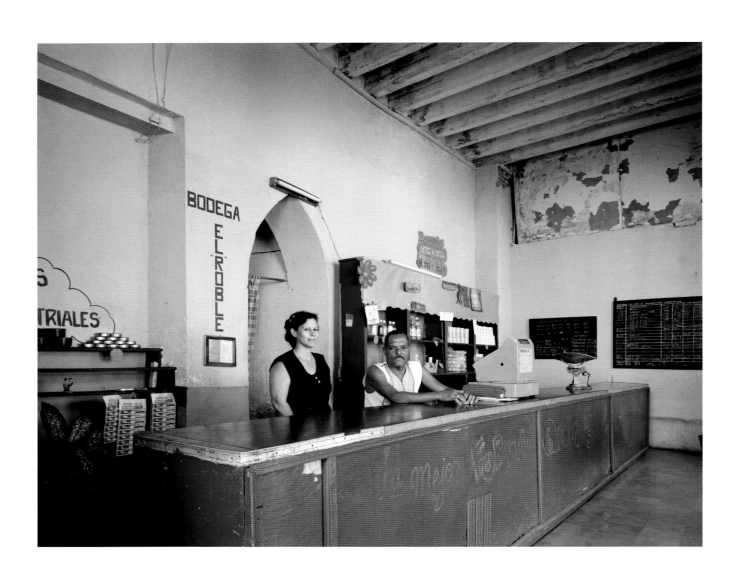

Paulino Lozano and Aida Ferrer
El Roble Ration Shop
Bodega "El Roble"
Trinidad, Sancti Spiritus

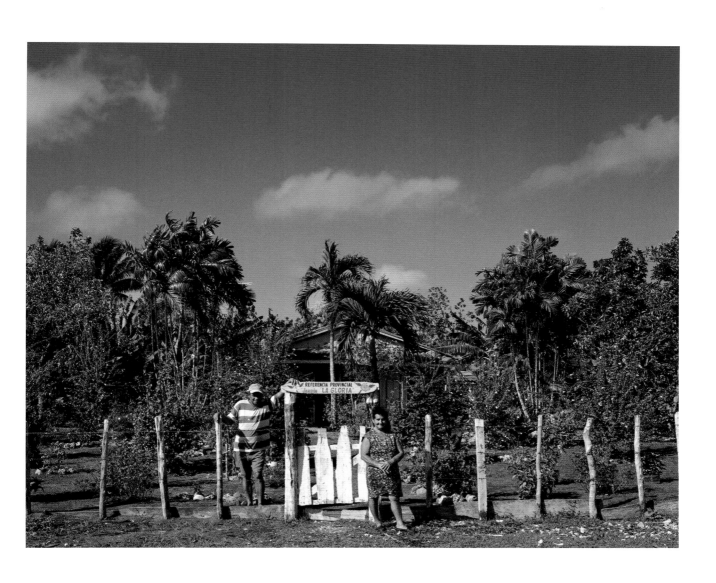

**Onelio Ortegas Morales and
Gloria Benitez Fernandez**
La Gloria special local garden
Referencia Provincial Jardin La Gloria
Cayo Ramona, Ciénaga de Zapata

useful 'very strong girl' - and of our shared jokes: 'Saddam Hussein!' (a Cuban newsreader of the 1990s had borne a striking resemblance). Nico's job was in a photographer's studio.

Julietta cut a corner as she turned off Avenida 5, the main drag from the Malecon to the upscale diplomatic quarter of Miramar. We passed the extraordinary Giacometti sculpture of the Russian embassy. New hotels were springing up here - we had filthy afternoon tea in the Melia Havana - and a shopping mall. There was a line of mothers waiting to get into a toyshop, and a place where Julietta bought a phonecard. Her marital home, in Playa, was a conversion-job. It had been excavated out of one side of the house which was occupied by Julietta's dear mother-in-law ('the wicked witch', she called her). Like many Cuban homes, it had a provisional, make-do quality - and was the more impressive for that. Julietta and her family have since embarked on a new life in Montreal.

When another memory of Cuba unspools in my imagination, it is spliced with footage of a celebrated film. One hot day when I had walked the length of the Malecon, the tang of the salt was still on my lips, and I was looking for refreshment in Old Havana. I was spoilt for choice. I could sit in front of the new Telegrapho Hotel, its sympathetically-restored exterior shielding all mod cons within. (The air-conditioned atrium boasted the exposed brick of the original building, a telegraph office.) I'd never noticed this property in the days when I put up at the adjacent Inglaterra, which was also offering a pavement dining experience.

Despite the lure of these attractions, I was tempted by the Hotel Parque Central, another new billet, on the far side of Prado. What caught my eye about it was its roof garden, or what I took to be a roof garden - a group of miniature figures could be glimpsed at tables and chairs beneath the boughs of an arbor. An arcadian abandon also reigned in the hotel lobby: from amidst dense and luxuriant foliage came the sound of running water. It might have been a distant falls, though it was in fact the plashing of an ornamental fountain. The soundtrack was completed, not by the susurrus of crickets, as you had every reason to expect, but by the pinging of text messages. The banal sonic backdrop to our workaday lives, this struck me - in Cuba a few years ago - with the force of a clarion call. It sounded the last trump for Castro's *revolución*, as surely as the roar of his tanks in the streets of Havana in 1959 had been the death knell for the old order of croupiers and call girls. This was a city from which it had been almost impossible, only a short time ago, to place a *phone call*, using one of those quaintly obsolete devices attached to the wall by a length of cable. The latest revolution to overtake Cuba was the digital one. If the communist bastion was now on-line, for how much longer would it stay on-message? (American telecommunications companies were given the go-ahead to upgrade fiber-optic and satellite links with the island under reforms introduced by President

Obama in 2009.) It was hoped that the much-vaunted achievements of the Castro regime, in health and education, for example, would outlive the ailing former president himself. But it struck me that he was being sung to the political hereafter, not by choirs of angels, but a chorus of cell phones.

Pausing in the lobby of the Parque Central just long enough to recover from my culture shock - one could be anywhere! One could even be, I realised, in Cuba - I rode the elevator to the top floor. I asked the American sharing the lift with me if *piso ocho* was right for the roof garden. 'The pool, do you mean?' he said. Encountering the rooftop in person, I found that it wasn't a sylvan nook at all, but an outdoor pool, just as the hotel guest had told me. The shimmering waters were thickly set around with pale bodies. This was another shock, of a perhaps more visceral kind. You get so used to seeing the black and brown bodies of Cubans in states of near undress that to come across a tightly-packed group of white people in the same condition was vaguely troubling. It was like stumbling on some sybaritic rite: wife-swapping, perhaps. It was the fact that it was going on in this eyrie of privilege - at the height of luxury, you might say - that gave it a quality of shame, somehow.

This scene recalled striking sequences from the film '*Soy Cuba*' (I am Cuba). A 1964 co-production between Soviet and Cuban cinematographers, it was directed by Mikhail Kalatozov and told four separate stories about the lot of the Cuban people almost half a century ago. The first narrative cut from the impoverished *cubanos* to the lotus-eating *yanquis*. One long scene, consisting of a single point-of-view shot, follows the camera at the open-air pool of a Havana hotel in the fifties. It descends the steps of the diving board, pans across acres of oiled foreign flesh to the very edge of the pool - and jumps in! The viewer finds himself all at once among the flailing limbs and garish bathing suits of the pleasure seeking vacationers. This would be film-making of a rare facility and brio, even with the sophisticated techniques at the disposal of today's studios. For a long time, I was baffled that the auteurs of the sixties - auteurs from the Soviet bloc, at that - had pulled off this cinematic coup. What unimaginable crane had swung the lens through those planes and distances? Why had the scene not come to glugging grief when the camera took a bath? I might have known that Cuban ingenuity had played its winning part. It turns out that there was no crane: the camera was simply passed from hand to hand, like a fire bucket, along a human chain of technicians. As for the climax of the shot, the unit had the brainwave of coating a watertight lens with a cleaner more generally used on the periscopes of submarines, which meant that the camera could be submerged, and raised from water, without droplets on the lens.

But this is the real gift of the *cubanos*, of course, a knack of making-do. Nothing sums this up more vividly for me

En el inmenso vestíbulo con aire acondicionado del Habana Libre, compramos unas cajas de chocolates en la tienda, en la que sólo se paga con moneda contante y sonante. Las plantas superiores del hotel estuvieron bajo el mando de Fidel y el Che en los días posteriores al "triunfo de la revolución", y fueron puestas al servicio de los gabinetes ministeriales del nuevo gobierno. En lugar del anticuado coche gringo sin capota, había una enorme rejilla de radiador, como corresponde. Los bombones eran un regalo para Hilda, mi ex casera en La Habana. Sigue viviendo en el mismo edificio de apartamentos, en las calles 25 y O, pero se había mudado a los aires más frescos de un piso superior. Su vista todavía abarcaba la estatua de la virgen del Carmen, destacándose encima de la maravillosa iglesia española del barrio, pero ahora Hilda también podía ver la lejana cúpula del Capitolio. Este gran edificio tiene exactamente el mismo aspecto que el Capitolio en Washington, su modelo, si no fuera porque en realidad levita sobre los descascarillados tejados de estuco de La Habana Vieja. Hilda no parecía haber cambiado en absoluto después de los casi 10 años desde que la vi por última vez. Acarició mis caderas y dijo con placer "¡Gordo!" Se supone que cuando alguien te dice "¡Estás muy gordo!", se debe considerar un cumplido, ya que unos cuantos centímetros de más en la cintura representan éxito material y vida desahogada, comida suficiente para comer. No tenía compañero. "¡Te dan más problemas que lo que valen!", dijo. En su lugar, disfrutaba de la compañía de un gracioso periquito, un regalo de cumpleaños de un canadiense que también se había hospedado con ella, y otro par de aves de fantasía. Además estaba Nico, su hijo mayor de edad, que aún vivía en la casa. Estaba a punto de marcharse a trabajar. Le recordé a Nico su inglés, eficaz aunque vacilante — frases como *"police-man"* y la útil *"very strong girl"*—, y los chistes que compartíamos: "Saddam Hussein" (un locutor de noticiero cubano de los noventa sorprendentemente parecido al iraní). Nico trabajaba en el estudio de un fotógrafo.

Julietta dio la vuelta a la esquina al abandonar la Avenida 5, la vía principal que va desde el Malecón hasta el elegante barrio diplomático de Miramar. Pasamos por la extraordinaria escultura de Giacometti de la embajada rusa. Aquí estaban surgiendo nuevos hoteles —tomamos un té vespertino, que me supo repugnante, en el Meliá Habana— además de un centro comercial. Había una fila de madres esperando entrar en una tienda de juguetes, y un lugar donde Julietta compró una tarjeta telefónica. Su domicilio conyugal, en Playa, era toda una obra de transformación. Había sido como excavado en un lado de la casa que ocupaba la querida suegra de Julietta ("la malvada bruja", le llamaba). Al igual que muchas casas cubanas, tenía un aspecto provisional, de "me las apañé como pude", impresionante. Poco después, Julietta y su familia iniciaron una nueva vida en Montreal.

Cuando otro recuerdo de Cuba se proyecta en mi imaginación, se empalma con escenas de una respetada película. Un día caluroso, en que había caminado a lo largo del Malecón, aún tenía el fuerte sabor de la sal impregnado en los labios y buscaba un refrigerio en La Habana Vieja. Tenía dónde elegir. Podía sentarme delante del nuevo hotel Telégrafo, en su exterior simpáticamente restaurado con todas las comodidades modernas. (El atrio climatizado hacía gala de los ladrillos del edificio original, una oficina de telégrafos). Nunca había reparado en este inmueble en los días en que me hospedaba en el vecino hotel Inglaterra, que también ofrecía la experiencia de comer en la acera.

A pesar del poder de atracción de esos lugares de interés turístico, me vi tentado por el hotel Parque Central, un nuevo hospedaje, por el lado más alejado del Prado. Lo que me llamó la atención de él fue su jardín en la azotea, o lo que me pareció tal —podía verse a un grupo de figuras en miniatura, a las mesas y en las sillas, debajo de los travesaños de una pérgola. Un abandono arcadiano reinaba también en el vestíbulo del hotel: desde el fondo de un follaje exuberante y denso llegaba un sonido de agua en movimiento. Podría haber sido una distante cascada, aunque se trataba en realidad del chorro de una fuente ornamental. Para completarlo todo, en la banda sonora estaba presente, no el chirriar de los grillos —como, por muchas razones, podía esperarse—, sino el golpeteo y los zumbidos de los mensajes de texto. El banal telón de fondo sonoro de nuestras prosaicas vidas; esto me conmocionó —allí, en Cuba, hace algunos años— con la fuerza de un toque de rebato. Sonaba la última trompeta de la revolución de Castro, con tanta seguridad como la sentencia de muerte que representó el rugido de sus tanques en las calles de La Habana en 1959 para el viejo orden de *croupiers* y *call-girls*. Esta era una ciudad desde la que hacía apenas unos años era casi imposible hacer una llamada telefónica mediante uno de esos dispositivos pintorescamente anticuados conectados a la pared con ayuda de un trozo de alambre. La última revolución que se ha apoderado de Cuba es la digital. Si el bastión comunista ahora estaba conectado a Internet, ¿por cuánto tiempo más podría seguir conectado su mensaje? (A raíz de determinadas reformas promulgadas por el presidente Obama en 2009, se les ha dado el visto bueno a empresas de telecomunicaciones de los Estados Unidos para que actualicen las líneas de fibra óptica y los enlaces por satélite con la isla). Se espera que los tan cacareados logros del régimen de Castro, en salud y educación por ejemplo, sobrevivan al propio ex presidente enfermo. Pero me asombró que en su viaje al más allá político lo acompañara no un coro de ángeles, sino un coro de teléfonos móviles.

Haciendo una pausa en el vestíbulo del Parque Central, justo el tiempo suficiente para recuperarme de

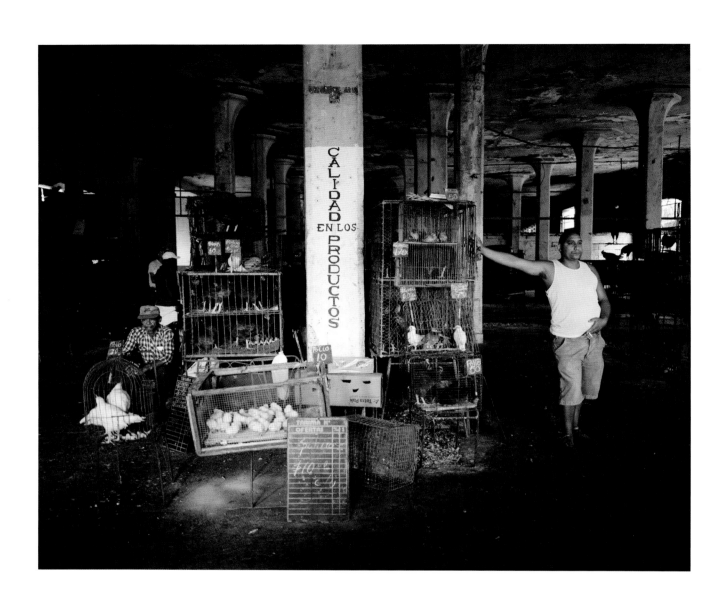

**Area for selling domestic birds,
The Cuatro Caminos Market**
Área de venta de Aves Domésticas,
Mercado Cuatro Caminos
Cerro, Habana

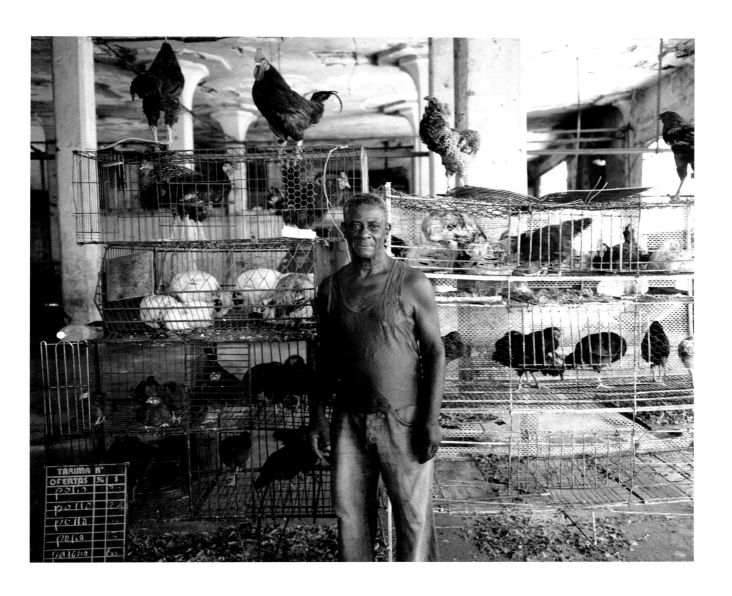

Ernesto Balado
Domestic birds seller, The Cuatro
Caminos Market
Vendedor de Aves Domésticas,
Mercado Cuatro Caminos
Cerro, Habana

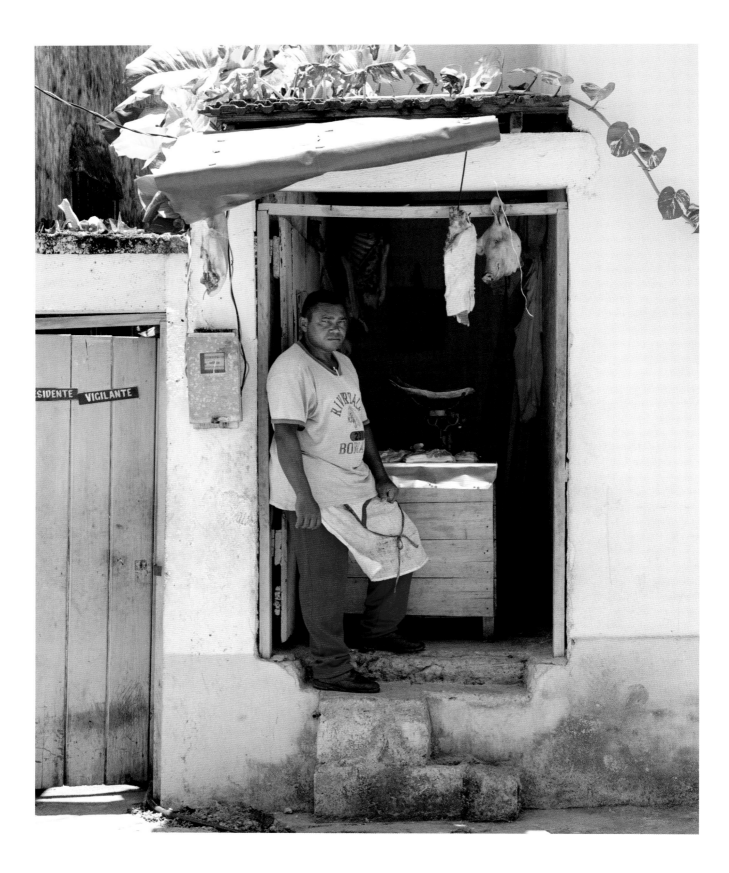

Alcides Muguncia
Butcher
Carnicero
Baracoa, Guantánamo

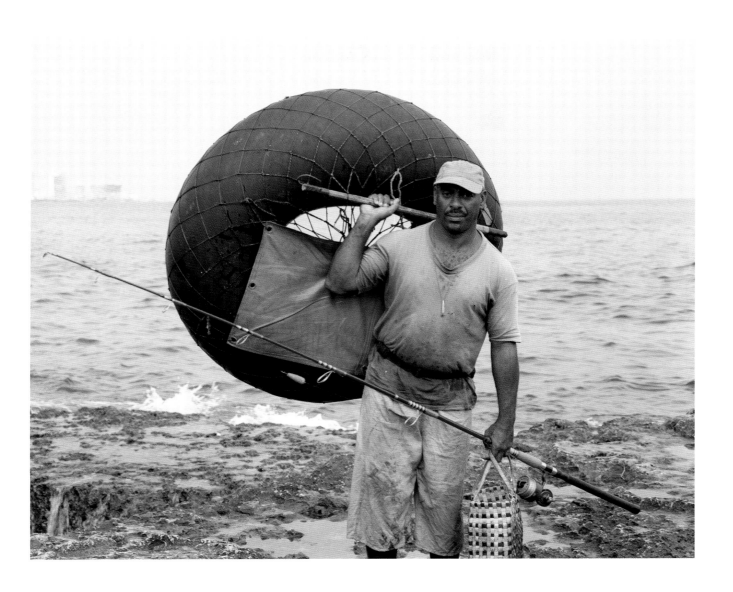

José Luis Leal
Fisherman
Pescador
El Malecón, Habana

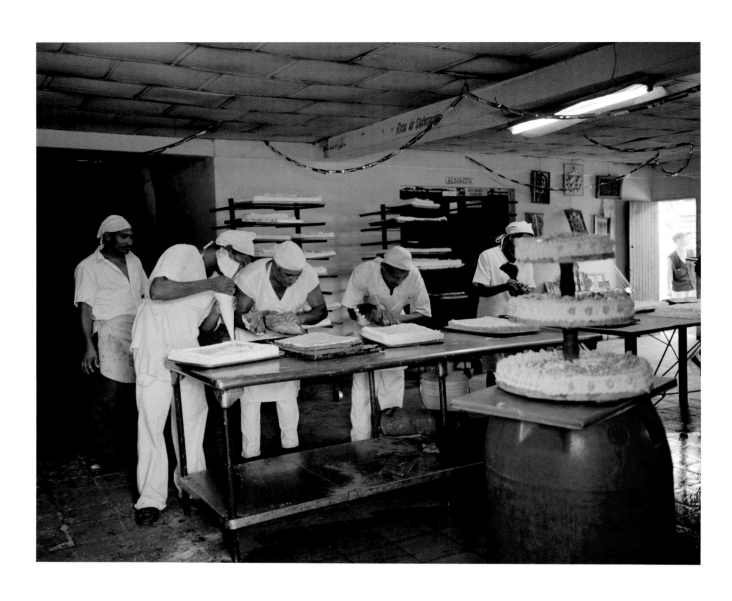

La Antonia Bakery
Dulceria La Antonia
Bartolomé Maso, Granma

Coppelia
Vedado, Habana

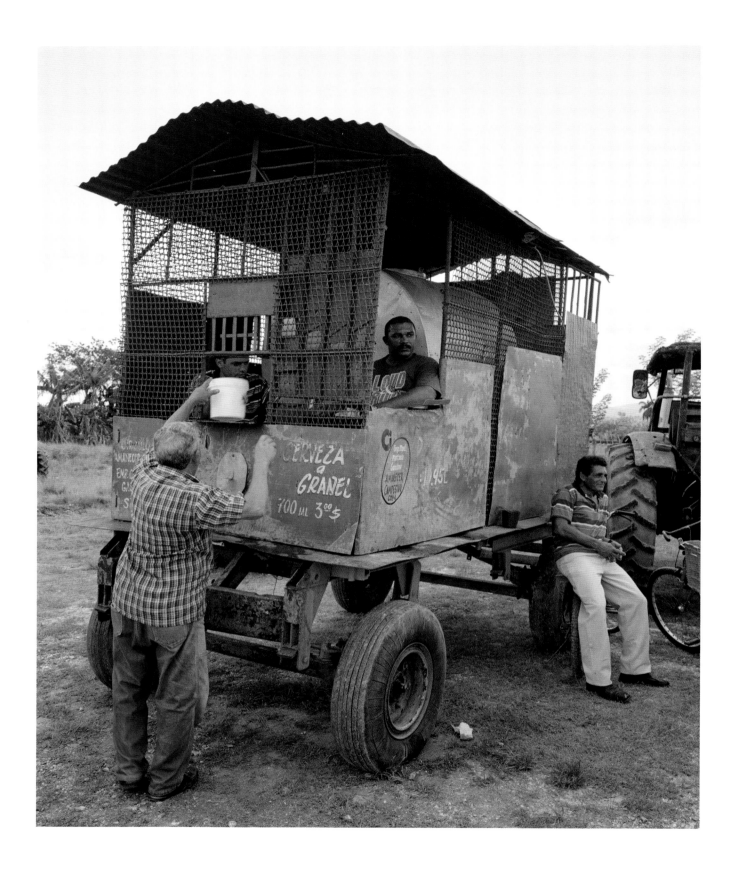

Farmers Party
Fiesta del Campesino
Santa Clara, Villa Clara

Cake shop
Casa del Dulce
Trinidad, Sancti Spiritus

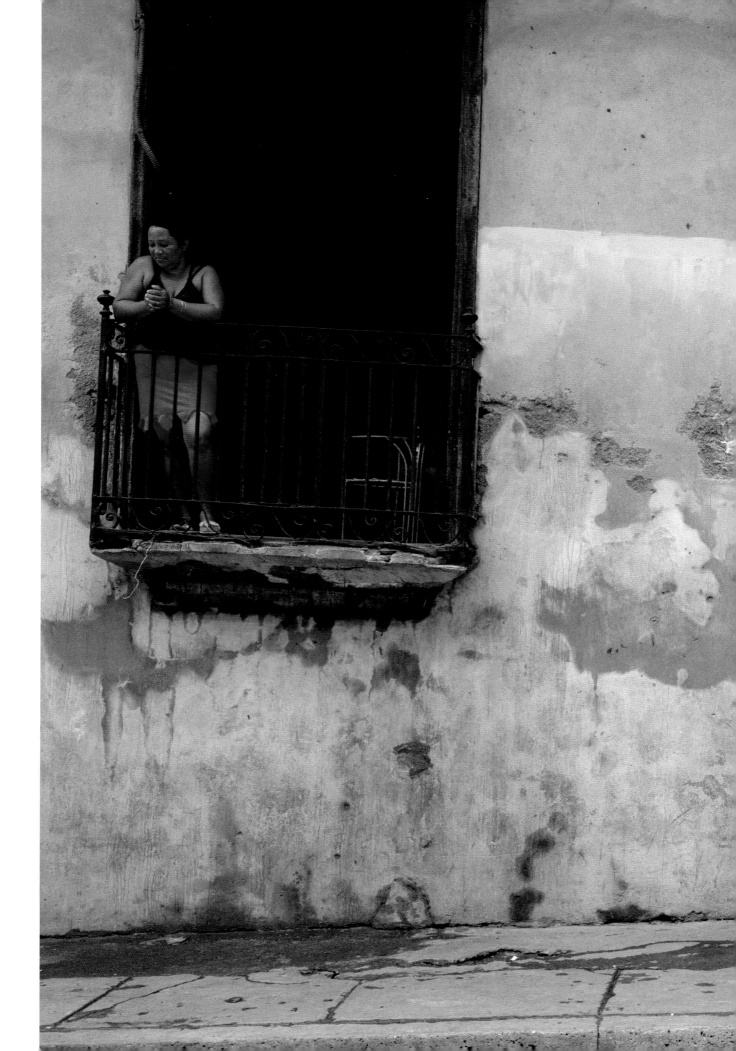

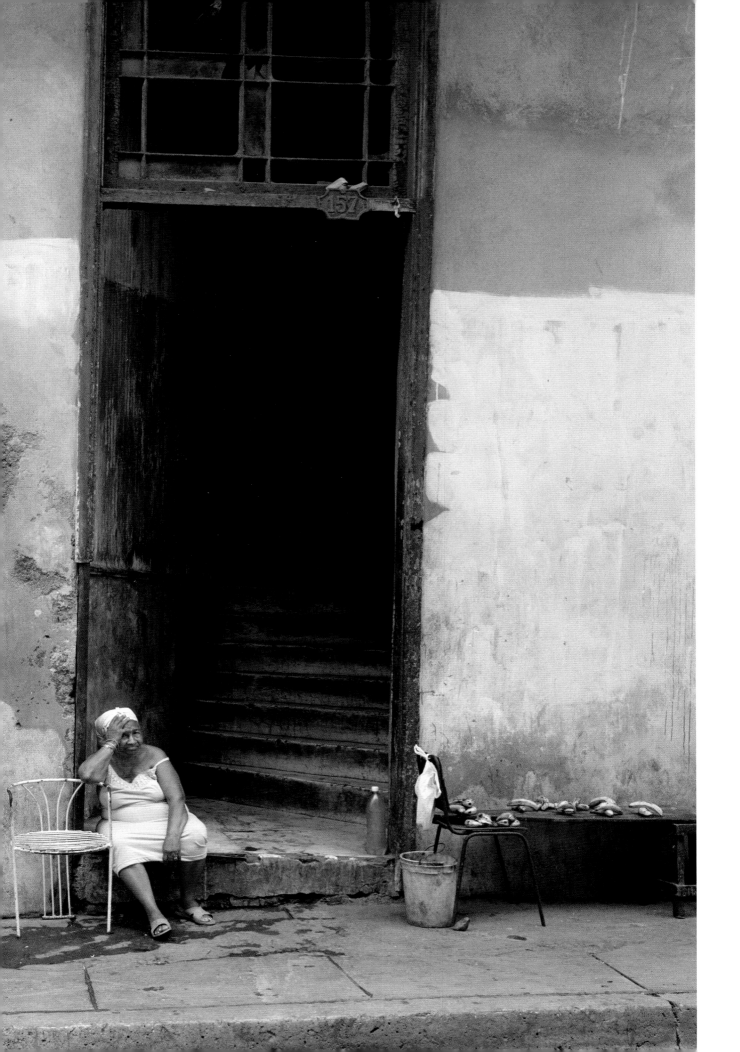

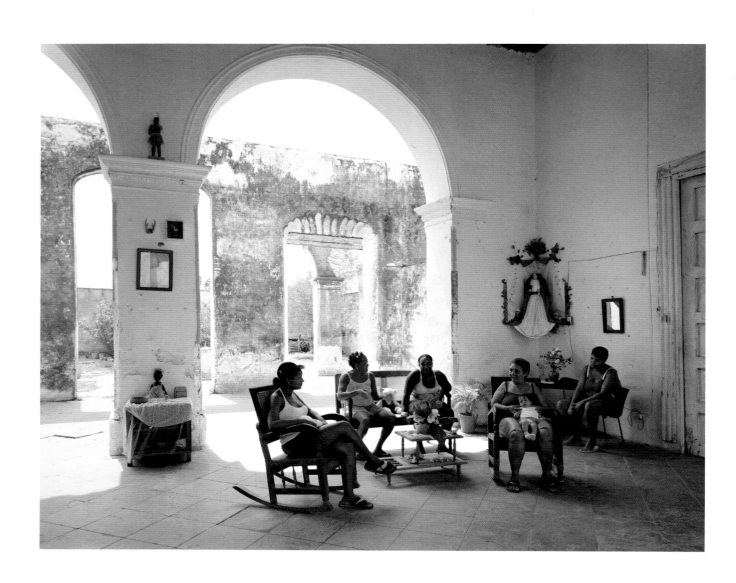

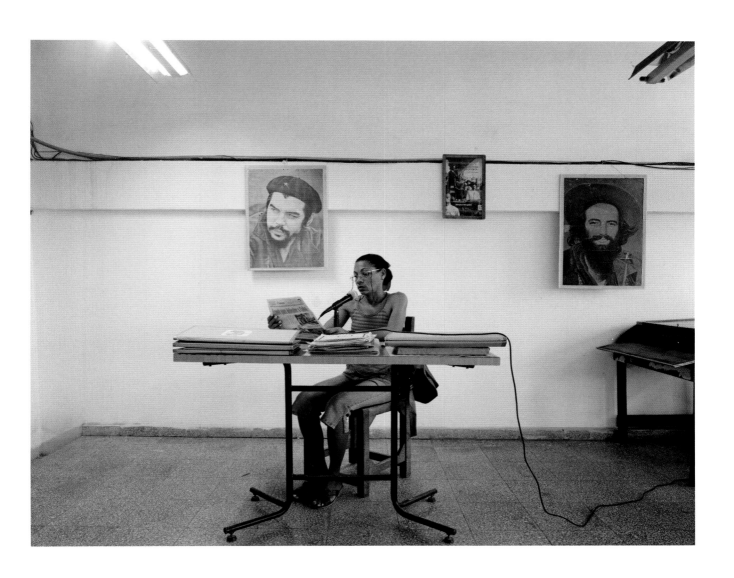

Gladis Santiesteban Pozo
Reader to tobacco workers,
Paulina Rubio Factory
Lectora de tabaquería,
Fábrica Paulina Rubio
Consolación del Sur, Pinar del Río

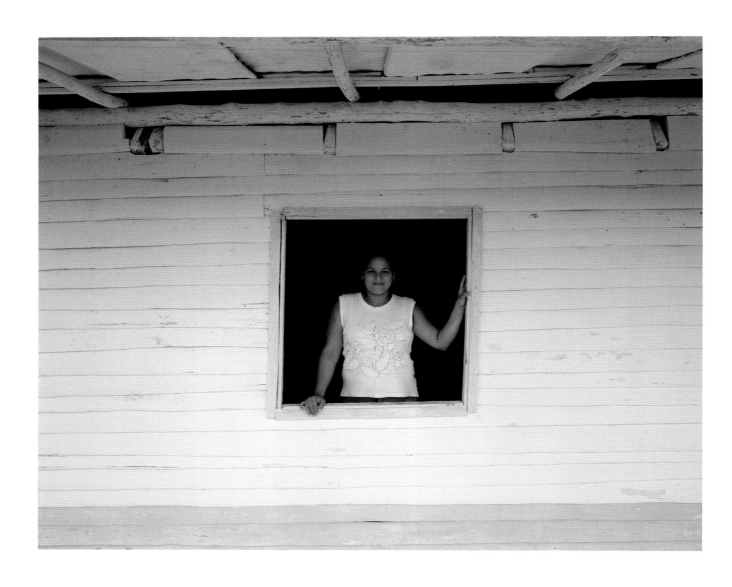

Mildrey Manzo
Caibarien, Carretera Yaguajay,
Villa Clara

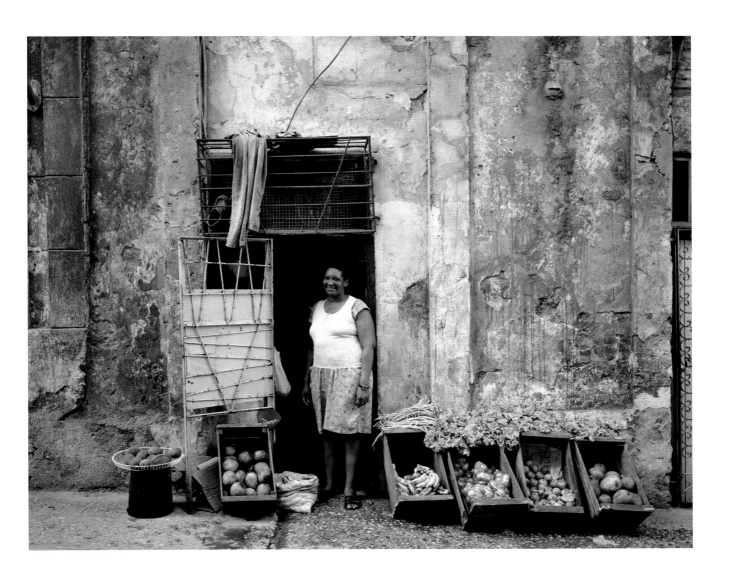

Josefina Rendón Díaz
Centro Habana

Chabely Elias Robaina
15th birthday party
Fiesta de Quince Años
Vedado, Habana

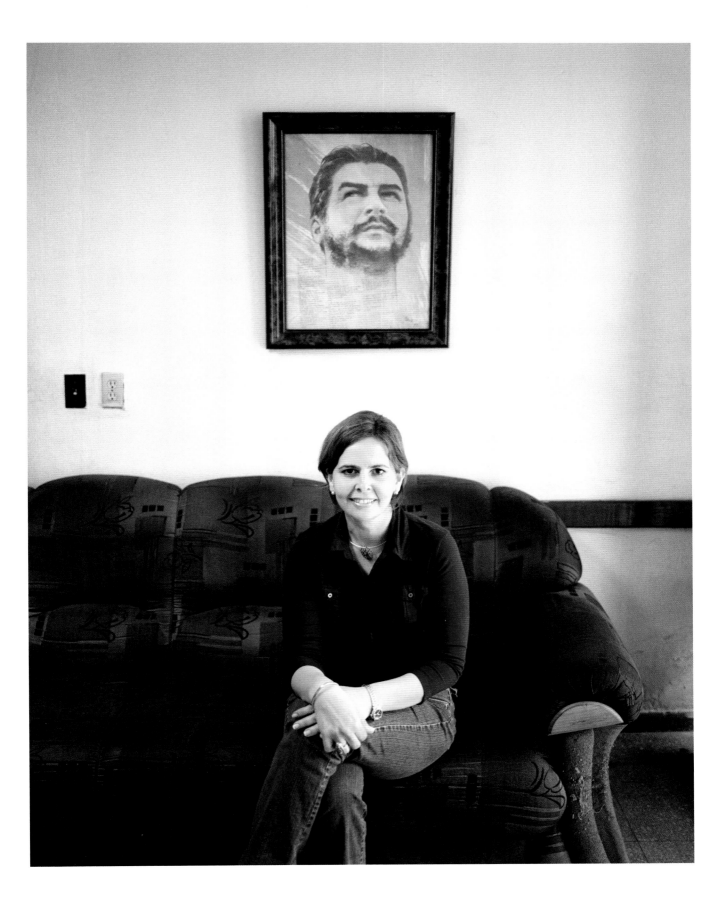

María Elena Tellez Piña
Community delegate, meeting of the No.10 CDR
(Committee for the Defence of the Revolution)
Delagada de Circunscripción Nro. 5, Asamblea de
Rendición de Cuentas, Comité para la Defensa de
la Revolución Nro.10
Vedado, Habana

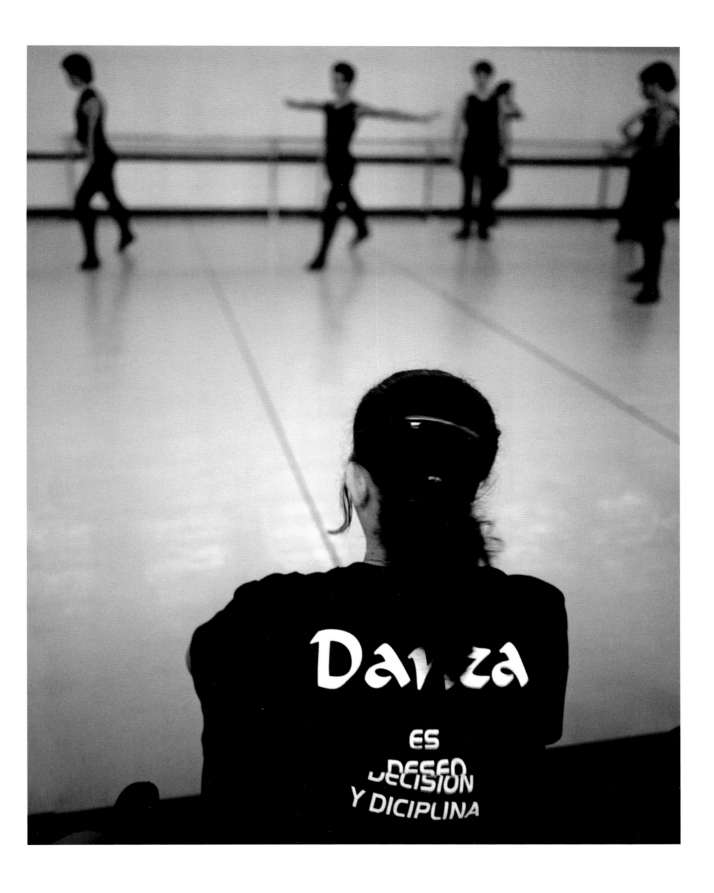

Ramona de Saa
Director, National Ballet School
Directora, Escuela Nacional de Ballet
Habana Vieja

than the perhaps unlikely image of a young man's fists slamming into a swinging car tyre. He was a boxer, a contender, and the dangling retread his sparring partner. One of the ways in which Castro wished to advertise the triumph of the revolution to the wider world was in the arena of sport. Cubans were banned from professional competition in 1962, with all efforts henceforth dedicated to the glory of the motherland. But while the state was prepared to lavish money on athletes who represented Cuba in international competition, in economic hard times such as the country has endured for two decades, the national trait of resourcefulness has come into its own.

'That's for practising punching, it's as good as a punchbag,' remarked Carlos Miranda, following my gaze to the hapless outer tube which was on the receiving end of punishment at the hands of one of his young charges. A short and sinewy ex-fighter himself, Miranda has trained at least two generations of talent at Havana's world famous boxing academy. But anything less like a crucible of champions would be hard to imagine than the makeshift ring that Miranda supervised in a concrete yard between Cuba and Parallel Streets.

The faded canvas was cordoned off by sagging ropes and overlooked by rusting iron bleachers. The ancient boxing gloves looked like Iberian hams. The tyro pugilists, some as young as five, ran to grab them when their coach said so: there weren't enough to go round. And yet, pound for pound, the graduates of this school of hard knocks had carried off more medals and belts than any other boxing school in the world. No wonder that when a sportswear multinational wanted to shoot a video starring those all-conquering Cubans Teofilo Stevenson and Felix Savon, each man a three-time Olympic heavyweight champion, the director and crew chose the unprepossessing intersection of Cuba and Parallel. Today's hopefuls included a nine-year-old kid in a worn blue shirt. Armando Martinez Jr. had the makings of a true fighter, according to Miranda. 'He's definitely got potential.' The boy was the son of a world champion; the brother of another. His father was Armando Marinez, champion in the 71 kilos division at the 1980 Olympics and also world champion; his sibling was Johanson Martinez, world champion at 81 kilos. Son followed father to distinction under Miranda's tutelage, as if each man was a King's Scholar at Eton rather than an alumnus of Havana's mean streets.

'Don't fool around,' barked the coach. 'Run! That's what I want!' His pupils began jogging around the outside of the ring, dodging the guy ropes that held it up. They ran for the same length of time as an amateur bout: four rounds of 2 minutes each. It was warm work for them, in the squint-making Cuban noon. But they knew better than to complain. Miranda was a hard task-master. No sooner was the run over than he ordered a testing session of calisthenics. 'I said "Abs!" So start! I don't want to see anybody freshening up.'

To me, the coach said *sotto voce* 'I must admit, I do talk to them very roughly.'

Miranda had been putting fighters through their paces for almost forty years. He had been in the corner for the mighty Savon. His charges had also included the World champion Freddy Soto. Another useful prospect was Luis Franco, in his early twenties, who had Olympic experience. Miranda had been training him since he was nine. As we talked, I tried to get under Miranda's guard, with a few exploratory jabs at the expense of the noble art, but the wily scrapper was too good for me.

'Dangerous? No, this is nothing like that. Boxing is one of the least dangerous sports in my opinion. *Tiempo!* the coach broke off to signal the end of stretching exercises. 'When the children first come here, what they do is play: there's no danger to their heads whatsoever,' he continued. 'They start to get more confidence. Yes, it could become violent if the coaches encouraged violence, but here what we're about is training.' As if to prove his enlightened point, the children came over to Miranda from time to time for a hug; his bark was evidently worse than his bite.

'I'm amazed that you produce champions here,' I told him.

'Yes, but it happens.'

'Why does Cuba turn out so many great boxers?'

'Because of the education system. The more people study and get prepared, the more they understand boxing. It's not all about violence and aggression. It's also about using tactics, techniques, intelligence. You know, aggression is greatly over-rated, in my view. In my opinion, the better as a person a boxer is, the better he is as an athlete.'

From the wall where the old tyres hung came the squeaking of sneakers on concrete, and the moaning of hawsers which hadn't seen oil in some time. The t-shirts of the boxers were sweat-soaked, their brows beaded. In some countries, a haymaking hook might be enough to lift you out of poverty. But for these young men, physical perfection, and perhaps a title or two, would have to be their own reward.

Miranda said, 'I have coached *professional* boxers, outside Cuba, and there are many good things in the professional game. But the greatest reward I have is when I see one of my boxers becoming a world champion.'

I said, 'Does a poor man make a better boxer than a rich one?'

'No. I believe necessity is what counts,' said Miranda. 'I'm not just talking about an economic need. Sometimes it's the need for recognition. A boxer might

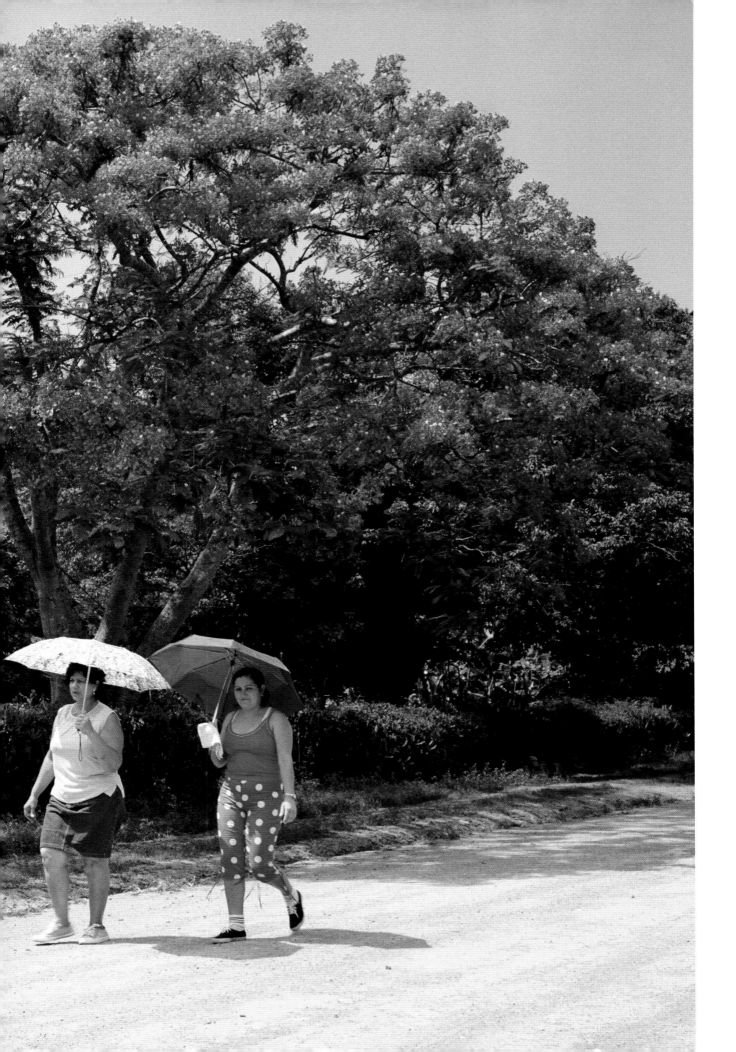

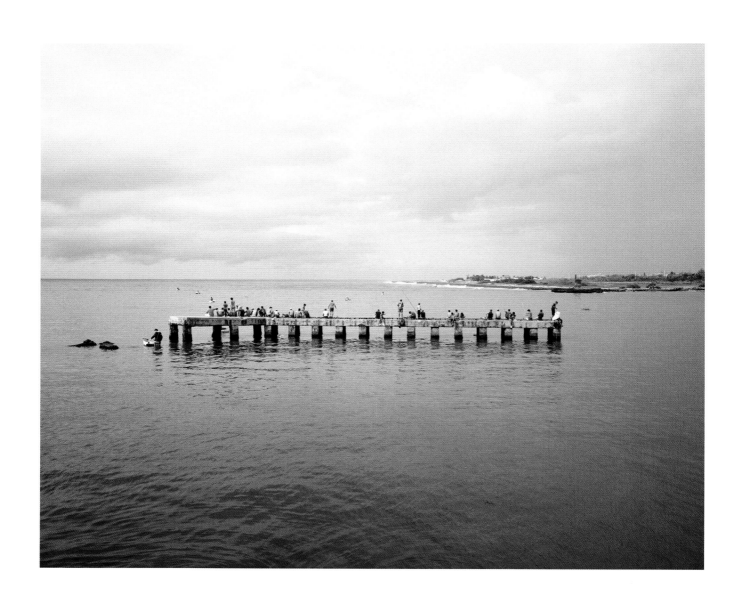

Previous page / Página anterior
Odalis Carmenate and Marisol Marrero
Flamboyan Tree
Árbol de Flamboyán
Buena Aventura, Holguín.

Above / Superior
Cojimar Beach
Playa de Cojimar
Habana del Este

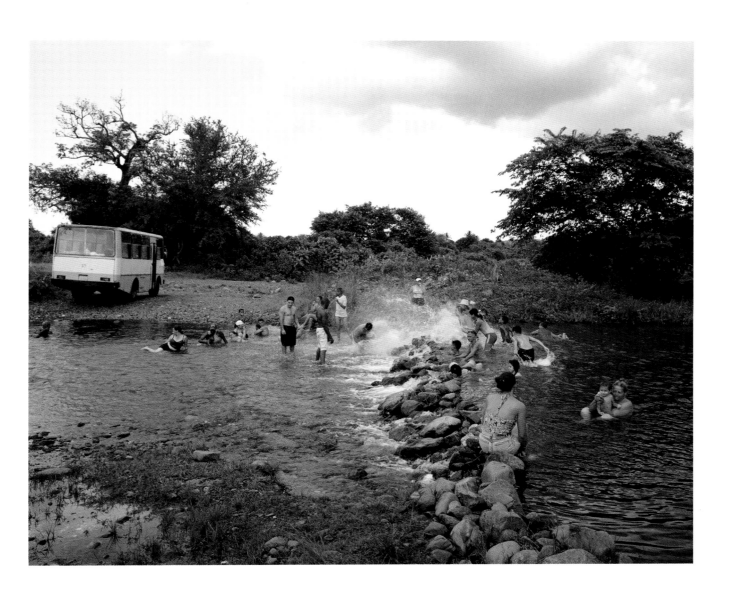

Sojo River
Rio Sojo
Biran I, Holguin

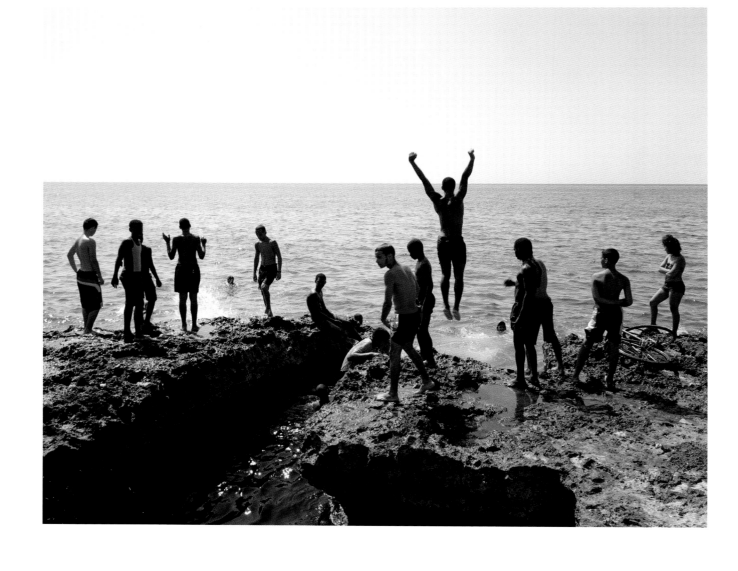

The Malecon
El Malecón
Habana

The Malecon
El Malecón
Baracoa, Guantánamo

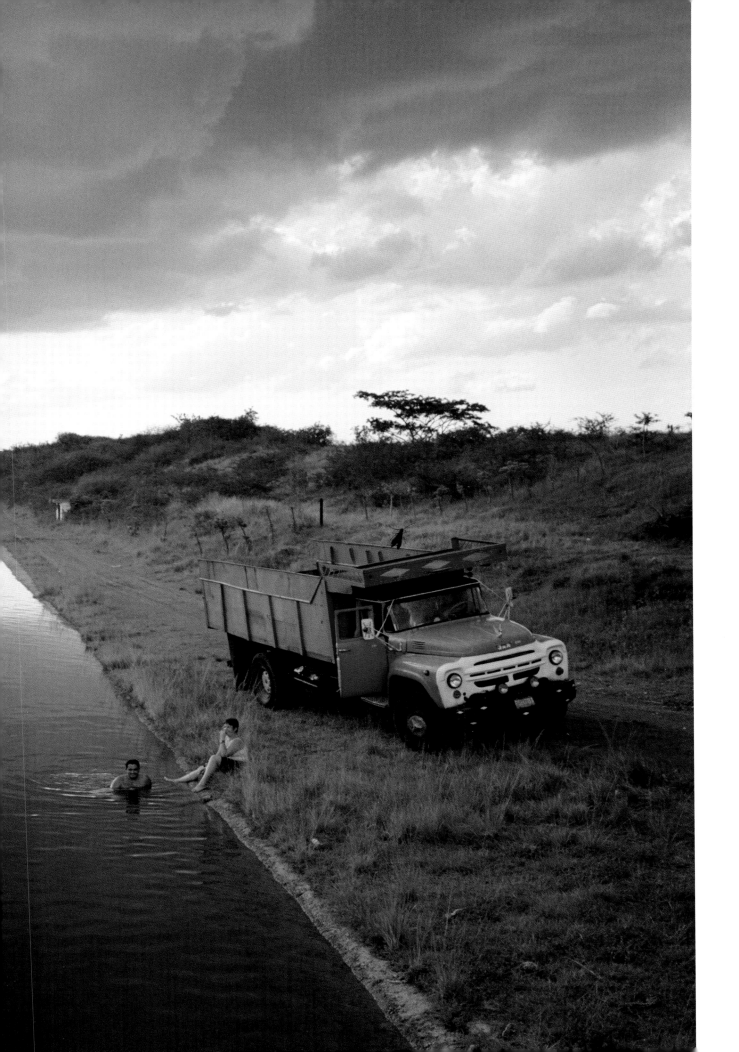

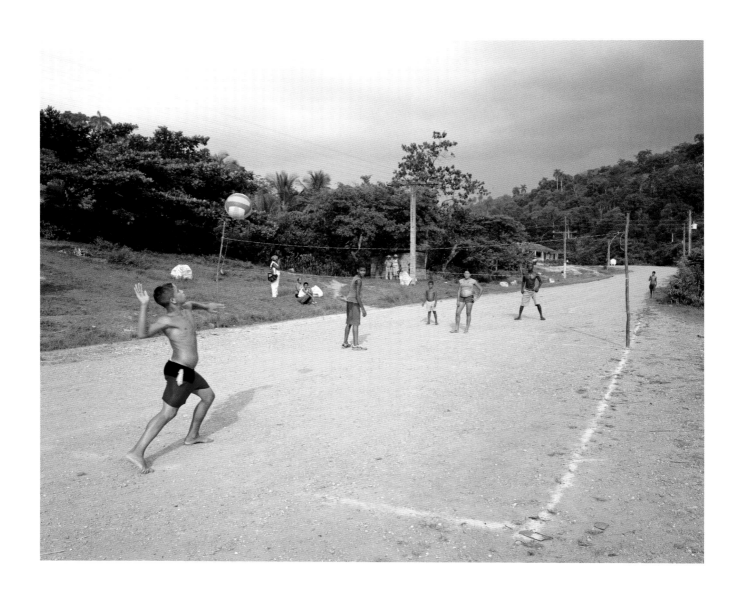

Previous page / Página anterior
Canal
Cienfuegos

Above / Superior
Arroyo Rico, III Frente,
Santiago de Cuba

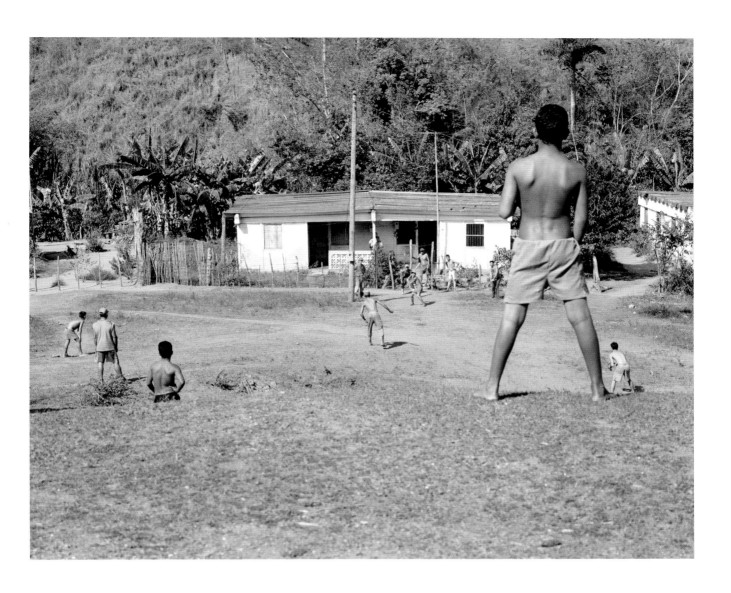

Ceibao,
Sancti Spíritus

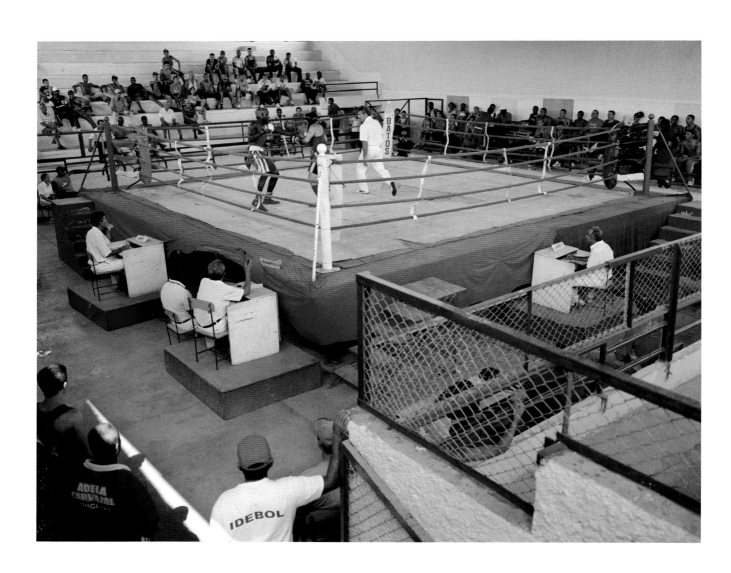

Playa Girón Tournament, Henry García
School of Boxing
Torneo Playa Girón, Escuela de Boxeo
Henry García
Holguin

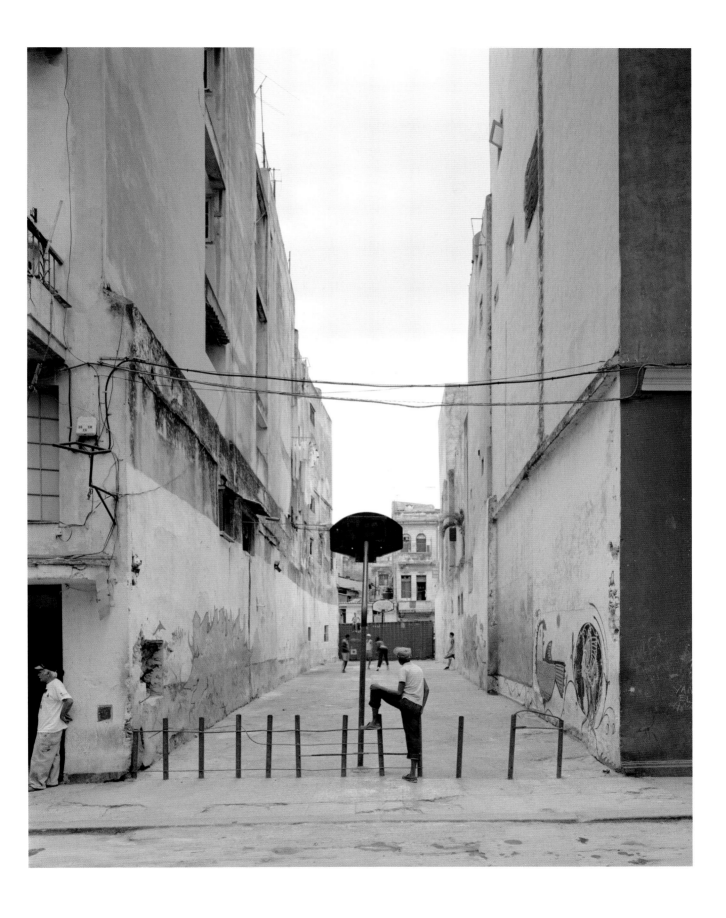

Basketball Court
Cancha de Basketball
Habana Vieja

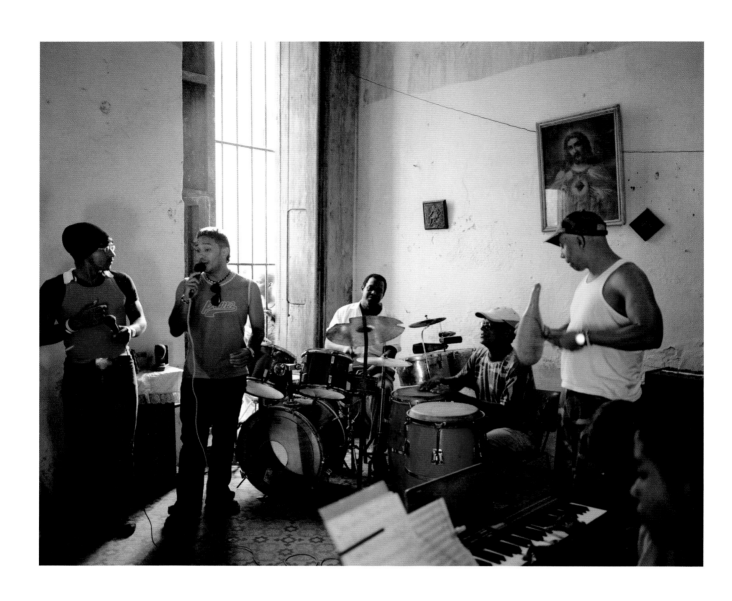

Group J.P and his Explosion
Grupo J.P y su Explosión
Cerro, Habana

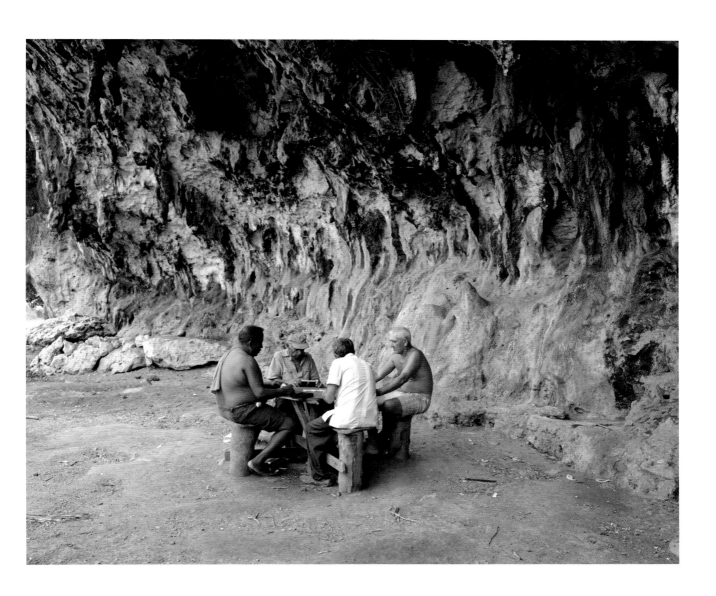

Game of Dominos
Jugadores de domino
Güin, Baracoa, Guantánamo

have material things but he wants to be recognised by the public. He wants to feel strong by doing a hard sport. It's always that little need for me, that's what I look for. When a boy comes here and says "I want to be a boxer" I ask about the parents, home, the family situation.'

I asked him, 'How soon can you tell if you've got a real boxer?

'Seconds,' said Miranda.

A last image of Cuba, from the contact sheets of memory: on the road to the Church of St Lazarus at Rincon, I watched penitents crawl for miles to commemorate the feast of the saint who rose again. By a Cuban irony as black as the tarmacadam, the pilgrims had set out on their trek as able-bodied men and women, but were inviting disability by grinding themselves against the blacktop. 'Some of them mix up St Lazarus with a god called Babalu-Aye,' said a nun called Sister Rita Llanza tolerantly. It was a liturgical cock-up typical of Santeria, Cuban voodoo, a profane marriage of the Catholicism imported by the Spanish and the faith of the West African slaves. Adherents of Santeria believed that Babalu-Aye would look down on their prostration and find the prospect pleasing. Sister Rita wasn't in the least put out by the Scriptural inaccuracies of the pilgrims, accepting their candles across the altar rail of the church in exchange for her cheaply printed parish newsletters. After all, wasn't it a cardinal rule of Santeria that initiates must first have been baptised? The Church in Cuba, for so many years oppressed, welcomed sinners wherever it could find them.

'And you: I suppose you are an Episcopalian?' Sister Rita asked me.

I'm sure the Sister wouldn't have minded in the least, but I didn't have the heart to tell her that I was a Santeria man myself, a Santero, or rather that I was part of the way down the road to initiation, a chicken having been sacrificed over my head in a solemn ceremony in the back room of a private home not far from the Hotel Nacional.

Religion has been strangely overlooked in the vogue for all things Cuban in the past decade or so, but it's part of the answer to the perennial question: how on earth do the Cubans keep the show on the road? As many as seventy five per cent of the islanders are adherents of Catholicism, or of its exotically garbled version, Santeria – including, it's said, the former altar boy Fidel Castro himself. The procession at Rincon will easily attract 50,000 people every year.

And so to the unanswerable, unduckable question: what next in Cuba? As mentioned above, the new President of the United States, Barack Obama, loosened America's restrictions on contact with the island in April 2009. He made it easier for Cuban-Americans to remit money to the old country, as well as such welcome gifts as clothes and bathroom sundries. But the greatest excitement was over new freedoms for members of the Cuban Diaspora, their children and grandchildren, to visit relatives on the island. Until Obama's reform, these reunions had only been possible once every three years.

So is the embargo about to end? And what will be the result of a greater corporate presence? Will Cuba leap out of Fidel's rusty old frying pan only to land in the fire – in this case, the unsleeping griddles of McDonald's and Burger King?

Though many commentators score Obama highly for boldness, few believe he's willing to scrap the embargo completely, while there are votes at stake in Florida and New Jersey. There, leaders of the exile community would only be willing to sup with either Castro brother on the end of a very long spoon – poisoned, in Fidel's case. And somehow it's hard to imagine a transplanted Chinese solution, in which the communist party retains political sovereignty while letting a thousand shopping malls bloom. Cuba as the Latin tiger? Look at the island on a map. It's not a fire-breathing termagant but a crocodile, basking in the soupy Caribbean. Surely the Cuban genius for improvisation will somehow deliver a *creole* solution, if the saints allow.

So much for snapshots from a metaphorical album; now the reader can resume the real business of appreciating Clive Frost's gallery of *cubanos*. We cannot all aspire to his striking gift of image-making. But even the least visually-minded of us comes away from exposure to Cuba with a photographic memory.

Stephen Smith
April 2009

mi choque cultural —podría estar en cualquier lugar, podría estar incluso, acababa de comprobar, en Cuba—, tomé el ascensor hasta el último piso. Le pregunté al estadounidense que compartía el ascensor conmigo si el piso ocho llevaba en efecto al jardín de la azotea. "¿La piscina, quiere decir?", aclaró. Al encontrarme frente a frente con la azotea, me di cuenta de que no era en absoluto un rincón silvestre, sino una piscina al aire libre, como me había dicho el huésped del hotel. Alrededor de las relucientes aguas había una densa colección de cuerpos pálidos. Este fue otro choque, tal vez de un tipo más visceral. Uno se acostumbra tanto a ver los cuerpos negros y morenos de los cubanos, casi desnudos, que encontrarme con un apiñado grupo de gente blanca en el mismo estado me resultó vagamente inquietante. Era como dar con una especie de rito sibarítico: intercambio de esposas, tal vez. Era el hecho de que se estaba produciendo en este nido de águilas de privilegios —en el pináculo del lujo, podría decirse— lo que de algún modo le imprimía un carácter de afrenta.

Esta escena recordaba secuencias impresionantes de la película Soy Cuba. Una coproducción de cineastas cubanos y soviéticos dirigida por Mijaíl Kalatozov en 1964, que cuenta cuatro historias diferentes sobre la suerte del pueblo cubano de hace casi medio siglo. La primera narración pasa de los empobrecidos cubanos a los indolentes yanquis. La cámara filma una larga escena, una toma con un único punto de vista, en la piscina al aire libre de un hotel de La Habana durante los años cincuenta. Desciende los peldaños del trampolín, sobrevuela kilómetros de carne extranjera embadurnada de aceite, hasta el mismo borde de la piscina... y ¡paf! Se zambulle. El espectador se encuentra de repente entre los miembros convulsos y los estridentes bañadores de los veraneantes ávidos de placer. Se trata de una producción cinematográfica de una desenvoltura y un brío insólitos, incluso frente a las sofisticadas técnicas actuales a disposición de los estudios. Durante mucho tiempo, me desconcertaba que autores de los años sesenta —autores del bloque soviético—hubieran dado este golpe maestro cinematográfico. ¿Qué inimaginable grúa había transportando la lente a lo largo de esos planos y esas distancias? ¿Por qué la escena no se fue a pique cuando la cámara se puso a bucear? Debí haber sabido que el ingenio cubano había desempeñado su parte, para bien. Resulta que no había grúa alguna: la cámara fue simplemente pasada de mano en mano, como un cubo de agua, a lo largo de una cadena humana de técnicos. En cuanto al clímax de la toma, el equipo tuvo la brillante idea de revestir la lente con un producto impermeable y un limpiador, que más bien se utilizan en los periscopios de los submarinos, lo cual dio como resultado que la cámara pudiese sumergirse —y sacarse del agua— sin gotas en la lente.

Pero ese es el verdadero don de los cubanos, no cabe duda, el don de apañárselas. Nada resume esto con mayor claridad para mí que la imagen tal vez improbable de los puños de un joven propinando golpes a un neumático de automóvil pendiente de una cuerda. Era un boxeador, un combatiente, y la rueda colgante su adversario. Uno de los ámbitos que Castro quiso utilizar para pregonar el triunfo de la revolución al mundo exterior fue el del deporte. A los cubanos se les prohibió la competición profesional en 1962, y a partir de entonces todos los esfuerzos se dirigieron a la gloria de la patria. Pero mientras el Estado estaba dispuesto a derrochar dinero en los atletas que representaban a Cuba en las pruebas internacionales, en tiempos difíciles como el que ha tenido que soportar la economía del país durante dos decenios, el carácter ingenioso de los cubanos ha pasado a ser fundamental.

"Esto es para practicar los puñetazos; es tan bueno como un costal", señaló Carlos Miranda, tras observarme mirar el desventurado neumático mientras era castigado una y otra vez por uno de los jóvenes apadrinados por él. Miranda, un ex boxeador fibroso y de baja estatura, ha entrenado a por lo menos dos generaciones de talentos en la famosa academia de boxeo de La Habana. Pero, cuando se observa el cuadrilátero improvisado a cargo de Miranda en un patio de hormigón entre las calles Cuba y Paralela, lo menos que uno puede imaginar es un crisol de campeones.

Unas cuerdas destensadas acordonaban la deslucida lona y sobre ella se erguían unas gradas de hierro oxidado. Los viejos guantes de boxeo parecían jamones ibéricos. Los pugilistas principiantes, algunos de sólo cinco años de edad, corrían a cogerlos cuando su entrenador se lo indicaba: no había suficientes para todos. Y, sin embargo, kilo por kilo, los licenciados de esta escuela de peleadores se han hecho con más medallas y cinturones que los de ninguna otra escuela de boxeo en el mundo. No es de extrañar que, cuando una multinacional de ropa deportiva quería rodar un vídeo protagonizado por Teófilo Stevenson y Félix Savón, esos indomables cubanos —ambos tres veces campeones olímpicos de peso pesado—, el director y el equipo técnico optaban por la modesta intersección de Cuba y Paralelo. Entre los aspirantes de hoy se encontraba un niño de nueve años de edad que llevaba una desgastada camisa azul. Armando Martínez, hijo, tenía las facultades de un verdadero pugilista, según Miranda. "Sin duda alguna, tiene un gran potencial". El muchacho era hijo de un campeón mundial y hermano de otro. Su padre era Armando Martínez, campeón de la división de 71 kilos en los Juegos Olímpicos de 1980 y también campeón del mundo; su hermano era Johanson Martínez, campeón mundial de los 81 kilos. El hijo seguía los pasos del padre hacia la gloria bajo la tutela de Miranda, como si cada hombre fuese un *King's Scholar* del Colegio Etonen lugar de un alumno de las calles de mala muerte de La Habana.

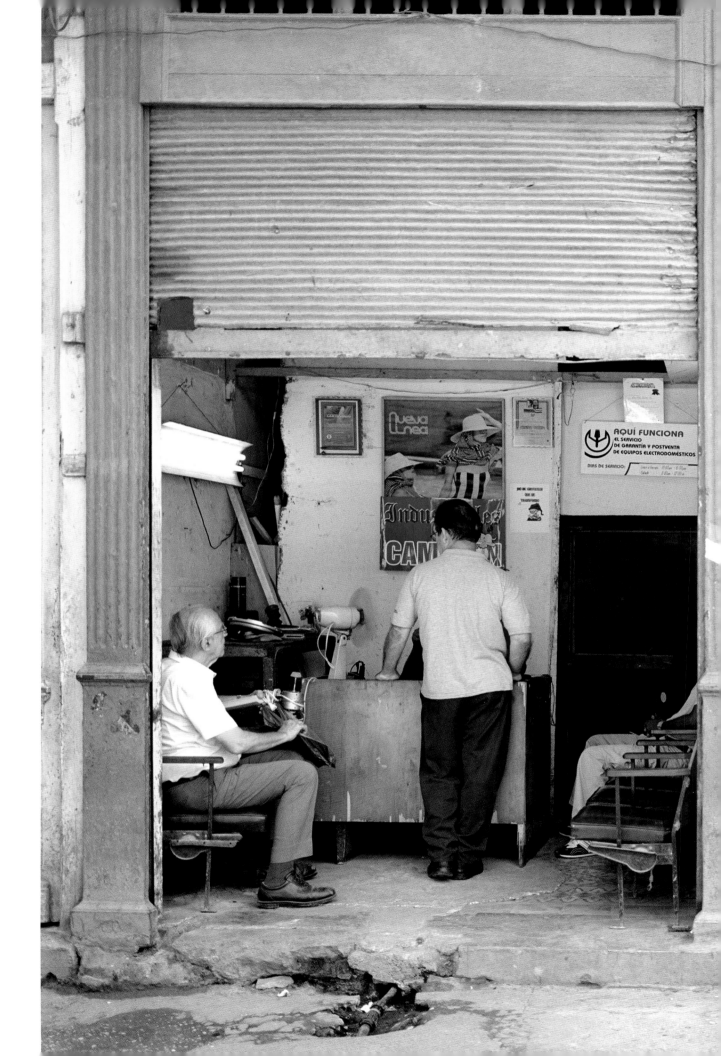

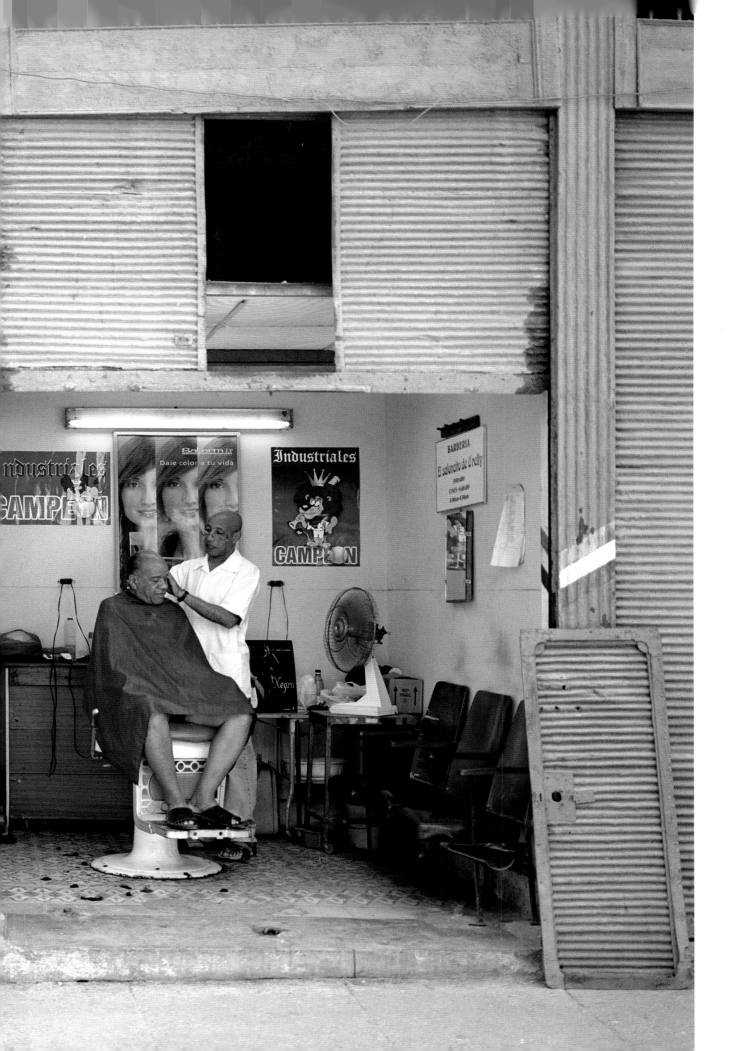

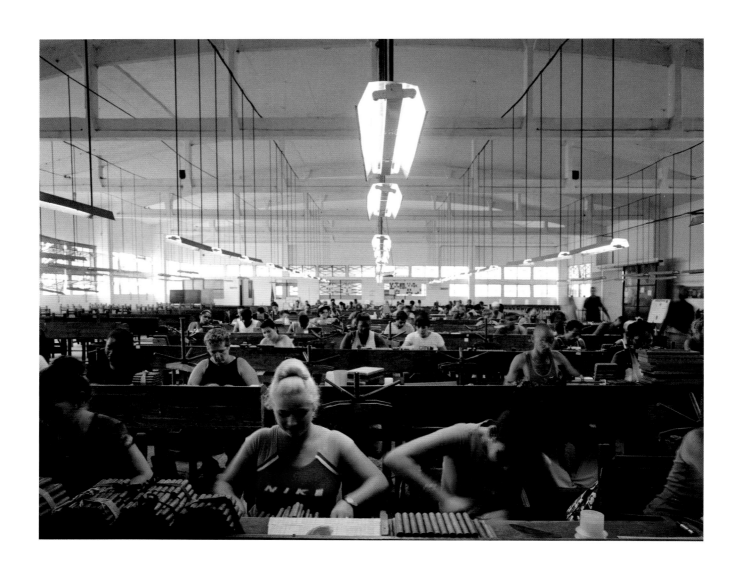

Previous page / Página anterior
**Barber Shop and Domestic equipment
Repair Shop**
Barberia y Centro de reparación de
electrodomésticos
O'Reilly Street, Habana Vieja

Above / Superior
**Puro Habano Cigar Workers, Paulina Rubio
Factory**
Torcedoras y torcedores del Puro Habano,
Fábrica Paulina Rubio
Consolación del Sur, Pinar del Rio

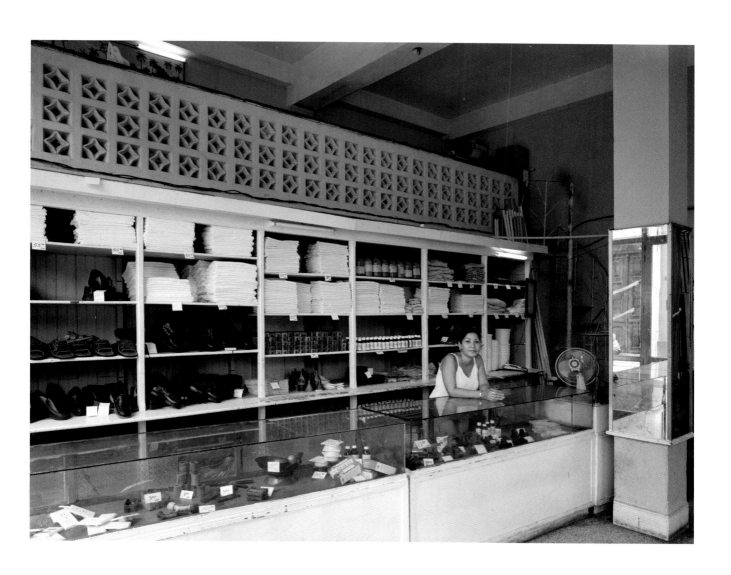

Mayra Cabanes
Variedades shop
Tienda Variedades
Santa Clara, Villa Clara

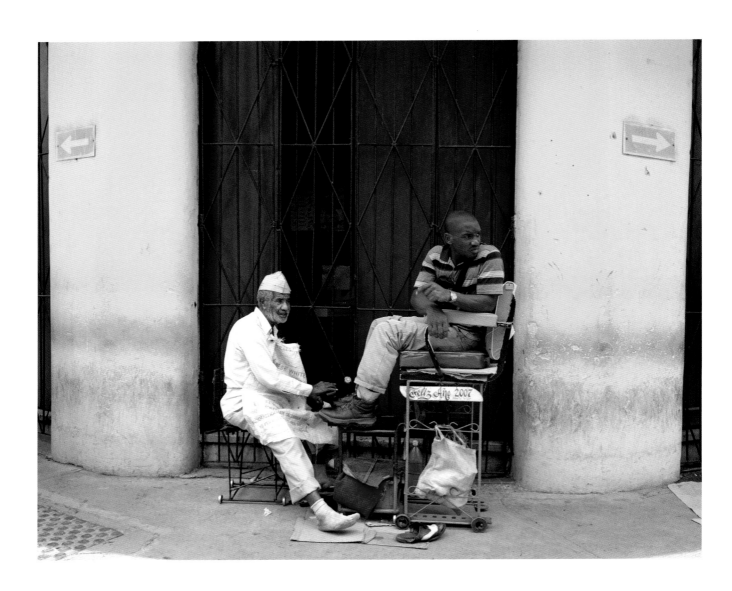

Santiago de Cuba

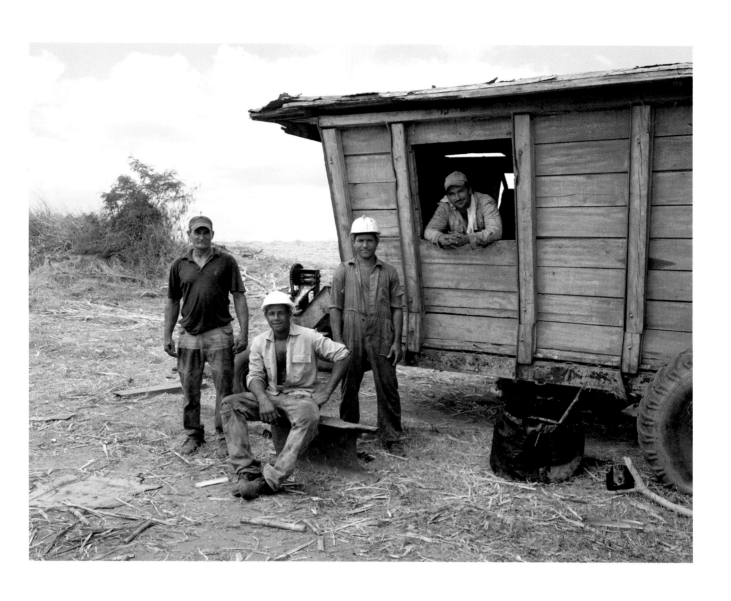

**Reinaldo Vázquez, Rafael Méndez, Julio Hernández
Ramos, Antonio Jimenez**
Sugar Cane Cutters
Trabajadores de Combinadas de azúcar
Trinidad, Sancti Spíritus

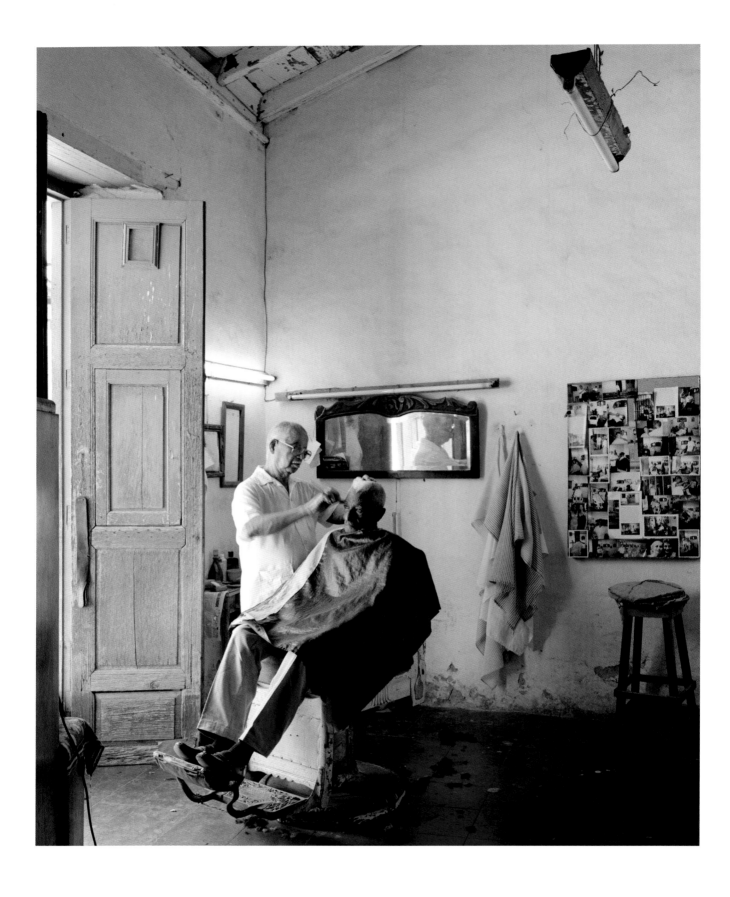

Orestes Ramírez Soa
Barbero
Trinidad, Sancti Spíritus

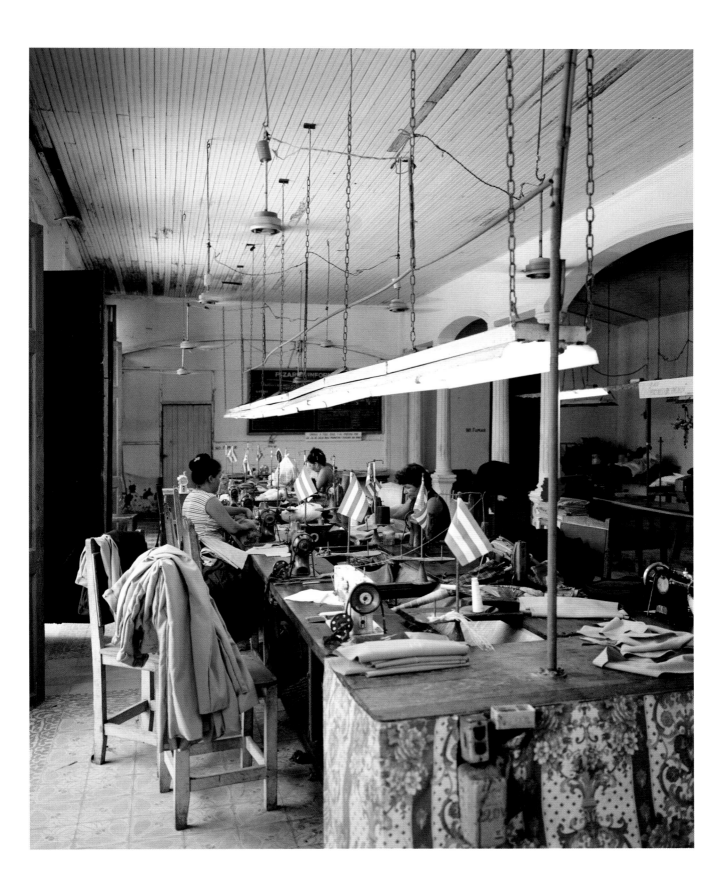

Felicia Mosqueda, Olga Colombie, Berta Machado,
Reina Milián Eloida Díaz
Confecciones Muñequería workshop
Taller de Confecciones Muñequería
Baracoa, Guantánamo

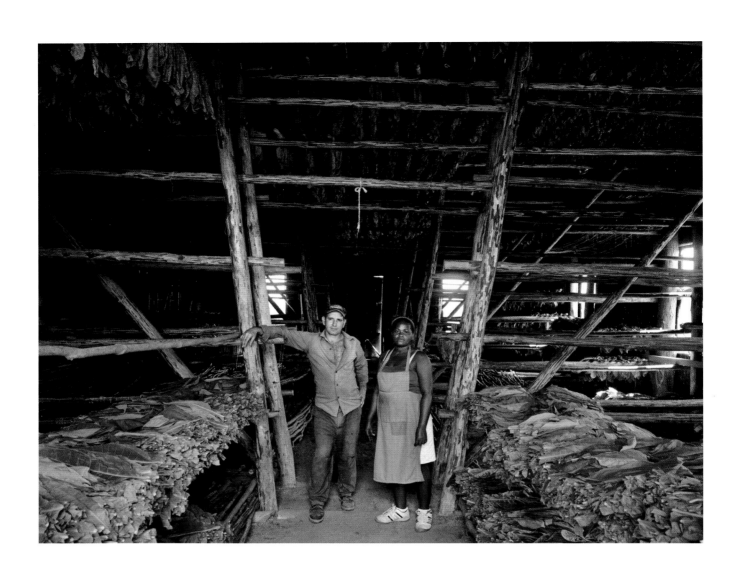

Niurka Padrón Moinelo, Adalberto Fragoso Fleita
Tobacco farmers
Campesinos Tabacaleros
San Juan y Mártinez, Pinar del Río

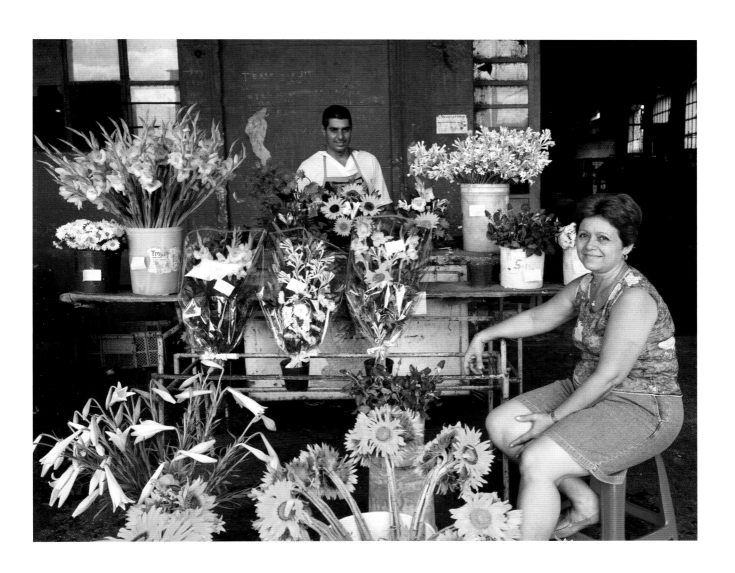

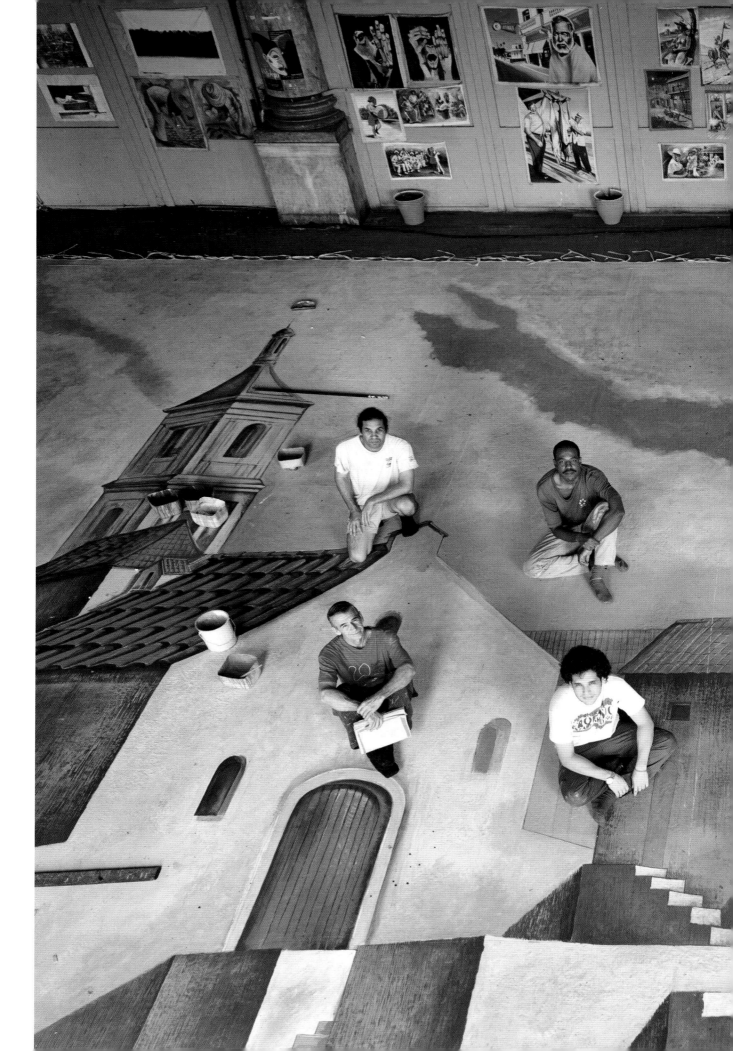

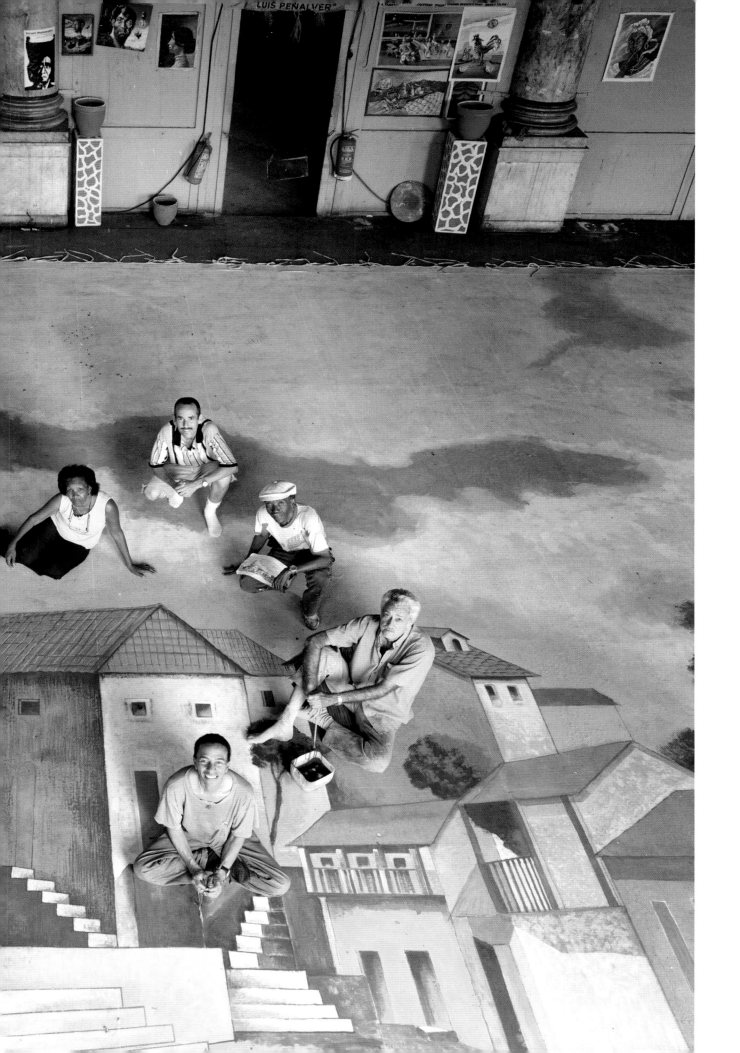

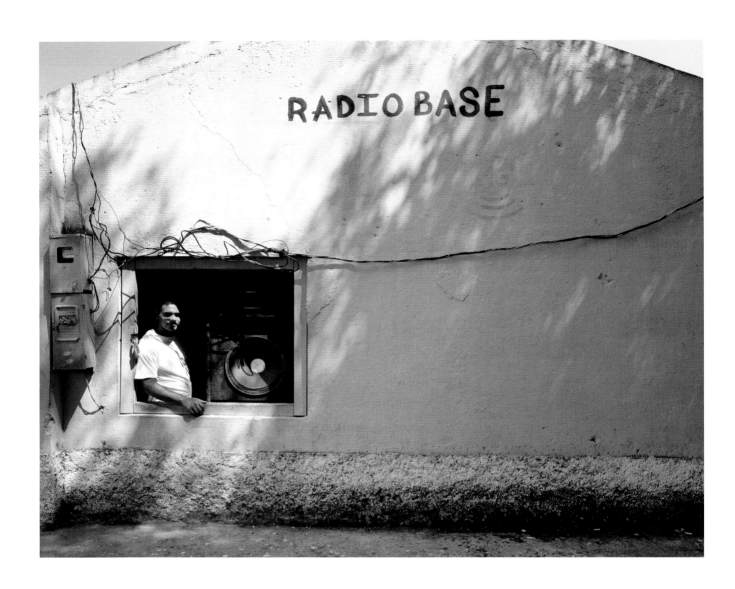

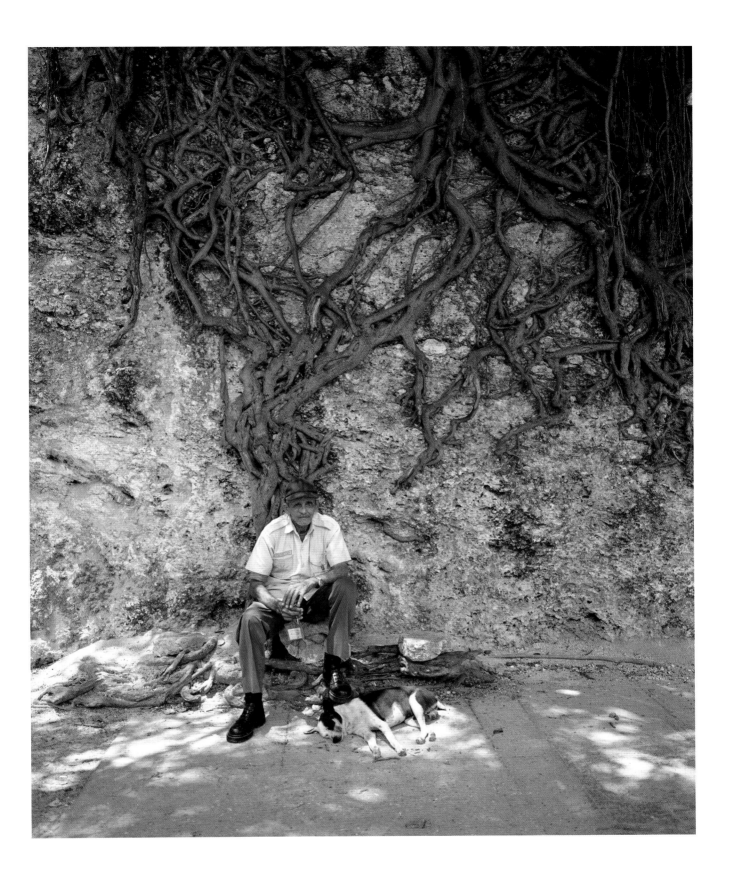

Pedro Vasa and / y Pinto
Security Protection
Guardia de Protección
Vedado, Habana

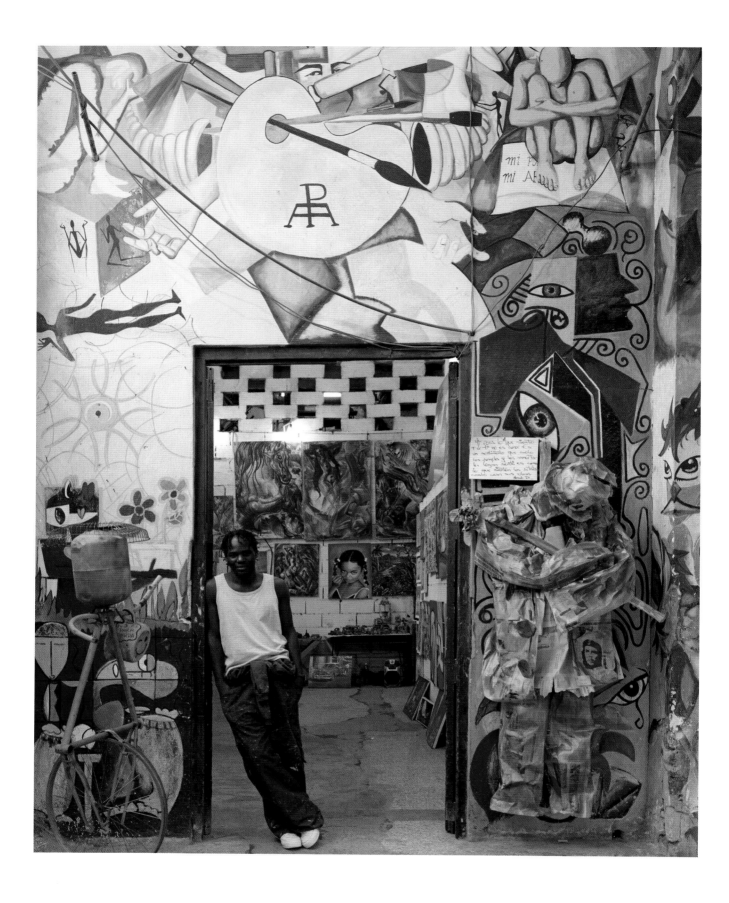

Alexander Poll Doval
Artist
Artista
Galeria Prado, Centro Habana

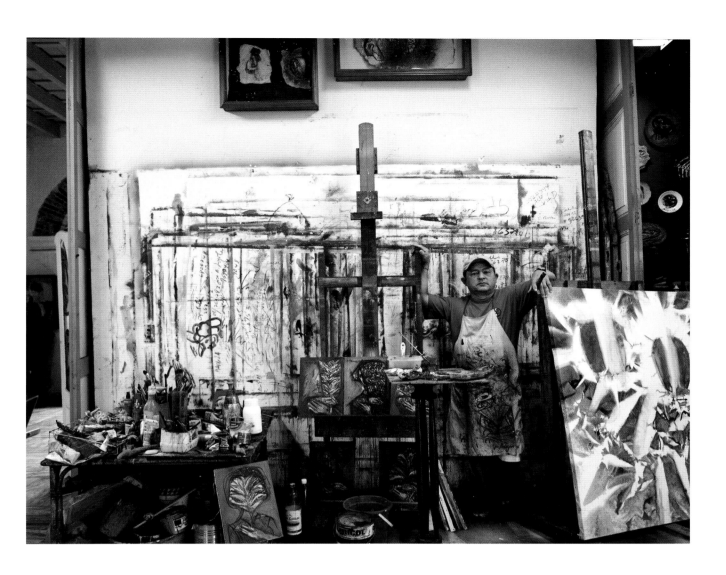

Nelson Dominguez
Artist
Artista
Galeria Los Oficios, Habana Vieja

Carretera Central,
Manzanillo, Granma

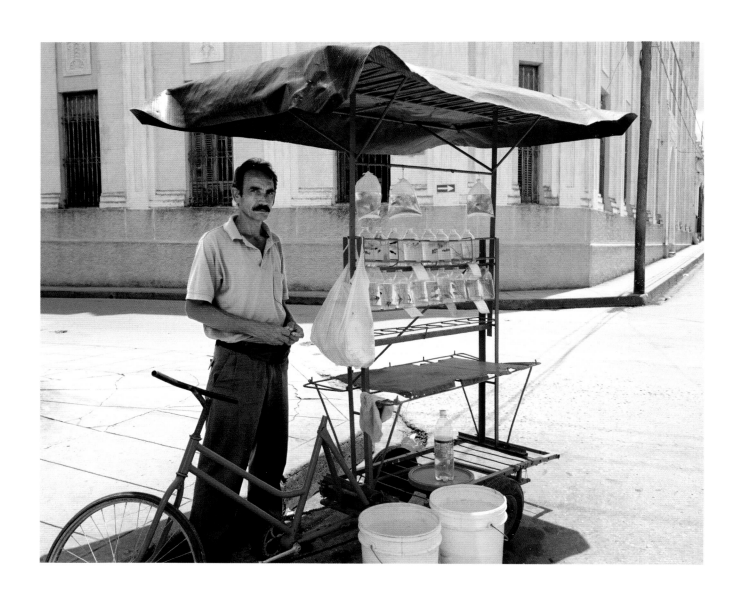

Manuel Jiménez
Tropical Fish Seller
Vendedor de Peces Tropicales
Santa Clara, Villa Clara

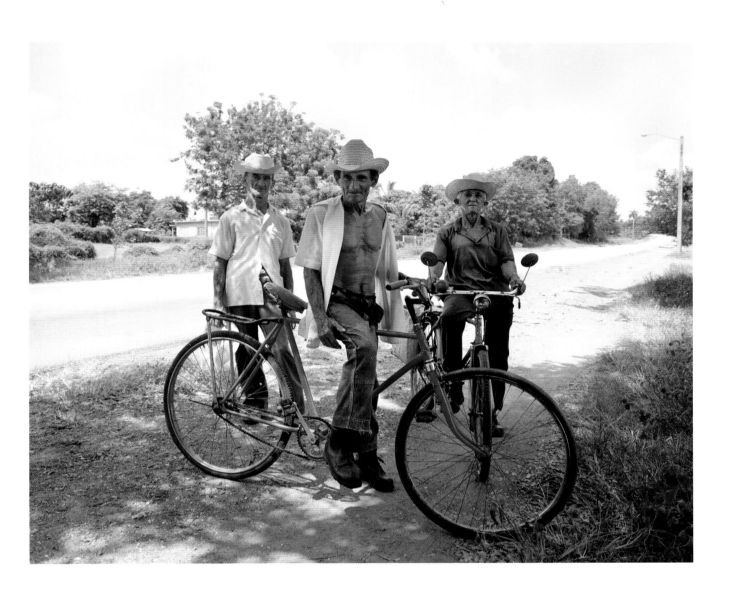

**Leopoldo Fernández, Amable Santiesteban,
Octavio Ricardo**
San Carlos, Holguín

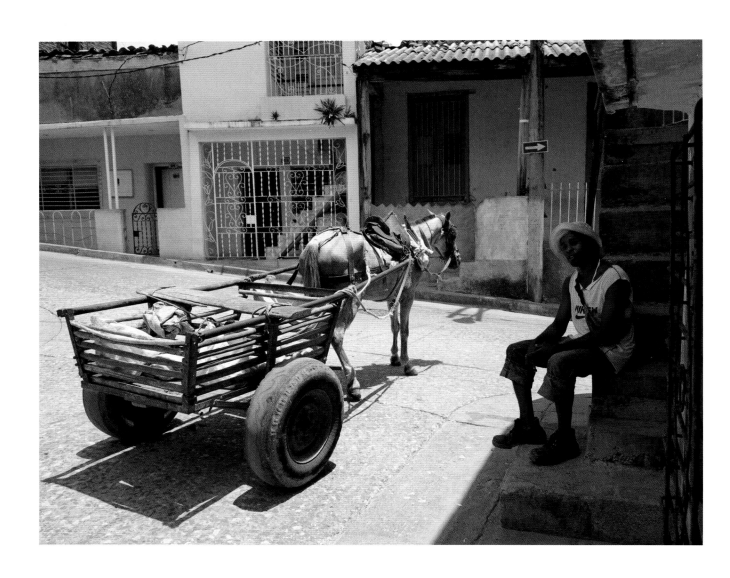

Yoandris Delis
Mango Seller
Vendedor de Mangos
Santiago de Cuba

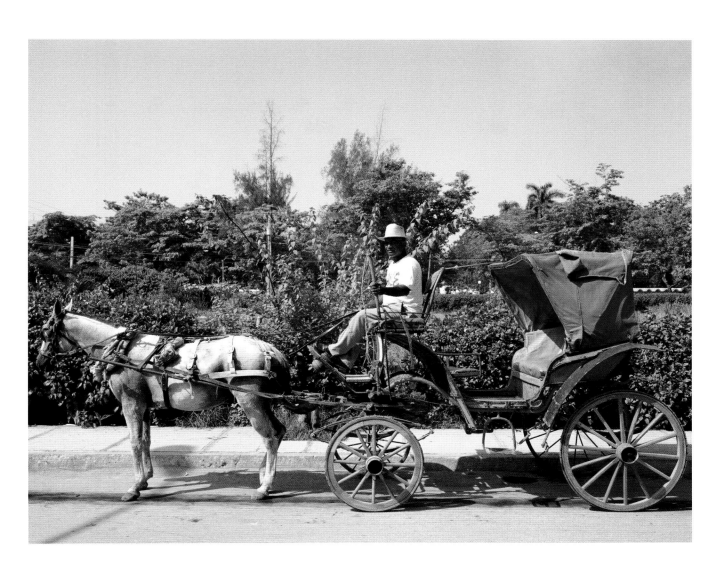

Coachman
Cochero
Bayamo, Granma

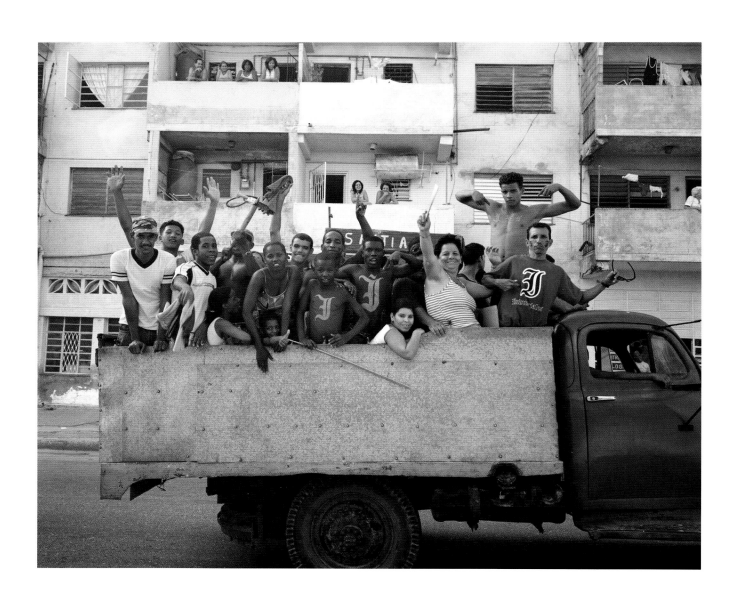

Supporters of Industriales baseball team
Fans del equipo Industriales de beisbol
Cerro, Habana

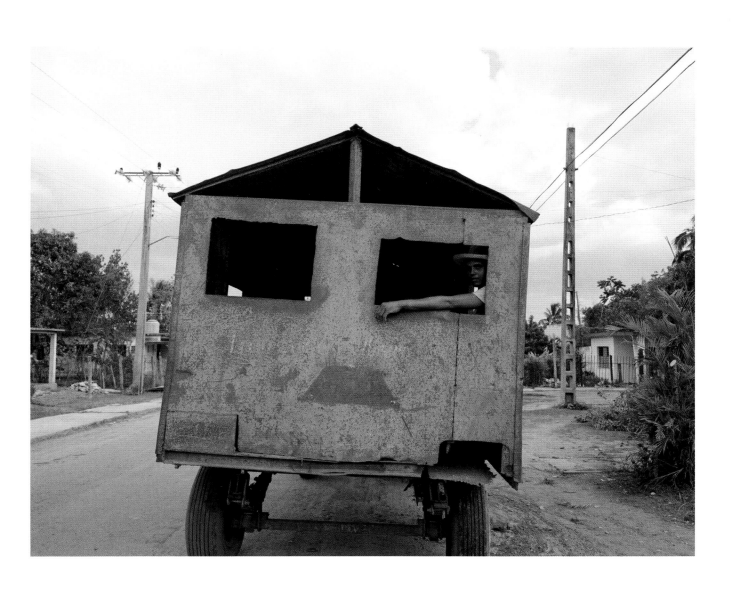

Agricultural transport
Transporte agrícola
Cruces, Cienfuegos

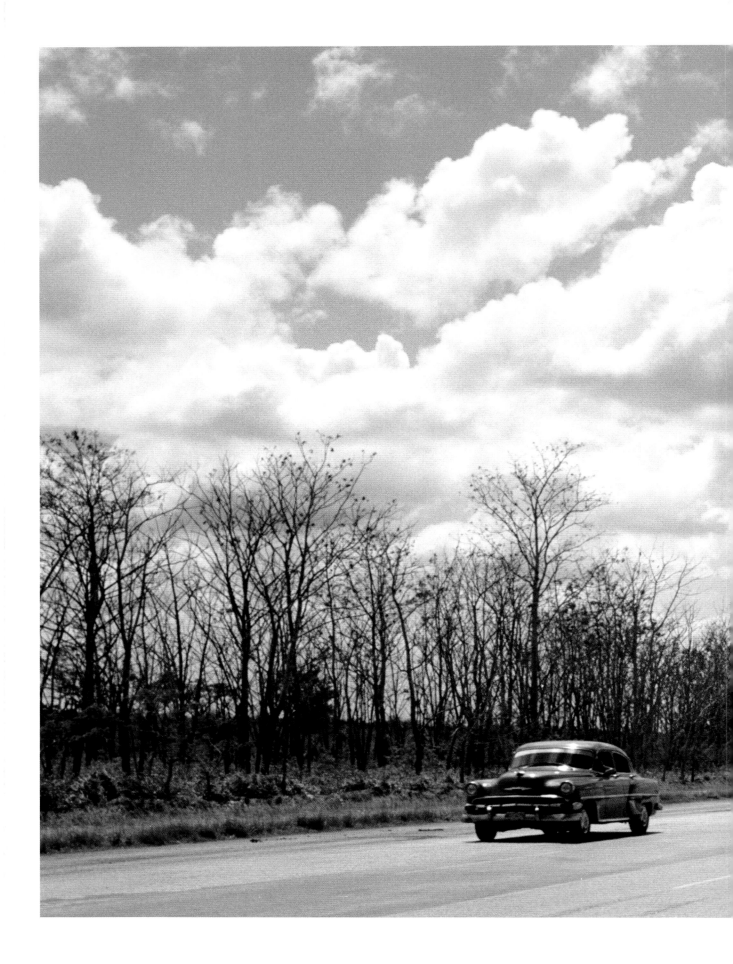

National motorway
Autopista Nacional
Central Australia, Matanzas

"No hagan payasadas", gritó el entrenador. "¡Corran! ¡Eso es lo que quiero!" Sus alumnos comenzaron a trotar alrededor del *ring*, esquivando las cuerdas que lo sostenían. Corrieron durante el mismo lapso que lo que dura un combate de aficionados: cuatro asaltos de dos minutos cada uno. Era un trabajo duro para ellos, con el calor y el deslumbrante sol del mediodía cubano. Pero sabían que no debían quejarse. Miranda era un maestro inclemente. Apenas terminó la carrera cuando ordenó una extenuante sesión de calistenia. "Dije ¡ Abdominales! ¡Así que a empezar! No quiero ver a nadie tomando el fresco. El entrenador me confesó en voz baja: "Debo admitirlo, soy muy duro cuando les hablo".

Miranda se había pasado casi cuarenta años preparando boxeadores. Había estado en la esquina del poderoso Savón. Entre sus pupilos estuvo también el campeón del mundo Freddy Soto. Otra buena promesa era Luis Franco, de poco más de veinte años de edad, que tenía experiencia olímpica. Miranda había estado entrenándolo desde que tenía nueve años. Mientras conversábamos, traté de poner en guardia a Miranda, con algunos *jabs* exploratorios indignos de este noble arte, pero el astuto luchador era demasiado bueno para mí.

"¿Peligroso? No, nada de eso. El boxeo es uno de los deportes menos peligrosos, entiendo yo. ¡Tiempo!" El entrenador se interrumpió para señalar el final de los ejercicios de estiramiento. "Cuando los niños llegan aquí, lo primero que hacen es jugar: sus cabezas no corren ningún peligro", añadió. "Empiezan a tener más confianza. Sí, podrían llegar a ser violentos si los entrenadores alentaran la violencia, pero aquí lo que nos interesa es entrenar". Como para demostrar la verdad de su lúcida opinión, los niños se acercaban a Miranda de vez en cuando para que les diera un abrazo; indudablemente, ladraba más que mordía.

"Me sorprende que usted produzca campeones aquí", le dije.

"Sí, pero así es".

"¿Por qué Cuba forma tantos grandes boxeadores?"

"Por el sistema educativo. Cuanto más estudia y se prepara la gente, más entiende el boxeo. No todo es violencia y agresión. Se trata también de usar tácticas, técnicas, inteligencia. ¿Sabe? La agresión se sobreestima demasiado, a mi juicio. Pienso que un boxeador, cuanto mejor sea como persona, mejor será como atleta".

Desde la pared donde estaban colgados los viejos neumáticos llegaba el chirrido de las zapatillas sobre el hormigón y el gemir de los amarres de metal que no

habían sido aceitados desde hacía un buen tiempo. Las camisetas de los boxeadores estaban empapadas de sudor y de sus cejas brotaban gruesas gotas. En algunos países, un gancho directo podría bastar para salir de la pobreza. Pero para estos jóvenes, la perfección física, y tal vez un título o dos, tendrían que ser su propia recompensa.

"He entrenado a boxeadores profesionales fuera de Cuba, y la competición profesional tiene muchos puntos fuertes —dijo Miranda. Pero la mayor recompensa que tengo es cuando veo a uno de mis boxeadores convertirse en un campeón mundial".

Le pregunté: "¿Un hombre pobre es mejor boxeador que uno rico?"

"No. Creo que lo que cuenta es la necesidad", dijo Miranda. "No me refiero sólo a una necesidad económica. A veces es la necesidad de ser reconocido. Un boxeador podría poseer cosas materiales, pero quiere ser reconocido por el público. Quiere sentirse fuerte dedicándose a un deporte duro. Para mí, siempre existe esa pequeña necesidad; eso es lo que busco. Cuando un muchacho viene aquí y dice "Quiero ser boxeador", pregunto sobre los padres, el hogar, la situación familiar".

"¿En cuánto tiempo puedes saber si se trata de un verdadero boxeador?", inquirí.

"En cuestión de segundos", aseguró Miranda.

Una última imagen de Cuba, extraída de las hojas de contacto de la memoria: en la carretera que conduce a la Iglesia de San Lázaro en Rincón, vi a penitentes caminar kilómetros y kilómetros, muy lentamente, para conmemorar la fiesta del santo que se levantó de nuevo. Por una ironía cubana tan negra como el asfalto, los peregrinos habían iniciado su caminata como hombres y mujeres físicamente sanos, pero trataban de malograrse a fuerza de darse golpes contra el pavimento. "Algunos de ellos asimilan San Lázaro a un dios llamado Babalú Ayé", dijo, indulgente, una monja llamada sor Rita Llanza. Se trataba de un revoltijo litúrgico típico de la santería —el vudú cubano—, un matrimonio profano entre el catolicismo importado por los españoles y las creencias de los esclavos de África Occidental. Los fieles de la Santería creen que Babalú Ayé los observa en su postración desde lo alto y que le agrada verlos así. A sor Rita no le molestaban en lo más mínimo las imprecisiones bíblicas de los peregrinos, y aceptaba sus velas en el comulgatorio de la iglesia a cambio de los boletines parroquiales que imprimía toscamente. Después de todo, ¿no era una regla cardinal de la Santería que los iniciados debían primero haber sido bautizados? La Iglesia en Cuba, oprimida durante tantos años, les daba la bienvenida a

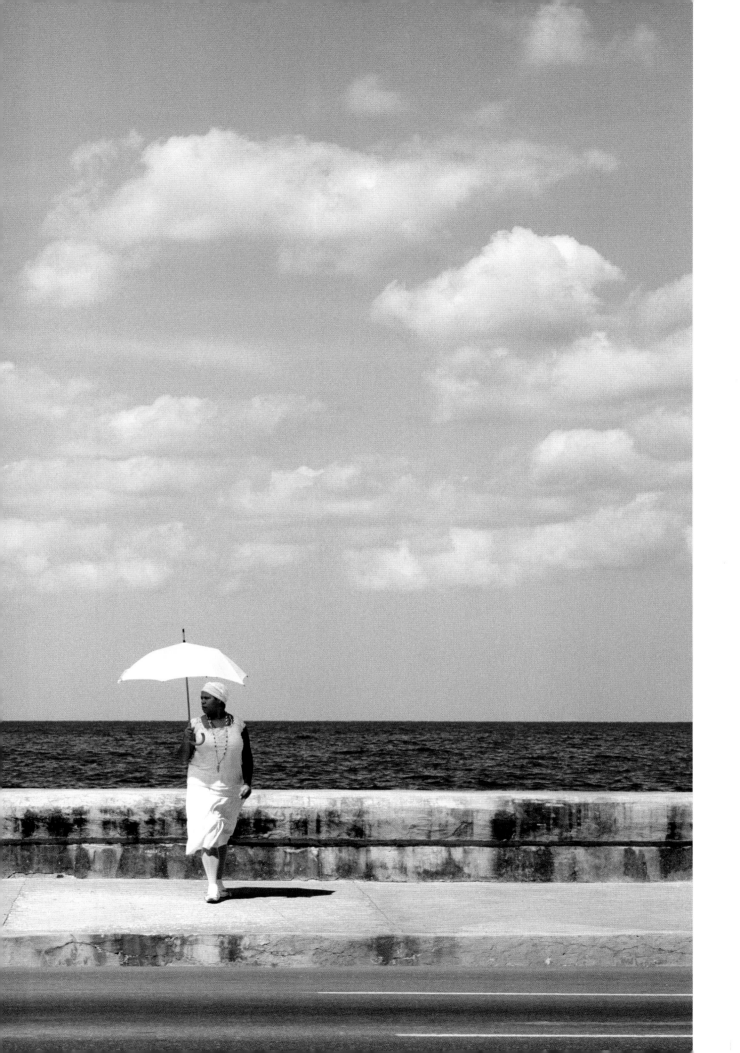

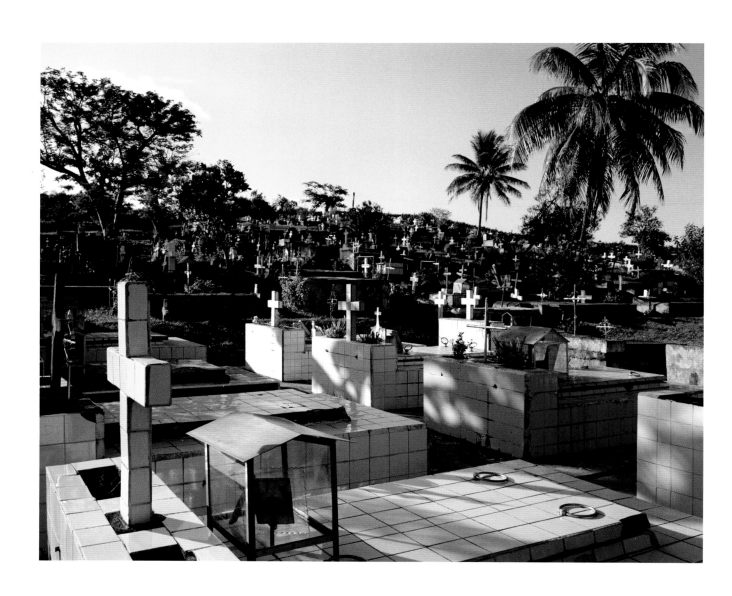

Previous page / Página anterior
Santera
El Malecón, Habana

Above / Superior
El Sitio Cemetery
Cementerio El Sitio
Sagua de Tanamó, Holguin

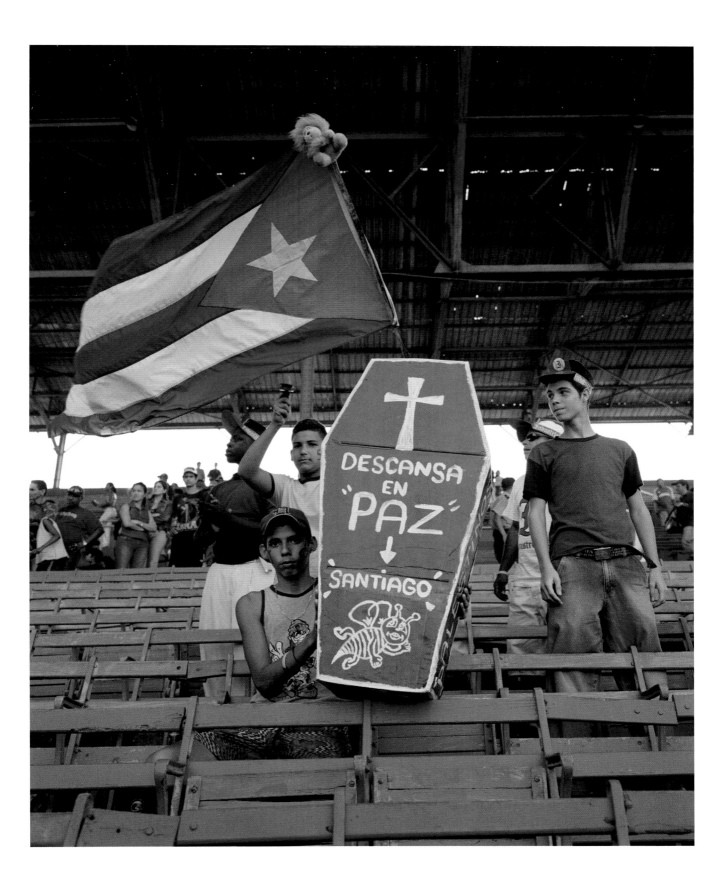

Supporters of Industriales baseball team
Fans del equipo Industriales de beisbol
Estadio Latinoamericano, Cerro, Habana

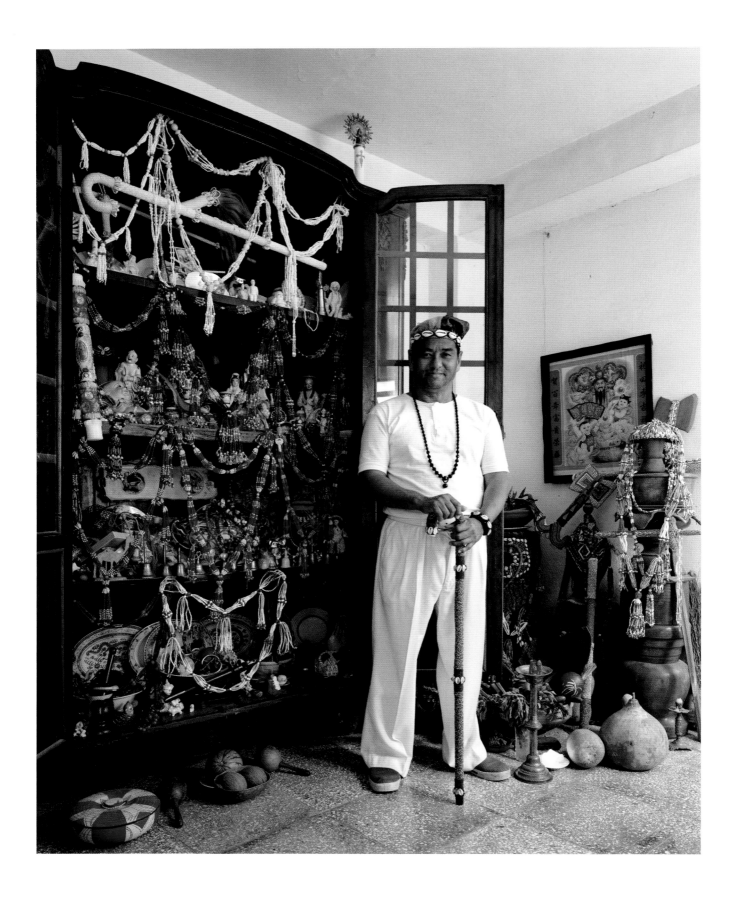

José Francisco Ung Villanueva
Ori ate, Santería religion
Ori ate de la religión Santería
Regla, Habana

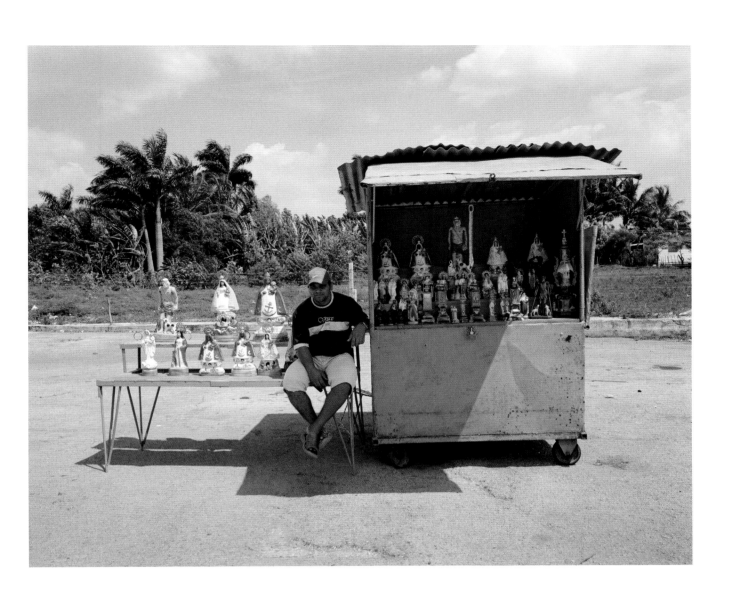

El Rincón Church
Iglesia El Rincón
Santiago de las Vegas, La Habana

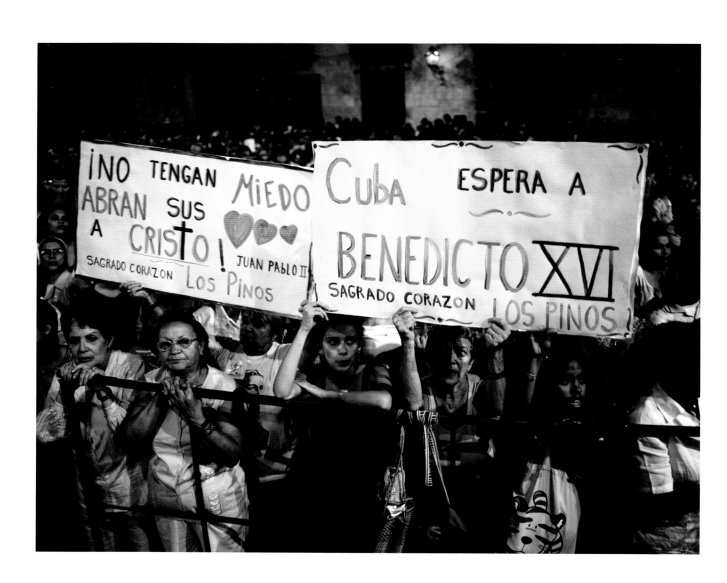

**Celebration of the Eucharist for the Secretary
of State to Pope Benedict XV1**
Celebración Eucarística Presidida por el
Secretario de Estado de SS Benedicto XVI
La Catedral, Habana Vieja

Damas de Blancos
Iglesia Católica Santa Rita,
Miramar, Habana

Mariela Castro
President of the National Centre
of Sexual Education
**Presidenta del Centro Nacional
de Educación Sexual**
Miramar, Habana

Rogelio Polanco Fuentes and Editorial Team / y Consejo Editorial
Newspaper, Juventud Rebelde
Periódico, Juventud Rebelde
Plaza de la Revolución, Habana

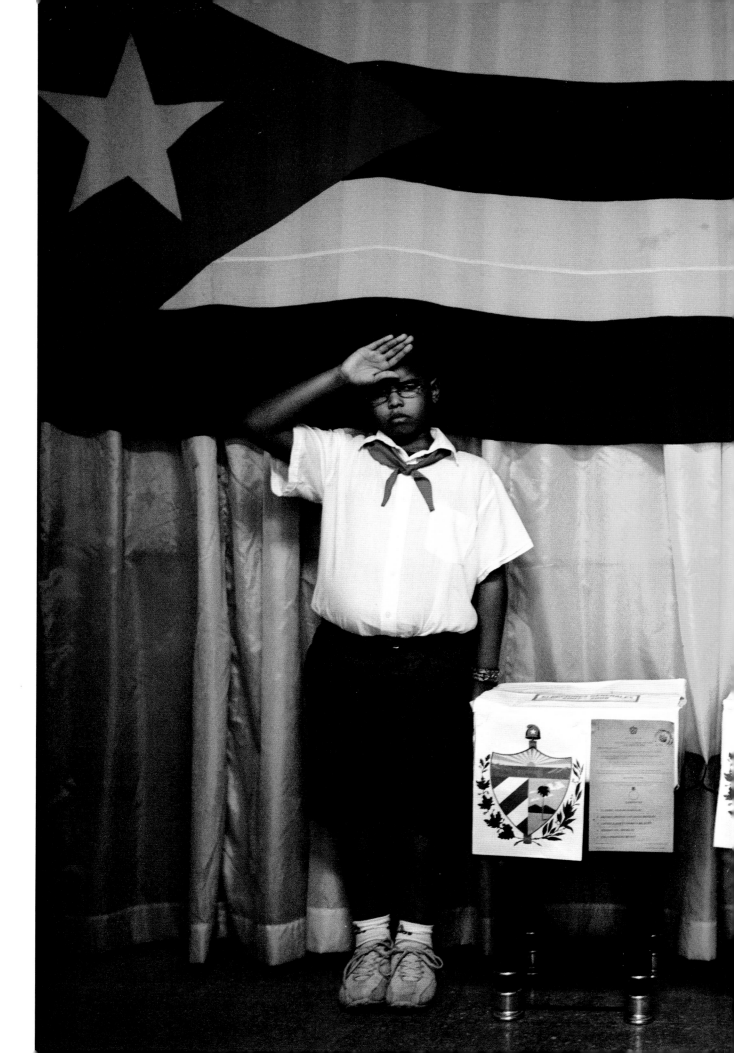

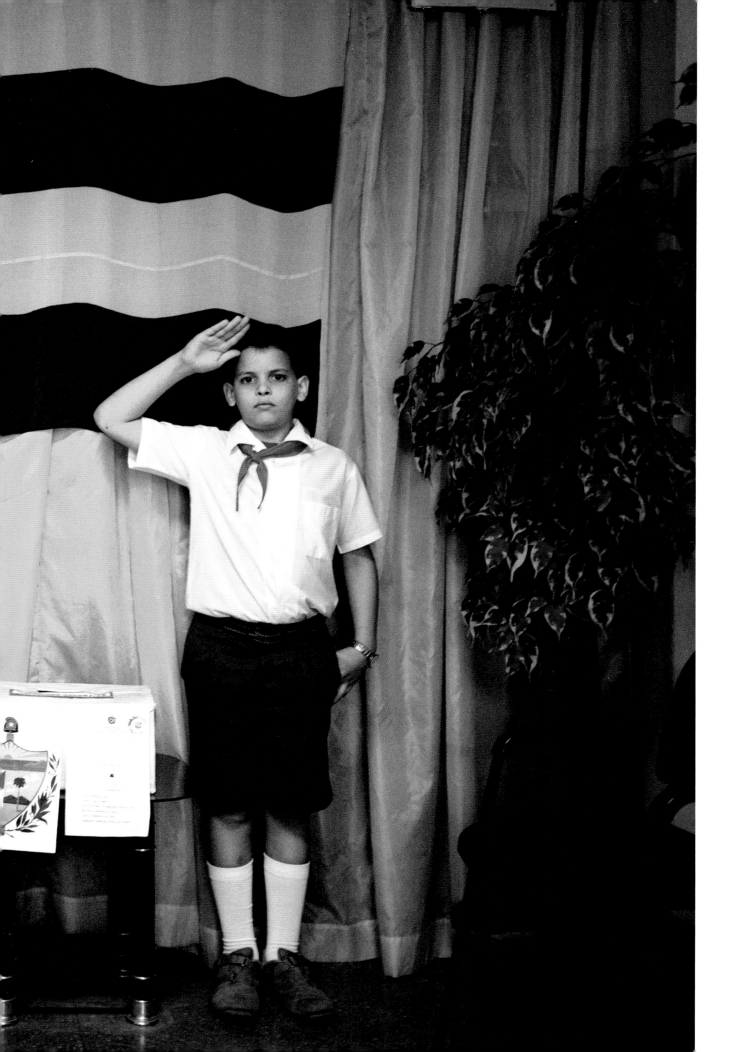

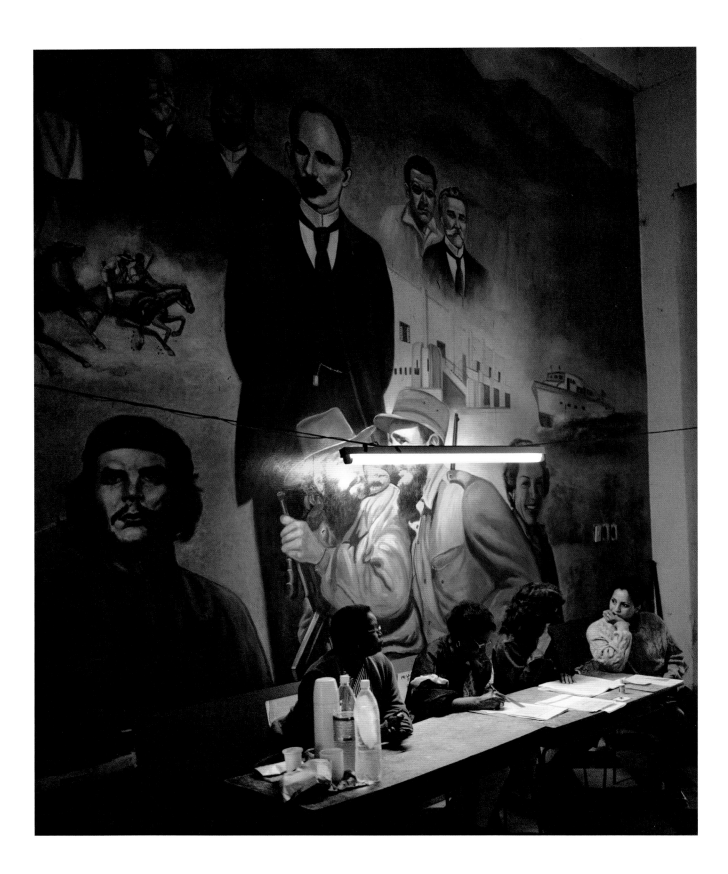

**20th January 2008 – elections, provincial and
national assemblies of popular power**
20 de Enero 2008 – elecciones, Asambleas
Provincial y Nacional del Poder Popular
Colegio Electoral Nrc 3, Prado, Habana Vieja

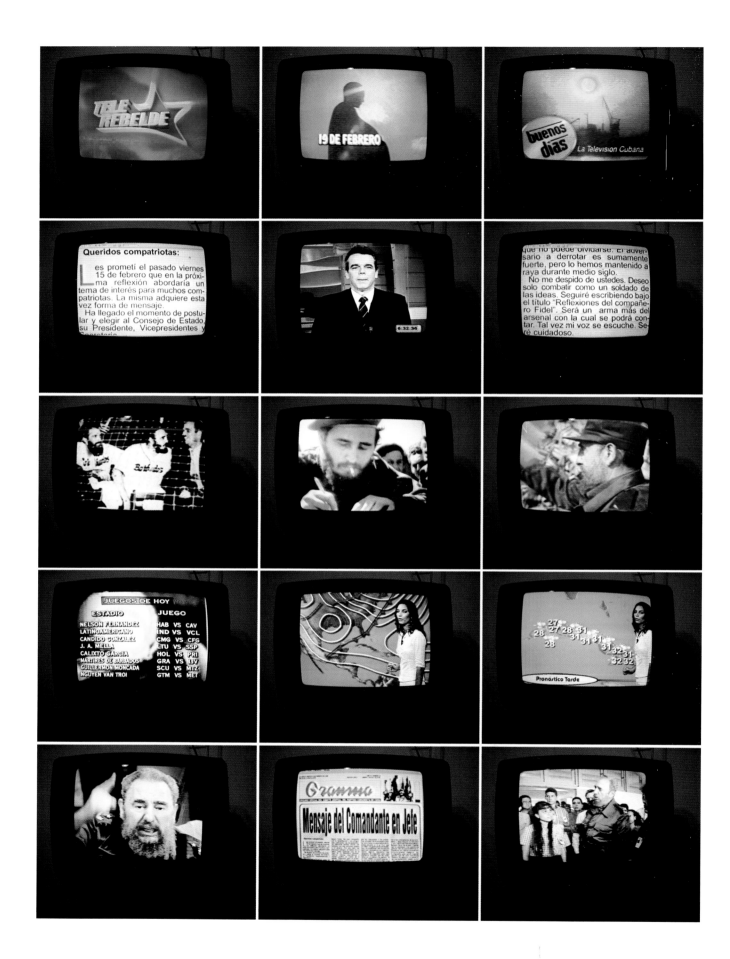

Floiran Arencibia
Journalist, Cuban television
Periodista, Television Cubana
19th February 2008 - Message from Fidel Castro
announcing his retirement as President
19 de Febrero 2008 - Mensaje de Fidel Castro
anunciando su retiro como Presidente

Jesús Felipe Martell.
Newspaper seller, Juventud Rebelde
and Granma
**Vendedor de periódicos, Juventud
Rebelde y Granma**
Parque Central, Habana Vieja

Eusebio Leal Spengler
Deputy for the City of Havana, National Assembly
of Popular Power
**Diputado por Ciudad de la Habana, Asamblea
Nacional del Poder Popular**
Palacio de las Convenciones, Playa, Habana

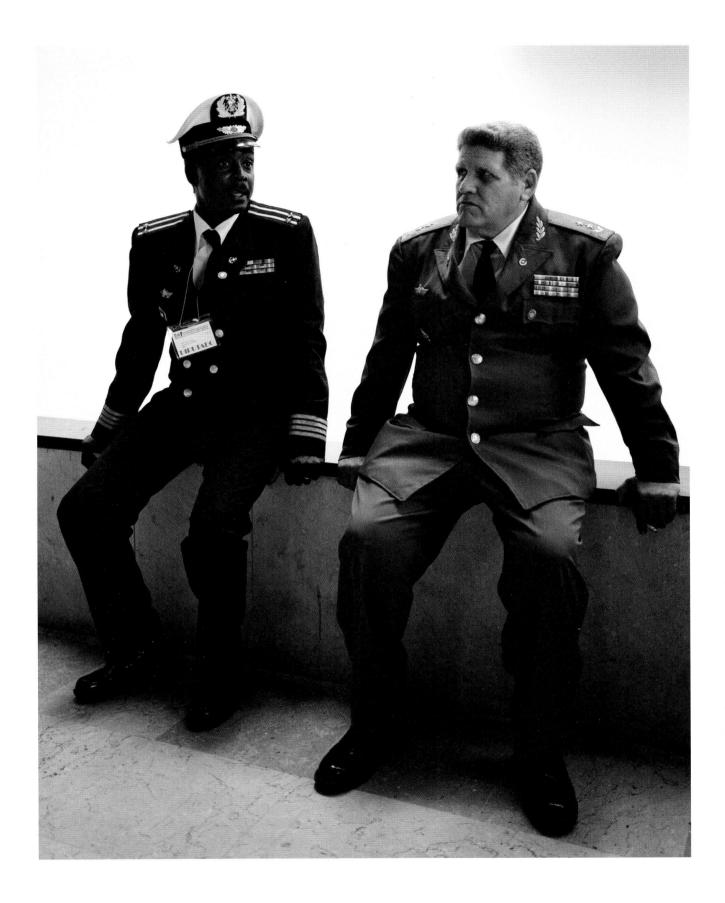

Carlos Lorenzo Garcia
Deputy for the City of Havana, National
Assembly of Popular Power
Diputado por Ciudad de la Habana,
Asamblea Nacional del Poder Popular
Palacio de las Convenciones, Playa, Habana

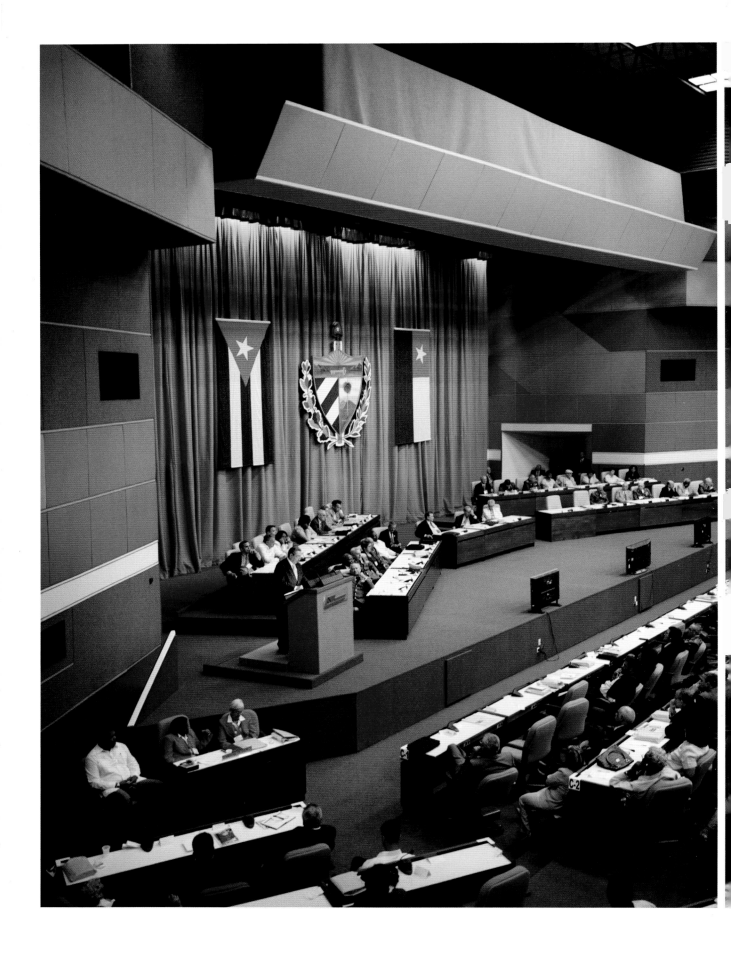

24th February 2008
Election of President Raúl Castro Ruz
24 de Febrero 2008
Elección del Presidente Raúl Castro Ruz

Seventh Legislature of the National
Assembly of Popular Power and Constitutional Session of
the Council of State, President, Vice-Presidents
and Secretariat

Séptima Legislatura de la Asamblea Nacional del Poder
Popular y Sesión Constitutiva del Consejo de Estado,
Presidente, Vice Presidentes y Secretario
Palacio de las Convenciones, Playa, Habana

los pecadores dondequiera que pudiera encontrarlos.

"Y usted... supongo que es episcopal", me tanteó sor Rita.

Estoy seguro de que a la hermana no le habría importado en absoluto, pero no tuve el valor de decirle que yo era santero, o más bien que estaba situado en algún punto del camino que conducía a la iniciación, ya que habían sacrificado un pollo sobre mi cabeza en una ceremonia solemne en la trastienda de una casa, no lejos del hotel Nacional.

Durante la última década o algo así, causa extrañeza que la religión no se haya sumado a esa moda por todas las cosas cubanas, pero es parte de la respuesta a la eterna pregunta: ¿Cómo diablos han podido mantenerse a flote los cubanos? El 75 por ciento de los isleños es adepto a la religión católica, o a su exótica versión distorsionada, la santería, incluido, según se dice, el propio ex monaguillo Fidel Castro. La procesión en Rincón atrae fácilmente a 50.000 personas cada año.

Y ahora la ineludible pregunta sin respuesta: ¿Qué le aguarda a Cuba ahora? Como dije anteriormente, en abril de 2009 el nuevo Presidente de los Estados Unidos, Barack Obama, suavizó las restricciones de los Estados Unidos a los contactos con la isla. Facilitó el envío de remesas de dinero de los cubano-estadounidenses hacia el añorado país, así como de los esperados regalos de ropa y artículos de baño. Pero lo que más entusiasmo causó fueron las nuevas facilidades otorgadas a los miembros de la diáspora cubana, a sus hijos y nietos, para que visiten a sus parientes de la isla. Hasta la reforma de Obama, estos encuentros sólo eran posibles una vez cada tres años.

Entonces, ¿se puede decir que el embargo está a punto de llegar a su fin? ¿Cuál será el resultado de una mayor presencia empresarial? ¿Saldrá Cuba de la vieja sartén oxidada de Fidel sólo para aterrizar en el fuego —las incesantes parrillas, en este caso— de McDonald's y Burger King?

Aunque muchos analistas le dieron una buena puntuación a Obama por su audacia, son pocos los que creen que esté dispuesto a suprimir el embargo por completo mientras existan votos en juego en la Florida y Nueva Jersey. Allí, los dirigentes de la comunidad en el exilio sólo querrán estrechar la mano de cualquiera de los hermanos Castro con un cuchillo bajo la manga. Y de alguna manera es difícil imaginar una solución china trasplantada, en la que el partido comunista mantenga la soberanía política mientras deje que florezcan mil centros comerciales. ¿Será Cuba el tigre latinoamericano? Miren la isla en un mapa. No es un dragón que respira fuego, sino un cocodrilo,

disfrutando del calor del sol en el vehemente Caribe. Seguramente el talento de los cubanos para la improvisación producirá, de alguna manera, una solución criolla, si los santos lo permiten.

Pongamos punto final a los retratos de este álbum metafórico; ahora el lector puede dedicarse a la tarea —esta sí, real— de apreciar la galería de cubanos de Clive Frost. No todos podemos aspirar a su sorprendente don para producir imágenes. Pero incluso el menos adicto a éstas, cuando se ve expuesto a Cuba, sale de allí con una memoria fotográfica.

Stephen Smith
Abril de 2009

Cover (and front cover/back cover spread)
Cubierta (y desplegable de la portada/
contraportada)
28th January – March of the Torches, 155th
anniversary of the birth of José Martí
28 de Enero - Marcha de las Antorchas, 155
Aniversario del Natalicio de José Martí
Universidad Alma Mater, Vedado, Habana

Inside Front Cover Spread
Interior del desplegable de la portada
Marriage Palace
Palacio de Matrimonios
Holguin

Inside Back Cover Spread
Interior del desplegable de la contraportada
Calle Neptuno
Centro Habana

Dedicated in gratitude to the loving memory of my parents
Dedicado en agradecimiento a la entrañable memoria de mis padres

John (Johnnie) Frost 28/2/1915 – 31/1/2004
Elizabeth (Betty) Frost 19/5/1920 – 14/12/2007

Their lives encouraged me to travel and explore the world
Their love and support made this possible in my life
Sus vivencías me animaron a viajar y a explorar el mundo
Su cariño y apoyo han hecho posible que pueda realizar este sueño

My sincere thanks to the following people who made this project possible
Mi más sincero agradecimiento a las siguientes personas, ya que han sido quienes han hecho
posible este proyecto
Igor Caballero, Mabel García, Rául Gónzalez Hernández, Armando Briñis Zambrano,
Carina Soto, Centro de Prensa Internacional, Magdalena García Moreno, Juan Carlos
Figueroa, Alan Pérez, Marguerite Caris Manzano, Katrin Pors, Isis Garcia Menendez,
Hosé Luis López y Miraida, Elizabeth Frost, Derek Frost, Yamila Santos Perez and all my other family
and friends who encouraged me to go.
Book Design Diseño del libro Marcus Haslam – marcus@hasdesign.co.uk
Images Post Production Imágenes posteriores a la producción Joe Thomas – www.joe-digital.com

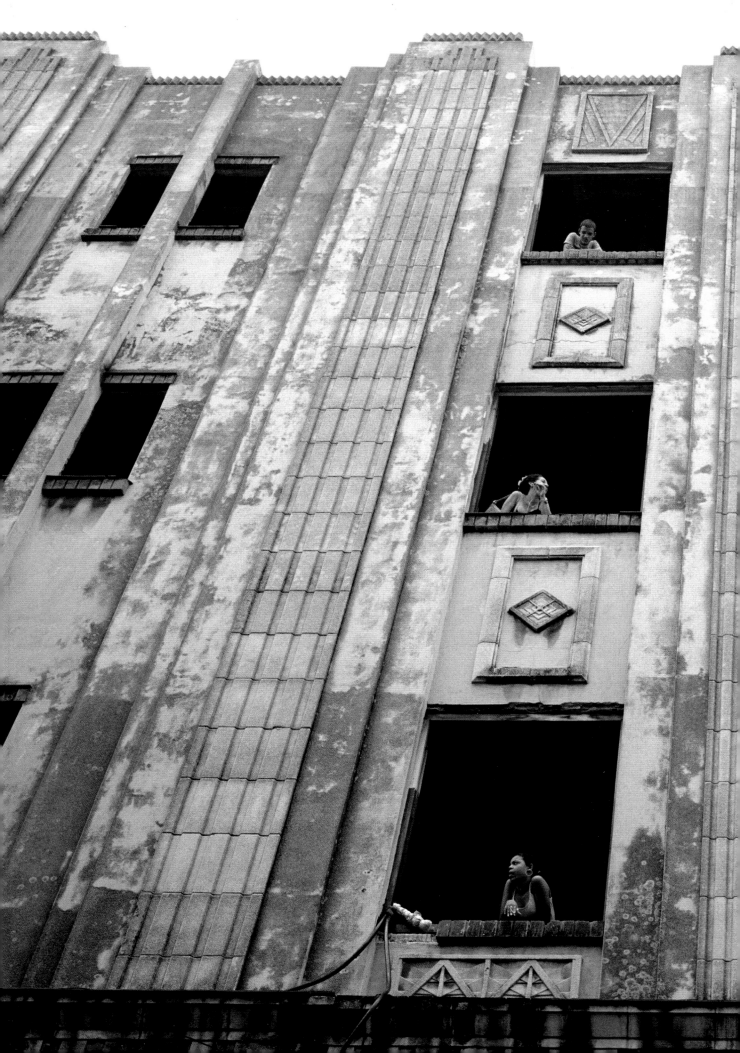